T0290524

MANAGING ARTS ORGANIZATIONS

MANAGING ARTS ORGANIZATIONS

DAVID ANDREW SNIDER

ROWMAN & LITTLEFIELD
Lanham • Boulder • New York • London

Published by Rowman & Littlefield
An imprint of The Rowman & Littlefield Publishing Group, Inc.
4501 Forbes Boulevard, Suite 200, Lanham, Maryland 20706
www.rowman.com

86-90 Paul Street, London EC2A 4NE

Copyright © 2022 by David Andrew Snider

All rights reserved. No part of this book may be reproduced in any form or by any electronic
or mechanical means, including information storage and retrieval systems, without written
permission from the publisher, except by a reviewer who may quote passages in a review.

British Library Cataloguing in Publication Information Available

Library of Congress Cataloging-in-Publication Data

Names: Snider, David Andrew, 1970- author.
Title: Managing arts organizations / David Andrew Snider.
Description: Lanham : Rowman & Littlefield, [2022] | Includes
 bibliographical references and index.
Identifiers: LCCN 2021037554 (print) | LCCN 2021037555 (ebook) | ISBN
 9781538160633 (cloth) | ISBN 9781538160640 (paperback) | ISBN
 9781538160657 (epub)
Subjects: LCSH: Arts--United States--Management. | Arts--United
 States--Management--Case studies.
Classification: LCC NX765 .S65 2022 (print) | LCC NX765 (ebook) | DDC
 700.68--dc23
LC record available at https://lccn.loc.gov/2021037554
LC ebook record available at https://lccn.loc.gov/2021037555

∞™ The paper used in this publication meets the minimum requirements of
American National Standard for Information Sciences—Permanence of
Paper for Printed Library Materials, ANSI/NISO Z39.48-1992.

For Alex, Henry, and Della, who make all things possible.

CONTENTS

A NOTE TO INSTRUCTORS

Managing Arts Organizations is aimed at students, educators, and working professionals. A free accompanying Instructor's Manual with interactive activities and lesson guides is available as a pdf by emailing textbooks@rowman.com. A free online cache of electronic, adaptable documents can be found at https://thedavidsnider.com/documents/. The password to access these documents is included in the Instructor's Manual.

I have taught arts management at the graduate and undergraduate levels for over a decade. I teach from the perspective of a working arts leader, using real-world examples, interactive activities, and practical exercises in the classroom because I believe our job as educators is to prepare students to succeed as arts managers now. I wrote *Managing Arts Organizations* in part because I wished for a more practical textbook that could help students and early career professionals understand arts management from a practitioner's perspective and activate their work with real-world knowledge.

In the Instructor's Manual, I lay out activities and lessons across a typical fourteen-week semester, but the exercises can be adapted and implemented in any order. Each week uses specifically related chapters. Every chapter has at least one related activity. The exercises and lessons can be used for in-class activities and assignments, or as homework, and will help regular readers advance their understanding as well. The online cache of documents includes budgets, exercises, and planning documents aimed at helping you actively explore and practice the ideas and activities in *Managing Arts Organizations*. I hope these accompanying resources help you use *Managing Arts Organizations* to advance your own work. Good luck!

PREFACE

What's past is prologue.

—William Shakespeare, *The Tempest*

The status quo is gone. The arts field is resizing, recombining, rethinking. Artists are creating directly for audiences online. Creativity is needed now more than ever, in all aspects of our lives. And as with any moment of cataclysmic disruption, the old rules no longer apply.

It's a new frontier for creating the future we want to see. It's a frightening time but also a glorious time to find—or redefine—how we manage the arts. Social justice is more important than ever. The lack of diversity, equity, and inclusion in the arts will no longer be tolerated. Digital content is exploding and here to stay, even in the nonprofit arts. The global pandemic may be the first major disruption to arrive in the twenty-first century, but it will certainly not be the last. Gone are the days of long-term subscriber bases and captive audiences. Arts organizations must become more flexible, adaptive, and nimble in order to survive and thrive.

Over the past thirty years, managing and leading the arts has developed into a thriving sector, as more and more organizations recognize the need for professionalism in producing, marketing, and supporting the arts. Arts organizations once felt they needed managers with backgrounds in for-profit business to guide and grow the business side of the arts. This led to a divide between artists and staff leadership, as one side was deemed creative and the other side "management." But in recent years, more and more arts managers are coming from the creative side, bridging the gap with artists and leading organizations with creativity and innovation.

The arts themselves are recognized as a primary economic driver, with gentrification and for-profit businesses following arts organizations into developing neighborhoods and reaping huge benefits. What's more, service organizations such as the National Assembly of State Arts Agencies (NASAA), informed by recent surveys from the National Endowment for the Arts and the U.S. Department of Commerce, testify

to the billions of dollars generated by the arts sector each year: "The value of arts and cultural production in America in 2019 was $919.7 billion, amounting to 4.3% of gross domestic product. The arts contribute more to the national economy than do the construction, transportation and warehousing, travel and tourism, mining, utilities, and agriculture industries."[1]

The growth of arts management as a field has engaged thousands of the best and brightest in our society as professionals and led to the development of degree programs at both the undergraduate and graduate levels across the United States, as well as inspiring an entrepreneurial spirit in millions toward managing their own arts careers independently. At the same time, arts management has become, in many ways, its own art form, as inspired and inspiring leaders have solved problems creatively and developed new ways of thinking in successfully leading the arts. A budget can sing beautifully, or clash harshly, with our mission. A fundraising campaign can inspire artists and artistry—or it can deflate and depress an organization. Great management invites creativity. Vibrant artistry welcomes strong management.

Managing Arts Organizations is aimed at students, educators, and working professionals. My purpose is to provide a playbook for anyone interested in navigating the arts and arts management in this new era. Through focused chapters, relevant case studies, and engaging interviews, I share how to adapt and innovate in these extraordinary times. Each chapter offers a set of guiding principles, followed by a more detailed exploration of the topic. From building programs and creating partnerships, to developing financial tools and deepening funding relationships, I share what I've learned as an arts leader from an artist's perspective and illuminate how arts management has become an art unto itself, with its own inspirations, its own craft, and its own challenges. I demonstrate how running an organization in a big city or a tiny town can be completely different—and how it can be the same.

I reveal how choices in staffing, funding, and programming propel and sustain— or detract from—an organization's ability to deliver on its mission. I show how core principles in financial management, programming, and planning can guide innovation and growth, even in the face of disruption. Each chapter offers practical tools for arts managers, including budget and planning documents, which are also provided electronically online so that readers can use and adapt these documents for their own practices. I also share experiences and insights from eleven other arts leaders focused on dance, music, theater, visuals arts, social history, philanthropy, and services for the field throughout the United States, to gain their shared wisdom and decades of experience.

An accompanying Instructor's Manual lays out interactive activities and lesson guides to help instructors and students deepen their learning. By the end of the book, readers will understand prevailing issues in arts management, from a diverse array of perspectives across disciplines and locations. With *Managing Arts Organizations*, students and working professionals will gain practical insights into how to succeed as an arts manager today, and the tools, processes, and best practices necessary for a career in arts management.

The content of *Managing Arts Organizations* was developed from twenty-five years of experience as an arts manager and ten years in the classroom teaching arts management at the graduate and undergraduate levels, along with a year of research, weeks of

interviews, and discussions with peers across the country. Each chapter is focused on a specific topic, with principles, stories, exercises, advice, and best practices related to that topic. The appendix includes eight case studies, each illuminating issues in arts management via a real-world scenario or organization. These narratives will enhance the reader's understanding of topics, including financial management; diversity, equity, and inclusion efforts; and accessibility across multiple disciplines, and represent more than five years of research and piloting of these cases in the classroom. Chapters include:

1. *Finding Our Purpose*: Why are you pursuing this work? By gaining clarity on why we do what we do, we build a stronger foundation as arts managers. This chapter challenges readers to articulate their purpose.

2. *Focusing on Our Principles*: What are the core principles of arts management? How can these principles inform our work? This chapter provides twelve core principles of arts management and how to apply them.

3. *Defining Mission, Vision, and Values*: How can organizations clearly and dynamically define their mission, vision, and values? What makes for a clear mission statement, substantive values, and a compelling vision? This chapter demonstrates how to develop mission, vision, and values statements and examines several real-world examples.

4. *Building Programming*: How do arts managers develop programming in dance, theater, visual arts, music, and for multidisciplinary events? This chapter explores how to build programming from the ground up, including how to budget for a new event.

5. *Growing an Organization*: How can you start a new arts organization? This chapter provides readers with step-by-step instructions on how to create and develop a nonprofit arts organization.

6. *Pursuing Diversity, Equity, and Inclusion*: How can you authentically and effectively pursue diversity, equity, and inclusion? What challenges exist? What backlash might we expect? This chapter provides an examination of this pursuit across disciplines, including achievements, challenges, and failures.

7. *Raising Money*: How can you raise money for the arts, including from individuals, foundations, corporations, and government agencies? This chapter delineates every aspect of fundraising for the arts, with specific lessons on making an ask, developing a moves management system, and growing relationships.

8. *Managing Money*: How are mission and money connected? How can financial tools and internal controls strengthen our companies and programs? This chapter teaches the basics of financial management for the arts, while also giving readers strategies on how to best support the work of the organization via strong and clear financial management. It includes lessons on the fiscal year, internal controls, and the avoidance of fraud.

9. *Budgeting Strategically*: How can you budget in a way that clearly supports your mission? This chapter guides readers through the budgeting process for an organization, including how to develop a budget over time. Various approaches

to budgeting and budget narratives are explored, with an emphasis on clearly communicating the organization's priorities and values by the numbers.

10. *Managing People*: How can you create the conditions for everyone to succeed, including yourself? This chapter explores how to successfully manage people, including approaches to job descriptions, evaluations, meetings, and communications. It also includes direction on how to manage staff and a board of directors.

11. *Engaging Audiences*: How can you effectively market the arts in the twenty-first century? How do you engage audiences who have so many options for engagement on their screens? This chapter explores strategies for audience engagement and the value proposition of live, real-time events in an age of Twitter and continual streaming. It is a deep dive into practices in arts marketing and audience engagement.

12. *Inspiring Students*: How can arts education programs inspire students, develop communities, and strengthen arts organizations? How can you develop a program from the ground up? What makes an arts education program sustainable? Best practices and guidelines for creating authentic, engaging, and prosperous arts education programs are discussed.

13. *Activating Communities*: How can you initiate and manage community arts projects aimed at enriching our communities while building partnerships, funding, and organizational growth? This chapter offers several brief case studies in community-based projects, including partnerships with the U.S. Department of Justice, the Fannie Mae Help the Homeless Program, the Smithsonian, and the White House.

14. *Adapting from City Mouse to Country Mouse*: How does arts management differ in urban and rural environments? What roles do arts organizations serve in rural versus urban communities? What's different and what's universal? This chapter will compare the role of the arts in rural and urban communities. Readers will learn about the strengths and challenges of each of these communities via research and real-world examples. They will also gain strategies in how to approach fundraising, programming, and organizational development depending on their environment.

15. *Rebuilding an Organization*: How can we rebuild an organization on the brink of collapse? What are the many factors involved in such a rebuild, from programming to board development to fundraising? How can we prioritize and plan for long-term and short-term goals toward success? This chapter examines how an arts manager can turn around a faltering organization and leave it thriving. This chapter includes issues of planning, fundraising, board and staff development, programming, outside partnerships, and financial management.

16. *Following a Founder*: How can you successfully succeed a founder? Why does this important transition often fail? How can you avoid common mistakes and lead an organization into a new stage of growth? The chapter includes practical lessons on how to successfully follow a founder as the new executive

or artistic director of an organization, based on four real-world examples of success in various disciplines and environments.

17. *Listening to the Field*: What are current arts leaders and managers thinking about the state of arts management in the early twenty-first century? How are organizations in multiple disciplines (theater, music, visual arts, dance) approaching their work in this challenging new age? Readers will hear from leaders from throughout the arts field and gain insights into the ways careers in arts management are changing, along with organizations and their programs.

18. *Looking Forward*: How have things changed in the wake of the global pandemic? What will return, and what may remain changed forever? This chapter examines trends and innovations in the arts world. Readers will gain insights into how funding, performances, programs, communications, and the overall arts ecology may be forever changed by this global event, as well as roles they may play in building arts organizations and activities in the twenty-first century.

The appendix provides eight real-world case studies demonstrating how practices in arts management can enhance or detract from the health of an organization, artist, or art itself. Three cases are based in the world of museums or the visual arts. The other five cases focus on a small-town municipality, a theater, an arts service organization, an arts education nonprofit, and a multidisciplinary arts center located in a rural community.

APPENDIX: CASE STUDIES

1. *The Case of the Indianapolis Museum of Art*: Why would a major art museum announce its desire to maintain its "traditional, core, white audience"? An ill-advised job listing leads to a leader's resignation. What lessons can we learn?

2. *The Case of Beeple and Breonna Taylor*: Will the visual arts become more expensive and exclusive, or can it inspire a new age of accessibility and social justice? A study of two very different paths in the visual arts: one toward equity, social justice, and collaboration, and the other toward wealth, exclusivity, and digital innovation.

3. *The Case of* Scaffold *at the Walker Art Center*: How can a series of missteps result in one huge mess? An ill-conceived art installation explodes into a major reckoning for an arts organization and an artist.

4. *The Case of Rita Crundwell*: A small-town controller embezzles over $53 million from her friends and neighbors. How did she do it? What could have stopped her? How does this case apply to arts organizations today?

5. *The Case of Theatre de la Jeune Lune*: A renowned theater company received the Tony Award in 2005. Three years later, the company was dead. What happened and why?

6. *The Case of Healing Arts Initiative*: A new leader discovers fraud at a beloved service organization. Within two years, the organization is gone. Why?
7. *The Case of Young Playwrights' Theater*: A small company dedicated to arts education demonstrates how to survive and thrive in the face of crisis. What elements were crucial to their success?
8. *The Case of Hubbard Hall*: A rural arts organization expands its programming and returns to its progressive roots. What role can a multidisciplinary arts organization play in the middle of farmland?

Through all of these chapters and case studies, readers will gain the skills and insights they need to innovate and adapt as arts managers.

There's no money. There's little hope. There are huge obstacles in the way. But there is a mission. A vision. A purpose. A passion. Great arts managers engage, adapt, and innovate with passion and purpose every day.

I was first an actor. Then a director. Then an educator. Then a manager. I was lucky enough to get jobs I was totally unprepared for and gain the opportunity to truly "fake it 'til I made it." Managing a staff or faculty, creating budgets, developing curricula—all of these are skills I've developed on the job, with real stakes attached. Because my training has been practical and peer based, I've always had a strong eye for what truly matters and how to adapt to new circumstances. How can we create, sustain, and improve great programs? How can we build organizations while developing people? How can we enhance lives—both those we serve and those who are serving—to create positive change in our world?

Managing Arts Organizations is for everyone who hungers to serve the world around them. It will give you a chance to live and learn through my experiences, including my mistakes. It will give you the skills and insights you need to manage the arts. It will give you a roadmap toward making meaningful change in the world.

I hope this book moves you—and moves you to take action in your own lives. To find a purpose beyond yourself. To find your mission and pursue it. To make the world a better place, from your own corner of the globe.

Let's begin.

NOTE

1. National Association of State Arts Agencies. "Facts & Figures on the Creative Economy." Last modified spring 2020. Accessed June 6, 2021. https://nasaa-arts.org/nasaa_research/facts-figures-on-the-creative-economy/.

ACKNOWLEDGMENTS

I have so many people to thank for making this book possible: First to my family—Alex, Henry, Della—who bring me joy every day, but especially to Alex, who gave me the love, space, and support to get all of this done. To my sister, Ann Hefflin, who inspires me as an educator every day. To my dear friend Darrin Bodner, for all the laughter and guidance over the years. Thanks to my in-laws, Bill and Barbara Arnold, for their constant love and help. To my parents, Brenda and the Rev. Dr. Marlin Snider, who taught me to pursue a mission-based life through their example. Thank you. I love you.

To my editor, Charles Harmon, who believed in this book and gave me wonderfully thoughtful feedback and guidance throughout the process. To Erinn Slanina, who cheerfully answered my endless questions and advised me with grace. To my colleague Katherine Danforth, for her careful and insightful proofreading. To all of the amazing arts professionals who enthusiastically and generously gave of their time, spirit, and experience, including Ben Cameron, Karen Zacarías, Anna Glass, Sarah Craig, Robert Barry Fleming, Nancy Yao Maasbach, Lisa Richards Toney, Chad Bauman, Mary Ceruti, C. Brian Williams, and Deborah Cullinan. Thanks to Jordan Oldham and Anna Glass of Dance Theatre of Harlem, Rachel Neville and Andrew Fassbender of Rachel Neville Studios, costume designer Natasha Guruleva, and dancers Jenelle Figgins, Emiko Flanagan, and Ingrid Silva, for allowing me to feature their work on the cover of this book. It is one of the most beautiful pieces of art I have ever seen, from the dynamics of the dance to the dancers to the flow of costumes and finally to the genius of the photography. This is art worth fighting for. All glory and tribute go to the artists themselves, to Dance Theatre of Harlem, and of course to Mr. Arthur Mitchell, who set an example for so many of us. Thank you.

Finally, a huge thank-you to all of my colleagues over the past twenty-five years, who guided me, taught me, and inspired me. To my mentors, Zelda Fichandler, Liviu Ciulei, Ron Van Lieu, Janet Zarish, Rosemarie Tichler, Ken Washington, Todd Wronski, and Robert Hupp. To the amazing board chairs with whom I have worked, including Russell Stevenson, Brian Kennedy, Miriam Gonzales, Andrew Pate, Jim

Reid, W. B. Belcher, and Margaret Surowka. To the two best bookkeepers on the planet, Leland Larsen and Anne Dambrowski, and to the best board treasurer ever, Judy Pate.

To my colleague David Howson at Skidmore College, who directs the Arts Administration Program with such intelligence and care. To Sherburne Laughlin and Ximena Varela at American University, who welcomed me into the faculty there and continue to wow me with their leadership and care of students. To the artists and managers who have joined me in the classroom over the years and added so much with every visit, including Donna Walker-Kuhne, Diane Ragsdale, Rachel Grossman, Morris Vogel, Elizabeth Sobol, and Dr. Barry Oreck.

To Patrick Torres, Brigitte Winter, Elizabeth Andrews Zitelli, Liza Harbison, Laurie Ascoli, Alison Beyrle, Yvonne Plater, Karen Evans, Jennifer Nelson, Karen Zacarías, Wendy Nogales, Molly Smith, Jocelyn Clarke, Dan Pruksarnukul, Linda Lombardi, Amrita Ramanan, Amelia Acosta Powell, Kathleen Masterson, George Grant, Nicole Bryner, Bryn Thorsson, Niki Jacobsen Torres, Dawn McAndrews, Joe Angel Babb, Katherine Danforth, Colleen Viera, Kristoffer Ross, Benjie White, and Darcy May.

I have been so lucky to work with all of you. Thank you.

1

FINDING OUR PURPOSE

What I really wanted was to help people be their best selves.

—Sarah Craig, executive director, Caffé Lena[1]

It is vitally important to define why you are pursuing this work, so that when times are tough, you can remember and stand fast on the bedrock of what you believe. Before defining your mission, vision, and values, here are ten steps to help you find and focus your purpose as an arts manager.

1. *Ask Yourself Why You're Here.* Why have you chosen a career in the arts? Years ago, I realized my professional mission is "to make things a little better." This sometimes seems too simple. But it fits and motivates me. Everywhere I go, every job I do, I seek to make things better, in any way I can. From improving an organization's finances to increasing its impact in the world, this mission or mantra keeps me focused and lets me know that I am doing enough today. Why are *you* here?

2. *Find Small Ways You Can Serve.* Look for ways you can help others in any job you do. Follow through and deliver results, however small they may seem. Being helpful and maintaining a positive attitude will eventually make you indispensable.

3. *Keep Your Focus on Others.* We all tend to drift back to worries about ourselves, many of which are valid. But if we can invite our focus to stay on others, we will find greater energy, purpose, and momentum toward outside tasks and meaningful work. When you feel yourself turning inward, challenge yourself to refocus outward. If you are awake to the environment and the people around you and able to offer them help, they will notice. Your efforts will pay off. Retune yourself to seek opportunities outside yourself.

4. *Challenge Yourself.* Approach every job as an opportunity to learn. Engage in work that pushes you past your comfort zone. Seek lessons and growth even in

1

the most mundane tasks. If a job is mostly focused on stacking boxes, seek the lesson in stacking those boxes. Maybe you need to learn patience, or focus. Or maybe you need to build up your back and arm muscles. Or maybe you need to practice being more in the moment. You can approach your work one of two ways: either as a *chore* to survive or as an *opportunity* to learn. The latter gives you opportunities to grow; the former is simply a waste of precious time.

5. *Pick Work That Aligns with Your Purpose.* This can be daunting and difficult, but millions of people spend decades doing work they hate. Or, worse yet, they do work they are ambivalent about. You might need to start with an internship or entry-level position. But if you spend some time looking at what kind of *work* and what kind of *people* you want to give your time to, you will start on a path where your values and career choices can align, more or less, going forward. What's more, once you experience work you believe in, you will know what it feels like and be able to adjust down the road, if and when you find yourself in work that is unfulfilling.

6. *Listen, Learn, and Push.* Once you gain the job, listen to what has happened there before. As a good mentor and friend advised me early in my first leadership position in an organization, "You need to sniff the fire hydrant before you pee all over it." Take some time to listen to the place, the programs, the rest of the staff. Seek out their insights and advice. Have one-on-one discussions. Take them to coffee or lunch. Open your door to their input. Then slowly start rearranging the chairs based on what you are learning and your vision for the future. Some changes can be quick, but mostly they should be on the periphery. If you find yourself in charge of an arts education program lacking a clear curriculum, with no faculty to teach it, and no tools to assess student learning, try not to throw up your hands and yell, "This stinks! We've got to blow this thing apart!" Instead, dive deep into understanding why the program is so beloved. Spend as much time as you can in the program. Work with the students. Teach it yourself if you're qualified and have time. Once you gain firsthand experience, start to tweak things, writing out the workshops, enlisting new teaching artists, implementing basic assessments that aim to reflect how well the program works. Then, a little more each month, each semester, each year, the program will grow. The great idea or feeling behind it can still be the core, while you finally, clearly define the why, how, when, who, and where of it all.

7. *Invest in People.* Find smart, hardworking, like-minded people and recruit them to your cause and company. Look for people doing similar work, either within your organization or elsewhere, and have a conversation about the work. Invest in your people. Create clear job descriptions, titles, salary levels, and assessment tools for job performance. Give employees the power to develop their part of the organization, stay in touch about their efforts with regular sit-downs, but also let them do their work. Fight for them—for recognition, for raises in salary, for their ability to do their work. Advocate for them, with your board, fellow staffers, funders, and the general public.

8. *Find Ways to Collaborate.* To create a deep impact via your work, find ways to partner and cross-pollinate your work with others. If you're with a tiny organization, once you've articulated what makes you special, approach larger organizations with a chance for them to gain from collaborating with you. Is there some kind of project you do that they cannot? If you're a larger organization, find ways to work with smaller organizations, assisting them perhaps with space or resources they lack, while gaining for yourself by highlighting your greater service to the field. In any case, once you expand your reach by linking arms with others, you open thousands of new doors toward impact. Your capacity grows, as does your profile. You gain a chance to bring your stakeholders to new opportunities, while being able to serve a new constituency via your partners. You can create sustainable programs and share some of the weight of the work.

9. *Assess Your Work.* Get serious about assessing what you do. Ask all the questions. Why does this part matter? Why are we doing this? What's the outcome we seek? Once you have asked the questions and rewritten your programming based on your interrogations, you are ready to zero in on what you intend to assess. What outcomes are most important to you? What do you feel you can really claim as a benefit you offer participants (as opposed to things they may gain elsewhere)? Then build out and experiment with tools to assess whether this growth has happened.

10. *Inspire and Be Inspired.* Rally others to your cause, whatever it might be. Think and write about why your work matters. Practice your pitch. Demonstrate your passion through your good works and tell others they can do the same. They are already part of your work, as supporters, donors, stakeholders. Tell them what inspires you about *them*. Then find ways to be inspired yourself. Look for good, brave work. Look for smart risk-taking. Look for people who inspire you. Take the time to meditate on them a tiny bit each day. Take in what moves you. Own your own work and the value you bring to the world.

NOTE

1. Author interview with Sarah Craig, May 5, 2021. All quotes from Sarah Craig that follow are from the interview, unless otherwise noted.

2

FOCUSING ON OUR PRINCIPLES

Arts management is an art form in the sense that it takes
courage and vision, like none other.

—Lisa Richards Toney, president and CEO of
the Association of Performing Arts Professionals[1]

INTRODUCTION

Arts management is the practice and profession of organizing, resourcing, and delivering the arts to audiences. Arts managers support artists in their work, with money, space, and time, while ensuring audiences can access their artistry via marketing, structure, and opportunity. Arts management became a modern career as part of the huge growth in the arts sector over the past sixty years.

In the last twenty years, arts management has become an art form unto itself. Some organizations, like the International Art School in Paris, think of arts management as reconciling two opposing sides: business and creativity.[2] But in my experience, arts management is more of a melding of business and creativity within each arts manager. Great management requires creativity. Productive creativity needs time management. Some of the best artists in the world, like Pulitzer Prize–winning playwright and screenwriter Katori Hall, run their rehearsal rooms like a well-oiled machine, clear on their creative objectives. Great managers, like Ben Cameron of the Jerome Foundation, are always thinking and working creatively.

No matter what role you play as an artist or arts manager, focusing on core principles will provide a solid foundation for thoughtful, collaborative, creative management.

FUNDAMENTALS

TWELVE PRINCIPLES OF ARTS MANAGEMENT

1. *Focus on the Art.* Remember *why* you do this work. It's to support, inspire, protect, and deliver great art to your community. Budgets, strategic plans, programs, and staff members can sometimes overwhelm us and make us forget why we began this journey in the first place. When you need inspiration, look again at the art. And if the art you are supporting does not satisfy you, ask why. Ask if it can grow. And if it cannot, move on.

2. *Money and Mission Are Deeply Connected.* If your mission is clear, your path to funding will be clear. If your fundraising is not working, you cannot deliver on your mission. The money you have and the mission you pursue rely on each other. You cannot have one without the other.

3. *An Organization Is Made Up of People.* Sure, you have bylaws, a budget, programs, and offices. There are regulations, policies, safety procedures, and handbooks. But your organization is really made up of people. How those people are treated—and how they feel about your mission—is at the heart of whether your organization will succeed or fail. Realize that every hire you make adds to the community of your organization in some way. Every committed link in support of your mission makes your organization stronger. Your organization is a living, breathing entity, and it lives and breathes through every person in it.

4. *It's a Marathon, Not a Sprint.* Unless you are hired as a consultant to do a short-term project, you should see yourself as a marathoner, not a sprinter. Pace yourself. Be in it for the longer haul. Take care of yourself. Eat well, get rest, spend time with your family. Avoid too many eighty-hour workweeks. Otherwise, when you finally cross the finish line, you will collapse.

5. *Make Friends.* Build a network of colleagues and peers for yourself outside your organization. Ask their advice. Share your work war stories. Grab coffee or lunch just to talk. Network and build partnerships with them. When you lead an organization, it can get very lonely. Even with a wonderful team and staff, only you know everything about the organization. Every person at your organization, including your board and staff, either supervises you or works for you. You need a network of peers outside the office to help you process your work and reflect your own value back to you, with no strings attached.

6. *Dream Big.* Find ways to have a big impact. See if you can create partnerships or projects that will put you in the news or create buzz for your organization while not costing much money. Think about how your mission might connect with larger organizations and serve a need they have, while they raise your reputation and public profile by association. Imagine how much your organization could grow in the next five to ten years, then start to map out a plan to make it happen.

7. *Plan, Plan, Plan.* From basic budgeting to strategic planning, make plans for how to get from A to Z. Make a strategic plan for the next two to three years of your organization. Then outline how your programs will grow as part of that plan. Plan projects two to three years in advance whenever possible. Create two- to three-year budget plans, to prepare for growth and/or changes in how your budget functions. Take the time to regularly plan. It's the only way to imagine your path forward so you can tell others where you are headed. A good plan will inform your decision-making, help your staff understand how their work fits the overall vision, and give you targets to pursue, so you are no longer just putting out fires every day but instead pursuing a clear vision and mission.

8. *Everything Is Interrelated.* One piece of the puzzle affects all the other pieces. If you improve how you budget, your fundraising and programming will improve. If you have an unhappy or uninspired staff, no amount of money or ambition will move them. If you decide to build or invest in a new space, recognize that everything else will change. Being aware that there are sinews across every aspect of arts management will keep you attuned to how one decision will affect many others.

9. *Listen and Lead.* Ensure you take the time to listen to your staff, the board of directors, your students, your funders—everyone with a stake in what you do. When appropriate, make decisions together. Then lead. Arts organizations and programs need leaders. Someone needs to take the first step and ensure the steps agreed upon are followed. Once a decision is made, keep listening to what everyone is learning, but make sure everyone is moving forward. Too often, once the decision is made, inertia sets in, and everyone feels so good about a decision that nothing goes forward from there. Push ahead.

10. *Balance Efforts with Resources.* Too often—especially in the arts—we push ahead with projects even without enough funding, staffing, or planning. Make sure you have the staffing, money, and time you need to pull something off. Ambitious projects are okay. But pushing through projects that are understaffed and underfunded only leads to burnout, regret, and often less-than-excellent art. If your board, staff, and funders are supportive of a project, ensure they know what it will really cost (including in time to recover from it) and show them the bill beforehand. Get their actual support—aka money and time—before committing to the project. Otherwise, you will be tap dancing on pins and needles, hoping the whole thing doesn't collapse before you can complete it.

11. *Keep Looking Forward.* Beware of getting bogged down in the challenges of a day, week, or month. Keep your eye on the prize of your long-term goals. What will the organization or program look like in two, five, or ten years? How are today's issues and decisions driving you toward (or away from) those goals? Take a breath and remember that today's problems are momentary compared to the long-term health of your mission and purpose.

12. *Ask Questions.* Too often we become socialized to believe we should already have all the answers. We believe only a dummy raises their hand and says, "I don't understand what you're talking about." But the truth is, there is great power in admitting you need more information—and in asking for it simply and directly. In every aspect of your work, never be afraid to ask questions. From budgeting to programming, there are too many aspects to understand all at once. Asking a question in a group meeting allows the group to further process and understand the answer—or to realize the answer does not yet exist and needs to be pursued for greater clarity. The strongest leaders often ask the most questions and are lauded for it. Because instead of keeping quiet, pretending to know something when they do not, and leading the whole place over a cliff, they are leading their teams to develop a culture of openness, rigorous investigation, and challenging the status quo.

FINAL THOUGHTS

These principles can serve as a foundation for our actions, especially during times of change and disruption. The circumstances and players may change. The core principles do not.

NOTES

1. Author interview with Lisa Richards Toney, April 23, 2021. All quotes from Lisa Richards Toney that follow are from the interview, unless otherwise noted.

2. IESA arts and culture, "What is art management?" Accessed March 27, 2021. https://www.iesa.edu/paris/news-events/art-management-definition.

3

DEFINING MISSION, VISION, AND VALUES

I think that we're about to go into a period of profound reorganization both in terms of our values, our missions, but also in terms of our philanthropic structures that will demand people think about themselves, communicate about themselves, and define themselves very differently than they have in the past.

—Ben Cameron, president of the Jerome Foundation[1]

INTRODUCTION

A clear, compelling, and easily understood mission statement serves as the touchstone for everything an arts organization does, which is why *getting it right is so important*. Why are you doing what you do? What guides your decision-making? Too often arts organizations allow their mission statements to drift or become outdated. As of this writing, the Museum of Fine Arts in Boston last updated their five-paragraph mission statement *over thirty years ago* on February 8, 1991.[2]

Sometimes staff members use different mission statements interchangeably. There might be one statement for fundraising, another one for programming, and another one on the website. Many staff members or board members opt not to bother with clarifying or updating the mission statement because there are so many fires to put out in their dysfunctional organization. This casual neglect of a mission is a huge mistake. A clear and compelling mission can solve a multitude of problems. It advances fundraising, because funders and donors are compelled by your focus; it drives programs with greater clarity and purpose; and it helps staff and board members prioritize decisions, based on the clear mission of the organization. Besides, without inspiration or clear direction, how can you do your best work? This chapter explores what it takes to create and maintain a clear mission, vision, and values for any arts organization.

FOUNDATIONS

FIVE FEATURES OF A GOOD MISSION STATEMENT

Creating a successful mission statement is not about astonishing people with compelling images or spicy verbs. It's about articulating a clear purpose for the organization that can be seen, felt, and assessed.

1. *Be brief.* A compelling and memorable mission statement is no longer than two or three sentences. If it's longer, you haven't figured out your true mission yet.
2. *Be specific.* Include where you are, what you do, why you do it, and whom you serve.
3. *Be different.* Why are you different from the thousands of others? Where are you located and why? How do you approach your art form(s) in ways unlike anyone else?
4. *Be exciting.* A good mission should make you sit up and pay attention. Anything that feels sleepy or too broad needs more work.
5. *Be impactful.* What impact do you seek? Why do you do what you do? Good mission statements focus on how organizations enrich lives, advance social justice, and heal communities via the arts instead of just "art for art's sake."

VISION STATEMENTS

Arts organizations often add a vision statement to express their intended impact and ethos. In the case of the Contemporary Visual Arts Network in the United Kingdom, their vision describes their approach to their work, while their mission specifically addresses what they intend to do. Their value statements further describe how and why they do what they do, as demonstrated on the next page in Box 3.1.

VALUES STATEMENTS

Values statements communicate an organization's priorities. They can be full sentences or single words. Ben Cameron, president of the Jerome Foundation in Minneapolis, Minnesota, says this about core values: "I was really shaped by a woman named Ronnie Brooks. I think her definition of a core value, which I've always carried with me and which I really ground myself in is that a core value, for an organization, has three discernible characteristics. She says basically a core value *permeates the organization.* So, if it's a core value for the artist and not the managers, it's not a core value. It's going to permeate the entirety of the organization, the board, and the staff.

"Second thing she says is every value has a *consciously rejected, yet equally viable, opposite,* which is really powerful to me. So, excellence is not a core value, because you can't choose to base your life on bad work. Excellence is a given. Financial responsibility is a given. Those aren't choices. What are you choosing to do and what is the thing

BOX 3.1. THE CONTEMPORARY VISUAL ARTS NETWORK³

Mission, Vision, and Values

The Contemporary Visual Arts Network represents and supports a diverse and vibrant visual arts ecology, embracing a broad range of artistic and curatorial practice across the nine English regions.

Our Mission is to support and promote the visibility and resilience of the contemporary visual arts ecology in England, advocating for our regional arts institutions, spaces, and artists, and working for a sustainable future for our world-class contemporary visual arts sector.

Our Vision embraces the broadest range of visual arts expression in a multidisciplinary, innovative, and resilient contemporary visual arts practice.

Our Values

We are sector led and mutually supportive.

We celebrate the distinctiveness and different contexts of the regions.

We embrace a broad range of artistic and curatorial practice.

We recognize and draw upon the expertise of regional groups to collectively build knowledge for the sector to share.

We are committed to collaborating and advocating for each other in order to benefit contemporary visual arts as a whole.

you were deliberately choosing not to do as the correlation? So, if you can't identify what you're going to stop doing, you got more work to do.

"And the third thing she always used to say is you'll know your core values because you'll continue to do it *even if you're punished for doing it.* It's a way to recognize it. And I've always thought that was really powerful for me. And every organization I've gone to, including Jerome, our first piece of work was to establish our core values and ground ourselves in values.

"My own observation is when I see organizations run into trouble, everybody is crystal clear on the mission, but there is wild disagreement about what the values are. And that a crisis will reveal the lack of cohesion around values. Whereas cohesive values make it possible for an organization to move very quickly in a time of crisis."

Here are the thoughtful, specific values articulated by Ben and the Jerome Foundation:

> *Diversity:* We consciously embrace diversity in the broadest sense. We support a diverse range of artists and organizations, including but not limited to those of diverse cultures, races, sexual identities, genders, generations, aesthetics, points of view, physical abilities, and missions. We support a diverse range of artistic disciplines and forms, created in a variety of contexts and for different audiences.

Innovation & Risk: We applaud unconventional approaches to solving problems and support artists and organizations that challenge and engage the traditional aesthetic and/or social dimensions of their respective disciplines. This may include, but is not limited to:

- expanding the aesthetic or social experience in the discipline in which they work and/or reclaim and revive traditional forms in original ways
- imaginative, rigorous, and well-executed
- technically proficient and exhibit a high level of craft
- compelling and has a distinctive vision and authentic voice
- connects with intended audiences/participants
- providing artistic experiences that communicate unique perspective/s, and invite viewers to question, discover, and explore new ideas in new ways
- bold and risk-taking

Humility: We work for artists (rather than the reverse) and believe that artists and organizations are the best authorities to define their needs and challenges—an essential humility reflective of Jerome Hill, our founder. The artists and arts organizations we support embrace their roles as part of a larger community of artists and citizens, and consciously work with a sense of purpose, whether aesthetic, social or both.[4]

What does your organization value most? Plan a process with your board and staff to articulate your core values together, write them down, and then test them out in the context of your work and community. Do they make sense? Do they ring true? Once you have articulated values for your organization, you need to ensure that your mission statement also reflects these values and derives in part from them. Reflect on how these values are manifest in your programming and policies. Examine whether these values are aspirational or realistic.

One of my mentors, Zelda Fichandler, the legendary producer and founder of Arena Stage in Washington, DC, often said that she was responsible for the "feel of the air" in the theater. She meant that she was responsible for how the atmosphere in the company culture felt. Was it warm and welcoming, or cold and harsh? Did artists feel free to play, or did they feel under pressure? Were newcomers welcome, or did the space feel exclusive? We perceive much more than we consciously realize as human beings, as detailed in Malcolm Gladwell's brilliant book *Blink.*[5] Millions of bits of information flow around and through us every day. So, this instantaneous judgment on how the air "feels" includes how everyone perceives themselves in pursuit of our cause.

VARIATIONS

A mission statement is an ambitious but focused declaration of purpose. A good mission drives us forward, always reaching for something not already achieved. It should be able to be stated by any member of your team, as written, but also in their own words in a

sentence or two. It sometimes takes three to five years of working at an organization with the board, staff, artists, and audiences to finally land on a clear mission that feels compelling and true.

As the executive and artistic director of the Hubbard Hall Center for the Arts and Education, I was slow to realize that Hubbard Hall not only "gathers people from all walks of life to create, learn, and grow together," but it also "develops, sustains, and promotes the cultural life of our rural community." Being in a rural environment is important to our purpose. It's different from so many other arts organizations. We are responsible for the cultural life of our community. It is a big, ambitious, but achievable goal. What do we mean by "all walks of life"? We can define that further: people diverse in age, ethnic and cultural background, gender and sexual identities and expressions, economic or educational backgrounds, mobility, ability, etc.

Mission articulation should also be a continual process, one that invites and demands further definition as you connect with more and more people. So, your mission can and should evolve, based on what you learn from your current activities. You should revise and share an updated mission statement at least every three to five years so you are continually awake and alive in this mission, and allowing those involved on the board, the staff, and the participants to play a role in revising it to fit your current ambitions and efforts. The mission should be a declaration of your intent and ambition. It should be specific to your situation, location, and what's sometimes called our "comparative advantage." Why are *you* special? Why do you exist? What's your reason for being?

Here are some strong examples of missions, visions, and values from arts organizations throughout the United States. Notice how some of these missions aim at greater social goods than what you might expect from a theater, museum, orchestra, or opera or dance company.

BOX 3.2. THEATER[6]

Milwaukee Rep—Milwaukee, Wisconsin
Mission
Milwaukee Rep ignites positive change in the cultural, social, and economic vitality of its community by creating world-class theater experiences that entertain, provoke, and inspire meaningful dialogue among an audience representative of Milwaukee's rich diversity.

Core Values
Quality
We pride ourselves on the superior quality of our work—artistically and administratively—as well as excellent staff and patron services that enable this work to be produced and received in the most positive way.

Inclusion
We explore and celebrate the broad diversity of our region and commit to nurturing an inclusive ethos that is welcoming and inspirational to all.

Relevance
We demonstrate how a theater company inextricably committed to the betterment of its locality can wield a nationally resonant, influential voice in the advancement of the art form in an ever-changing world.

Innovation
We expand boundaries and explore the full scope of theatrical storytelling through narrative, across art forms, new technologies, and inventive messaging strategies.

Sustainability
We pursue our mission in a responsible manner that equally respects artistic innovation and financial integrity while being mindful of the impact on our human resources.

You can see in Milwaukee Rep's mission and values in Box 3.2 a desire to have a large social impact on their community and the world at large. Their mission is jam-packed with specificity. They prioritize social change and follow up with a definition of how they pursue that change ("world-class theater experiences"), resulting in specific actions ("entertain, provoke, and inspire") and an audience that represents "Milwaukee's rich diversity." In assessing its usefulness as a statement, one wonders whether all staff members and artists can remember this mission statement or if there's a shorter mantra or blurb they use instead. Their chosen verb "ignites" has become a favorite in arts mission statements in recent years. It is more exciting than other common mission verbs like "starts" or "supports" or "engages."

Here is what Chad Bauman, the executive director of Milwaukee Rep, says about the Rep's mission statement and why they changed it:

In 2015, we changed the mission of the company at Milwaukee Rep, which is highly unusual for a company that's been in operations for more than 60 years. But we put two things into our mission statement that hadn't previously existed. The first was that it now calls for us to create positive change in our community. The second was that we were called to be reflective of Milwaukee's rich diversity.

Milwaukee has a lot of positive things about it. I love living in the city, but it's also got a lot of areas to improve. It's pretty well known as the most segregated city in the United States, and it's palpable. It's palpable when you're here in the city. And so, if we're looking to create positive change in our community and be representative of the rich diversity of the city, then it really meant that we had to focus on equity, diversity, and inclusion in almost every single thing that we did.[7]

BOX 3.3. VISUAL ARTS[8]

Whitney Museum of American Art—New York, New York
Mission & Values
Mission

The Whitney Museum of American Art seeks to be the defining museum of twentieth- and twenty-first-century American art. The Museum collects, exhibits, preserves, researches, and interprets art of the United States in the broadest global, historical, and interdisciplinary contexts. As the preeminent advocate for American art, we foster the work of living artists at critical moments in their careers. The Whitney educates a diverse public through direct interaction with artists, often before their work has achieved general acceptance.

Values

The Whitney Museum of American Art was founded by Gertrude Vanderbilt Whitney in 1930. An artist and philanthropist, she believed that artists were essential to defining, challenging, and expanding culture. The Museum became a site where artists and audiences engaged openly with untested ideas. Today, this history informs who we are and how we serve our public. The Whitney believes:

- In the power of artists and art to shape lives and communities;
- that we must be as experimental, responsive, and risk-taking as the artists with whom we collaborate;
- in creating experiences that engage and raise questions for our audiences, and, in turn, learning from our audiences;
- that our work embraces complexity and encourages an inclusive idea of America;
- in the importance of history: that the past informs our present and that contemporary art can help us better understand our past and realize our future;
- that we must lead with expertise, debate, self-reflection, and integrity; and
- that the Whitney thrives because of relationships—among artists, audiences, staff, and board alike—forged from dialogue, premised on respect, and committed to a shared purpose.

The Whitney Museum is clearly focused on being a national leader in American Art, as their mission distinguishes and challenges them. Unlike Milwaukee Rep, the statement skips any local connection and instead puts its focus on their national audience. The statement also emphasizes a diverse public and connecting early career artists to this diverse audience. They assert their responsibility to quantify, preserve, and pass on the history of American art. One challenge with a mission this broad and nationally focused is that it can be less helpful in guiding decisions around programming and

arts education internally. If they are truly national and not necessarily local, do they have a vibrant online presence or an ability to share their work online? Based on this statement, how do they decide what work should be presented or preserved each year beyond being Modern American?

BOX 3.4. DANCE[9]

Alvin Ailey American Dance Theater—New York, New York
Mission & Core Values
The mission of Alvin Ailey Dance Foundation is to further the pioneering vision of the choreographer, dancer, and cultural leader Alvin Ailey by building an extended cultural community that provides dance performances, training and education, and community programs for all people. This performing arts community plays a crucial social role, using the beauty and humanity of the African American heritage and other cultures to unite people of all races, ages, and backgrounds. Mr. Ailey said, "I am trying to show the world we are all human beings, that color is not important, that what is important is the quality of our work, of a culture in which the young are not afraid to take chances and can hold onto their values and self-esteem, especially in the arts and in dance. That's what it's all about to me." His words inform the organization's core values:

Reaching Excellence—Innovation with Passion: Alvin Ailey's groundbreaking legacy drives us to ever-greater heights of excellence, which we pursue with integrity, commitment, and creativity—now and into the future.

Moved to Inspire—Inspired to Move: Mr. Ailey taught us to "hold a mirror to society so that people can see how beautiful they are." Our performances and education programs illuminate the human spirit, unlock potential, and spark change.

Build Community—Celebrate Diversity: The Ailey organization expresses itself through the universal language of dance, rooted in African American tradition. On stage and off, we seek to bring together an inclusive community with no limitations.

Progress with Purpose—Perform with Respect: We connect through a common love of dance and treasure our heritage. We aim to be collaborative and nimble, while maintaining a cohesive and supportive work environment.

The mission of Alvin Ailey American Dance Theater is so unique because it not only conveys a hugely ambitious mission to "unite people of all races, ages and backgrounds" with African American heritage, but it also quotes its founder in the mission statement and hardwires his vision into the company's current mission statement.

This is a brilliant way to continue a founder's vision and purpose. Often a company evolves quickly beyond its founder, or at least transitions forward and works to distinguish itself from the beliefs of its previous leadership. But in Alvin Ailey's case, the invocation of this esteemed artist makes sense. The company is still named for him. It features and builds upon his artistic work. If one wonders how Alvin Ailey would feel about the company's current pursuits, they need only look at the current mission statement to see him there. The statement also points to the fact that the company is supported by funders and donors who feel strongly about Ailey as a person and who wish to see him honored. Good mission statements give you a clear sense of what it would be like to work at a company. With this statement, it's clear that you would learn a lot about Alvin Ailey and would be expected to embrace his vision.

BOX 3.5. MUSIC[10]

Oklahoma City Philharmonic—Oklahoma City, Oklahoma
Our Mission
The Oklahoma Philharmonic Society, Inc. exists to provide inspiration and joy for the community through orchestral music.

Vision Statement
Our vision is to enrich the lives of those we touch, to enhance the cultural life of the community, to educate future generations about the value of music, to entertain our audiences, to elevate the quality of every performance, and to serve as a leader for positive community growth through the performance of excellent symphonic music, and to cooperate with other arts agencies for the betterment of our community.

Our Core Values

Excellence	Collaboration
Integrity	Education
Tradition	Gratitude
Creativity	Enjoyment
Innovation	Inclusivity
Diversity	Sustainability

The Oklahoma City Philharmonic's mission and vision statement are simple but compelling. They are easier to repeat than some of the previous examples. You know from this statement that they are focused on providing "inspiration and joy" for their community (assuming the greater Oklahoma City area) through orchestral music. They do not claim to be national or even state leaders of the art form, and instead they focus on serving their local community.

Their vision statement goes into more detail about the change they seek to provide, including music education. They claim to "elevate the quality of every performance," implying they seek excellence in every performance. They then offer a long series of words to reflect their values. One could argue that this covers more territory and gives more insights into the company's culture. "Gratitude" is a value listed, which also seems to align with their humble mission statement. At the same time, having too many values listed can dilute their meaning. Listing terms without further defining *why* or *how* these terms specifically apply to your work can make them seem more like a list of terms agreed upon by the board of directors during a strategic planning retreat, rather than an actual envisioned and lived set of company values.

BOX 3.6. OPERA[11]

Seattle Opera—Seattle, Washington
Vision
Seattle Opera is a cultural icon of a major world city that speaks to all communities of, and visitors to, the Puget Sound region.

Mission
By drawing our community together and by offering opera's unique fusion of music and drama, we create life-enhancing experiences that speak deeply to people's hearts and minds.

The Seattle Opera takes an even simpler approach to its mission and vision statement than the Oklahoma City Philharmonic, without listing any values online. They also do not define *why* they do what they do. What change do they seek? The vision is ambitious, seeking to speak to everyone who lives in or even visits the Puget Sound region—but why? What does the Seattle Opera want to say, and what do they want these residents and visitors to gain from hearing from the opera? Similarly, the mission focuses on speaking deeply to "people's hearts and minds," but to what end? What do they want people to do, learn, or pursue by speaking to them? This is a common mistake in mission statements. It says *what* their approach to the art form seeks to literally do ("inspire people," for example), but it does not say *why* they are doing this. Besides the cliché of "speaking to people's hearts and minds," why would you want to work there? It's important to describe what change you seek in the world, so that your staff, board, artists, donors, and audiences can understand and support your purpose.

FINAL THOUGHTS

When defining or refining your mission, vision, and values, focus on who you are, what you do, how you do it, and *why*. Be specific but ambitious. Involve your staff,

board, and supporters in crafting your statement. Share it publicly and keep refining it until it feels clear, powerful, and authentic. As you become clearer on what you do and why, you will be able to grow your programming and your organization.

NOTES

1. Author interview with Ben Cameron, April 16, 2021. All quotes from Ben Cameron that follow are from the interview, unless otherwise noted.

2. Museum of Fine Arts Boston, "Mission Statement." Accessed April 11, 2021. https://www.mfa.org/about/mission-statement.

3. Contemporary Visual Arts Network, "Mission, Vision and Values." Accessed April 5, 2021. http://www.cvan.art/mission-vision-values.

4. The Jerome Foundation, "What We Do." Accessed May 31, 2021. https://www.jeromefdn.org/what-we-do.

5. Malcolm Gladwell, *Blink: The Power of Thinking Without Thinking* (New York, NY: Little, Brown & Company, 2005).

6. Milwaukee Rep, "Mission & Core Values." Accessed March 27, 2021. https://www.milwaukeerep.com/about/mission-core-values/.

7. Author interview with Chad Bauman, April 21, 2021. All quotes from Chad Bauman that follow are from the interview, unless otherwise noted.

8. Whitney Museum of American Art, "Mission & Values." Accessed March 27, 2021. https://whitney.org/about/mission-values.

9. Alvin Ailey American Dance Theater, "Mission & Core Values." Accessed March 27, 2021. https://www.alvinailey.org/about-us.

10. Oklahoma City Philharmonic, "About Us." Accessed March 27, 2021. https://www.okcphil.org/about-us/.

11. Seattle Opera, "Vision, Mission & History." Accessed March 27, 2021. https://www.seattleopera.org/mission.

4

BUILDING PROGRAMMING

*There is something that is always going to remain magical and interesting about
live performance. There's no doubt in my mind about that.*

—Chad Bauman, executive director, Milwaukee Rep

INTRODUCTION

Delivering great programming is how we activate our mission and serve our community. Programming is what we mean by *productions, exhibits, concerts, and special
events*, both digital and live. This chapter explores how to plan, produce, and present
great programming.

FUNDAMENTALS

FIVE KEY PROGRAMMING GUIDES

Here are five vital points to consider when planning a season of work. This checklist
applies to all arts disciplines, including museums, music venues, theaters, dance companies, and artist-driven events.

1. Substance
 - What is your mission? How will that mission be reflected in the work you
 will produce or present? If you are planning a single artist-driven event,
 what is the purpose of that event?
 - What artistic risks do you want to take? If you have an artistic director or
 curator, what is their vision for the season? What might your audiences need
 to see that will stretch or challenge them?

- How will these productions or presentations fit or grow the kind of work you have done before?
- How do these selections reflect the diversity, equity, inclusion, and accessibility demanded by audiences today?
- How will this work affect your staff, artists, and audiences?

2. Money
 - What's the overall budget for the year and per event or production? How many productions, exhibits, or presentations are you planning?
 - Is there any history of revenues and expenses you can compare to guide how much risk you can take and what you might expect to earn at the box office from this kind of event, based on other organizations? How can you predict this? How sure can you be?
 - If you are a new event or organization, how much contributed support or paid ticket sales do you have already for this endeavor? How much will you rely on the box office to cover your costs?
 - Will this season or event contribute income to your bottom line or require contributed income to break even? Is there a way to produce or present the event that would gain you more funding or earned income (either with sponsorships or a celebrity in the cast to raise the box office)?

3. Marketing
 - Who is your target audience?
 - How will this event or season meet the demands of your regular audience while potentially expanding your reach into new audiences?
 - How will you sell this event or season? What is the budget and capacity of your organization to sell it? Does that capacity match the degree of risk you are facing?

4. Space and Production
 - Where will these events happen? How does that space serve the piece and help to make it successful?
 - Is the event digital or live? If digital, do you have the technology and staff to produce it well? How will your online platform support the event? Is the functionality fresh and fluid so it supports the artistry presented? If live, how many audience members can you safely accommodate? How will they enter, engage, and then leave the event?
 - What production team or teams do you have to produce or present these events?
 - How much time do you need to produce or present the event? How much time between events do you need? How much time do the artists need to prepare and produce the event?

5. Personnel
 - Who will do the work? What artists will you engage to perform, direct, or design the piece? Or what company might you hire to present the piece for you? In visual arts, what company or gallery might lend work to you or tour to your space?

- How can you build an excellent team you can afford?
- How diverse are your artists and staff? How can you build diversity in your teams, programs, and ultimately your audiences?
- What local personnel might you hire for the piece? What personnel might need to be traveled to your location and housed for the duration? How does that affect your budget plans?
- Do you have sufficient staff to manage the project?

PRESENTING, PRODUCING, OR HOSTING: WHAT'S THE DIFFERENCE?

Presenting means a venue is featuring an artist, musical act, dance, or theater show as part of its regular season, but the work is entirely created and prepared by the artist or company bringing the work to the venue. The venue provides the space, technical support, house management, box office, and marketing. The venue would negotiate a contract with the artist or company and sometimes guarantee a certain fee, a split of the box office, or a combination of both. Presenting lets venues feature a variety of artists and performances with less risk, because they do not invest in rehearsing or producing the entire show.

Producing is when a venue creates and builds an entire project on their own (or with producing partners). The company decides on the project, recruits the artists, contracts them, designs and builds the production, markets the show, and finally opens and manages all the performances. This can be a more lucrative approach, because all of the box office income goes directly to the producer. But it is also the riskier approach, because costs and investments in time, space, personnel, and materials are higher than presenting or hosting. If the show is a flop, the production can inflict a huge deficit on an organization. In order to survive, producing organizations need to plan a balance of projects throughout the year to guarantee a mix of popular hits and risks.

Hosting denotes a space rental or donation of the space to an event. In these cases, the venue would provide the space, technical support, house management, and maybe box office/ticketing support, depending on the contract and the fee being paid to the venue.

NEW EVENTS

With a new or singular event, you need to balance your ambition for the event with a conservative view for planned expenses, advance sales, and sponsorships to ensure you at least break even on the project, while building your brand for excellence.

Ideally, you should plan to gain some net income to the positive on the event, so that you can build up your capacity for the next event. You want to come out of the event with some money and a reputation for success so that investors, sponsors, and ticket buyers will be ready to jump at the opportunity to attend or invest in your next event. You will want to budget for this event in a way that guarantees you have some cash leftover to produce the next event.

In Table 4.1, you can see a producing budget for a Big Dance Party. Note that this event requires a capital investment of $5,300 to produce this event (labeled Total Estimated Production Capital Requirements), before any tickets are sold. This event budget also projects a surplus of $4,450 from the event, which you can then invest to capitalize your next performance or event. Note, too, that your projected attendance is only at 70 percent, which is considered ambitious but realistic for most arts producers. See the online cache of documents accompanying this book to access this budget electronically, so you can experiment with projecting your own event budget. There are formulas already in the worksheet to calculate expense totals and potential earnings.

Whether you are an art gallery, a theater, a music venue, or a dance company, once you have a history of producing or presenting, you should have some financial data and audience feedback to guide you.

CAPITALIZATION

In producing, when we refer to an event or production being fully *capitalized*, we mean the event or production has enough capital (aka money) to move forward. On Broadway, for example, producers will have a minimum of money they need to raise in order to launch a production. When producers are being recruited to support a show, they are each asked to contribute a certain amount toward the total capitalization cost of the show. In recent years, the cost to capitalize a Broadway show has ballooned into the tens of millions of dollars.

An event or show that results in a *surplus* means the organization brought in more money than it spent on the event, and therefore it has enough capital to invest, or capitalize, another event—though any investors who provided capital for the original event must first be paid back.

In the case of the Big Dance Party, let's assume an investor gave you the $5,300 you needed to produce this event. Given your return on your investment was a total of $9,750, you paid back your investor and had $4,450 in capital for your next venture. Given you needed more than $4,450 to do the event, you will likely still need an investor for your next production, but you are growing your capacity to produce more. If you had incurred a *deficit* on the event (meaning you spent more money than you brought in), you would not be paying your investor back and you would not have any money to spend on your next event. More importantly, your reputation and track record would be negative, so future investors might run away when you ask them for money. Your initial investor may also be reluctant to fund future projects, unless they believe in your vision and do not mind losing money to support that mission. All of this is predicated on the idea that you are not yet a nonprofit entity but instead an independent producer or artist. As we will discuss in the next chapter, if you form a nonprofit, your investors can become donors, and anything they give you becomes a tax-free donation, which they can write off on their tax returns for the year.

Table 4.1. Big Dance Party Producing Budget

Expenses		Big Dance Party	
PHYSICAL PRODUCTION			
Stage Rental		$1,000	Large stage rental for two days at $500 per day
Chair Rental		$500	250 chairs @ $2 each for two days
	SUBTOTAL	**$1,500**	
ARTISTIC STAFF (designers, directors, etc.)			
DJ		$1,000	
	SUBTOTAL	**$1,000**	
CAST & STAFF (management and tech)			
Stage Manager		$500	One SM at $500
Crew		$500	Five students @ $100 each
	SUBTOTAL	**$1,000**	
MARKETING			
Fliers		$500	2,000 printed color fliers
	SUBTOTAL	**$500**	
SPACE			
Hall Rental		$0	In-Kind Donation
	SUBTOTAL	**$0**	
ADMINISTRATIVE & GENERAL			
Management Fee		$300	Event management provided by Mgmt. Inc.
	SUBTOTAL	**$300**	
TOTAL DIRECT PRODUCTION COSTS		**$4,300**	
DEPOSITS & RESERVES			
	Deposit(s)	$1,000	Space security deposit
	Reserve Funds	$0	
	SUBTOTAL	**$1,000**	
TOTAL ESTIMATED PRODUCTION CAPITAL REQUIREMENTS		**$5,300**	
ESTIMATED TOTAL POTENTIAL GROSS RECEIPTS			
	Seats	500	
	Performances	1	
	Ticket Price	$25	
		$12,500	Total Potential Gross
ESTIMATED ANTICIPATED GROSS RECEIPTS			
	Est. Average Paid Ticket	$25.00	
	Projected Paid Attendance	70%	
		$8,750	
	Return of Theater Deposit	$1,000	
	Total Return on Capital Investment	**$9,750**	
PROJECTED NET PROFIT/ (LOSS)		**$4,450**	

On Broadway, where shows are mostly for-profit projects, producers tend to lose money on most shows.[1] They produce theater because they love it, have money to spend on theater, and occasionally earn back their losses on the rare hit show.[2] The examples where an investor actually makes money producing art are few and far between. The smash *Hamilton* is one of those rare exceptions. This phenomenal musical by Lin-Manuel Miranda, about the first treasury secretary of the United States, grossed more than $75 million at the box office in its first ten months on Broadway, against an original investment of just $12.5 million.[3]

CRAFTING CONTRACTS

Another key element of producing the arts is having clear contracts for all the artists and technicians involved. If you have an organization, managers or technicians may be employed by you as "at will" workers, meaning they are employees without contracts and are free to quit at any time. But all other employees should have a contract. Contracts are your opportunity to lay out a clear schedule, expectations, pay schedules, and the amount of payment. Without clear contracts, there will often be confusion or disagreements about expectations at some point in the process. With contracts, any disagreement can be compared to the contract to see what's already been agreed upon.

Prior to writing a contract, one of your first questions will be: is this artist represented by a union? Union representation brings in several expectations already established by the union, to protect both the artist and the employer. Unions will provide and require their own contract forms, and they expect each producer to abide by the rules and regulations established in their contracts and policies.

If no union representation exists, you will need to create a draft contract, being as equitable as you can be, and providing it to the artist when making an offer of employment, so that they and/or their agent or manager can review it, give feedback or notes if need be, and decide if they want to do the project with a final version of the offered contract in hand. Think about what you might need to include in a contract, based on what arts discipline you are producing. Box 4.1 contains a list of artist union websites. These live links are also available in the online cache of documents. When in doubt, contact the appropriate union for guidance on how to engage one of their members in a project. Given that many union requirements exist to keep artists safe, healthy, and well paid, it is a good practice to engage nonunion artists with pay and expectations as close to union levels as possible.

VARIATIONS

WHAT SHOULD SOMETHING COST?

Union pay rates can serve as a guide for what weekly artist fees might be, to help you craft a realistic budget. You also should note the cost of living in your locality to ensure

BOX 4.1. ARTIST UNIONS

Actors/Dancers—Theater
AEA—Actors Equity Association
https://www.actorsequity.org/

Actors/Dancers—Film/TV
Screen Actors Guild–American Federation of Television and Radio Artists (SAG–AFTRA)
https://www.sagaftra.org/

Opera Singers/Chorus/Dance
American Guild of Musical Artists (AGMA)
https://www.musicalartists.org/

Tech/Production
IATSE/USA
https://www.iatse.net/

Designers—USA 829
https://www.usa829.org/

Musicians
American Federation of Musicians
https://www.afm.org/

New York Unions/Guilds
https://www1.nyc.gov/site/mome/industries/guilds-orgs.page

you are paying a fair wage. Living and working in New York City is different than living in a small town in Iowa. Look at the cost of real estate, your state's minimum wage, and the costs of food, transportation, and healthcare to help guide you to fair payments.

The global pandemic, accompanying recession, and a clear need for greater equity have shone a light on salary disparities throughout the arts. In the visual arts, the amount paid for prized artwork continues to climb to crazy heights. Combined with innovations in online and digital content, the cost of art can vary wildly. In March of 2021, the artist Beeple sold a "non-fungible token" or NFT, of his piece *Everydays* at Christie's for a whopping $69 million. Given this NFT is a string of data that cannot be held or seen outside of its form as a digital file, and that the digital artwork came from a trained computer programmer with no training in art, Beeple's financial success sparked outrage and a fierce debate over the value of art. Innovations in digital content are upending all kinds of traditional models of producing art, especially financial.[4]

DIGITAL CONTENT

Presenting and producing digital content at arts organizations exploded in 2020. The suspension of live events drove organizations to push archived performances and live popup events online. As the pandemic continued, arts organizations invested in creating new online platforms and fresh digital content aimed at keeping audiences engaged while venues remained dark. The Metropolitan Museum of Art created four interactive videos online so visitors could "enter" the museum, rotate their view at will, and explore the museum's artwork. The Actors Theater of Louisville produced plays online, using the strengths of video editing while also filming the performances in three-dimensional space (as opposed to the Zoom boxes audiences had quickly tired of). But for all these efforts, a study conducted in late 2020 by the research firm La Placa Cohen confirmed that only 13 percent of audiences were *paying* for the digital content offered by arts organizations, while this new content competed for audiences against the vast commercial content of Netflix, Amazon, and Hulu.[5] Digital content will likely play a larger role in how arts organizations connect with audiences going forward. But until digital content also provides much-needed income, it is difficult to imagine nonprofit arts organizations having enough resources to invest enough to truly compete for online audiences. Live events, where audiences come together and share a communal experience unlike anything online, will continue to be arts organizations' strongest selling point.

MUSEUMS, THEATERS, DANCE COMPANIES,
MUSIC, AND MULTIDISCIPLINARY VENUES

In each arts discipline, there are specific factors to consider when programming a show or season. Here are some examples of ways each discipline requires special care and planning.

Museums

For visual and sculptural arts, some of your specific producing concerns can include:

- How will you control the temperature, lighting, and humidity in the space where you will display the art? Great care must be taken to not damage the artwork while it lives in your space. Museums and artists lending or exhibiting artwork will usually require, in their contracts, a certain range of temperature, lighting, and humidity at all times in the space.
- What insurance do you have in place to pay for any damage or replacement of the artwork? Two of museums' largest expenses are facilities and insurance. Again, most contracts for the visual arts require a certain level of insurance be in

place and guaranteed before the artwork is ever booked. Insurance companies will require regular audits of your temperature and humidity controls, to ensure you can protect the artwork.

- How will you secure the artwork? Visual and sculptural artworks can be damaged and stolen. What security systems do you have in place? How many guards? How many docents? What are the policies and procedures in place to ensure the art's safety? If you have ever been asked by a security guard at a museum to "step back" because you are too close to a painting, you have experienced these policies in action.

Theaters

Theater, which relies on human beings performing and is constantly alive and in motion, may require a deeper focus on:

- What happens if an actor becomes ill or does not arrive on time to the theater? Do you have understudies or replacements for your actors? If not, what happens when an actor cannot perform? Backup plans will be needed. Emergency-aid kits will need to be readily available in case of illness or injury during rehearsals or performances.
- How will you ensure the show is ready to open by opening night? Time management will be crucial, as will scheduling everyone's time efficiently.
- How can you guarantee there is an audience for every performance? You might have two months, six months, or even a year of shows to fill with audiences. Ensuring your marketing plan is ready and activated months before rehearsals start will be very important.

Dance Companies

With dance companies that are touring or performing for weeks or even months at a time, special care might be needed for the following:

- How will you help dancers avoid injury or exhaustion? What physical therapies, massages, or physician visits will be provided by the company, to ensure dancers are healthy and well-rested?
- What special events, field trips, or break times might be planned during a long tour, to support dancers' happiness and mental health?
- How will the required lighting and other technical equipment be transported from venue to venue? Can this equipment be provided by the host sites per

contract, or will the company need to bring its own technical equipment in order to have the correct lighting for these dances?

Music Venues

At music venues, you may need to worry about:

- What is the current sound system? How many speakers, monitors, and microphones are there in the space? Is there wireless equipment or just wired?
- How long is the venue available for rehearsals and sound checks prior to performances?
- What is your maximum audience capacity, and how can you fill the venue to that capacity while still ensuring safety?
- What alcohol and food can you serve during events?
- What security do you need?
- What does each band or artist require in their contract? Can you fulfill those requirements?

Multidisciplinary Venues

At multidisciplinary venues, you often need to worry about:

- How can your production team manage multiple events on the same night, in multiple spaces?
- How many lighting rigs, sound systems, and technical crews must you maintain to accomplish all of our programming? When during the year can you schedule "downtime" for these systems and people to catch their breath and do basic maintenance on the equipment?
- What events are you hosting, presenting, or producing, and how do you approach each of these kinds of events? Which types of events will make money for you and which will cause you to lose money? How can you balance these across a whole year of programming?

THE IMPORTANCE OF CONTRACT RIDERS

Contract riders are addendums to the full contract that often carry an artist's specific requirements, including their technical equipment. The rock band Van Halen famously required in their contract rider that music venues provide them with M&M's as a snack backstage, but with all of the brown M&M's removed. Why? Because they knew that if they saw brown M&M's in their bowl, the venue producers had not read the entire

contract rider. This let them know that the venue might not have installed their heavy lighting equipment correctly and would require their crew to double-check everything for safety. In one easy glance, they could see whether their contract had been carefully read and honored.[6]

TYPOLOGIES

Organizations that have been around for many years sometimes create a budgeting tool to compare previous types of projects to the ones planned, in hopes of better predicting how a project might do at the box office and with audience demand. These tools are sometimes called *typologies*.

When I planned seasons at Arena Stage, we employed typologies to help guide our budgeting going forward. These included budgets based on types of past projects, including New Play: Comedy, Classic: Drama, Big Musical, New Play: Drama, Classic: Comedy, etc. Each typology came with some assumptions. There are three theater spaces at Arena: the 650-seat Fichandler, the 550-seat Kreeger, and the 220-seat Kogod Cradle. We would budget with each of these typologies in a specific space, so we knew whether we expected to fill a small, medium, or large space. We typically capped our assumptions at around 70 percent box office (meaning we were betting that 70 percent of the house would be full at every performance).

We looked at five to ten years of producing history on these types of projects to guide what we thought the box office might be, and then we created a budget for the new shows based on what we could afford to lose or gain with each project. We were typically choosing ten projects for the year. Based on the numbers, our audience expectations for projects (new plays were less popular than big musicals), the amount of time we had, our production capacity, our artistic vision for the year, and what projects were available or possible for the year, we would lay out a calendar and a budget.

If this season and budget did not gain us a certain amount of income at the end of the draft, we would go back to the drawing board. We would plug in different projects, pull some things out, and add others in, until we got closer to our income target. Each time the marketing and production departments would draft projected income and expenses based on the project. This gave an enormous amount of power to those two departments. While the artistic development department was busy developing projects that interested the artistic director, the marketing and production staff could de facto cancel a project based on what they said it would cost or bring in. Finally, with the addition of a celebrity casting here or a switch from a larger cast play to a smaller cast play, we would land on ten projects, usually with five shows in the Kreeger, two in the Cradle, and three in the Fichandler. The Kreeger was the medium-sized space and had the most traditional theater space, making it the easiest to program. Our largest space, the Fichandler, was very tough to program. Being in the Fichandler required a show to work in the round while also guaranteeing that close to six hundred people wanted to see it every time. Big classics, musicals, or comedies tended to fit in there. The Kogod Cradle, the smallest space, originally conceived as a place for continual new

work development, ended up being used the least, because at 220 seats, it just could not generate much earned income, unless a celebrity did a small cast show there.

At a large organization like Arena Stage, money is always a factor in planning. Unfortunately, it can often become the driving factor as well. We no longer had the luxury of planning seasons for their artistic merit and then figuring out how to pull them off. We had to plan seasons with artistic merit, while allowing money to often make the final call on whether we could do a show or not. Keeping your overhead costs in control is vital, so that your mission and artistry are not compromised. Sometimes a building or other capital costs can become a trap.

REMEMBERING YOUR MISSION

Remember that your programming is the *manifestation of your mission* to most of the community. Artistic ambition mixed with pragmatism is the key to your success. Figure out as much as you can in advance, plan and budget conservatively, and find balance in what you are doing. If one thing serves a regular audience and is assured to be a hit, take a risk in another part of the season. If you find you mostly serve white audiences, plan more diverse programming so your audience can become more diverse. Diversity will improve your finances, mission delivery, and relevance. A lack of diversity usually spells doom on all fronts, because it means your work is not relevant, interesting, or financially viable in the long term. Producers, artists, and organizations sometimes fear that an investment in more diverse programming and audiences will cost them money. They fear taking a risk on diversity. But as documented eloquently in Donna Walker-Kuhne's classic book on audience engagement, *Invitation to the Party,*[7] efforts to engage a more diverse audience with better and more diverse programming will pay off in increased ticket sales and a higher quality of artistry and artistic product.

Engage the audience you seek in a long-term conversation with work that is relevant and rewarding. Find ways to authentically connect with more diverse audiences and lower the barriers to engagement. Listen to what you learn from this season and bake that learning into your next season. Balance risks with audience demands. Look beyond just this season to think about how it will affect your long-term health and sustainability. Think about how these choices will affect your audiences and your staff. Can you be proud of this work? Will it make you want to go to work the next day even more? Will it make the organization admired by audiences, donors, funders, and your peers? Why are you doing it? How will you do it?

FINAL THOUGHTS

Programming is the heart and soul of what you do and who you are as an organization. How well you plan all aspects of your season can set you up for success or failure, now or in the near future. Be bold.

NOTES

1. As of this writing, the rare nonprofit theater companies with Broadway houses include the Roundabout Theater Company, Manhattan Theatre Club, and Lincoln Center Theater.

2. Frederic B. Vogel and Ben Hodges, *The Commercial Theater Institute Guide to Producing Plays and Musicals* (New York, NY: Applause Theatre & Cinema Books, 2006).

3. Meghan Murray, "*Hamilton* Won More Than Twitter," Darden School of Business, July 27, 2016: 6.

4. Kyle Chayka, "How Beeple Crashed the Art World," *New Yorker*, March 22, 2021.

5. La Placa Cohen, "Culture and Community in a Time of Crisis," La Placa Cohen, October 21, 2020. Accessed June 28, 2021. https://culturetrack.com/research/covidstudy/.

6. Julie Zeveloff, "There's a brilliant reason why Van Halen asked for a bowl of M&M's with all the brown candies removed before every show." Accessed March 29, 2021. https://www.insider.com/van-halen-brown-m-ms-contract-2016-9.

7. Donna Walker-Kuhne, *Invitation to the Party* (New York, NY: Theatre Communications Group, 2005).

5

GROWING AN ORGANIZATION

I want to think about this completely differently than we have before.

—Anna Glass, executive director, Dance Theatre of Harlem[1]

INTRODUCTION

After your programming is established, you may need an organization to manage, protect, support, and sell that programming. Be aware that creating an organization can be expensive and a lot of work, including establishing a staff, a board of directors, and facilities. In order to assist you in your quest, this chapter will explore how to establish and grow a nonprofit arts organization.

FUNDAMENTALS

For-profit or nonprofit? What type of organization do you need?

Once you are sure you need an organization, consider if you want a *for-profit* or a *nonprofit* company. A *for-profit* entity relies entirely on earned income and is easier to set up, because you do not need a board of directors or to gain nonprofit status from the Internal Revenue Service (IRS). While for-profits must follow all local, state, and federal regulations, they do not need to maintain a mission nor, if they are a private company, do they need to disclose their finances to the public. Individual owners are free to profit from the business. Music venues, dance clubs, comedy clubs, and private galleries are usually for-profit. As discussed in the last chapter, Broadway theaters are mostly for-profit, as are most movie theaters. Independent artists can set up a business entity in their name to shield them from taxes and manage their brand, while still maintaining complete control over their work. Setting up an independent business entity can be done by a lawyer or manager, or even with an online legal service.

Nonprofits receive both earned and contributed income, including individual donations, foundation gifts, corporate support, and government grants. They are therefore less reliant on earned income than for-profits, and free from paying taxes on most of their income, their purchases, and property taxes on all their mission-related property. But nonprofits must be mission-driven, and no one involved can profit from the organization's activities. This does not mean that staff cannot be paid a decent wage or even bonuses when the company can provide them, nor does it mean that nonprofits cannot have surpluses at the end of their fiscal year. It simply means there are no stockholders or board members earning profits from the organization.

501(C)(3) STATUS

Nonprofit organizations are organized as corporations. 501(c)(3) is the Internal Revenue Service (IRS) tax designation for incorporated charities, including nonprofit arts organizations. 501(c)(3) entities typically have charitable, educational, or religious missions, do not earn profits for themselves or others, and create a non-political public good; therefore, any donations are tax-deductible.[2] 501(c)(3) corporations do not pay income or property tax, but they do pay payroll tax.

A 501(c)(3) exemption is the most popular type of tax exemption, with 74 percent of all 501(c) companies being 501(c)(3). However, there are *twenty-eight* other 501(c) eligible corporate structures, including: 501(c)4: Civic Leagues, Social Welfare Organizations, and Local Associations of Employees; 501(c)5: Labor, Agricultural, and Horticultural Organizations; 501(c)6: Business Leagues, Chambers of Commerce, Real Estate Boards, etc.; 501(c)7: Social and Recreational Clubs; and 501(c)8: Fraternal Beneficiary Societies and Associations.[3]

STARTING A NONPROFIT ARTS ORGANIZATION

After establishing programming driven by a clear mission and worthy of public support, you can create your nonprofit organization. Here are twelve steps to guide you in establishing a nonprofit arts organization in the United States:

1. Develop programming and a mission statement.
2. Raise funds to support the work.
 - Prior to establishing your 501(c)(3) status, all donations are considered private gifts, and must be reported as taxable income.
3. Recruit volunteer board members.
4. Decide on a business address for the organization.
5. Develop a budget for your programming and first year of existence.
6. Create basic *bylaws* for the organization.
 - *Bylaws* are the "constitution" of an organization. They articulate how the organization will be governed and managed, how the board of directors is chosen and managed, and when the organization's fiscal year begins and

ends. They can and should be reviewed and updated on a regular basis (typically every five to ten years) to reflect current laws and changes to the organization's mission delivery.

7. Write *Articles of Incorporation* for the company.
 - *Articles of Incorporation* are a document stating the establishment of a corporate entity, describing what type of organization it will be (nonprofit), its official address, the list of board members and their addresses, and the name of the corporation.
8. File business license applications and registrations to local and state agencies.
9. Hire or recruit volunteer staff.
10. Apply to the federal Internal Revenue Service (IRS) for 501(c)(3) with form 1023,[4] submitted along with your Bylaws and Articles of Incorporation.
11. Receive your approval from the IRS, granting your organization its 501(c)(3) standing.
12. Start taking tax-free donations and contributions.

The Incubation Option

If you are not ready to build a new 501(c)(3), but you want to be able to receive donations and apply for funding, you may choose to begin instead working under the umbrella of an incubating organization. Companies like Fractured Atlas in New York City offer groups the opportunity to be sponsored and apply for grants and receive funds via *their* 501(c)(3) status. As a fiscal sponsor, Fractured Atlas applies for grants to funders in support of their "sponsees," taking an 8 percent fee from whatever they raise for these organizations. This incubation model allows new groups to raise money and grow their capacity before taking the plunge to build their own 501(c)(3) organization.[5]

NONPROFIT ORGANIZATIONAL STRUCTURE

A nonprofit operates with a board of directors at the top, followed by senior staff leaders such as an executive director, artistic director, and managing director. The board of directors are all volunteers, so that they can stay devoted to the mission of the organization, and represent the interests of the organization, its constituents, and its community independently. They hire, evaluate, and, if need be, fire the senior leadership of the organization. The rest of the staff reports to the senior leadership and manages the artists, programming, facilities, and production. Because the nonprofit is granted tax-free status by the federal government and therefore receives tax-free donations from donors, funders, businesses, and government agencies, the entire organization is considered to be in the public trust. Any malfeasance or fraud at a nonprofit is breaking that trust and failing the public and its government representatives who granted the organization special status in order to serve others. Figure 5.1 shows a typical organizational structure for a large nonprofit arts organization.

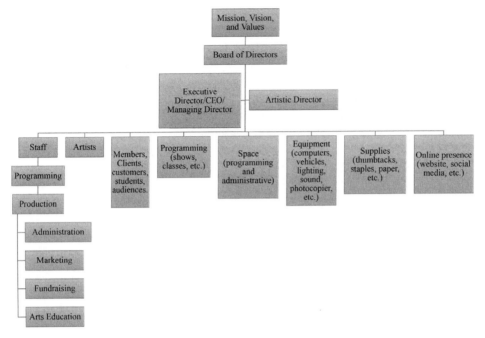

Figure 5.1. Organizational Structure.

Note that the mission, vision, and values dictate everything else. Even though this structure shows the board of directors clearly over the senior staff, ideally the relationship between staff leadership and the board is collaborative. Hopefully different departments can also cross-pollinate ideas and efforts and collaborate more than this graphic implies. Smaller arts nonprofits tend to have less silos between people and activities, with more opportunities for arts managers to web across topics in their work, from production to education and from fundraising to marketing.

Questions of Equity

Many arts organizations are reconsidering this traditional hierarchical structure, because it places power at the top, it often inspires huge pay gaps between leaders and lower-level staffers, and it is sometimes seen as supporting systemic racism and misogyny. As the pursuit of diversity, equity, and inclusion has finally become a priority for arts organizations, serious debates have begun over whether a new structure should be adopted to provide greater equity across staff, artists, and board members. Anna Glass at Dance Theatre of Harlem is among those leaders rethinking how their organizations are structured:

> I'm really focused on consensus building. I feel very strongly about listening to others' opinions. I want to think about this completely differently than where we

have been before. We've seen hints of what's possible. Some of our dancers are extraordinary instructors. We are looking at, what would it look like if we had touring happening in specific moments during the year? And then the rest of the year, our company artists are our teachers, or out in the public school system? Or they're producing content, digital content.

What would it look like if we reimagined the role of an artist and had multiple income streams, paying for those individuals versus what we've had before? Touring revenue somewhat covered the expenses associated with the company, but not a hundred percent. And the revenue from the school covered the instructors, our teachers; and the revenue from our community engagement work covered our teaching artists. What if it was one group of people doing that work and all those sources of revenue were paying for that one group of people? So those are things that we are really sort of delving into. I don't have answers to any of it but I know that we're not going back to where we were before.

Some leaders, including Chad Bauman at Milwaukee Rep, hold fast to a traditional hierarchical structure, for understandable reasons. As Chad notes:

I don't know how to lead by consensus. The board has hired the artistic director and me to lead the company, to make difficult decisions when difficult decisions need to be made. That's my job, so I'm not going to be apologetic for that.

I think the key is getting enough inputs from a wide and diversified group of people in order to make a good decision. But at the end of the day, the truth is that executive directors and artistic directors are paid to make decisions. By the time problems get to you—these are not black and white issues. If they were easy black and white issues, those problems would never get to you. The problems that get to you are always in the gray area. You're always going to have to balance pros and cons of multiple different areas and make the best decision that you possibly can, knowing that every single decision you're going to make is going to probably piss off somebody. There's no way that you're going to get around that. But the unifying factor for the company is if you are *fulfilling your mission*, and you're *doing it well*, and *people feel valued and respected*. They might disagree with your decision. They might think that too much power rests in one decision maker, but if you hit those three, I feel like they are a unifier.

S.W.O.T. AND STRATEGIC PLANNING

When planning to grow an organization, completing a S.W.O.T. analysis (Strengths, Weaknesses, Opportunities, Threats) for your company is a good place to start. This strategic planning tool allows you to explore your fledgling organization's Strengths and Weaknesses (both are internal forces), along with your Opportunities and Threats (external factors facing your organization). Ideally bring together your existing board members and staff to brainstorm about these topics, so that the deeper ideas and issues can rise to the top and some consensus can be reached about priorities. Have an outside facilitator manage the process if possible, so that you can fully participate and not be seen as directing the outcomes. Then take your findings from the S.W.O.T.

exercise and bake them into a brief and active strategic plan, articulating up to four main focal points for developing the organization over the next two years, with concrete action steps attached to each intended effort for staff and board to pursue. Monitor your progress on the action steps at every board and staff meeting to ensure you are moving forward. In two years, celebrate the growth in the organization and complete another analysis and planning to pivot toward new goals.

ORGANIZATIONAL COMPONENTS

Every nonprofit arts organization includes: a board of directors, a budget, a staff, policies and administration, programming, facilities and technology, fundraising, financial management, and marketing. Here are some key points to consider while developing each component:

A Board of Directors

Your first board members will likely be your friends, colleagues, and even relatives, anyone who believes in you and what you are trying to do. The board of directors is entirely volunteer so they can be independent members of the public and devoted to guiding the organization's mission, vision, and policies. The two key tasks for the board are to 1) hire, evaluate, and (if need be) fire the staff leadership; and 2) to ensure the organization has the resources it needs to deliver on its mission. They, along with the staff leadership, also ensure the company follows all laws and regulations and has policies in place to protect its staff, patrons, artists, and board members. Boards at new organizations often meet monthly for the first few years of the organization, as they act in some ways like volunteer staff members. Ultimately you want to be able to create committees focusing on fundraising, governance, facilities, etc. and transition the full board to just six or seven meetings per year, with committees meeting more often to pursue strategic objectives on their topics.

Budgeting

In your first year's budget, your income will likely consist of individual donations from friends and family and maybe a few small grants from local businesses. Alternatively, if you are launching with a single major supporter backing your work (one larger donor or a business or government agency underwriting your work), your income may consist of one very large gift and several other tiny individual donations. Your expenses might include the typical nonprofit expense categories of staffing and payroll, artists and program personnel, non-personnel program expenses (materials and supplies), facilities, utilities, equipment, insurance, marketing, fundraising, and finance. If you do not have an office or staff or property yet, you might not need much insur-

ance (except for some general liability) or facilities or staffing expenses yet. Often the first year is entirely focused on programming, managed by the volunteer (or barely paid) founder.

Staffing

Establish what positions you absolutely need and fill them with qualified staff members from diverse backgrounds. Focus on creating positions that will support mission critical parts of your organization, including programming, fundraising, and marketing. Because overhead costs can balloon as you add staff (via payroll but also insurance, facilities, etc.), avoid "staffing up" too fast. Keep lean until your programming requires you to hire more people.

Policies and Administration

Work with your board of directors to ensure you have clear bylaws as the basis for the rest of your policies. Tap colleagues or nonprofit resource centers to gain templates and examples of employee handbooks, financial policies, and facilities policies. Build what you need quickly to support what you are currently doing.

Programming

Focus as much as you can on your programming. Ensure it is excellent and growing. You may be tempted to begin programs in arts education and community engagement to augment your main artistic-product. First ensure your main artistic offerings are thriving, then consider if you have the capacity to grow additional programs. If arts education or community engagement is your main focus, carefully expand into other offerings only after these are well-established and rigorous. Keep your programming focused while you start the organization. You are otherwise in danger of drifting from your mission, and firmly growing the organization around that mission will be tougher to accomplish.

Facilities and Technology

Grow your facilities carefully. Stay adaptive and flexible. You may or may not need office space. You may need a performance space, but only a few times a year. Explore partnerships and rentals that fit your needs and do not saddle you with too much debt. Your staff may grow soon, and then that tiny office space with a five-year lease will be a big problem. Ensure that you, your staff, and artists have the technology you need to innovate and communicate.

Fundraising

Individual donors will provide most of your funding in the first few years. Determine what foundations, government agencies, and corporations might also support you and reach out to them. Fundraising is largely about relationships—relationships with funders, donors, and corporations. Building and maintaining those relationships is perhaps the most important step to growing your ability to raise funds for your company. Establish a fundraising database in some form, where you can quickly see who your funders are and when applications and reports are due. Whether this database is online or just in a worksheet in Google Docs or Excel, you will need this information almost every day, as you work to ensure you never miss a deadline and always schedule time in between deadlines to build a relationship with your donors and funders.

Financial Management

Solid and clear financial management is key to any company's success. You need to know what you have, where you have it, when more is coming, and where you are spending it to guide the organization and drive your mission both in the short and long term. Find a good bookkeeper, hire them, and hold on to them. Purchase bookkeeping software to help you track income and expenses.

Marketing

Communicating *who you are* and *what you do* is critical for a new organization. Establish a strategic mix of online and in-person marketing efforts. If you cannot afford a full-time staff position focused on marketing, consider contracting a person skilled in social media and online marketing. Establish a strong website for your organization, full of vibrant photographs, showcasing a clear mission and vision, with easy functionality for patrons. You will need to manage your ticket sales, class registrations, and donations all online, either directly on your site or linked to another platform in some way that appears seamless to users. Establish accounts on at least Instagram, Facebook, and Twitter. Keep someone focused and active on these accounts so you can engage patrons in daily interactions. Subscribe to an online platform for e-blasts such as Constant Contact, so you can stay in touch with patrons and send them regular reminders for upcoming classes and performances.

As you develop each part of your new nonprofit, pay special attention to how all these components interrelate and rely on each other. Quality programming requires clear financial management in order to thrive. A solid staff needs updated technology to do their work. A board of directors relies on having clear policies and procedures in place. As you grow one, grow them all.

VARIATIONS

How you approach one aspect of your organization can affect everything else, as demonstrated in these examples of how physical space informed the company culture at three very different arts organizations.

FACILITIES AND COMPANY CULTURE

Bean Bags

Company culture sometimes manifests in the "way the air feels" in a place. How does it feel to be there? Welcoming? Empowering? Warm? Exciting? It's often a mix of policy, people, and facilities that makes up a company culture. Is there an ability to work remotely when necessary? Does each staffer have the space and quiet they need to work? Is staff supportive of each other? And does the physical space feel comfortable and equitable in some way? It's important to ensure your physical plant supports and reflects your intended company culture.

During my tenure as producing artistic director and CEO, my company, Young Playwrights' Theater, twice won $100,000 from the DC Commission on the Arts and the Humanities for infrastructure development—equipment, staff, planning, etc. One item purchased with this grant was bean bags for the office. The staff wanted to inspire a sense of comfort and camaraderie and for artists and teaching artists to feel welcome to hang out in the office, and for students to feel at home. Bean bags were strewn around the office: between the desks, in our studio, etc. Within a few days of setting up the bean bags, more artists and students were spending time in the office, because there was a comfortable and inviting place for them to visit.

Meeting Space

When I began my work as executive and artistic director at Hubbard Hall, my office only contained one chair: mine. There was nowhere for anyone else to sit. As quickly as possible, I moved large bookshelves and file cabinets out to make enough space in my tiny office for a few chairs for visitors. Suddenly, my office was more welcoming and functional for others, including staff members, board members, donors, and community members. If you have nowhere for others to sit, they will not feel welcomed. They won't be able to engage you in conversation. And they won't stand around waiting for you to find them a seat.

Employee Fishbowls

At Arena Stage, in the Mead Center for American Theater, only two people had solid wooden doors to their offices, the executive director and the artistic director.

They had solid walls. They could close their doors, meet privately, and take breaks whenever they needed them. Almost everyone else on staff had a clear glass door and glass walls, or they worked in an open cubicle on the office floor. As you walked around the offices, looking at the walls of workers exposed through glass in their cubes, the image was not unlike a series of glass fishbowls. No one had privacy, except those in the top two leadership positions. Unfortunately, this physical signal reflected and propelled the overall company culture.

The space seemed to say that there were two leaders who really mattered. Everyone else worked in support of them, completely exposed and unable to rest or have any privacy in their "offices." I missed having an office with a door and felt the need for privacy. I needed quiet time alone periodically, in order to recharge for large group settings throughout the day. But there was no way to get a solid door. We could not hang curtains. I did not feel welcome to question this reality. What to do? Somehow, I needed to find some privacy, without upending the office design and culture. At home I noticed piles of my children's artwork. There were so many paintings and drawings, with not enough space on the walls in our house. *Bingo.* I slowly started to bring in my children's artwork and cover my glass walls with their paintings and drawings. No one said a word. I had my privacy, thanks to my kids' crayons. In retrospect, I should have asked for a curtain. Too often we feel powerless to make the space we need in order to do our best work. Arts leaders and managers need to keep this mind, making our workspace, and our ability to work from home, a priority.

FINAL THOUGHTS

Building an organization requires strategic planning and a lot of work. Think about how one aspect of the organization relates to the rest. Work to move all components forward at once, so that every aspect is improving and can better support the whole organization. Focus on the mission. Consider what you need in order to deliver this mission. Then build it.

NOTES

1. Author interview with Anna Glass, April 28, 2021. All quotes from Anna Glass that follow are from the interview, unless otherwise noted.

2. Internal Revenue Service, "Exemption Requirements—501(c)(3) Organizations." Accessed April 14, 2021. https://www.irs.gov/charities-non-profits/charitable-organizations/exemption-requirements-501c3-organizations.

3. Charity Navigator, "Types of Nonprofits." Accessed April 14, 2021. https://www.charitynavigator.org/index.cfm?bay=content.view&cpid=1559.

4. Internal Revenue Service, "Application for Recognition of Exemption." Accessed April 6, 2021. https://www.irs.gov/charities-non-profits/application-for-recognition-of-exemption.

5. Fractured Atlas, "Fiscal Sponsorship." Accessed April 20, 2021. https://www.fracturedatlas.org/fiscal-sponsorship.

6

PURSUING DIVERSITY, EQUITY, AND INCLUSION

Profitability lies in social justice. We keep planting the seeds, we keep telling the stories, we keep showing that when we work in the interest of all humanity, we all flourish.

—Robert Barry Fleming, executive artistic director,
Actors Theatre of Louisville[1]

INTRODUCTION

Diversity is not our problem, it's our promise. It's our promise because it leads to unparalleled heights of creativity, expression, and excellence. It's our promise because it leads to higher performing and more sustainable institutions. And it's our promise because it allows us to live by our democratic ideals of fairness and equality.

—The Honorable Elijah Cummings, speaking at the
League of American Orchestras 2016 National Conference[2]

The arts are facing a reckoning. With the murders of so many people of color at the hands of police, and with time to examine discriminatory practices in arts organizations, diversity, equity, and inclusion (DEI) have finally become priorities. Most arts organizations have published statements in support of greater equity, and they have apologized in some way for their role in oppression and suppression. Many organizations have adopted new DEI policies. But very few organizations have taken concrete action to invest significant resources, staff, and programming in this pursuit. It is vital that arts organizations differentiate between statements and real action. This chapter explores how to engage *authentically* in these efforts, and what arts organizations are doing, despite the many challenges.

FUNDAMENTALS

George Floyd was murdered by the police in Minneapolis on May 25, 2020, as an officer knelt on his throat for seven minutes and forty-six seconds.[3] Mr. Floyd's murder sparked a huge surge in social activism and support for the movement for black lives. The arts sector was forced to face its own systemic racism and the many discriminatory systems, policies, and choices still being made.

Arts organizations put out statements in support of Black Lives Matter and the pursuit of DEI, while *slowly* beginning the actual work. Many arts leaders, including Lisa Richards Toney, president and CEO of the Association of Performing Arts Professionals (APAP), underlined the necessity to decenter whiteness in the arts, and declared that "we will never go back."[4] As the arts sector figures out how to invest and engage in these efforts, here are five fundamental steps to more authentically pursue DEI in arts organizations:

FIVE FUNDAMENTAL STEPS TOWARD DIVERSITY, EQUITY, AND INCLUSION

1. *Audit Your Policies, Procedures, and Practices.* Systemic racism lives throughout the ways we work, from contracts to scheduling and from design to hiring. Do a deep dive of all your practices, as well as the practices of your consultants. Challenge your cultural assumptions. Identify potential harms and blind spots, and then make a strategic plan to revamp how you work. Engage your entire staff and board in the process. Couple any statements of support with real action. Put your policies where your mouth is. Create processes for identifying, reporting, and dealing with harms.

2. *Make a Strategic Plan to Diversify Your Staff, Board, and Programming.* Until you have a comprehensive plan with money attached, it is all theoretical hopes and dreams. While you are transforming your company culture, figure out how to welcome staff members from more diverse backgrounds to your organization, with competitive salaries, help with finding housing if they are relocating, and even a signing bonus. Expand staff benefits to provide robust family and medical leave across the organization. Diversify your regular programming, with a long-term commitment to new audiences and artists. Pursue board members with diverse backgrounds. Tie these plans to your overall organizational five-year plan.

3. *Commission or Purchase New Work.* Focus on artists of color. Commit to a specific timeline for producing or exhibiting the work. Ensure that curation and production are led by managers of color. Plan your audience development well in advance, so this new work is not met by an all-white audience when it premieres. As *We See You, White American Theater* demands, ensure critics of color from prominent news outlets review the work. Avoid segregating this work to once a year or in a specific timeslot and space each year. Make it normal to have artists of color throughout your season without question. In

the case of museums, explore *deaccessioning* some of your core collection, selling some of the work of your white artists in order to purchase more work by artists of color.

4. *Develop Your Audience.* Figure out who you have, who you must gain, and who you are willing to lose. Make a plan to grow new audiences who are compelled by this work. Examine if your current subscriber base holds you back from change.

5. *Raise Money Dedicated to DEI.* Without the funds to support your plans, you will not be able to do any of it. Talk with your local and national funders and ask for their support. If you are in a small community and smaller organization, determine the funds needed to pursue the goal and establish a plan to raise resources from your smaller donor base or reallocate funds from other efforts. Gain commitments from your larger corporate supporters to support this work, so that they can be a positive driver toward diversity.

CHALLENGES TO DIVERSITY, EQUITY, AND INCLUSION

There are many challenges standing in the way.

The Arts Are Exclusive

Internal diversity relies on external diversity. If you want your staff, artists, and organization to embrace DEI, you must also look to your audiences. But arts audiences do not reflect the diversity of the U.S. population. The October 2020 report *Culture + Community in a Time of Crisis*, published by the research firm La Placa Cohen, began: "The culture sector has an inclusion problem."[5] The report, based on the responses of 124,000 individuals and 653 arts organizations, reflected that arts audiences are still *overwhelmingly* white, with 85 percent of audiences identifying as white, while the U.S. population is only 63 percent white. Only 5 percent of audiences are Hispanic/Latinx, while being 16 percent of the population; only 3 percent of audiences are Black/African American, while being 12 percent of the population; 4 percent of audiences are Asian or Pacific Islander, while being 6 percent of the population; less than 1 percent of audiences are Native American or Indigenous persons, while 1 percent of the U.S. population identifies as Native American or Indigenous. Clearly the arts need to develop more diverse audiences to avoid becoming irrelevant

Funders, Subscribers, and Prices

Examine how your funding, sales, and marketing efforts support or detract from DEI. In April 2021, SMU DataArts published *The Intersection of Funding, Marketing, and Audience Diversity, Equity, and Inclusion.*[6] They found that while diversity increased

some over the studied period of 2011–2017, the number of audience members from lower socioeconomic backgrounds actually *decreased*. Meaning exclusivity is *increasing*. Funders and donors have varying effects on DEI, with foundation, government agencies, and smaller corporate support helping efforts, while *large corporate support seems to suppress diversity*, in part because larger corporate donors focus the organization's marketing toward its higher-end, traditionally white subscribers and donors.

A large subscriber base actually thwarts diversity, according to the report, because most subscriber bases consist of older white audience members. Maintaining these subscribers keeps arts organizations from further diversifying. Individual donors had no apparent effect on racial diversity, but they did help with socioeconomic diversity, as they tend to support those efforts. It is also clear that government agencies and foundations have begun prioritizing DEI efforts in their grant making. Focusing on diversity in marketing also seems to help draw more diverse audiences, though *pricing* can still push against diversity efforts. In general, it seems that if larger arts organizations need to keep their big corporate sponsors, their mostly white subscriber bases, and their higher ticket or entry prices in order to survive, they have some real disincentives against diversity.

The Importance of Community

One of the keys of improving DEI at your organization is to deepen ties to your local community. In March 2021, SMU DataArts published *The Alchemy of High-Performing Arts Organizations, Part II: A Spotlight on Organizations of Color*,[7] examining how organizations focused on artists, audiences, and communities of color have succeeded in developing more diverse audiences and organizations. The report highlights that these organizations often have deeper roots and ties to their local communities, coupled with high-quality programming, allowing more diverse communities to actively and organically participate in their organizations as audience members, artists, staff, and board members.

The study also revealed the importance of strategic visioning toward diversity, and that several external factors do stand in the way of this work, even for more diverse organizations, including racism, gentrification, lack of access to institutional funding, and racial unrest. Important internal factors for authentic efforts toward diversity included: mission alignment with these efforts, adaptive capabilities of the organization, investments in marketing and fundraising, a multiyear horizon of planning, and a healthy culture that invites participation. Through their commitment to their communities, organizations of color maintain more diverse audiences, artists, and staff, and continue to deepen their engagement with donors and community members. But they also often lack the greater institutional funding found at historically white organizations. Their local communities have limited resources to help. Their ability to grow is hindered by the majority of resources still being funneled to historically white institutions by historically white funders and donors.

The Problem with Funding

"60 percent of arts funding goes to 2 percent of the cultural institutions."[8] The vast majority of wealth in the arts is still funneled to very few cultural organizations. The 2017 study *Not Just Money: Equity Issues in Cultural Philanthropy* found that, while awareness of and commitment to DEI has grown among arts organizations, arts leaders, and funders, actual equity in funding *decreased* due to long-term systemic issues. The report's findings also concluded that:

- Leaders in philanthropy are not from diverse backgrounds, and that lack of diversity results in a lack of funding toward diversity.
- Cultural organizations focused on audiences and artists of color face many organizational challenges and a vicious cycle, including less capacity to gain more earned or contributed income, less access to large grants, less access to reserve fund opportunities, and less full-time staff, due to these lessened resources.

As the report concludes:

The inequities reported here will continue to widen unless there is a meaningful adjustment in funders' thinking about the role of art and culture in our communities, and a values shift that stops privileging the few at the expense of the many. The most important work ahead centers on acts of imagination and organizing. With creativity, boldness and collective action, a new era of more equitable and inclusive cultural philanthropy is within reach.

The systemic racism found in funding cycles, priorities, and institutions continues to feed inequities in the arts. To truly pursue DEI, the money needs to flow more equally. Without equal funding, any efforts toward greater diversity will continue to be thin.

Donor Denial

Be ready for donors and board members to fight against diversity, under the guise of defending the arts and arts organizations. Arts managers must face angry donors when engaging in conversations about potentially taking names off buildings, selling artwork, or even repurposing substantial gifts in the name of DEI.

Some donors, audience members, and staff members will kick back. One prominent supporter of the Getty Museum in Los Angeles attacked the museum's board and staff in February 2021 for adopting DEI policies, as reported by the *New York Post*. This donor denied any presence of racism in the museum and therefore objected to any admittance of racism or efforts to root it out. In the donor's view, racism seems to be based in a vicious intent, as he stated in his open letter to the Getty board of directors: "Either the Getty is a horrifically racist institution, in which case the leadership that

has presided over this evil, including the trustees, should resign immediately to restore the public trust. Or the Getty is virtue-signaling to an insidious movement that seeks to transform every important American institution in the hopes that its public penance works as a kind of talisman." But systemic racism simply exists, without clear intent or awareness, which is why it is systemic.

Setting aside the donor's description of the movement for greater DEI as "insidious," his statement is also undermined by his own insistence that "the museum has a long history of making inclusive art choices, including in its Pacific Standard Time collaboration, which looks at contributions across Latin and North America." Pointing at projects aimed at inclusion does not effectively deny systemic racism. In this and other reactions from white stakeholders, there seems to be a basic disagreement on the definition of "racism."

In his brilliant book *How to Be an Antiracist*, author and activist Ibram X. Kendi explains why the argument of being "not racist" is a tool of systemic racism:

> "Racist" is not—as Richard Spencer argues—a pejorative. It is not the worst word in the English language; it is not the equivalent of a slur. It is descriptive, and the only way to undo racism is to consistently identify and describe it—and then dismantle it. The attempt to turn this usefully descriptive term into an almost unusable slur is, of course, designed to do the opposite: to freeze us into inaction. . . . One either allows racial inequities to persevere, as a racist, or confronts racial inequities, as an antiracist. There is no in-between safe space of "not racist." The claim of "not racist" neutrality is a mask for racism. . . . Denial is the heartbeat of racism, beating across ideologies, races, and nations. It is beating within us.[9]

But for some donors, even the recognition of racism threatens the arts: "You take these policies to its logical end, and it will destroy the arts," said the Getty donor. "It takes away from creativity."[10] What this donor and *so many others* fail to realize is that the professional arts have never included everyone. Dismantling racism also requires dismantling some of the inherent power dynamics in the arts, including the sway and power of the largest donors, who might also contribute the largest blind spots.

Staffing

Some long-term arts leaders will resist progress and fight to keep their power and their salaries, as demonstrated in the case of Bob Lynch and Americans for the Arts (AFTA). Lynch, who served as president and chief executive of AFTA for *thirty-five years*, seemed tone deaf to internal calls for change and transparency from his staff in 2020, in what many referred to as a toxic work environment. An open letter from AFTA employees was eventually published:

> While the organization was publishing articles about the #MeToo movement, it was simultaneously protecting perpetrators of sexual harassment within the organization and on its advisory groups. . . . While posting about Black Lives Matter on Instagram,

the organization silenced criticism from its own employees asking for changes related to racial equity in the organization's policies or programming.[11]

Quanice Floyd, a member of AFTA's Arts Education Advisory Council, took Lynch and AFTA to task in an op-ed titled "The Failure of Arts Organizations to Move Toward Racial Equity"[12] in November 2020, for "hoarding power and blocking pathways for professional advancement in the field for BIPOC arts leaders." As brilliantly detailed by Floyd, AFTA, the largest and most influential arts advocacy organization in the United States, practiced old-school inequities that made it incapable of advocating for DEI efforts unless and until deep systemic changes took place. As Floyd pointed out, AFTA held its power in part by keeping funding for itself rather than distributing it to the arts field:

> According to AFTA's 2018 990 tax filing, the President and CEO's salary was almost $800,000 per year. AFTA sits on a $16M budget and over $100M in endowment and we have yet to see that being invested into the arts community. For decades, senior leadership of primarily white institutions (such as AFTA) have acted as gatekeepers, hoarding power and blocking pathways for professional advancement in the field for BIPOC arts leaders. These same institutions are the ones that continuously get awarded resources from the philanthropic sector over and over again while community-based and grassroots arts organizations who are actually doing "the work" struggle to keep it together.[13]

On December 3, 2020, Bob Lynch and AFTA published a newly adopted *Statement of Recommitment to Racial and Cultural Equity*, apologized for "not doing enough," and restated their commitment to diversity.[14] But it was too late. Just two weeks later, on December 17, 2020, Lynch and AFTA had announced his leave of absence from the organization.[15] In order to authentically pursue DEI, changes in staff and leadership are often necessary, as is a reexamination of salary levels and financial policies, all of which seems clear in the case of Bob Lynch and AFTA.

The Pay Gap

As cited by Quanice Floyd in the case of AFTA, the pay gap between arts leaders and entry-level workers is still vast. But it is no longer okay for the executive and artistic leaders to receive salaries in the high six figures or more, while interns and fellows toil away for little to no pay whatsoever. In part because GuideStar and social media have made it too easy to discover the top salaries and then share them online, especially with arts organizations stating their support for equity while still supporting such inequity. *We See You, White American Theater* demands replacing unpaid internships with paid entry-level jobs, while establishing a 10 percent salary rule, with the lowest wage at an organization to be no less than 10 percent of what the top earner receives. In some recent arts organization structures, this would mean the lowest wage at the organization might be $170,000, given that some recent artistic directors have

earned $1.7 million each year. Clearly, we need to stop copying Corporate America and start shifting resources from the top and spread them across the organization, if we are ever to attain equity.

Corporate Influence

Over the past seventy years, the nonprofit arts sector in the United States worked to replicate Corporate America in order to build more sustainable, financially healthy, and influential organizations. Museums, theaters, dance companies, orchestras, and music venues have hired strategic consultants from the corporate world to assist with planning, union negotiations, and special projects. These corporate advisors then applied their traditional, capitalist-focused systems to arts organizations and practices, thereby further transferring and focusing arts organizations in ways that prioritize economic power and influence over DEI efforts. See the appendix to read a case about the Indianapolis Museum of Art and how corporate influence helped lead them astray.

Some of the unintended consequences of this pursuit have been the accumulation of greater wealth among fewer arts organizations, the establishment of some large endowments or cash reserves at well-resourced and white institutions, and the building of world-class (aka large and expensive) facilities that rely on huge amounts of earned revenue to be sustained. These trends toward wealth and power in arts organizations now conflict with arts organizations' desire to pursue DEI *without* also losing their wealth and facilities. The fact is that any authentic pursuit of this work will require organizations to lose or at least *share* their traditional resources in order to succeed. Without a real realignment of resources in the arts, DEI may continue as *buzzwords* more than reality.

Stopping AAPI Hate

The organization Stop AAPI Hate[16] recorded 6,603 incidents of racism and discrimination against Asian Americans and Pacific Islanders (AAPIs) from March 2020 through March 2021.[17] In March of 2021, a series of shootings aimed at Asian women again highlighted the need to stop the hatred for and attacks on AAPI people. These attacks came after a year of documented increased assaults on AAPI people, partially as a result of racist misinformation spread regarding the global pandemic. On March 19, 2021, the Public Theater in New York City published an email that began:

> The deadly shootings that took place in Atlanta were a hate crime. They were not the product of "a really bad day," but a manifestation of generations of anti-Asian hatred, racism, and violence that have only escalated since the pandemic began, and Asian Americans have suffered for far too long. Enough is enough. We stand in solidarity with the Asian American and Pacific Islander community and condemn these acts in the strongest sense. This senseless violence is deeply rooted in anti-Asian racism and white supremacy. It is on all of us to question and understand the roles

we play in perpetuating these harmful beliefs and actions and the roles we must play in breaking them down—to end the hate that continues to cause Asian Americans to live in constant fear and grief. We know that being anti-racist includes acknowledging the AAPI experience, and we will continue to reach out to, listen to, and support our Asian American and Pacific Islander artists, staff, community members, and audience members who are hurting.[18]

Brilliantly, the message did not end there but included resources to report hate crimes and find help in the community: "To Report Hate Crimes Against the AAPI Community: Asian American Federation, NYC Commission on Human Rights; For Safety Resources and Bystander Intervention Information: Hollaback, Safe Walks NYC, Asian American Federation, Stop AAPI Hate; To Support the Families of the Victims via the Asian American Resource Center: Atlanta's Shooting Victims' Family Fund; Mental Health Resources: Asian Mental Health Collective, SAMHSA Hotline: 1-800-662-HELP (4357), NYC Well; Additional Organizations that Support the AAPI Community: Asian American Legal Defense and Education Fund, OCA National." By providing links to resources for all kinds of help, from physical recovery to mental health, the Public Theater demonstrated that the arts want to more actively serve communities and the social good. But the arts need to activate this intent further, with more equitable programming, staffing, and accessibility all the time and not just with words in the wake of tragedy.

VARIATIONS

THE DNA FOR DIVERSITY

Efforts toward DEI of course vary from organization to organization and from discipline to discipline. Some arts organizations like Global Arts Live in Boston, Massachusetts, are better positioned because their programming is focused on world music and therefore has always focused on diversity. Other organizations face greater challenges when considering how to advance diversity, like the Saratoga Performing Arts Center in Saratoga Springs, New York, which relies on an almost entirely white, older subscriber base, exists in a largely white community, and does not control their programming, relying on Live Nation to book big-selling acts to sell out their venue.

DISTINCTIONS BY DISCIPLINE

Beyond specific organizations, some arts disciplines are better positioned in this work, in part because of the nature and history of their discipline.

Opera

Practices of brown, black, and yellow face casting have persisted in opera in recent years, as of this writing, and opera companies still rely largely on classics that can be

racist and misogynist in their plots, and therefore harder to relate to contemporary audiences, or to justify the huge expense involved in mounting them. OPERA America, the national membership organization of American opera, has a statement supporting DEI on their website. Their statement on inclusion underlines the fact that opera as a discipline is taking baby steps toward inclusion, in part because it is an art form that has been historically exclusive:

> Inclusion: Opera company leaders have begun to examine the attitudes, behaviors and barriers that underlie the art form's exclusive traditions, while exploring ways to weave new connections into the mosaic of contemporary American life.[19]

In 2019, African American playwright and director Tazewell Thompson premiered *Blue*, a new opera about police violence, at the Glimmerglass Festival in Upstate New York. This new opera told the story of a Black family dealing with police violence, and starred singers of color, with what the *New York Times* called at the time "one of the most elegant librettos I've heard in a long time."

Then in 2021, Glimmerglass announced it was building a new outdoor stage, so that operas could be safely mounted outside. They would also shorten classic operas to ninety minutes, down from the regular three hours, signaling a shift in the design of the discipline that was almost unthinkable a few years before. Finally, they unveiled a new three-year initiative titled "Common Ground," which would bring six new pieces about life in America to the stage. The shift for operas to be shorter, with artists of color writing and starring in them, along with a stronger mix of new work and classics, bodes better for the discipline's future. At the same time, if more opera companies can produce shorter versions, with smaller production expenses, they will be better able to financially prioritize true DEI, though the high costs of production were never an excuse for not doing this work in the first place.

Opera companies need to hire more directors, conductors, designers, and managers of color as well, so that performers of color are no longer being directed and managed by all-white creative teams.[20] Putting people of color forward on stage without diversifying the teams off-stage simply deepens systemic racism and tokenizes performers. Opera must embrace the need and the opportunity to give creative artists and managers of color the freedom to tell their stories fully. They can also finally stop casting "the voice," regardless of race, and instead cast the artists.

Museums

Museums have some of the greatest challenges and strengths when it comes to pursuing DEI. The American Alliance of Museums (AAM), the national membership organization for museums, features strong language in support of this work on its website:

The Alliance highlights diversity, equity, accessibility, and inclusion as a key focus area in its current strategic plan. We believe that equity is our goal, inclusion is how we move toward that goal, and diversity describes the breadth of our experiences and perspectives.[21]

Museums with flexibility and a focus on their local communities, including the Speed Museum in Louisville, Kentucky, or the Museum of Art and History in Santa Cruz, California, are more readily able to engage diverse audiences and artists. Larger museums, especially those with large permanent collections of older works, have a harder time because their core collection does not reflect the diversity of artists and audiences today.

Deaccessioning

The practice of *deaccessioning*, or selling off part of a core collection at a museum, has historically only been warranted in extreme cases, as when a piece is damaged or proven to be a fake, and for funds to bolster a collection. But in 2020 the Association of Art Museum Directors signaled their approval for this practice, even to raise general operating funds for museums, given their financial strain in the wake of the global pandemic. Some museums have begun to sell some of the work of white artists in order to purchase work by more diverse artists. The Everson Museum in Syracuse, New York, sold a Jackson Pollock for $12 million to raise funds to purchase work by artists of color, which they have already begun to pursue. Surprisingly, even though this practice is aligned with growing a museum's diversity and relevance to a contemporary audience, critics, donors, and even board members have attacked museums for daring to sell any of its collection. The Baltimore Museum of Art canceled a scheduled auction just two hours before the sale was to begin, after two donors withdrew $100 million in pledged gifts and several donors and board members complained to the state attorney general about the planned sale.[22] While following a strict policy to sell works is vital to ensure a collection is never diluted in favor of quick cash, museums with permanent collections must wrangle with how to grow their DEI if they only have a collection of almost entirely white artists.

Even modern art museums like the Whitney in New York sometimes misstep in their attempts toward diversity, including when they featured a group of Black artists in the summer of 2020 in support of the Black Lives Matter movement, but they failed to pay the artists of color fairly or notify them of their exhibit at the Whitney, resulting in the museum apologizing and closing the show early.[23] As museums figure out their true path to DEI internally and externally, they each must struggle with how to honor artists, staff, board, donors, and audiences with work that is relevant and true to who they are.

Dance

Similar to OPERA America and the American Alliance of Museums, Dance/USA features language on its site about its pursuit of equity:

> Equity: Through the lens of equity, Dance/USA strives to remove the boundaries erected by a legacy of racism, classism, ableism, ageism, homophobia, transphobia, sexism, gender bias, and xenophobia and we work to dismantle institutional and systemic oppression that attack the dance field's progress, impede the creation of work, and negatively impact dance audiences and communities.[24]

The specific ways Dance/USA intends to do this work seems unclear, however. The International Association of Blacks in Dance (IABD) spoke more directly to the movement for black lives in 2020, dedicating a page of their website and much of their advocacy to demand real systemic change:

> IABD has got you. We have got each other. Who else will? Many of you have been out here doing this work for a very long time. Now we call for real change and through our collective voices, we will be heard. The International Association of Blacks in Dance has played a vital role in the lives of so many in the dance industry on a national and international level. IABD has saved lives, changed lives, provided opportunities, given hope and been a place of safety and refuge. . . . Time has run its course and a reckoning is at hand. When there is no commitment, when there is a blatant disregard for one's contributions, when one bears false witness, then ultimately there is an explosion, and that's what has finally happened. BOOM. Family I repeat—ALL THE PEOPLE, ALL THE TIME.[25]

Along with MOBBallet, which focuses on "curating the memoirs of Blacks in Ballet,"[26] the IABD, Dance Theatre of Harlem (DTH), and many more organizations led by artists of color launched an even deeper conversation about the need for dance to be a place of safety and honor for all artists, especially for artists of color.

Ballet and other forms of dance have historically excluded artists of color and therefore audiences of color. But pioneering artists, such as Arthur Mitchell, Alvin Ailey, Janet Collins, Debbie Allen, and so many more, forged paths for diversity in dance with their own work. These pathways now guide more artists and companies to better embrace the creative power and financial rewards from engaging these artists and audiences. Aligned with the previously noted findings of SMU DataArts, DTH has continued its strong commitment to its community while training and featuring world-class dance and dancers. Because organizations like DTH, Alvin Ailey, IABD, and MOBBallet now exist, artists and audiences can see their way to greater diversity in dance, if the field can support and prioritize them.

Music

> *After a pandemic that has asymmetrically affected those who have less, and who are marginalized or oppressed, orchestras—and all arts organizations—must come back with a new will to engage with their whole communities.*

—Simon Woods, CEO of the League of American Orchestras,
New York Times, February 28, 2021[27]

Ever since the Great Recession of 2008, resident orchestras have been in trouble. Affording orchestras year-round is becoming tougher and tougher, threatening the opportunity to further diversify these orchestras, let alone sustain them. Focusing on issues of equity, diversity, and inclusion can therefore be especially challenging while orchestras fight for their very survival. In *Making the Case for Equity, Diversity, and Inclusion in Orchestras: A Guide from the League of American Orchestras*,[28] however, the League poses and attempts to answer several telling questions on this work and why it matters:

- Why do we need to talk about racism and antiracism? My orchestra isn't racist.
- If we program unfamiliar music by Black composers, won't we lose audience members?
- At a time when our survival is at stake and resources are limited, how can we afford to engage in this work?
- We make no judgments about race as connected to artistic quality. Won't a focus on EDI and antiracism compromise the artistic quality of our orchestra?
- My community doesn't have many Black people in it. How are EDI and antiracism work relevant for us?
- Our orchestra is already diverse, and our blind auditions give everyone the same chance. Isn't that enough?

These published questions and the answers (spoiler alert: diversity *increases* profitability) demonstrate that the orchestra community is at least attempting to grapple with these issues. But implementing changes, even while reinventing their business model, will be the true test of success.

Contemporary music artists and venues have more flexibility in their programming and so have more freedom to engage diverse artists and programming more quickly. So much American music has been invented and popularized by Black artists, from jazz and rock and roll to rap and hip-hop, that many contemporary music venues rely more on artists of color than white artists. At the same time, booking companies for larger venues like Live Nation may experience more pressure to provide more diverse programming going forward, depending on how much pressure the venues receive from their audiences.

Theater

Perhaps the most vibrant and exhaustive set of demands toward making the arts more equitable and antiracist has come from *We See You, White American Theater*. On June 8, 2020, more than three hundred Black, Indigenous, and People of Color (BIPOC) issued this treatise as a clarion call to White American Theater, demanding equity and revolutionary change in practices and policies that harm Black, Indigenous, and People of Color working in the theater today. Seven months later, when they published their report on the results to date for their efforts, over 104,500 people had signed their Change.org petition in support of the cause, and hundreds of theaters had published statements and actions taken in response to their demands. Their original treatise begins in part:

> Racism and white supremacy are cultural formations constructed to rationalize unjust behavior for economic gain, and eradicating them requires radical change on both cultural and economic fronts. We also wish to underscore that our emphasis on anti-racism should not be taken as an excuse to overlook sexism, ableism, ageism, hetero-normativity, gender binarism, and transphobia, as our identities are intersectional.[29]

BIPOC artists and administrators' demands were organized with the following segments: Cultural Competency; Working Conditions and Hiring Practices; Artistic and Curatorial Practices; Transparency, Compensation, Accountability and Boards; Funding and Resource Demands for BIPOC Theater Organizations; Commercial Theater and Broadway; Unions; Press; Academic and Professional Training Programs.

From contract riders to hair and makeup supplies, this precise and compelling document demands that White American Theater dismantle systemic racism from theater practices. It shines a light on practices causing harm, but seemingly invisible to white people. It demands equal pay, staffing, governance, and artistic control. It states again and again what should seem obvious but somehow has not been: that BIPOC artists and administrators must be treated equally, with cultural competency and care equal to those of the historically dominant white culture. Now that most theaters have posted positive responses on their websites, time will tell if White American Theater can meet these demands with action.

FINAL THOUGHTS

Arts organizations have a lot of work to do to establish equity in paying our staffs, funding our organizations, supporting our artists, and engaging our audiences. For far too long, arts managers and leaders have accepted the fallacy that there is not enough time or resources to develop a workforce, audience, or artistry that is more diverse and inclusive. Arts managers have allowed their busy and stress-filled work to keep them from reflecting and taking action to truly live their values. They have supported a still largely white audience, artistry, and donor base. The pandemic, Black Lives Matter,

and the #MeToo movement have combined to reveal again what Dr. King called the *fierce urgency of now*. If we continue with the status quo, we are dooming our work and our field to irrelevance. At the same time, as Robert Barry Fleming, executive artistic director of Actors Theatre of Louisville, reminded me, arts leaders must remember that we live and work in a country built on capitalism, racism, and slavery. The arts are one part of a complex global infrastructure of racist power.

As artists, we can and must lead the way, while being honest with ourselves about the challenges we face.

NOTES

1. Author interview with Robert Barry Fleming, April 26, 2021. All quotes from Robert Barry Fleming that follow are from the interview, unless otherwise noted.

2. League of American Orchestras, "Making the Case for Equity, Diversity, and Inclusion in Orchestras." Accessed May 2, 2021. https://americanorchestras.org/making-the-case-for-equity-diversity-and-inclusion-in-orchestras/.

3. Associated Press, "Prosecutors say officer had knee on George Floyd's neck for 7:46 rather than 8:46," *Los Angeles Times*, June 18, 2020. Accessed June 27, 2021. https://www.latimes.com/world-nation/story/2020-06-18/derek-chauvin-had-knee-george-floyd-neck-746-rather-than-846.

4. The Wallace Foundation, "What Audiences Want from the Arts as the Pandemic Rages On," The Wallace Foundation. October 13, 2020. Accessed May 2, 2021. https://www.wallacefoundation.org/knowledge-center/pages/reimagining-the-future-of-the-arts-session-one-what-audiences-want.aspx.

5. La Placa Cohen, "Culture and Community in a Time of Crisis," La Placa Cohen, October 21, 2020. Accessed June 28, 2021. https://culturetrack.com/research/covidstudy/.

6. Dr. Zannie Voss, Dr. Glenn Voss, and Young Woong Park, "The Intersection of Funding, Marketing, and Audience Diversity, Equity, and Inclusion," SMU DataArts, April 2021.

7. Dr. Zannie Voss and Dr. Glenn Voss, "The Alchemy of High-Performing Arts Organizations, Part II: A Spotlight on Organizations of Color," SMU DataArts, March 2021.

8. Holly Sidford and Alexis Frasz, "Not Just Money: Equity Issues in Cultural Philanthropy," *Helicon Collaborative*, July 2017.

9. Ibram X. Kendi, *How to Be an Antiracist* (New York: Penguin Random House LLC, 2019).

10. Kirsten Fleming, "Famed Getty Museum blasted for 'virtue-signaling' diversity effort," *New York Post*, February 20, 2021. Accessed May 1, 2021. https://nypost.com/2021/02/20/getty-museum-blasted-for-virtue-signaling-diversity-effort/.

11. Jeff M. Poulin, "It Is Past Time to Hold Americans for the Arts Accountable for Its Actions," *Medium*, November 25, 2020. Accessed June 12, 2021. https://jeff-14644.medium.com/it-is-past-time-to-hold-americans-for-the-arts-accountable-for-its-actions-6370aecfb87e.

12. Quanice Floyd, "The Failure of Arts Organizations to Move Toward Racial Equity," *Hyperallergic*, November 11, 2020. Accessed June 28, 2021. https://hyperallergic.com/600640/the-failure-of-arts-organizations-to-move-toward-racialequity/?fbclid=IwAR00AF_v5IE_nuofWzsydk5M3Rxp2ZeavcvPKcJEwPLCNKdbL_XbkSm1lY.

13. Ibid.

14. Robert L. Lynch, CEO, Americans for the Arts, "A NOTE TO OUR STAKEHOLD-ERS ABOUT RACIAL AND CULTURAL EQUITY," December 3, 2020. Accessed May 2, 2021. https://www.americansforthearts.org/news-room/americans-for-the-arts-news/a-note-to-our-stakeholders-about-racial-and-cultural-equity.

15. Taylor Dafoe, "The President of Americans for the Arts Will Take a Leave of Absence Following Allegations of a Toxic Work Environment," *artnet news*, December 17, 2020. Accessed May 2, 2021. https://news.artnet.com/art-world/americans-for-the-arts-robert-lynch-1932470

16. https://stopaapihate.org/.

17. Nicole Chavez, "Asian Americans reported being targeted at least 2,400 times this year," *CNN*, May 6, 2021. https://www.cnn.com/2021/05/06/us/asian-americans-stop-aapi-hate-report/index.html.

18. The Public Theater, "Enough is enough." Published March 19, 2021, via email.

19. OPERA America, "OPERA America's Commitment to Equity, Diversity and Inclusivity." Accessed May 2, 2021. https://www.operaamerica.org/r/audiences-community/4554/opera-americas-commitment-to-equity-diversity.

20. Joshua Barone, "Opera Can No Longer Ignore Its Race Problem," *New York Times*, July 16, 2020. Accessed June 29, 2021. https://www.nytimes.com/2020/07/16/arts/music/opera-race-representation.html?referringSource=articleShare.

21. American Alliance of Museums, "Diversity, Equity, Accessibility and Inclusion." Accessed May 2, 2021. https://www.aam-us.org/programs/diversity-equity-accessibility-and-inclusion/.

22. Matt Stromberg, "How 'deaccession' became the museum buzzword of 2020," *Los Angeles Times*, December 29, 2020. Accessed May 2, 2021. https://www.latimes.com/entertainment-arts/story/2020-12-29/deaccession-museum-art-auctions-2020.

23. Valentina Di Liscia and Hakim Bishara, "Whitney Museum Cancels Show After Artists Denounce Acquisition Process, Citing Exploitation," *Hyperallergic*, August 25, 2020. Accessed May 2, 2021. https://hyperallergic.com/584340/whitney-museum-black-lives-matter-covid-19-exhibition-canceled/.

24. Dance/USA, "Dance/USA Core Values." Accessed May 2, 2021. https://www.danceusa.org/danceusa-core-values.

25. The International Association of Blacks in Dance, "Let's Take a Moment." Accessed May 4, 2021. https://www.iabdassociation.org/page/moment.

26. MOBBallet.org, "About Us." Accessed May 4, 2021. https://mobballet.org/index.php/about-us/.

27. Simon Woods, "What Orchestras Must Do, After Covid," *New York Times*, February 28, 2021. Accessed June 27, 2021. https://www.nytimes.com/2021/02/28/opinion/letters/covid-orchestras.html.

28. League of American Orchestras, "Making the Case for Equity, Diversity, and Inclusion in Orchestras." Accessed May 2, 2021. https://americanorchestras.org/making-the-case-for-equity-diversity-and-inclusion-in-orchestras/.

29. *We See You, White American Theater*, "BIPOC DEMANDS FOR WHITE AMERICAN THEATRE," June 8, 2020. Accessed May 2, 2021.

7

RAISING MONEY

We're doing a 128-million-dollar capital campaign and too much of it is often fo-
cused on getting the gift and not about making people feel good about giving the gift.

—Nancy Yao Maasbach, president of the
Museum of Chinese in America[1]

INTRODUCTION

Fundraising is a series of actions, strategies, and relationships that anyone can master. It's about giving funders and donors what they need so that they can give you the money they want to give. *They* need a cause, a recipient, and somewhere safe to place their support. *You* need funds to deliver your mission. A survey published by SMU DataArts and the Wallace Foundation in 2020, *The Alchemy of High-Performing Arts Organizations*, demonstrated that organizations with a clear, compelling mission and deep ties to their communities were likely the best prepared to survive and thrive.[2] This chapter will explore the basics of fundraising, as well as how to approach specific fundraising targets and audiences, including donors, foundations, corporations, and government entities.

FUNDAMENTALS

WHERE DOES THE MONEY COME FROM?

On average, 60 percent of income for nonprofit arts organizations in the United States is earned (ticket sales, entry fees, etc.). Another whopping 40 percent therefore needs to be raised from individual donors (24 percent), government agencies (9 percent), foundations (4 percent), and corporations (3 percent).[3]

While the national average may be 60/40 between earned and contributed incomes, many arts organizations operate with a different balance. If an organization is focused on arts education and sells less tickets, they might maintain 10 percent earned and 90 percent contributed income. Or if an organization primarily relies on box office or entry fees, they may draw 80 percent earned and 20 percent contributed annually.

A split closer to 50/50 is ideal, because it allows for a better balance of income and shared risk across resources. If an organization relies heavily on earned income, there is enormous pressure on the marketing and sales teams in the organization. If it relies too much on contributed income, a sudden drop in funding might end the organization. Nonprofit arts organizations are supposed to be mission-driven. Gaining substantial contributed support is crucial.

FIVE FUNDRAISING FUNDAMENTALS

If you have a distinct mission and relevance to your community, raising money is much easier. Here are five fundraising fundamentals to guide your thinking.

1. *A Great Mission Attracts Money.* Your mission needs to be clear and compelling. Your work must authentically grow from that mission. So many artists and arts organizations are asking funders and donors for money. If you're not clear on what you do and why, why would they choose you?
2. *Relationships. Relationships. Relationships.* With donors and funders, you are building relationships, building trust, and building partnerships. Actively tend to these relationships. Let them know they matter to you as friends, allies, and partners so that they truly feel a part of your organization.
3. *Continually and Clearly Communicate What You Do and Why It Matters.* Communications, marketing, and fundraising are interrelated. Your communications must convey why your work matters beyond the latest event or show so that funders, donors, and audiences are consistently hearing why you deserve support without being continually asked for support.
4. *Be Ambitious but Realistic.* Base fundraising goals on clear-eyed research and reality. Rally your board, staff, donors, and funders around exciting projects and programs, inspiring them to give their all, but know your limitations, based on your community, the current economy, and the political climate. Don't set outrageous goals based on hopes and dreams. Realistic wins are better for you and your organization than ambitious failures or continual stress.
5. *Prioritize Social Justice and Cohesion.* In the wake of Black Lives Matter and COVID-19, funders and donors expect artists to address the greater needs of our society. At the same time, funders are under pressure to fund efforts in social justice, food scarcity, healthcare, education, and more. If you aren't able to articulate how you serve some of these greater social needs, funders may not be able to prioritize you.

SOURCES OF CONTRIBUTED INCOME

Contributed income for nonprofit arts organizations consists of individuals, foundations, corporations, and government agencies. In this section we will explore each source and how to pursue their support.

Individual Donors

The majority of support for the arts in the United States and around the world comes from individual donors. Individuals can be tough to gain as donors. Competition is fierce. But they are also easier to rely on than foundations or government agencies. While there are still very deep pockets giving millions of dollars each year, millions of people also give at the $50 level, the $100 level, the $1,000 level, and the $5,000 level. These relationships are hopefully long term and not just based on money. For every time you ask them for support, you should have at least three contacts with them throughout the year that have nothing to do with asking for their support.

Individual donors come in many shapes and sizes. Some want to just support your work with a few extra dollars. Some are deeply compelled by your organization because they have seen firsthand the magic you offer each of them and the effects you've had on their children. They sometimes budget to give you a big gift at the end of the calendar year, as a holiday gift. They sometimes sign up to be sustaining supporters and donate $10 from their banking account each month. They give you their money, trusting in you to do the right thing for their community.

Once you have enough resources, and you have enough donors to justify it, you should research donors with an online search tool like *Wealth Engine*, which will help you understand how much money and assets a donor may have, in order to guide your "ask" to them.[4] As discussed later in this chapter, the "ask" is the amount you request from a donor. Researching how much donors give to other organizations and how much they can afford can sometimes guide you to the correct level of "ask." Ideally you build an authentic relationship with each donor so that the "ask" is natural and not just based on independent research. Individuals never mind when someone thinks they have wealth. They do sometimes mind if that assumption is just based on research and not a mutually beneficial relationship.

Foundations

Next to individual donors, foundations are perhaps the most reliable funders for the arts. Unlike government or corporate support, gifts from foundations can be competitive, but they also usually come without strings, meaning they give more often for general operating support and without restrictive requirements on what you can do with the money. Once you have gained entry into a foundation's funding portfolio, you can often count on that support for years to come.

Foundations come in many different shapes and sizes. There are large foundations like the Andrew W. Mellon Foundation (with assets of $6.8 billion)[5] or the Ford Foundation ($14 billion),[6] who focus on effecting serious social change with major gifts. Then there are small family foundations, which seek to support smaller operations via gifts of $5,000 or $10,000 each year, with only basic reporting required in order to satisfy the grant requirements. Smaller foundation gifts (anywhere from $5,000–$30,000) tend to come with a simple award letter, usually accompanied by a phone call from the program officer, letting you know you have won a grant.

Almost all major foundations tend to be urban-based, either in New York, L.A., San Francisco, D.C., Minneapolis, or another major market. Foundations in rural areas tend to be quite tiny, often with no office space (or simply an extension available at a board member's law office) and tending to grant only $250–$1,000 per year. They often require you to gain an invitation in order to apply, and said invitation can be difficult to gain, given many of these foundations still work entirely via regular mail. In both environments, finding and connecting with a staff member at the foundation is the key to gaining entry, learning how to apply, and having an advocate on the inside of the foundation for your work.

To be ready to apply for foundation grants, you must familiarize yourself with *what* your organization does and *how* they do it until you can write clearly and compellingly about it. Record what you do, in program summaries, assessments of student learning, photos, and videos. Compile draft proposals, including all the core language about your key operations and programs, so you can quickly adapt those to many different audiences. Research available funding from foundations and government sources, while wooing and developing individual donors who might give to your company or give *more* to your company than they have before.

Ben Cameron, president of the Jerome Foundation, talks about the changing strategy for their foundation, as they strive to serve the field and society even better: "I think that for us at the foundation, I hope we've learned a new way of thinking about long-term and what it means to be in it for the long game. As you probably know, foundations are required to divest themselves 5 percent of their assets every year, basically. That's the law. You have to give away 5 percent. It's more complicated and nuanced than that, because you also pay excise taxes that didn't count, and you can average it over time, but the shorthand is 5 percent a year. And most foundations zealously guard that 5 percent, because the reality is when you do add those other things in, you really are spending not 5 percent a year. You're spending more like 7 percent or 8 percent, because none of your investment fees count. Your excise tax doesn't count. There are a lot of other things that have to go out the door. And so if you're not growing at least 8 percent a year, you're actually losing traction against inflation.

"And the idea about the 5 percent, which is demonstrated over time is, yes, some years, you'll be really underspending, but when markets crash, you'll be probably overspending if you're average. But over time, consistent 5 percent giving allows you to weather that, and allows over time the budget to keep moving forward, which means you're increasingly of service to your community. You're able to do more. But really

what does that mean when our communities are in such distress? And so our strategy, we were really inspired by the Ford Foundation, who basically has pledged a billion dollars. And we looked at their formula, and said, 'Well, how much do they give away a year?' And they give away between 500 million and 600 million. So, they basically committed twice their giving budget basically.

"So, we said, 'Well, we give away about 4 million, what would it be like for us to give away twice our giving budget?' And we committed to do that, but we also said, 'Look, let's take the long view.' Let's say basically we're going to make this commitment, but we're going to do it over a five-year period, and we're deliberately going to do it mostly in years three, four, and five, because we think the special initiatives that are up right now around relief and work relief, they're going to disappear after a year or two. If we learned anything from the recession, they're going to be gone. And everybody's going to say, 'Why haven't you fixed this yet,' and there won't be special efforts there, and the problems aren't going to be solved. So, let's make that commitment, but let's think about what that means to hold back on it, so we can be a value when other things disappear. So, we're learning to think beyond the immediate horizon into longer-term service."

Corporations

Corporate support relies on your being able to help a business raise their profile or pursue one of their company's strategic goals, including: associating them with excellence and the message that they are supporting the community; connecting them with high-profile politicians or community leaders; showcasing them as a caring company; providing opportunities for their employees to volunteer.

To secure corporate support, you will need to create a one or two-page document detailing how your company's work can help their company in all these areas. What value do you offer them? Attach real numbers to these values, including how many people you serve, how many eyeballs see your emails and mailings, how much money you generate for the local economy, and how much you draw from other sources, so they know they are in good company. Prepare talking points and look for opportunities to connect with managers from corporate entities. Ask them to meet with you, ideally over lunch or coffee, so you can gently pitch them on gaining their support. Invite them to a performance or program so they can see your work in action. Then play the gracious host: meet them at the event, introduce them to artists or students after the event, and follow up with a phone call to move the conversation forward.

Corporate funders are also realizing they have a responsibility to better support social justice and equity. In a report released in April of 2021 from SMU DataArts,[7] researchers demonstrated that large corporate support can be shown to *suppress diversity* in arts audiences, in part because it has historically supported the status quo in programming. Mary Ceruti, the executive director of the Walker Art Center in Minneapolis, talks about how corporate funders are beginning to change: "I think here in

BOX 7.1. TARGET

Sometimes fundraising connections come from obscure personal connections. As a corporate entity, Target mostly distributes small grants to nonprofits within a certain radius of each store. But early in my tenure as CEO of Young Playwrights' Theater (YPT), I developed a connection to a staff member at the Target Foundation in their home office in Minneapolis. In this case, my wife had worked with someone who ended up married to this manager at the Target Foundation. When I heard that Target was planning to build its first store in Washington, DC, a few blocks from our offices in Columbia Heights, I reached out to this person to introduce myself.

He was visiting DC in a few weeks and we set up a time for him to visit our offices. I learned in that meeting that Target was in fact about to build a big store in our neighborhood. They also needed to find ways to ingratiate themselves to the local residents, who were concerned about how this big box store might change the community. I pitched him the idea of supporting our In-School Playwriting Program, which was based at Bell Multicultural High School in the neighborhood. They needed access and authentic connection to our neighbors and students. We needed their financial support.

They offered us a national grant of $15,000 annually for three years. At the time, this was the largest corporate support YPT had ever received. This national grant also enhanced our reputation with other businesses, and allowed us to raise more money from other corporations. It became a great story for us, to be able to say we were partnering with Target to bring this great program to students. Later that year we even gained a $5,000 grant from the Foster's Beer Company, all the way from Australia, in part because we had proven we were worthy of support from a large business. After the Target store opened a few years later, their national support of YPT dried up. But that was okay, because we had used the opportunity to grow our funding with so many more businesses. One opportunity can lead to years of growth for your company, if you leverage it correctly and abundantly.

Minneapolis, the corporate community is alert and invested in trying to address racial injustice and are paying attention to that issue both from an employee perspective and a customer perspective and a brand reputation perspective. I think that means that board members are paying attention. I don't have to convince them that this is something we should be paying attention to, they know that. I think the majority understand that our relationships to our communities has to be different."

Government Agencies

In the United States, government support at the federal level is relatively small. Less than .015 percent ($162.5 million in 2020) of the federal budget supports the National Endowment for the Arts (NEA). This despite the fact that, according to the NEA and the Bureau of Economic Analysis, the arts *contributed* approximately *$877.8 billion* or 4.5 percent to the nation's gross domestic product (GDP) of the U.S. economy in 2017.[8] States often offer even less support than the federal government, and the situation from state to state varies greatly. The big gift to the nonprofit arts from the U.S. government is the tax-exempt status granted by the 501(c)(3) designation, which saves the arts billions of dollars in taxes each year.

The New York State Council on the Arts awarded $43.8 million (or 2.27 percent of the New York State total budget of $192.9 billion) in 2020 in support of theater, music, dance, and visual arts,[9] while the arts provided more than $114 billion to the New York State economy in 2018.[10] The Oklahoma Arts Council, on the other hand, offered only $2,285,086 in 2020, or less than one-tenth of 1 percent of that state's budget, even though the arts provide $872.8 million to the Oklahoma state economy[11] and generate $6 in local and state tax revenues for every $1 spent supporting the arts.[12] Like lots of things in the United States, where you live and work matters a great deal in terms of how the arts are perceived and supported.

So, how do you gain greater government support? For federal agencies, the application, and catching their attention, are key. The NEA covers too many organizations to have deeply personal relationships with many. Clearly communicating that they can rely on your excellence, your pedagogy, and your evaluation prowess are keys to gaining their support. Being reliable and doing the kind of work they can stand behind and celebrate is essential. Once you are in the cycle, you can usually count on being funded again in the future, as long as you do good work and report on that work fully and on time.

For local government support, explore your state arts council and see if you can gain any local municipal support from your county, city, town, or village. Reach out to each and ask if you can meet with someone there to introduce yourself and talk about your work. See if you can start a relationship that may come to fruition later. Do not underestimate how much a meeting and connection with a person on staff at a local agency can help you down the road. The staff at government agencies are usually overworked, underpaid, and serving hundreds of organizations at once. Anything you can do to politely and professionally communicate with funders and agencies can help you rise above the pack.

FUNDRAISING CYCLES AND SYSTEMS

Fundraising never stops in an arts organization. It is therefore vital to maintain a fundraising calendar year-round, with deadlines and cycles outlined for each source of funding. Foundations and government agencies usually publish their application deadlines online. With corporations, you will often need to find a staff contact, who can

usually consider a request throughout the year. Corporate funding is more likely earlier in the calendar year, however, when companies typically have more funds available. Individual donors are engaged a few times each calendar year: with a major mailing and end-of-year campaign just before the December holidays; a spring campaign or Gala fundraiser; and again during the summer with a matching or programming campaign.

Matching Campaigns

Individual donors love to feel their donations have an impact. Matching campaigns give them the opportunity to double their donation, because a company or another individual has offered to *match* whatever is raised for a specific project or within a certain time frame. Sometimes the matching donor or company is identified, but often they are kept anonymous. Sometimes the match is only given in response to new donations, but it is more often offered as a blanket challenge for donors to meet the larger amount. In either case, offering up a "match" and the opportunity for donors to feel their gift will double in impact is a great story that helps drive people to give. Focusing on a specific program or physical facilities helps give donors the vision of what their support will do. Donors love having concrete, meaningful impact. Often, they will give more if they can also put their names on it. In cities, donors tend to crave naming opportunities, while in rural settings they often want to avoid being highlighted because they fear their neighbors will perceive them as wealthy or arrogant and would rather keep their support more private.

A Moves Management System

David Dunlop, a fundraiser at Cornell University, first discussed the concept of a "moves management" system and described it as "changing people's attitudes so they want to give."[13] In other words, a moves management system is the way in which you track your interactions with potential donors and funders and proactively plan how you will "move" them up in their support of the organization. This system can be set up in your database via Customer Relations Management (CRM) software or simply as a managed file in an Excel spreadsheet. The system lists the donor's name and contact information, along with every gift they have given and when, and all the ways in which they have connected with the organization (via attendance or communications). It also plots out what steps are next and how the organization will manage its relationship with them to advance their gifts and deepen their connection to the organization over a certain period of time.

Managing the system successfully requires at least one dedicated staff member in your fundraising or development department, because keeping in contact and aware of donors and funders takes staff time, as does planning events and future contacts. If donors and funders feel heard and valued with a personal connection to the organization,

they may increase, or at least sustain, their support. If they feel ignored, mistreated, or overwhelmed, they will likely retreat and never give again.

Some donors prefer to stay anonymous. They often either feel humble about their gifts or they prefer to not be targeted by others for their funds—or they simply feel embarrassed being recognized publicly. When you first gain their support, you should confirm with the donor how they would like to be recognized, simply by offering an "Anonymous" option on their gift card, envelope, or web donation, or by explaining what you normally do and communicating that they can let you know if they have another preference. If they become a major donor, you can continually check in with them on whether they are ready to be recognized.

For donors who give a larger amount, you will want to send them a special, handwritten note in the mail, thanking them for their donation and perhaps expressing an interest in having coffee or lunch with them to discuss the company and their interests. You will often discover through this kind of follow-up meeting that a donor loves your company and wants to increase their support (and can do so). At this meeting, however, you should not ask for more money. You should simply thank the donor and develop your relationship while hearing why they support you and what interests them most about your work. Then invite them to an upcoming workshop or event. At this event, welcome them personally and ensure they are taken care of with good seating, easy ticketing, etc. Then, after they have attended a few more events, you can circle back to them to ask for another donation.

Developing Relationships

The key to growing donations is to grow your relationships with donors as individuals, and not just as piggy banks. The following scenario is one example of how to advance a donor relationship.

A potential donor attends a performance at your venue. She likes the show and briefly talks with you after the event. You give her your contact info and promise to follow up. Within two days, you call her. She is interested in talking more and attending your next performance. Do you: say you are happy to arrange free tickets for her and a guest; offer to transfer her to your box office; offer her free tickets generally but do not push her to reserve; or remind her when the box office is open? You should, of course, choose the first option: arrange free tickets for her and a guest.

This person has cared enough to attend and inquire. If advancing your relationship requires two free tickets, so be it. Take the high road and provide free tickets. Or, if she insists on paying for her tickets, graciously accept, and offer to provide her next tickets for free. You want donors to support you. You want potential board members to attend and get involved. You don't need the box office revenue enough to risk insulting them.

If you can identify a new major funder or donor, or a program officer of a funder who could help you develop your support, first ideally have coffee or lunch to convey

to them why your work is so important *or* get them to come to one of your events so they can see the work firsthand. Eventually, at YPT, we developed a program that allowed board members or donors to come into the classroom and see the programming in action. Board members or donors could invite one or two guests to this event, with the hope that they'd be introducing a new supporter to the company. These visits also provided much-needed inspiration for those current board members and donors.

Making the Ask

Once individuals are interested, draw them in. If someone sees your work and expresses their delight and support, you should ensure that they are included in your next fundraising campaign. You should call them later that week to get their feedback and ask if they have time to meet up soon to discuss more. Rather than just send them a form letter, be sure to write them a personal note on the letter, asking them for their support. Or, if you can have lunch or coffee with them soon, sit down with them, and when the time is right in the conversation, say something like: "I'm so glad you enjoyed the show last week. I'm wondering if you'd consider a gift of $1,000 this year."

Then *be silent and wait. Wait* for them to respond. If there's silence between you, the impulse will be to speak and take them off the hook: "Or, if that's too much, just think about it and let me know." *Do not say this.* Stay quiet. Wait for them to respond. The worst possibility is that they say "no." But they will respect the direct question, and no one is offended if someone else thinks they have more money than they actually do. It's not an insult, as long as you respect their answer. "That sounds fine." Or "My God, I don't have that kind of money." Or "I think I can do better than that. How about $5,000?" You won't know unless you let them *respond.*

Be prepared to tell the donor what their gift would mean to the company. How many people will be served with an additional $1,000? What are the key programs in need of funding? What is the company's impact on the community? How will this gift help? In order to raise money and treat people honorably, you need to be prepared. You need to know *why* you are asking for the money, *why* they should give it to you, and why they should *feel good* giving it to you.

Annual Reports and Thank-a-Thons

Two of the best tools to move donors toward increased support are the Annual Report and the annual Thank-a-Thon. The Annual Report is a printed, designed document showing your accomplishments from the previous year, from your participant numbers to your financials for the year and all of the programs, events, and performances accomplished. This report usually includes a thank-you section for that year's donors, funders, and sponsors, where you can list your supporters right in the same document that shows how much their support meant to you. You also can in-

clude photos from throughout the year, to show the faces of those who are supported by your work.

A *Thank-a-Thon* is a kind of telethon in reverse. At the end of your fiscal year (or whenever makes most sense to you based on your fundraising calendar), you can devote a day, evening, or just an afternoon to having a phone bank aimed at calling that year's donors and simply thanking them and telling them how much their support means to you. No asking for money. No pitching. Just calling to say thanks. One of the best ways to do this is to recruit board members, staff members, and students or artists from your programs. Take over your office lines or set up a special call time with an online service. Each person should get a call list with twenty to thirty numbers, depending on how many people are calling and how long your list is. Many people will *think* you are calling to ask for more money. When you do not ask and instead express gratitude and interest in them, donors are delightfully surprised and pleased. For those individuals who seem *unenthused* by the call, the board member, staff member, or student can simply go through their points short and sweet and wrap up before the person becomes too annoyed.

BOARD FUNDRAISING

A board of directors has two major responsibilities: 1) to hire, evaluate, and (if need be) fire staff leadership, and 2) to ensure the organization has enough resources to pursue its mission. *This means fundraising.* Functioning boards have an agreed-upon fundraising goal in each year's budget so that the amount the organization expects the board to raise is crystal clear. Often, boards establish a *Give and Get* expectation, meaning each board member commits to *giving* a certain amount of their own money and *getting* a certain amount of money from friends and colleagues. Sometimes they commit to a *Give OR Get*, meaning they might achieve a dollar amount either way but not necessarily both. Organizations tend to favor the "and" model, because it means board members will give their own funds but also help grow the organization's support by soliciting others.

THE DREADED GALA

Gala fundraisers usually involve a dinner or cocktails in the evening, with attendees in fancy dress and a high ticket price. Historically galas have been seen as profile raisers and opportunities to attract larger donors with high-profile guests or honorees. They are built to feel exclusive. Arts organizations use them to raise a certain amount of money for the year while also drawing in new donors and corporate supporters. The challenge with galas is that they usually require a lot of staff time and money to plan and execute well. Often the amount of money *raised* barely surpasses what has been *spent*.

The key to raising enough money lies in gaining corporate supporters to underwrite the event and asking a few individuals to give big gifts toward the gala. Board members are often asked to give additional gifts to ensure a gala's success. If a paddle

raise is done during the gala (when an auctioneer leads the crowd to raise their paddles with increasing support of a program or project), larger donors might be asked in advance to help drive the paddle raise by offering donations they were already slated to give during the year, as a "plant" to help drive the crowd's excitement and giving. Because of the cost, the staff time required, and the exclusivity focused on larger donors, many arts organizations are rethinking their galas and trying to find better ways to drive giving online and provide a sense of being special for donors without requiring a meal and an expensive evening out.

KEY TOOLS

As you develop your approach to fundraising, the workload becomes easier if you build and maintain a few key tools. These include:

1. *A decent database.* This can be as simple or complex as you need, based on how many contacts you have and how much money you are raising each year. It could be a simple Excel spreadsheet or an advanced CRM (customer relationship management) system you pay for and have customized to your business, depending on what you need it to do and how much money you can afford to spend on it. Make it work for you, but ensure that you have one.
2. *Core fundraising language.* This should exist in a standard grant narrative you maintain and refresh every year, with your best language describing your mission, programs, needs, and goals. Each time you start something new or start a new season, write fresh language on why it matters, what needs it may serve, and what you need to raise in order to do it. Having standard but compelling language at the ready makes prepping new grant narratives and donor letters much easier.
3. *Examples of recently successful campaign letters and designs.* Keep examples on file, from your organization and others, of donor letters and campaign language and designs so you can refer to them and consciously repeat or veer away from them with your next campaigns. Be aware of what you have done in the past and how well it has worked. Reflect on how well your audience of donors and funders reacted to these messages and if you need to change anything. Reflect on what else was happening in the world during those campaigns and whether you showed awareness in what you did. Asking for support during a presidential campaign or a global pandemic can be very different than it is during a less eventful summer season.
4. *A fundraising calendar.* When are your scheduled campaigns and the actions necessary to execute them successfully? When are grants and grant reports due? When do your corporate supporters need to hear from you for this year's asks and reports? When does the board need your support, and when are their deadlines to give or get?

5. *A moves management system.* As discussed earlier in detail, this framework helps you track, pursue, and care for donors.
6. *Designated staff and board leadership.* Who is doing all this work? Do they have the time and resources needed to succeed?

VARIATIONS

EQUITY AND DIVERSITY

In recent decades, larger arts organizations have often required tens of thousands of dollars for their board Give and Get, as a way to ensure the board significantly supports the organization, but also as a means of making board membership feel exclusive and a symbol of status and financial success. Many organizations are now dismantling the necessity of a Give and Get, and instead they are looking for ways board members might contribute other than financially. This way board members who have a variety of skills, backgrounds, and community networks can serve an organization without necessarily having the means to give a lot of money. This shift away from a firm Give and Get will allow board members from more diverse backgrounds socioeconomically, racially, or by age, gender identity, sexual orientation, ability, and mobility to serve and enrich organizations with greater relevance, experience, and time, while eliminating the barriers created by requiring a certain amount of wealth to participate.

RURAL BOARDS

Organizations in more rural environments tend to keep their boards as "working boards" for the life of the organization, or at least for a much longer time than in urban settings. A "working board" denotes that the board members offer skills and "hands-on" work for the organization, acting as another level of staffing for the organization rather than serving just as big picture visionaries, fundraisers, and stewards for the organization, as is expected in most urban-based long-living organizations.

This is in part because board members in rural areas generally tend to have less wealth but more time available than their urban counterparts, because many are retired and often less affluent. While this rural board approach leaves organizations often struggling for cash in the long term, it also provides rural organizations with much-needed support for staffing gaps as well as stronger ties to their local community. In contrast, most arts organizations in urban settings focus on transforming their boards from "working" to "fundraising" once they are ready to leave the organization's *Founder Stage*. While this approach often results in much larger donations and grants, urban-based board members are often too busy in their own professional lives to contribute much help beyond the money they bring or give to the organization. Both approaches are valid and helpful, in very different ways.

THE FOUNDER STAGE

The Founder Stage of an organization is when the founder is still leading the company and the board of directors still consists of the founder's friends and colleagues. This stage is when the organization is still more of a single person's passion, helped by those who believe in them and not yet fully professionalized with the policies and structure necessary for greater growth and impact over a longer period of time.

A CHANGING LANDSCAPE

In the wake of the global pandemic and recession, questions abound about how and whether the arts can still be a priority to funders and donors. Major foundations are being called on to support healthcare, food scarcity, and social justice efforts in new ways, while government agencies are facing deep cuts in their state budgets. Many corporate entities are cutting staff and office space to help their bottom lines and may not be able to fund the arts at previous levels. The importance of individual donors is therefore greater than ever. The stock market and housing real estate continue to thrive, making some individuals wealthier than ever. But will individuals be able or willing to cover huge gaps in lost earned income and government support? If super-wealthy donors save an arts organization, will that organization still be able to make choices those donors disagree with?

In *Navigating Uncertain Times: A Scenario Planning Toolkit for the Arts & Culture Sector*,[14] the Wallace Foundation and AEA Consulting constructed four potential futures for the arts to help organizations plan: Cooperative Living, New Means of Gathering, Digital Connection, and Social Disintegration. In the first three, more positive scenarios, they predicted the need for foundations and individuals to increase their contributions in order for the arts sector to survive. In the final scenario, Social Disintegration, funding for the arts is shown to disintegrate entirely, along with society. Dark stuff.

FINAL THOUGHTS

Fundraising can be a fun and rewarding process. With the right tools in place and your mission and values clear, your fundraising can thrive. Be authentic and honest. Communicate why you need support. If you are clear on who you are, what you do, and why, others will support you.

NOTES

1. Author interview with Nancy Yao Maasbach, May 24, 2021. All quotes from Nancy Yao Maasbach that follow are from the interview, unless otherwise noted.

2. Dr. Zannie Voss and Dr. Glenn Voss, "The Alchemy of High-Performing Arts Organizations," SMU DataArts, August 2020, 2–21.

3. Americans for the Arts, "Arts Facts: Source of Revenue for Nonprofit Arts Organizations (2017)." Accessed March 30, 2021. https://www.americansforthearts.org/by-program/reports-and-data/legislation-policy/naappd/arts-facts-source-of-revenue-for-nonprofit-arts-organizations-2017.

4. Wealth Engine, "The Wealth Engine Advantage." Accessed March 30, 2021. https://www.wealthengine.com/.

5. The Andrew W. Mellon Foundation, "Financials." Accessed March 30, 2021. https://mellon.org/about/financials/.

6. The Ford Foundation, "How We Make Grants." Accessed March 30, 2021. https://www.fordfoundation.org/work/our-grants/how-we-make-grants/#:~:text=The%20Ford%20Foundation%20is%20the,an%20endowment%20of%20%2414%20billion.

7. Dr. Zannie Voss, Dr. Glenn Voss, and Young Woong Park, "The Intersection of Funding, Marketing, and Audience Diversity, Equity, and Inclusion," SMU DataArts, April 2021.

8. National Endowment for the Arts, "During Economic Highs and Lows, the Arts Are Key Segment of U.S. Economy." Accessed March 30, 2021. https://www.arts.gov/about/news/2020/during-economic-highs-and-lows-arts-are-key-segment-us-economy#.

9. The New York State Council on the Arts, "About NYSCA." Accessed March 30, 2021. https://arts.ny.gov/our-mission.

10. The New York State Council on the Arts, "Arts Add $114B to New York State Economy." Accessed March 30, 2021. https://arts.ny.gov/blog/arts-add-114b-new-york-state-economy.

11. Oklahoma Arts Council, "Why the Arts Matter." Accessed March 30, 2021. https://www.arts.ok.gov/Why_the_arts_Matter.html.

12. Oklahoma Arts Council, "FY2020 Impact Report," Oklahoma Arts Council, 2021. https://www.arts.ok.gov/pdf/about_us/Impact_Report_FY20_GA.pdf.

13. The Geis Group, "Moves Management." Accessed March 29, 2021. https://geisgetsresults.com/moves-management/.

14. AEA Consulting, "Navigating Uncertain Times: A Scenario Planning Toolkit for the Arts & Culture Sector," AEA Consulting and the Wallace Foundation, October 22, 2020. https://www.wallacefoundation.org/knowledge-center/pages/navigating-uncertain-times-a-scenario-planning-toolkit-for-arts-culture-sector.aspx.

8

MANAGING MONEY

I think the biggest key to my success is that I don't believe I know everything.

—Anna Glass, executive director, Dance Theatre of Harlem

INTRODUCTION

Now that you have raised money, you need to manage it. Keep it. Grow it. Use it in service of your mission. You need to know *what* money you have, *where* you have it, *when* any more is coming, and *how* you are spending it. This chapter will introduce the fundamentals of financial management, including the fiscal year, internal controls, and key vocabulary, while attempting to explain *why* financial management matters so much. Financial management is where money and mission meet.

FUNDAMENTALS

FIVE KEY CONCEPTS

Here are five key concepts in financial management to keep in mind:

1. *Money Is the Fuel for Delivering Your Mission.* If you don't manage your money well, your mission cannot happen.
2. *Make Sure Your Finances Get Plenty of Sunlight.* Ensure at least three people know everything at all times. Gain a regular audit from an independent auditor. If you know something others do not, share the information as soon as you can with your peers or superiors in the company. Secrecy sets up opportunities for—at the very least, the appearance of—fraud.
3. *Your Company Culture Can Help or Hurt Your Financial Management.* Clarity breeds responsibility. Distrust breeds misbehavior.

4. *Budgets Are Where the Rubber Meets the Road.* Ensure your budgets are clear and carry the convictions of your company values and mission. If your mission says you serve students through after-school programs, ensure your after-school programs are prioritized in your numbers. If your mission aims to preserve buildings, ensure your budget reflects a majority of expenses aimed at preservation.

5. *Never Be Afraid to Ask Questions.* Questions are the key to financial clarity, strong internal controls, and effective financial management throughout your company. No one knows or understands everything. Empower others to ask questions, and your systems will be stronger, better supported, and more effective.

TAX-FREE WITH STRINGS

The U.S. Revenue Act of 1954 established the tax codes as we know them today. Section 501(c) of the Internal Revenue Code states that, in order to enjoy tax-exempt status, a nonprofit institution must be organized and operated purely for nonprofit reasons with none of its earnings going to any member of the organization.

The 501(c)(3) status means that a nonprofit arts organization in the United States does not need to pay taxes on most of its income, saving the arts sector billions of dollars each year. But every organization must pay into Social Security and payroll taxes for its employees. Organizations are also charged Unrelated Business Income Tax (UBIT) on income not relating to their nonprofit mission (think T-shirts, coffee mugs, or money made on a café or restaurant operated within and by the arts organization) if they earn $1,000 or more in a given year. If a nonprofit maintains a for-profit business on its premises (think renting space to a for-profit café not owned by the organization), the organization can be charged property taxes on that portion of their real estate.

MIND THE GAAP

General Accepted Accounting Principles (aka GAAP) are the rules applied in financial management. The Financial Accounting Standards Board (or FASB) is the body that continually reviews, revises, and educates about GAAP. FASB has a website, https://www.fasb.org/home, as does the Financial Accounting Foundation, with more info on the GAAP: https://www.accountingfoundation.org/home. These are where accounting standards and rules originate. You can scan the QR codes below to access these sites on your phone:

THE FISCAL YEAR

A *calendar year* tracks time. A *fiscal year* tracks money *across* time. It is important to understand the difference. A *fiscal year* runs twelve months and begins at the top of whatever month the organization chooses, as articulated in the organization's *bylaws*.

Arts organizations often choose July 1–June 30 as their fiscal year, in part because their season of public offerings tend to fall heavily in the fall-winter-spring seasons. Sometimes organizations choose January 1–December 31 to align with the western calendar. Some choose September 1–August 31, if their work is tied even more closely to a school year. Box 8.1 provides a visual for the cycles of a typical fiscal year.

BOX 8.1. THE FISCAL YEAR

Typically running July 1 to June 30 or January 1 to December 31, a fiscal year can be any twelve months set within an organization's bylaws. For our purposes, we will assume a fiscal year beginning July 1.

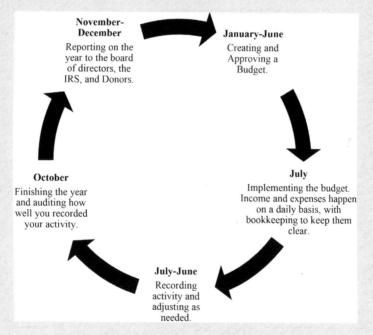

November-December
Reporting on the year to the board of directors, the IRS, and Donors.

January-June
Creating and Approving a Budget.

July
Implementing the budget. Income and expenses happen on a daily basis, with bookkeeping to keep them clear.

July-June
Recording activity and adjusting as needed.

October
Finishing the year and auditing how well you recorded your activity.

As you can see, planning the next budget and reporting on the previous fiscal year overlap with the current fiscal year's activities. The CEO or executive director reports to the board of directors at least six or seven times per year and would be in consistent contact with the board treasurer.

Cycles of the Fiscal Year

Some standard tasks and cycles repeat every fiscal year, as the organization plans, executes, and then reports on its financial activities. The following is a step-by-step walk through a typical fiscal year's activities. This schedule assumes a July 1–June 30 fiscal year. It begins in January because that is when budgeting for the *next* fiscal year often begins. Current year's activities continually overlap with the planning for next year and the reporting on last year.

January–June

- Budgeting begins sometime in January and involves your executive director, board treasurer, and finance committee.
- The draft budget includes next year's budget, this current year's budget, perhaps the past two years of actuals, and this year's actuals to date, as well as a budget narrative.
- At least five or six drafts of the budget are reviewed between February and June.
- Budget drafts are also reviewed by the board's fundraising committee so that they can be aware of and approve fundraising targets.
- Programming portions of the budget should be reviewed by senior staff to gain their input.
- During this time period, the executive director also confirms and hires an independent auditor to conduct the annual audit sometime between July and November.
- The final draft of the budget should be distributed to the full board three weeks prior to the final board meeting of the year so they can thoroughly review it and ask any questions prior to the final board meeting of the fiscal year in June.
- At the final board meeting in June, the board discusses and approves the budget, hopefully with everyone having had their questions or concerns answered earlier.
- With an approved budget in hand, the executive director can confirm program plans and staff salaries for the next fiscal year.★ Staff evaluations often occur between this final board meeting and the beginning of the fiscal year, so that the leadership can inform staff of their next year's pay rate during this meeting.
- Within two or three weeks after the final board meeting, the new fiscal year begins.

★ Note: At large organizations, staff and board will often draft and approve the programming and marketing portions of the budget a few months before the end of the fiscal year, so that planning and commitments for the next year can begin in earnest.

July–October

- Last fiscal year's financial records and transactions are reviewed by the treasurer, bookkeeper, and executive director, in order to prepare the financial statements for the auditor.
- The on-site and remote parts of the audit are conducted.
- The audit is completed.
- The 990 is completed, often also by the auditor.
- The draft audit and 990 are submitted to the board of directors in October for review and approval.
- The 990 is signed by the executive director and sent to the Internal Revenue Service (IRS) by the fifteenth day of the fifth month following the fiscal year. For organizations with a fiscal year that runs July 1–June 30, therefore, form 990 is due November 15. For organizations with a fiscal year that runs January 1–December 31, the 990 is due May 15. Organizations can typically request an extension of three months to submit their 990 if need be. Not filing a 990 for three years or more usually triggers the revocation of your 501(c)(3) nonprofit status.

Throughout the year

- Money (including donations, grants, and earned income) comes in, is recorded, and is deposited.
- Bills come in, and checks are cut and recorded.
- Transactions for both income and expenses are recorded in some way, hopefully with a bookkeeping software such as QuickBooks.
- The executive director and bookkeeper meet weekly to discuss the company's finances and confirm bills to be paid. At a larger organization, the finance director or comptroller would handle this work.
- Monthly income statements on profit/loss (aka income/expense) are generated.
- The monthly cashflow is updated.
- At regular board meetings and meetings of the board finance committee, the executive director and treasurer report to the board on the company's financial status.
- By midway through the year, the staff and board finance committee begin to plan next year's budget based on current performance, new plans, etc.

Table 8.1 demonstrates staff tasks throughout the fiscal year and their timing.

INTERNAL CONTROLS

Once you begin a fiscal year, *Internal Controls* are the guard rails, safety checks, and fail-safes. to ensure your money is secure and clearly managed. They are the people, processes, and tools used to manage your money throughout the fiscal year. *People* include the treasurer, executive director, and bookkeeper, but also the entire staff. *Processes* are

Table 8.1. Staff Tasks for the July 1–June 30 Fiscal Year

Next Fiscal Year Budget Drafts 1–4 Completed	January–May
Final Fiscal Year Budget Approved by Board of Directors	June Board Meeting
Audit of Previous FY Completed and Approved	By October
Submit 990 to IRS	15th Day of the 5th Month following the End of the Fiscal Year
Quarterly Statement of Activities Reviewed	October 1/January 1/April 1
Checks and Cash Secured in Locked Safe	Immediately/ASAP
Cashflow Budget Reviewed and Updated	Monthly
Checking and Savings Accounts Monitored	Ongoing as Needed
Current Bills Paid	Within 30 Days
Received Checks and Cash Recorded and Deposited	At Least Weekly

what you do and how you behave to ensure clear and rigorous financial management in your organization. *Tools* include items (an office safe, online database, checking and savings accounts) and documents (budget, balance sheet, audit, 990) used to protect, report, and manage your money clearly and safely.

Segregation of Duties

This best practice in financial management requires different people to perform different tasks, allowing more air and sunshine to flow onto your operations and avoiding possibilities for fraud. If someone opens the mail, another person records income and expenses from the mail, and yet a third person actually deposits the income and pays the bills, a clear path of how income and expenses are flowing from the organization can be seen and established. The person who cuts the checks should not also sign the checks. The person depositing money should not be the only person with access to those account records. And so on. The executive director and the treasurer should not be the same person, as these two roles are meant to oversee finances from different perspectives, in case one catches something the other misses.

Clear Reporting Documents

Weekly and monthly income and expense reports should be distributed, especially when money is running tight, so that senior staff can see and understand where the income and expenses are being spent. A simple *Financial Dashboard* followed by a *Summary Income and Expense Statement* allows everyone to watch trends and not get bogged down in the nitty gritty of gaining and spending weekly. At the same time, if a department is being asked to cut costs or withhold services, a more *Detailed Income and Expense Statement* can be shared with that department head and fellow senior staff positions, so everyone is on the same page and can collaborate on solutions.

Regular Meetings

Meetings of senior staff members, or at least of the executive director and book-keeper or finance director, should happen weekly to review and discuss finances. Questions should be encouraged and answered or answered at the next meeting. A culture of transparency and responsibility needs to be developed, avoiding any sense that just one or two people hold the purse strings and the knowledge. Moments of crisis require *more* transparency, not less.

Shared Knowledge

The executive director, board treasurer, and the accountant or bookkeeper should know everything about the financial status of the organization at all times. This lessens the opportunity for fraud. It also protects everyone involved from the *appearance of fraud*. When one or two people know something "secret" about the finances, it begs the question of *why did only they know this? What was being hidden and why?* Open communication keeps sunlight on the numbers for all to see, so that financial risks, opportunities, and threats are known by both the staff and the board. As you will see in the case of Rita Crundwell in the appendix, if one person gains control of all aspects of financial management, it should be a *huge* red flag.

A Board Focused on the Big Picture

Since the board of directors is ultimately responsible for the company's fiscal health, its members must understand and be able to guide policies related to the company's finances. This often means encouraging questions and discussion at the board level, while also offering information to the board in a way that helps this policy discussion and avoids getting bogged down in details. Financial dashboards are a useful tool in keeping the board focused on the big picture. They are graphic representations of year-to-date income and expense, year-over-year comparisons, and fundraising targets versus actuals.

Ending the Year

If your fiscal year begins July 1, then at the beginning of that date each year, you start fresh, with a whole new budget that has hopefully been finalized and approved at the last board meeting. Any surplus income from the previous fiscal year now goes on the *Balance Sheet* as an Asset until the board decides what to do with it. Any unpaid expenses go on the *Balance Sheet* as Liabilities. Your new budget is just that: brand new. It can include spending some surplus from the previous year if your board has approved that in the final budget voted on in June. But think of the end of your fiscal

year on June 30 as "done, pencils down" for that year. The next day is the beginning of a whole new financial journey for the year. You still have to reflect and report on the previous year via your 990 and audit or financial review in the coming months. But theoretically that year is done and cannot be undone. Your auditors may make slight adjustments in how you dealt with certain income and expenses, but the game for that year is over.

THE AUDIT

After spending a few weeks reviewing your financial records for mistakes or unresolved issues from the previous fiscal year (documents including your General Ledger, Balance Sheet, and Profit and Loss Statements), you will also need to secure an independent auditor to do your audit for the previous year. Usually, this is worked out and the auditor is hired several months beforehand. Assuming your fiscal year ended June 30, your 990 would be due to the IRS by November 15 (as it is always due by the fifteenth day of the fifth month after the fiscal year ends, unless you are granted an extension by the IRS).

The 990 (the annual tax return required by the IRS for any nonprofit organization) needs numbers from the audit, to ensure they are the correct and final numbers for that previous year, and so the audit needs to be completely done on or about the end of October, to have enough time to file the 990 by November 15. Auditors normally require at least three to four weeks to finish an audit after they have completed their interviews and inspection of documents on-site, which only happens after they have received and had a few weeks to review all the final financial documents from the year before.

Thus, nonprofits typically send final documents to the auditor by the end of August, so the auditor can review them and do an on-site visit in the nonprofit's offices by mid- or late September. By late September, the auditor's interviews and reviews should be finished, and they begin to write up their report. Within the next few weeks, they send any final questions to the CEO, bookkeeper, and/or treasurer, and they do their best to answer. The auditor will also preview their report to the nonprofit, especially any citations they might be considering, but also to highlight any large adjustments they felt it necessary to make and highlight these for the board.

It's a strange dance, in part because nonprofits pay the auditor to perform the audit, while maintaining the auditor's independent objectivity. But as part of your fiscal year cycle, having this audit performed is essential, to assure yourselves, your board, and your donors and funders that you are using the funds given to you or earned by you in the public trust toward your mission. It is also essential to switch auditors at least every seven to ten years, so that the relationship does not become too comfortable and therefore biased.

THE BALANCE SHEET

After you realize a deficit or surplus for the fiscal year, that result is listed on your *Balance Sheet* and either improves or lowers your fund balance. A *Balance Sheet* (also known

as a Statement of Financial Position) shows an organization's *Assets*, *Liabilities*, and *Net Assets*. It shows the *Assets* on one side and the *Liabilities plus Net Assets* on the other. Each side (or top and bottom) equal the same and therefore "balance." The Balance Sheet answers the organizational question, "How are you?" because it shows what an organization has (*Assets*), what it owes (*Liabilities*), and what is left (*Net Assets*). It shows the body of the organization but not its activities, which are instead shown in the *Profit and Loss Statement* (also known as the Income Statement). Table 8.2 shows an example Balance Sheet.

Table 8.2. The Balance Sheet

ASSETS		
Current Assets		
Checking Account	500.00	
Savings	10,000.00	
Money Market	40,000.00	
Total Current Assets		50,500.00
Property and Equipment		
Equipment	2,000.00	
Total Property and Equipment		2,000.00
Total Assets		**$52,500.00**
LIABILITIES AND FUND BALANCE		
Current Liabilities		
Deferred Revenue	10,000.00	
Accounts Payable	500.00	
Total Current Liabilities		10,500.00
Fund Balances/Net Assets		
Board Designated Reserve Fund	40,000.00	
Unrestricted Net Assets	1,000.00	
Net Income	1,000.00	
Total Fund Balance		42,000.00
Total Liabilities & Fund Balance		**$52,500.00**

The top half describes exactly what you have as *Assets*: $500 in the checking account, $10,000 in savings, $40,000 in a money market account, and $2,000 in equipment; the bottom half shows *how you think about and designate what you have*: *Liabilities*, including *Accounts Payable* (the amounts you owe others), any payroll you owe staff for time worked already but not yet paid, and the *Deferred Revenue* you cannot access yet (like subscription fees paid for next year's shows). Then *Net Assets* or *Fund Balances* at the bottom includes everything leftover from subtracting your *Liabilities* from your *Assets*, including your *Unrestricted Net Assets*, which is a number showing your total fiscal score based on your history so far. *Net Assets* will also include any *Temporarily* or *Permanently Restricted Net Assets*, including an *Endowment*, *Cash Reserve*, or *Board Designated Reserve*. *Net Income* indicates a current surplus for the year of $1,000.

NOTES ON BALANCE SHEET IN TABLE 8.2

Unrestricted Net Assets

Why are the *Unrestricted Net Assets* $1,000? If this company has been in existence for three years and had a $1,500 surplus year one, then a $250 deficit, then another $250 deficit, their *Unrestricted Net Assets* would be $1,000.

Net Assets

Net Assets also include what's left of your Assets after Liabilities have been pulled out of them. So, if you have $52,500 in *Assets*, as shown in Table 8.2, and you owe $500 to others in *Liabilities* and have $10,000 in *Deferred Revenue*, your *Total Net Assets* would equal $42,000.

Net Income

If you have a surplus or deficit year to date, it shows up on the bottom of your balance sheet under *Net Assets*. This organization is showing a $1,000 positive net income year to date.

Board Reserve Fund

If the money in your Money Market account has been designated by the board as a *Board Reserve Fund*, it shows up as that on the bottom part in the *Net Assets* section as *Board Designated Reserve Fund*.

KEY CONCEPTS AND VOCABULARY

Mastering the following vocabulary and concepts will help you manage your money:

The 990 is the U.S. tax form required to be filed by every nonprofit arts organization managing more than $50,000 in activity each year. The 990 is due on the fifteenth day of the fifth month following the end of an organization's fiscal year. So, if a fiscal year ends on June 30, the 990 is due November 15. An organization can request an extension of a few months to file their 990 if need be. Not filing a 990 for more than three years can result in the loss of an organization's tax-free status.

Accrual-Based Accounting is regulated by Generally Accepted Accounting Principles (GAAP), and it is the common form of accounting that uses tools like the Balance Sheet and Income Statements to manage *assets* as well as cash, and to record expected income, expenses owed, and assets owned. Accrual accounting is a much

more accurate and helpful approach to accounting to ensure an organization understands its true financial position, including its debts, cash on hand, expected income, and depreciation on its assets.

Actuals denote the real income and expenses from previous periods of time.

The Audit is the process through which an independent accountant reviews the financial transactions and records of the previous fiscal year. The audit also reviews how the organization is managing its finances and reports any concerns to the board of directors as part of the audit. Maintaining an independent auditor and changing auditors every five to ten years to ensure independence is a key strategy to good financial management. This type of audit is known sometimes as a *friendly* or *invited* audit. An *invasive* audit is when an organization or individual is audited by a government agency without invitation. An invasive audit can be triggered randomly, by lottery, or because the agency has concerns about that individual or organization's financial practices.

A Balance Sheet (also known as a Statement of Financial Position) shows an organization's Assets, Liabilities, and Net Assets. It shows the Assets on one side and the Liabilities plus Net Assets on the other. Each side (or top and bottom) equal the same and therefore "balance." The Balance Sheet answers the organizational question *"How are you?"* because it shows what an organization has (Assets), what it owes (Liabilities), and what is left (Net Assets).

Bookkeeping is the act of recording income and expense and sometimes generating payroll and paychecks, updating Balance Sheets, and generating Income or Profit and Loss statements. It is the front line of financial management because this work is often the first step in seeing and recording what's coming in and going out.

A Budget is a plan for income and expenses during a specific period of time and for specific activities. A budget is also a roadmap and guide for how you will implement your mission via money. The annual organizational budget answers the essential question: *"What are you planning to do next year?"*

A Budget Narrative explains the budget in a narrative form. It attempts to answer anticipated questions about the budget and explain major changes from year to year. There are several formats for narratives, depending on the intended audience and purpose.

Bylaws are the "constitution" of an organization. The bylaws are a required document for arts nonprofits to be organized and maintained. They lay out how the organization will be governed and managed, how the board of directors is chosen and managed, and when the organization's fiscal year begins and ends. They can and should be reviewed and updated on a regular basis (typically every five to ten years) to reflect current laws and changes to the organization's mission delivery.

Cash-Based Accounting is when an organization monitors its finances simply based on how much cash it has on hand. This is a common way for "startup" or volunteer-led organizations to manage money, but it quickly loses its usefulness when an organization starts to fundraise, buy equipment, or borrow money. Once those activities begin, a cash-based accounting becomes insufficient and unreliable.

A Cash Reserve is an amount of money set aside by the organization as a "rainy day" fund, to be used in case of temporary deficits. Reserves are usually Board Re-

stricted, meaning the Board must approve accessing and using them. This best practice prevents the staff from using them too often to shore up shortfalls. The policy also supports a more conservative financial culture focused on keeping and building the reserves rather than spending them too easily or quickly.

A Cashflow tracks the flow of cash in and out of the organization. A projected cashflow demonstrates the annual budget across twelve months, so that managers can forecast when an organization's cashflow might be tight or flush throughout the year. Each month the cashflow is updated with the actuals from the previous month, allowing projections to become more accurate as the year proceeds.

A Chart of Accounts is the number code for how to record your ongoing income and expense transactions, so you can then pull up reports quickly and easily. Each organization sets its own preferred list of numbers as its Chart of Accounts based on its typical activity. It then must maintain and manage these numbers so they are consistently used over the years, so financial activity can be compared and reported clearly. When a museum pays artists, they may land on "020" as the code for "paying artists." If they have various codes depending on what space the work will be exhibited in, they might designate "001" as the code for their main exhibit space. Then, if the organization pays an artist for a new work that will be exhibited in the main gallery, that payment might be "booked" by the bookkeeper and tagged with the code "020-001." In the future, if the museum director wants to see how much they have spent on artists for the main gallery during any given time, the bookkeeper can pull a report on "all artwork payments for the main gallery" by putting in the code "020-001." The Chart of Accounts is the listing of all coded numbers, for both income and expenses.

Deferred Revenue is earned income you cannot use yet, even though you have it in the bank, like subscription fees received for *next* season. Deferred Revenue appears on your Balance Sheet under Liabilities, because you owe services against that earned income, and therefore it is a kind of debt. Once the next season begins, the Deferred Revenue is released into your Net Assets, and so moves down the Balance Sheet.

A Deficit means you finished with more expenses than income.

Depreciation is how an organization accounts for its assets losing value over time. When a new asset is purchased (for example, a new couch for the office), the value of that purchase is placed on the Balance Sheet. The organization decides at what rate to devalue the item. For equipment or furniture, this is often done over five years. If the couch cost $500 and it is depreciated over five years, it will lose $100 of value each year on the Balance Sheet ($500 divided by 5 years = $100 per year). Once its value is zero, it may still be useful in the office to sit on, but it is considered worthless financially. If an organization can budget for depreciation, this means it will add an expense line for depreciation each year and try to save the amount of total depreciation happening to its equipment and sometimes even to its buildings. In theory, by budgeting for depreciation, the organization is saving up money to replace these items when they inevitably break or age out of their usefulness.

Direct Costs are the expenses you need in order to deliver your programming, including the artists, production expenses, program materials, marketing costs, etc.

An Endowment is a permanently restricted amount of money, which supports an organization's long-term planning and growth. The main amount is "locked" in the endowment and not accessible. The interest earned on this amount, via investments, provides regular long-term income for the organization. Often smaller organizations refer to their "endowment" when they truly mean their Cash Reserves or Board Restricted Cash Reserves. A true endowment is a legal construct and cannot be breached by the board or staff without unlocking that construct.

FICA (Federal Insurance Contributions Act) is the legislation establishing Social Security. Organizations must pay into an employee's Social Security with each payment.

A Financial Dashboard is a graphic representation of an organization's income, expenses, and fundraising targets year to date. A dashboard is usually presented to the board of directors as a means of keeping the board focused on the larger financial picture and can be specialized based on what metrics the board would like to use to gauge the organization's financial progress.

The Fiscal Year is the twelve months guided by the budget. *When* these twelve months occur is decided in a company's bylaws.

Fixed Costs are costs that won't change in a given year and are therefore "fixed" for the life of the budget. Your rent, staff salaries, and monthly payments on that new copier are costs you can put into your budget and cashflow as steady and reliable.

A General Ledger tracks all income and expense transactions for the fiscal year, using the Chart of Accounts to tag each transaction with a preassigned number. The General Ledger contains the most detailed information on what happened financially during a fiscal year. It provides the source data for summary reports, including Profit and Loss Statements.

GuideStar.org is the site featuring the 990's and financial histories of nonprofit organizations. If you want to see what a nonprofit arts organization's annual budget, debt, or top staff salaries were in recent years, check out this site.

Indirect Costs are the overhead expenses needed to do your work, but not directly related to any one effort. Indirect costs include facilities, insurance, portions of full-time staff salaries, and accounting costs. Demonstrating how these indirect costs contribute to the total cost of your programming is an important part of budgeting, especially when fundraising.

Internal Controls are the people, processes, and tools through which an organization manages and protects its finances.

Liabilities are what you owe others, including your current unpaid bills and payroll owed to your employees for time already worked but not yet paid. Liabilities also include your Deferred Revenue.

Permanently Restricted Assets are the funds that have a permanent limit put on them, usually by the donor, funder, or the organization's board. These funds are always meant for a specific purpose and never used for any other purpose, unless the restriction can be somehow lifted.

A Profit and Loss Statement (P&L, also known as an Income Statement) shows all of the income and expenses of an organization during a specific amount of

time, usually per week, month, or year. It answers the essential question of "What are you doing?"

Projections indicate income and expenses predicted for the future.

A Surplus means you finished a fiscal year with more income than expense.

Temporarily Restricted Assets are the funds that have some kind of temporal restriction on them (i.e., they cannot be used until a certain time occurs). For example, if a grant is received in one fiscal year but aimed at programming for the next fiscal year, it will be recorded as received but then put on the Balance Sheet as Temporarily Restricted. Once the next fiscal year begins, the restriction is lifted.

Unrestricted Net Assets are the money, values, and assets that are not encumbered or limited in any way. Net Assets are sometimes used to gauge an organization's overall financial health, because they show a tally of how the organization has done over the years, representing in part the total of surpluses and deficits incurred over the years. If the Unrestricted Net Assets is a negative number, it can be a major red flag that the organization is in trouble.

Variable Costs are costs that might go up and down each month. Fuel payments go up and down with the seasons and global markets. Artist expenses change depending on what and how much programming you're doing.

VARIATIONS

COMPANY CULTURE

One of the most important tools in financial management is *company culture*. Does everyone know how money is managed in your organization? Do they feel a shared responsibility to ensure the safety of the company's finances? Or do they feel they are owed more than they are paid? Do they feel the company doesn't care much about money or those who work there? Do they feel, if given the chance, they would deserve taking a bit more? Research shows that people who steal from organizations *do not* see themselves as villains. They see themselves as victims, or as at least *deserving of more*. Any extra amount they glean from the organization is self-justified as being *owed* to them. If everyone involved in your organization is clear on expectations, feels cared for, and is devoted to the mission, the chances of fraud drop enormously.

Culture Checklist

Following is a quick checklist to gauge your company culture's relationship to finance. Does the company culture support the following statements? If not, you might have work to do.

1. A company's mission relies on having sufficient funds to implement that mission.

2. A nonprofit is granted the ability by the public, via the government, to receive contributions and grants tax free in pursuit of its mission. The money used by the company is therefore in the public trust and intended solely for the organization's stated charitable or educational purposes.

3. Employees and artists must be paid equitably for their work.

4. The company and community rely on people of integrity and honesty to keep this mission and its funding safe, reliable, and growing, in order to better serve its community for many years to come.

Cash During COVID

At the top of the COVID-19 crisis, I worried that access to funds from our bank would become more restricted if online systems and banking became compromised at some point, either by system failures or a market crash. I decided to withdraw $9,000 in cash from our accounts and lock it safely in our in-house safe. I immediately notified, in writing, via email, our bookkeeper, our board treasurer, *and* our board chair that I was doing so. Why? So that everyone knew, understood my intent and reasoning, and realized where the money was going. Can you imagine if I had failed to send that email and a month later, in our banking statements, the bookkeeper or treasurer suddenly discovered I had withdrawn $9,000 from our accounts and not said anything? An awkward conversation, at the least, would have ensued, and perhaps a loss of trust. At the worst, such confusion would have led to accusations of fraud.

In addition to alerting my colleagues to the withdrawal, I also immediately articulated a process through which we could ensure the cash was safe and accounted for. Every week, the bookkeeper and I, at different times and without alerting each other as to when, would go into the safe and count the cash, then sign and date a written register that we had done so and found the $9,000 still there. This may have seemed like overkill to many, but it was a way for me to protect the company and myself. What would happen if, for some reason, there was only $5,000 in there in six months? Could we simply trust that neither I nor the bookkeeper had taken it? With the regular, independent count and the register, we could log when the money had last been counted and by whom, and we could confirm with the board that this large amount of petty cash was secure.

Note: This action requires trust. This level of trust requires time. I did this after having been with the company for six years. A new executive director would probably want to ask permission, rather than simply take action. When you are new to any job, it takes some time to build trust.

A Theft

While I was leading Young Playwrights' Theater (YPT) in Washington, DC, our offices were located in a shared community center in a restored embassy building next

to Malcolm X Park. Another theater's offices were located in the basement of the same building. One weekend there was a theft in the building. Captured on security video, three robbers broke into the basement, armed with guns. They found a closet containing sledgehammers and commenced breaking down the doors of several offices in the basement, including the theater.

Earlier that night, the theater had held a performance and did some brisk business, gaining about $6,000 in cash. There was not time to run to the bank to deposit that cash. Unfortunately, there was also no safe in the office. The cash was stashed in a desk drawer, to be deposited early the next day. You may be able to guess what happened next.

The robbers found the cash and took it. This was a huge blow to the company. As with any nonprofit theater, every dollar mattered. If the company had had the right tools, including a safe, and processes, with a policy on how to secure the cash in a safe or get the cash to the bank after hours, they might have been saved from this theft. Luckily no one was in the office, and so no one was hurt.

An Office Safe

One of the most important tools in financial management is an office safe, where you can securely store money and documents. When I first arrived at Hubbard Hall, I was dismayed to discover that the previous executive director would often leave box office cash simply stashed on a shelf in his office. He would also open the mail, sometimes leading to cash or checks waiting in his office for days or weeks to be processed.

I quickly bought and installed a safe, so no checks or cash were ever left lying around. I established clear protocols with staff on how to handle mail and make deposits. We put finances on our regular staff weekly agenda, so the whole staff would discuss our finances and financial management each week. I empowered staff to know these processes, own them, and implement them on their own. We created a more positive, open culture of allowing questions to be asked each week about our finances. This also raised our expectations that contributed and earned income would be protected and managed well, and our financial management would grow from being somewhat haphazard to strategic, safe, and rigorous.

Valuing Bookkeepers

There is often a lot of onerous, stressful, and even boring work in bookkeeping. Patient, kind, smart, and savvy bookkeepers are very rare. If you can find one, hold on to that person.

During a major capacity-building grant at YPT, I decided, along with a team of consultants, that it would be a good idea to revamp our Chart of Accounts to more clearly show the costs of programs. This involved a herculean amount of work for our bookkeeper, as he had to retroactively revamp our financial records to fit this new model.

"Can we talk?" he asked one week during his usual weekly drop-off and pickup of bills and other paperwork. I could tell he was frustrated and tired. "I'm not sure this is worth it anymore," he said as we sat and I shut my office door. I realized he was at the breaking point. I launched into a heartfelt but gentle crusade to keep him on board, working out my thoughts in front of him, detailing my own doubts on whether this was worth the amount of work he was having to do, commiserating with him over his frustration at the consultants recommending these changes.

"They don't understand how much work this is!" he said, and I parroted. I went on about how much it meant to me that he was tackling all of this. How much it meant to YPT and to our future that we be able to better report our spending in this new way. I asked him to keep trying and assured him that, if he decided he couldn't do it, we would abandon the plan and keep things as they were, rather than lose him as our bookkeeper. I did not want to lose him over this. But I also hoped that, given more time and support, he would come around. I wrapped up our conversation by saying we needed to give him a raise and ensure he was being paid for every minute he spent on revamping the system. He left my office calmed and ready to at least try again. He stuck with it, and me, and we did revamp our entire Chart of Accounts that summer.

We just needed to have a real, unhurried conversation, aimed at understanding each other, our concerns, and how we might move forward. For me, it was another lesson in the value of sitting down in the same room and discussing challenges together. We gain so much through body language, tone of voice, and eye contact. In person, we can take on challenges so much more fully and humanely, and we dispose of the kinds of toxic worries that get inflamed so easily through emails and texts.

FINAL THOUGHTS

Financial management provides the structure, the roadmap, and the capacity to do great work. In this chapter, we have explored several practices that are crucial to effective money management. They may seem like separate functions at times, but they are, in fact, individual pieces of a puzzle—a puzzle that ties together all aspects of financial management, and hopefully supports and helps you grow your organization.

Money is the fuel for your mission. How you manage your money must therefore be informed and defined, in part, by your mission. If you are focused on large touring exhibits, the rhythm and focus of financial management must reflect that. If you work primarily with students in schools, your fiscal practices must support that. And if you produce huge, community-based productions, your financial management must be organized around that. In every case, effective financial management will help to plan, protect, and strengthen an organization's artistic work.

In this chapter, we have covered:

- The fundamentals of financial management
- Generally Accepted Accounting Principles
- The fiscal year

- Internal controls
- The Audit and Balance Sheet
- Key vocabulary
- The importance of company culture, an office safe, and valuing bookkeepers

See the appendix for case studies relating to financial management.

9

BUDGETING STRATEGICALLY

We're not overly reliant on individual donors. We're not overly reliant on earned
income. It all works together, hopefully.

—C. Brian Williams, founder and executive director, Step Afrika![1]

INTRODUCTION

Before you can start any activity, you need a budget. You are otherwise flying blind and setting yourself up for failure. If you want to do impactful, important work, you need to lay out how you are going to do it *by the numbers*. With a budget, you can decide how to handle challenges and opportunities throughout the fiscal year, or even within a single program or project. This chapter will explore how to create a budget for a program, an organization, and an entire fiscal year, in ways that will help grow your organization, your programming, and even your fundraising. You will also learn how budget narratives can help to clarify and promote your financial strategy and gain support from your funders, donors, and board members.

FUNDAMENTALS

Budgets are where the rubber meets the road. They show what you are *really* doing as an organization, and what you are investing in. A budget shows others exactly what you intend to do, with whom, for whom, and how you intend to pay for it. Every budgeting process is unique and should be tailored to the company's needs. But it also shares some core fundamentals, like time, relationships, and several drafts.

WHAT IS A BUDGET?

A budget is a roadmap, a plan, and a guide. It is also a tool for managing your resources and efforts. In most budgets, income is listed at the top and expenses at the bottom. When managing an organization, you will need at least three types of budgets: an Annual Budget, also known as your Organizational Budget; Program Budgets; and your Cashflow Budget, which lays out your Annual Budget month by month, so you can project your cashflow and prepare for what lies ahead.

APPROACHES TO BUDGETING

Top-Down or Bottom-Up?

Top-Down budgeting denotes that staff leadership will articulate the total budget and each department's budget for the fiscal year. They then pass down these budgets to their middle managers, who will need to implement programming within these budgets. This is more often used at new organizations or those under extreme financial stress, when leadership needs to make tough decisions and pass these decisions down to those managers who may not have enough information to understand the organization's current situation.

Bottom-Up means that senior staff leadership will ask middle managers to define what they need to maintain or grow programs in the next fiscal year; those numbers are then plugged into the total budget and fiscal strategy. This allows middle managers to drive at least the expense models for the coming year, in part because they know better than anyone what the programs need to succeed or grow, since they are managing on the front lines of these programs.

Typically, during any normal budgeting process, when the organization is fairly healthy and stable, a mix of *Top-Down* and *Bottom-Up* comes into play. Hopefully middle managers can provide input on how their budgets might change in the next fiscal year, while senior leadership always needs to dictate to a certain extent the final numbers, since they have more information and can see the big picture of the organization better than those implementing programs daily.

Zero-based or Historical?

Zero-based budgeting implies you are starting budgeting from zero, with a *blank slate*, as if you are creating a new organization or completely revamping an existing one. It is rare, because it means disregarding your history. In 2021, during the age of COVID-19 and massive disruption, most arts organizations were forced to restart with an eye to zero-based budgeting.

Historical budgeting involves looking at the past few years of actuals to build your next budget with historical trends in mind. Who tends to fund you and for how much? How much money do you gain from your box office or fees? How much have you

spent each year and over the last few years on programming, facilities, staff, and insurance? Your actual numbers will reflect what really happened, and you should budget within 0–15 percent increases or decreases from them for the next year. Once you have your program budgets in place, you should decide if you want to begin with the Income or Expense side of the budget. Usually, you do a little of both at once, finessing each side until you find the right numbers to fit the year you expect to have.

THE BUDGETING PROCESS

- *Make a plan with your board of directors*, including your treasurer, finance committee, fundraising (aka development) committee, executive committee, and the full board. Set deadlines for each draft and a specific person responsible for each step of the process.
- *Decide if you want to budget top-down or bottom-up and zero-based or historical.* It will depend on your organization's size, staff, history, and status. If you are in the middle of a leadership transition or strategic planning process, that may affect how you budget for the year. If a new leader is arriving soon, you may want to involve them in some decision-making about next year.
- *Take reality into account as much as possible.* Find out as much as you can from potential funders. Raise as much income as you can prior to the beginning of the fiscal year. Consider your history with funders, programs, and the local and national landscape for the upcoming year.
- *Create the budget.*
 - Decide whether to begin with income or expense.
 - Collaborate with staff and board members.
 - Think creatively.
 - Listen to your environment. What is happening politically or globally that might affect your next fiscal year?
- *Allow time for your budget to evolve.*
 - Because your reality may shift, funding may collapse, or new opportunities may present themselves, you will want four to six months to *research, revise,* and *reconsider* this budget before it's approved.

The Three R's of Budgeting: Research, Revise, Reconsider

Research
- Talk with all your current funders to see if you can rely on their support next year.
- Discuss any new funders or donors with your fundraising staff to see if any are reliable for new or larger gifts next year.
- Approach your largest donors with a conversation about the company's work, their current giving, and the question of whether increasing (or at least maintaining) their gifts might be possible this year.

- Study the financial markets, even if you are just paying attention to financial news online or on cable news. Gain a sense of how the U.S. economy is doing and may do over the next year, because it may affect your funding.
- Pay attention to political races, which may affect national or local funding. Is there a presidential race in the next year? Your funding might be down if individuals are giving more to upcoming political campaigns.
- Discuss with your board of directors all of their ideas and concerns for the next year.
- Have your fundraising committee review drafts of the budget, in order to help inform the numbers and motivate committee members to own these numbers as their responsibility?

Revise

- Every week, put your latest information into the budget draft by updating your numbers and budget narrative.
- Don't wait to revise your numbers. Do so as soon as you can, so you can strategize on how to deal with this new information (either good or bad).
- Update your board treasurer and finance committee and send them a revised draft when they are ready to consider it.
- Keep in contact with your treasurer so you can keep the finance committee moving through new budget drafts at least monthly.

Reconsider

- Give yourself permission and time to reconsider your numbers and strategy for the next year.
- Allow current events and new information from your research to inform you and the budget.
- Keep updating your budget narrative to include new insights and strategies.
- Embrace changing course or making hard decisions now. They will be much harder if you kick them down the road.
- Bravely lead your board to accept and approve the best budget for the organization for next year, even if there are risks. Balance those risks with solid planning.

Program Budgets

Drafting program budgets, as seen in Table 9.1, is often the first step in budgeting for a year. *Direct costs* are listed in the Program Budget. *Direct costs* are the expenses you need to deliver your programming, including the artists, production expenses, program materials, marketing costs, etc. *Indirect costs* to the program are then added in the main budget. *Indirect costs* are the overhead expenses needed to do your work, but not directly related to any one effort. Indirect costs include facilities, insurance, portions of staff time, and accounting costs. Demonstrating how these indirect costs contribute to

Table 9.1. Program Budgets

		Program One	Program Two	Program Three
INCOME				
Contributed	Foundations	$42,000	$45,000	$5,000
	Government Support	$20,000	$8,000	$0
	Corporations	$5,000	$10,000	$2,500
	Individuals	$15,800	$1,500	$9,750
	TOTAL CONTRIBUTED	$82,800	$64,500	$17,250
Earned				
ESTIMATED TOTAL POTENTIAL GROSS RECEIPTS				
Total Tickets Available		200	0	100
# of Performances		2	0	10
Full Ticket Price		$25	$0	$35
		$10,000	$0	$35,000
ESTIMATED ANTICIPATED GROSS RECEIPTS				
Est. Average Paid Tix		$20.00	0	$20.00
Projected Paid Attendance		100%	0	70%
TOTAL PROJECTED EARNED		$8,000	$0	$14,000
TOTAL INCOME		**$90,800**	**$64,500**	**$31,250**
EXPENSES				
Program Personnel		$68,000	$47,500	$27,500
	Artists	$38,000	$25,000	$10,000
	Teaching Artists	$20,000	$15,000	$12,500
	Assistants	$10,000	$7,500	$5,000
Non-Personnel		$13,000	$11,500	$2,000
Program Support				
Supplies	Pens	$2,500	$500	$0
	Paper	$3,000	$1,500	$500
	Metrocards	$1,500	$0	$0
	Tickets	$3,500	$8,500	$0
	Food	$2,500	$1,000	$1,500
Financial		$0	$0	$0
Fundraising		$0	$0	$0
Marketing		$9,800	$5,500	$1,750
	Printing	$5,000	$2,500	$500
	Postcard/Poster Design	$2,500	$1,000	$250
	Brochure Design	$1,000	$500	$0
	Supplies/Postage	$800	$500	$500
	Photography/Videography	$500	$1,000	$500
TOTAL		**$90,800**	**$64,500**	**$31,250**

the total cost of your programming is an important part of budgeting, especially when fundraising.

The income for programs one and three includes paid ticketing or entry fees. Program two relies entirely on contributed income. Once these program budgets are drafted, they can be tied into the main budget as demonstrated in Table 9.2.

Table 9.2. Organizational Expenses

		EXPENSES				
		FY 21 Budget	Program One	Program Two	Program Three	All Expenses
Personnel						
	SALARIES TOTAL	$341,000	$143,200	$83,850	$57,350	$341,000
	CEO	$85,000	$17,000	$17,000	$17,000	$85,000
	Program Manager	$65,000	$39,000	$9,750	$3,250	$65,000
	Development Associate	$48,000	$19,200	$9,600	$9,600	$48,000
	Artists	$73,000	**$38,000**	**$25,000**	**$10,000**	$73,000
	Teaching Artists	$47,500	**$20,000**	**$15,000**	**$12,500**	$47,500
	Assistants	$22,500	**$10,000**	**$7,500**	**$5,000**	$22,500
	Total Salaries and Benefits	$399,317	$160,920	$93,947	$71,479	$399,317
Program Support						
	Facilities TOTAL	$50,500	$15,150	$10,100	$12,625	$50,500
	Rent or Mortgage	$36,000	$10,800	$7,200	$9,000	$36,000
	Phone & Internet	$8,500	$2,550	$1,700	$2,125	$8,500
	Maintenance (Cleaning)	$6,000	$1,800	$1,200	$1,500	$6,000
	Supplies TOTAL	$69,500	$25,900	$20,100	$12,750	$69,500
	Equipment Rent and Maintenance	$7,500	$2,250	$1,500	$1,875	$7,500
	Website/IT Maintenance	$3,500	$1,050	$700	$875	$3,500
	Administrative and Program Materials	$26,500	**$13,000**	**$11,500**	**$2,000**	$26,500
	Depreciation	$15,000	$4,500	$3,000	$3,750	$15,000
	Printing/Copying	$12,000	$3,600	$2,400	$3,000	$12,000
	Postage/Delivery	$5,000	$1,500	$1,000	$1,250	$5,000
	Transportation TOTAL	$1,500	$450	$300	$375	$1,500
	Cab/Bus/Mileage	$1,500	$450	$300	$375	$1,500

Rental	$0	$0	$0	$0
Insurance TOTAL	$12,000	$3,000	$2,400	$3,600
Insur/Board/Liab/Bus	$12,000	$3,000	$2,400	$3,600
Professional Development TOTAL	$7,750	$1,938	$1,550	$2,325
Publications/Dues	$750	$188	$150	$225
Conference and Class Fees	$2,000	$500	$400	$600
Staff and Board Training	$5,000	$1,250	$1,000	$1,500
Hospitality TOTAL	$3,500	$875	$700	$1,050
TOTAL	$144,750	$31,563	$35,150	$48,475
Financial	$15,000	$3,750	$3,000	$4,500
Fundraising	$90,000	$22,500	$18,000	$27,000
Marketing	$28,925	$1,750	$5,500	$9,800
Printing	$13,000	**$500**	**$2,500**	**$5,000**
Postcard/Poster Design	$5,000	**$250**	**$1,000**	**$2,500**
Brochure Design	$2,125	**$0**	**$500**	**$1,000**
Supplies	$5,550	**$500**	**$500**	**$800**
Photography/Videography	$3,250	**$500**	**$1,000**	**$500**
TOTAL	$677,992	$131,042	$155,597	$250,695

Income and Expense Categories

Income for any arts organization usually includes a mix of earned and contributed incomes. *Earned income* includes ticket and entrance fees, class tuitions, rental fees, and anything else the organization *earns* for the year, including any interest earned on savings accounts or cash reserves. *Contributed income* includes individual donations, foundation gifts, government grants, and corporate gifts or sponsorships. Typical expense categories include:

- *Staff and Payroll*
 These expenses include full-time and part-time staff salaries and payroll taxes, meaning Social Security, Medicare, and federal and state withholding. This category might also cover any fees the company pays for its payroll to be managed, if the organization outsources this service.
- *Artists and Program Personnel*
 This category includes all artists, teaching artists, and personnel hired for programming. Actors, dancers, designers, directors, visual artists, and stage managers all fall into this category. Whether these positions are treated as contractors or employees depends on the state law where an organization is located. In New York State, for example, labor laws are clear that all performing artists in productions are to be paid as employees and therefore via payroll, with taxes deducted and Social Security and Medicare matched by the employer. Unlike employees, contractors are paid a straight agreed-upon fee, and not through payroll, so no taxes are withheld. Contractors are issued a 1099 at the end of the year and are responsible for paying taxes on that income when they file their tax returns each year.
- *Fringe*
 Fringe expenses include extra employee benefits including healthcare, childcare reimbursement, life insurance, or any other benefits provided as part of employment packages.
- *Non-Personnel Program Expenses*
 This category includes all the materials you will need for programming, besides personnel, including the cost of sets, lights, costumes, arts installations, and any other programming materials.
- *Facilities*
 This is the cost of your building, your office space, and/or your theater, museum, etc.—all costs related to owning, renting, or otherwise maintaining your spaces.
- *Utilities*
 These are your electrical, heating, air-conditioning, phone, internet, etc. expenses.
- *Supplies*
 This category covers anything you need outside of programming, including paper, pens, cleaning supplies, etc.

- *Equipment*

 These are costs relating to technology or equipment you need to run the business, including computers, phones, iPads, scanners, etc.

- *Insurance*

 These expenses cover all your insurance policy fees, including general liability, property, directors and officers (insuring your board in case of lawsuits), and disability.

- *Marketing*

 This category covers all of your year-round marketing expenses, including designs, materials, online fees, and any personnel or marketing firms contracted to assist with marketing efforts.

- *Fundraising*

 These expenses include everything spent on fundraising events, like your Gala, as well as any personnel contracted to support fundraising or to run fundraising campaigns.

- *Finance*

 Your audit expenses are included here, as well as any other outside assistance with finance, including a contracted bookkeeper if you do not maintain one on staff. Because freelance bookkeepers usually work off-site at a home office and do the work at their own pace, they can often be paid as contractors.

- *Depreciation*

 It is very healthy for an organization to budget for depreciation. This means the organization is saving money to pay for equipment and facilities that will someday be worthless. It is not a solid expense that must be spent this year. It is a statement of purpose, to save toward future needs.

- *Cash Reserve Build*

 Similar to depreciation, this line item is not a solid expense but rather an intention to save funds toward a cash reserve. At the end of the year, as with depreciation savings, this will technically represent a surplus for the year. But stating it as an expense in the budget declares the intent to gain and "spend" this amount to build a cash reserve. Having any amount of cash reserve on hand strengthens the organization's financial position greatly, as a "rainy day fund" in case of emergency.

A Balanced Budget

After you have articulated all your projected expenses and income for the year, you will want to ensure your budget is *balanced*. If your total income is $516,432, then expenses should total $516,432. Even though your actual end-of-year numbers will not be perfectly balanced, you want to demonstrate that you have a plan for gaining the necessary resources to do what you plan to do. In order to get to that final balanced number, you can adjust categories of income and expense that tend to be fluid anyway, including individual donations in the income section and supplies in the expenses.

An Approved Budget

During the final board meeting of the fiscal year, the board will vote to approve the next year's budget. The full board therefore needs to receive the final draft of the next year's budget *at least* two or three weeks before this final meeting. You will want any questions or discussions about the budget to happen among the board and staff mostly *before* this final meeting. The meeting and vote should be, by the time of the actual meeting, largely a formality, endorsing the fiscal plan for next year already discussed deeply among staff and board. You do not want to risk dissent, new discoveries, worries, or a lack of a vote during that final meeting. If your budget is not approved, you will enter the next fiscal year with no clear guidance on how to pay people, what to spend on programming, or how much to spend on utilities. You will also have no clear mandate on how to raise or earn money.

Surplus versus Deficit

It is impossible to end the year at a perfectly balanced net of zero with exactly equal income and expense. You will have either a deficit or a surplus. The goal of each fiscal year is to pursue your mission with vigor while trying to finish the fiscal year in a better position than when you started it. You might end with a deficit because you proactively used reserve funds to grow your programming, staff, or facilities. You may have expanded your staff and programs in ways you did not expect when you created the budget, because opportunities presented themselves to serve your mission further. If you and your board made a plan for how this deficit would be balanced with a surplus the next year, or in light of surpluses in recent years, you are still in a better position. On the other hand, an unexpected surplus for the year must be given a purpose by the board, either as new cash reserves or as a source for growth in the next fiscal year. Clarity, purpose, and communications are all key in managing your finances.

Building Up Reserve Funds

For many years the recommendation was that arts organizations should maintain enough cash reserves to support three months of expenses at all times. For most organizations, this three-month reserve has never been realistic. But having some kind of cash reserve does significantly help your organization adapt and survive tough moments. Gaining a surplus for the year and using it to develop a cash reserve is laudable. That reserve fund build should be included on the expense side of the budget as its own line, showing the reserves as a projected expense and savings. Otherwise, that financial goal for the year is not clear in the budget. This can be a controversial approach, as technically according to Generally Accepted Accounting Principles (GAAP), this would be a surplus and can only become a reserve fund after the end of the fiscal year, when the board designates it as such. But having your buildup of reserve funds shown clearly as a concrete goal in the budget, as an expense, can more clearly communicate your intent

and shows funders your good practices in saving that amount. It also puts this goal front and center for your board of directors and staff.

VARIATIONS

FINANCIAL MANAGEMENT AND FUNDRAISING

It's important to understand that financial management, especially budgeting, also plays a huge role in your success or failure in fundraising. The two are closely intertwined. The way you articulate your budget can either be clear and compelling, telling a story on how you plan to gain support and spend it toward your mission, or it can be a misleading or muddy mess, showing funders you either don't know what you are doing or, worse yet, that you are not doing what you *say* you do. Securing funding in the arts is so competitive, with only about 15 to 20 percent of submitted proposals approved for funding. Funders and donors need to know that you are prioritizing your programming *financially* by seeing it clearly in your budget. Any major confusion or disconnect in the proposal tends to eliminate it from serious contention.

The Importance of Formatting

Winning funding will be very difficult if your program expenses are not clearly prioritized in the budget. When I arrived at Young Playwrights' Theater (YPT), the expense side of the budget looked like this:

Table 9.3. Original Young Playwrights' Theater Budget[2]

		FY 2005 Board Approved Budget	FY 2004 Projected Actuals	FY 2004 Budget	Variance FY 2005/2004
EXPENSES					
SALARIES	Artistic Salaries	$99,500	$102,317	$101,500	−$2,817
	Admin Salaries	$86,000	$25,000	$26,000	$61,000
	Payroll Tax	$14,754	$10,796	$10,754	$3,958
	Benefits	$31,652	$14,582	$21,160	$17,070
	Non Fringe Staff	$6,100			
	Total Sal.	$238,006	$154,177	$159,414	$83,829
GEN. ADM.	Total Gen. Admin.	$79,507	$60,041	$71,101	$19,466
PROF FEES	Total Consultant Fees	$27,371	$11,184	$10,175	$16,187
	Total Fundraising	$22,082	$14,545	$17,700	$7,537
	Total Marketing	$15,218	—	$13,100	$15,218
PROGRAMS	After-School Workshop	$15,000	$10,488	$20,000	$4,512
	In-School Program	$40,000	$18,030	$11,800	$21,970
	Express Tour	$47,000	$25,500	$20,000	$21,500
	Special Projects	$1,000		$1,000	$1,000
	New Writers Now	$1,500	—	$960	$1,500
	Total Program Expenses	$134,500	$69,322	$55,810	$65,178
TOTAL		$486,684	$293,965	$325,250	$192,719

Table 9.4. Revised Young Playwrights' Theater Detailed Expenses

Expenses	FY 12 Budget	Gen Admin	In-School Program	Express Tour	After-School Workshop	Special Projects	New Writers Now	All Program Expenses
Personnel								
Salaries	$250,000	$29,000	$84,000	$43,250	$42,800	$22,950	$28,000	$250,000
Payroll Fees and Tax	$27,700	$4,155	$9,695	$6,925	$4,155	$2,770	$0	$27,700
Health and Dental Benefits	$18,000	$2,700	$6,300	$2,700	$2,700	$1,800	$1,800	$18,000
Total Salaries and Benefits	$295,700	$35,855	$99,995	$52,875	$49,655	$27,520	$29,800	$295,700
Contracted Artists and Non-Salary Program Personnel	$92,800	$0	$55,350	$27,450	$8,000	$1,000	$1,000	$92,800
Non-Personnel Program Support								
Facilities	$70,800	$15,760	$20,160	$11,040	$20,160	$240	$3,440	$70,800
Supplies	$55,600	$9,945	$14,430	$15,830	$10,135	$2,630	$2,630	$55,600
Transportation	$4,500	$300	$2,125	$1,425	$600	$25	$25	$4,500
Insurance	$10,000	$1,500	$2,500	$3,000	$2,000	$500	$500	$10,000
Professional Development	$20,500	$3,075	$5,125	$4,650	$4,600	$1,025	$2,025	$20,500
Hospitality	$8,500	$1,275	$2,125	$1,500	$2,050	$425	$1,125	$8,500
TOTAL	$169,900	$31,855	$46,465	$37,445	$39,545	$4,845	$9,745	$169,900
Financial	$18,600	$2,790	$4,650	$5,580	$3,720	$930	$930	$18,600
Fundraising	$20,000	$3,000	$5,000	$6,000	$4,000	$1,000	$1,000	$20,000
Marketing	$38,000	$2,700	$24,700	$5,400	$2,100	$2,300	$800	$38,000
TOTAL	$635,000	$76,200	$236,160	$134,750	$107,020	$37,595	$43,275	$635,000

The original budget in Table 9.3 told a distorted story and seemed to prioritize overhead expenses. The overhead costs of staff, office space, supplies, and utilities exist *only* to plan, implement, and *serve your programs*. If the overhead costs are not clearly tied into your programs, it seems that you are spending money on staff and facilities unnecessarily. Some portion of your costs is to *administrate* the company: hiring people, providing benefits, paying the rent, marketing the company to the public, etc. But those expenses usually only amount to approximately 15 percent of your total budget. Another 10 percent might be aimed at fundraising activities, but the remaining 75 percent or more should support and activate your programs in some way. By the time I left YPT, the annual expense side of the budget looked more like the budget in Table 9.4 on the previous page.

More complicated, yes, but clearer on how the overhead costs *support the programming*, with each program listed in its own column and including indirect costs. This shows how these costs were *necessary* to implement the mission. It also, more clearly, shows the total cost of each program. If the After-School Workshop is shown to only cost about $15,000 for the year, but you are asking a funder to give $15,000 in support of this program, they are likely to question why they are being asked to support the *total cost of this program*. They may also ask why the program is so cheap, given the company seems to be spending over $200,000 on unrelated overhead costs. With the Detailed Expenses budget, you are showing how all the indirect costs are vitally necessary for your programs to function and also showing the *total costs of each program*.

Rather than appearing to cost $15,000, the After-School Workshop is shown to cost over $100,000, making that $15,000 request seem much more reasonable. This revised format also demonstrates that the company spends one third of its annual budget on the In-School Program, underlining how important *that* program is. After all, if your programs were not happening, your overhead costs would be pointless. If you are not delivering on your mission, there is no reason to have a full-time staff or office space or supplies. Everything is and must be directed to your mission delivery. The income donated to your organization must be used in the service of your mission. When I arrived at YPT, the income section of the budget looked like this:

Table 9.5. Young Playwrights' Theater Income

		FY 2005 Board Approved Budget	FY 2004 Projected Actuals	FY 2004 Budget	Variance FY 2005/2004
INCOME					
CONTRIBUTED					
	Foundation	$294,550	$130,925	$110,500	$163,625
	Corporation	$14,734	$15,238	$12,000	–$504
	Government-Federal	$18,000	$20,000	$20,000	–$2,000
	Government-Local	$43,400	$41,380	$120,000	$2,020
	Individual	$44,100	$25,701	$25,300	$18,399
	Total Contributed	$414,784	$238,244	$287,800	$181,540
EARNED					
	Total Earned	$71,900	$60,721	$37,450	$11,179
TOTAL INCOME		**$486,684**	**$293,965**	**$325,250**	**$192,719**

This showed little detail and relied too much on guesses and speculation. There was no clear plan for how the money would be raised or from where. It relied too much on surprises and gifts from the gods, and not enough on clear relationships with funders, a clear fundraising plan for donors, and the kind of moves management system detailed in the earlier chapter on raising money. By the time I left YPT, the Income section looked more like this:

Table 9.6. Young Playwrights' Theater Revised Income

INCOME		FY 12 Budget	Probability Rating
CONTRIBUTED	**Foundations**	$178,500	
Committed or Received	Beckner Fund	$15,000	Committed
High @ 70–100% submitted	Cafritz	$15,000	$5,000 High/$10,000 Received
Moderate @ 41–69% submitted	Capitol Hill Community Foundation	$8,500	High
Low @ 0–40% submitted	Community Foundation	$25,000	Received
	Fowler	$8,000	High
	Mead	$12,000	Moderate
	Meyer	$40,000	High—$30,000 Gen Ops and $10,000 MAP
	MARPAT	$15,000	High
	Professional Athletes Foundation	$15,000	Received
	Prince	$25,000	High
	Corporations	$39,000	
	PNC	$11,000	High
	Ronald McDonald	$15,000	High
	Verizon	$3,000	High
	Wachovia	$10,000	High
	Government-Federal	$71,000	
	NEA	$71,000	$61,000 Committed/ $10,000 Moderate
	Government-Local	$119,000	
	OLA	$32,000	High
	DCCAH	$45,000	High
	Neighborhood Investment Fund	$32,000	$19,000 Committed, $13,000 High
	UPSTART (Reserves)	$10,000	Received
	Total Individual	$151,000	
	Board	$32,000	High

INCOME		FY 12 Budget	Probability Rating
	Board Giving	$12,000	High
	Board Getting	$20,000	High
	Combined Federal Campaign	$6,000	High
	Other Individuals	$67,000	High
	Harman Family Foundation	$7,500	High
	Hermanowski	$3,000	High
	Kincaid and Lainoff Foundation	$7,500	High
	Posner Foundation	$28,000	High
	Total Contributed	$519,500	
EARNED	Tour	$10,500	Moderate
	Fees	$45,000	Committed/High
	Total Earned	$55,500	
	Reserve Fund	$60,000	Received
TOTAL INCOME		**$635,000**	

This format provided a clearer map of where money would be coming from, how confident we felt about each source, and where we might make adjustments. Unlike a large producing organization, YPT relied mostly on contributed income. The development of a diverse fundraising portfolio was critical to our success. The company eventually had a strong enough fundraising staff and fundraising cycles established that we could adjust and try to find new sources for funding, even midyear. We restored and grew cash reserves to over $530,000 and eventually entered every fiscal year with about half of that next year's funding already secured or committed.

The work paid off. YPT grew secure in fundraising, lauded for financial management, and could start planning two to three years in advance and dreaming big. This resulted in our gradually publishing the student plays, filming all of our performances, developing a thriving alumni network and on and on, leading YPT to become a national leader in arts education. All, in part, because of improved financial management and better budgeting.

BUDGET NARRATIVES

One final but vital component to budgeting, financial management, and fundraising is the *Budget Narrative*. Narratives come in several formats, depending on their audience. They all attempt to anticipate and answer *questions* regarding the budget. They also often function as a value and strategy statement, explaining how and why decisions were

made in a budget. *Organizational Budget Narratives* accompany an annual budget when shared with the board of directors. They are focused on the big picture and organizational strategy. They explain why changes are being made in income and expenses. They advocate for certain changes, like staff salary increases, program expansions, or strategic cuts. They inform the board why the budget looks the way it does. *Line-Item Budget Narratives* provide further detail for program-related budgets. They are often used to justify expenses to senior staff or supervisors.

Government Grant Application Narratives tend to require narratives that explain every amount in more detail, so you are required to attest to how your income and expenses will work if funded. *Federal Budget Narratives* are often simpler, requesting only a few paragraphs detailing the state of the organization. You can find examples of all these types of budget narratives in the accompanying Instructor's Manual and the online cache of documents.

For every budget and every narrative, focus on who your audience is. What do they need to know, and why? If you want them to approve this budget, how can you explain the values and strategies of the budget in a compelling way? If you want them to fund you, how can you be clear about your intentions and why their funding will be best spent by you? Treat every narrative like your chance to tell a stranger why you chose these numbers, whom they affect, and how they can help your work.

FINAL THOUGHTS

A budget can be a thing of beauty. A thing of clarity. A roadmap that shows your mission playing out in vibrant colors of numbers, showing the path you plan to chart for the next year, along with all the artists, students, and audience members you intend to affect with your work and mission. It can show others exactly what you intend to do, with whom, for whom, and how you intend to pay for it. It's about being as specific as humanly possible and putting the vision for what you intend into numbers. Numbers that can then carry your intention and your mission to others.

In this chapter, we have covered:

- Approaches to budgeting
- The budgeting process
- Researching, revising, reconsidering
- Program budgets
- Income and expenses
- A balanced, approved budget
- Surplus versus deficit
- Financial management and fundraising
- Budget narratives

NOTES

1. Author interview with C. Brian Williams, May 5, 2021. All quotes from C. Brian Williams that follow are from the interview, unless otherwise noted.

2. Note: These budgets have been altered to protect confidential information.

10

MANAGING PEOPLE

You have to understand that you only come with the strengths that you come with, and that you need people around you who have strengths that you don't have, and you need to create the conditions for them to be successful.

—Deborah Cullinan, CEO of Yerba Buena Center for the Arts[1]

INTRODUCTION

An organization is made up of *people*. How you manage those people will define how healthy, adaptive, relevant, and sustainable your organization will be. This chapter explores how to manage human resources, including your board and staff, along with strategies to keep them healthy, happy, and productive. In recent years it has become painfully apparent that the arts have unfairly burdened people with too much work and too little pay to get the job done. While there is a mission, programs, payroll, rent, and space, there are always people at the center.

FUNDAMENTALS

Clear communications and a healthy balance between resources and expectations are essential to successfully manage people. The following steps will help you grow authentic relationships with your colleagues, so that you can develop a healthy and more satisfying work environment.

FIVE WAYS TO BETTER MANAGE YOUR PEOPLE

1. *Be Clear.* Be clear with your expectations. Be clear with your ambitions. Be clear on your limitations. If you are asking people to do a lot, admit that you

are asking them to do a lot. If you need more help and resources, tell your superiors. Ensure that everyone is clear on what you expect and why. Communicate challenges to the board so they can help carry the burden.

2. *Be Forgiving*. No one and nothing is ever perfect or perfectly done. Mistakes are opportunities to learn. Focus on fixing issues. Rally your team. Fix them together.

3. *Create Cycles*. An established rhythm of cycles in your year can help people know when to push, when to work overtime, and when to rest. More and more, our work has become a nonstop push forward. Certain professions tied to school years and other calendars have natural ups and downs. In the arts, we sometimes need to create these cycles. Avoid constantly overlapping one year into the next. Instead, create cycles of beginnings, middles, and ends, so everyone can feel natural highs, lows, and *rests*.

4. *Set Goals for Growth in People as Well as in the Organization*. Evaluate each person's performance and rearticulate their job description each year *with them*. Set goals each year for what they want to accomplish and learn, in addition to what the company would like them to accomplish. Help them see growth in themselves through their jobs, so that each year represents progress for *them*, as well as the organization.

5. *Maintain Clear Policies and Systems*. If everyone is clear on how and why you operate the way you do as a company, they can plan appropriately and rest assured in how things operate. If there is confusion with human resource systems, such as taking vacation, getting reimbursed for out-of-pocket expenses, or even which holidays are company days off, this lack of clarity can breed feelings of being abused or ignored.

THE STAFF

Leadership

Leading is sometimes defined by its root meaning as "to go before as a guide." It is also defined as those who live by example. If budgetary cuts are to be made, the leader should be cut first. If new growth is needed, the leader should be pointing to that new growth and rallying the staff to plan and execute this growth. The leader will not accomplish all of the growth herself, but rather she will empower others, through training and advocacy, to help lead the way, with the leader continuing to shine a light on the goals and the guidelines, and whatever parameters the growth needs to address.

An Employee Handbook

A positive culture relies on doing fulfilling work, at least some of the time; being paid decently for said work; having a clear employee handbook with clear, fair policies

to protect employees; and gaining chances to have input on the job and programs going forward, all while feeling safe and respected in the workplace. If you do not have an employee handbook, start to develop one immediately. Include clear policies and procedures about pay; vacation time; full-time versus part-time status; holidays; sexual harassment and discrimination; accessibility; diversity, equity, and inclusion; intellectual property; use of company equipment; and so on. The more specific and transparent the handbook is, the better. Make it readily available, electronically, for all employees continually, and have new hires review it and sign a form stating they have received and read it before they start working for you. Consult your region's nonprofit governance experts, like New York State's New York Council on Nonprofits (NYCON), for further legal advice on what to include.

Employees versus Independent Contractors

Every state has its own specific labor laws, but overall, if a person works on the premises with equipment provided by you, the employer, or online with tech or online platforms provided by you; is directed when and how to do their jobs in any way by you; and is paid via company payroll, with taxes withheld, they are an *employee*. If an individual uses their own equipment, does their work how and when they want, or is simply hired to do a task and not directed on how to do that task by you, they are an *independent contractor*, paid a flat fee, and fill out a W-9 when hired and receive a 1099 from the company at the end of the calendar year for them to pay their own taxes. In New York State, the labor law clearly states that any artists performing or working for an organization for a specific production or project are employees, and the organization must therefore pay them via payroll, paying taxes and Social Security for the employee. If an artist or company is simply booked to show up and play a concert, create a painting, dance a dance, or perform their one-woman show, without any input from the company on how they do it, they can be a "presenter" and therefore an independent contractor.

Feedback

Your staff needs to feel engaged and valued. There is always too much work to do and barely enough resources to get it done. But honoring and engaging your staff will help them stay balanced and not burn out. Part of this approach relies on open communication about what *they* need in order to do their jobs well. Find out what equipment, time, funding, and human resources they need. After you hear from them, honor their requests. Work with them to do what can be done within current resources, with an eye to raising more money; hiring more people, if need be; and properly equipping their program.

When they do well, sing their praises. When they mess up, sit down with *questions* and not accusations: "How did we end with this result?"; "What could we have

done differently?"; "What will we do next time?" Own your part in the mistakes and avoid placing blame. After all, you run the company. You hired them and missed the chance to guide them to another answer. Analyze what happened and how to actively fix it. Find new ways to offer them professional development opportunities and ways to grow with new challenges in their jobs. Sit down each year with them to review their job description and offer assessments of their work based on that job description.

Give them the chance, with you, to revisit their job description and make edits, based on the previous year's learning and accomplishments. Give them the chance to make edits based on how they now see their job working. Create a culture and policies through which employees can see themselves working with you for many years, growing and learning until they arrive at a moment when it feels right to leave for new opportunities.

Clear Job Descriptions

Staff members need guidance, clear job descriptions, independence to do their work, and resources. Evaluate each person's performance and rearticulate their job description each year with them. Use their specific job description to evaluate their performance. Table 10.1 demonstrates an example evaluation based on a manager's job description.

Table 10.1. Employee Evaluation Form

EMPLOYEE:	
SUPERVISOR'S NAME:	Length of time you have supervised this employee:

The Program Director for Hubbard Hall plans, implements, and helps to communicate all Hubbard Hall education programs, including all regularly scheduled classes and educational special events. The Program Director works closely with the Communications Manager to help communicate Hubbard Hall's programming to the public and with the Executive & Artistic Director to strategically plan program growth and chart a path for long-term learning through the arts for students of all ages.

PRIORITY	EVALUATION STANDARDS
1–Essential	O–Outstanding. Exceeded all expectations and goals.
2–Important	A–Above Expectations. Met all goals and exceeded some.
3–Somewhat Important	M–Met Expectations. Met most or all goals.
	B–Below Expectations. Did not meet goals or met them partially; improvement needed.
	U–Unsatisfactory. Failure to meet goals is unacceptable.

JOB FUNCTION REVIEW

PRIORITY	*RATING*	*DUTIES*
		Program Development • On-site event planning and execution; scheduling & calendar updates; • Developing/writing course descriptions; instructor inquiries (phone/email);

PRIORITY	RATING	DUTIES
		• Recruiting/supporting instructors and teaching resources/facilities; • Managing instructor contracts and submitting hours for payment; • Developing overall program objectives, implementation, and assessment.
		Enrollment and Registration • Process student inquiries (phone/email); course enrollment/records; collecting and processing tuition payments; • Managing scholarship applications/responses; attendance records; participation consent forms and database updates; • Transfer/withdraw/defer/refund requests; class cards; volunteer hours related to scholarships (work/study).
		Communications • Market programming, including managing plans for the promotion of fall, spring, and summer programs; • Oversee development and implementation of class catalogs; • Oversee posting of event posters and fliers; • Updates online for course/event specific information; • Posting Facebook events and status posts as needed; post-event updates and images; YouTube video updates.
		General • Attend regular staff roundtables. • Answer questions and inquiries from the general public, including answering phones when necessary and email requests as appropriate. • Represent the Hall at public events, including arts fairs and conferences. • Mentor fellows and interns as assigned. • Other duties as assigned by the Executive and Artistic Director.

PERFORMANCE REVIEW

PRIORITY	RATING	
		JOB KNOWLEDGE. Evaluate the knowledge and use of information, procedures, materials, equipment and techniques, etc.
		QUALITY. Evaluate accuracy, completeness, timeliness and follow-through of work.
		PLANNING/ORGANIZING. Consider such areas as responding to varying work demands, developing efficient methods, setting goals and objectives, establishing priorities, and utilizing available resources.
		COMMUNICATION. Evaluate clarity and consistency of internal communications with other employees and management.
		PRODUCTIVITY. Evaluate the volume and timeliness of work based upon the requirements of the job.

(continued)

Table 10.1. *(continued)*

	INITIATIVE. Consider self-starting ability, resourcefulness, and creativity as applied to duties and responsibilities
	COORDINATION/COOPERATION. Consider relationships with other employees, external contacts, and artist-participants.
	DEPENDABILITY. Consider punctuality, regularity in attendance, meeting deadlines, and performing work without close supervision.
	PUBLIC AFFAIRS. Consider ability to communicate with the public in a helpful and informative manner.

OVERALL EVALUATION OF PERFORMANCE

(Rating)

COMMENTS SUPPORTING THE OVERALL EVALUATION

FUTURE PLANS/ACTIONS

EMPLOYEE COMMENTS

EMPLOYEE SIGNATURE **DATE**

SUPERVISOR SIGNATURE **DATE**

Focused Evaluations

Staff evaluations should be conversations rather than monologues. The supervisor and reporting employee should each review the evaluation in advance and come up with suggested ratings for each category ahead of time. Then the supervisor should schedule an hour with each direct report to share their views and hear from the employee. While you are going through the job description and evaluation point by point, your focus should stay on the job and the person's performance of that job. A spirit of inquiry should prevail, with a focus on 1) whether the job description accurately fits what the employee is doing in the job; 2) how the employee is performing in each aspect of their job; and finally, 3) how to help improve their performance, if need be, from both the employee's and the company's perspective. What resources might be needed? What is in the job description that no longer applies? What is in the job that has yet to be added to the description? How has the employee applied themselves to each of these points? How could they be empowered to perform even more efficiently and effectively next year? What does the company need them to do? What goals and learning does the employee want to achieve?

Add notes to the job description so it can be formally revised after the evaluation. If tough situations or trends need to be discussed, try to keep the focus on the job description and avoid personalization. Rather than saying, "You do this, and it does not work," focus on the job itself: "It says here your job supports this. But right now, I see how this part does not work. Let's talk about how we can improve it. What do we need to do or change?" The supervisor has the ultimate decision on the employee's ratings, but they should stay open to changes and dialogue as the conversation continues. If any ratings of "below expectations" exist, ensure the employee understands the timeline for improving on those points and what would happen if those points do not improve by a certain date. Also establish how and when they will be evaluated on that improvement and when you will check in at regular intervals before the deadline.

Then, once the hour is up, finalize the scores. The supervisor should add narrative notes about the employee's performance, email the evaluation to the employee for their comments, and then they both should sign a copy of the final signed version given to the employee electronically. If need be, these evaluations can then be shared with a human resources director or the board of directors. Hopefully, at the end of the conversation, each person feels energized, heard, and clear on how to move forward. If the meeting instead feels awkward or tense, analyze whether or not your evaluation process is clear enough or whether you and a colleague need to discuss the situation before following up with the employee.

When you are worried or in doubt about a situation, err on the side of asking a colleague to join you for the initial evaluation. For senior staff members, this may include fellow senior staff or board members. For middle or lower staff members, it may include their direct supervisor or another middle manager. If you have a large enough staff, you may want to implement a policy of having another person present for all your evaluations, as another witness and point of view in the conversation. But keep

the conversation focused between you and the employee, so that the evaluation does not become diluted or too long.

360-Degree Evaluations

Some arts organizations also use 360-degree evaluations, when evaluating a new leader, in a moment of organizational transformation, or when morale becomes low and hearing from employees across the organization becomes a priority. Implementing 360-degree evaluations can also help flatten a hierarchical leadership structure, if a company seeks to become more democratic or uproot traditional power dynamics, including issues involving systemic racism. A 360-degree evaluation can be a powerful tool, especially in moments when an organization is changing or needs to change. But according to the American Psychological Association, poorly run 360-degree evaluations can do more harm than good.[2] Implementing this kind of evaluation requires organizations to enlist outside help, while thinking deeply about and clearly communicating the goals in doing this work. Handle these with care.

In this evaluation model, ideally an executive coach or evaluation expert from outside the organization is engaged to manage the process. This manager identifies five to ten staff members working with the person to be evaluated. These staff members are then asked to submit anonymous feedback to specific questions in writing about this person's job performance, usually via an online survey. Similar to your goal in the more traditional one-on-one evaluation, keeping the evaluation's focus on the job and not the person is crucial to staying productive and avoiding personal attacks. The coordinating manager or coach then compiles the feedback and creates a private process to deliver the feedback to the employee being evaluated, hopefully including their direct supervisor.

Because the feedback in the 360-degree model is anonymous and coming from multiple points of view, it can be very challenging and potentially overwhelming for the employee being evaluated. The way the evaluation is delivered to the employee is therefore critical. Having a mechanism for the employee to respond to feedback is crucial, as is including concrete goals for the employee to pursue from the evaluation. Given the intensity of this model, companies may also need to provide psychological or executive coaching for employees after the evaluation, to help those employees positively process the feedback and transform it into action.

Authentic Relationships

One of the challenges of management can be in prioritizing time to build a relationship with people *beyond* current work priorities or tasks. Because arts and mission-based work is always so driven, and usually underfunded, managers can become too hyper-focused on the tasks and objectives at hand. They can fail to invest time and

energy in having fuller, more authentic relationships with their teams. If you focus entirely on your "to do" list, your relationships will become brittle and easily break under work-related stress.

Casual Conversations

Find time to simply talk with colleagues, about their lives, their commute to work, their families, the latest binge-worthy show on Netflix, or gossip on Facebook. Grab time to go for coffee together or have lunch. In these seemingly trivial side moments, you will develop real relationships, beyond your current tasks. Relationships in which you and your colleagues can feel better connected, heard, and understood. Relationships in which you and they both feel better trusted or seen by each other. These interactions lay the groundwork for staff to care about each other and feel cared for, even in moments of great work-related stress or challenges.

If attention is not given to these relationships, staff members start to associate each other just with work objectives and challenges. They lose sight of each other as people. Stress levels build until staff members no longer want to work there, which weakens the organization and stops the company from delivering on its mission.

Balanced Resources and Efforts

Ensure your efforts are balanced with your available resources. If need be, inform your board of directors of the need for greater resources, in order to fulfill the mission in a healthy and safe way for everyone. Otherwise, you are passing along the inequity too often expected in the arts, especially in the nonprofit sector. An attitude of "do more with less" tends to prevail, and this can lead to extreme burnout. During the shutdown caused by the global pandemic, many arts leaders realized that constantly working in the shadow of a looming deficit and debt is an unhealthy cycle, and it needs to change.

Wasting Individuals' Time, Money, and Goodwill

Underfunded programs or companies sometimes rely on the personal commitment and resources of individual staff members to make up the gap. If there is an expectation for staff to work crazy, long hours to complete administrative tasks or run programs, an unfair expectation is being imposed on them. If additional hours and compensation are not negotiated in good faith, you are relying on that individual's free time, money, and goodwill. Expectations that a career in the arts means working long hours for little pay understandably forces many people to choose another career path and seriously hurts a company's ability to build institutional memory and strength. Diversity, equity, and inclusion are also impossible to achieve when arts organizations rely

on staff members being able to work extra hours for no extra pay. These requirements, along with unfair practices like unpaid internships, reflect systemic racism, misogyny, and socioeconomic bias, and they assume that the individuals in these jobs have some kind of independent wealth, family support, or access to loans in order to do this work. Remember that your staff is at the core of what you do. If staff members are treated unfairly, your mission to serve others will eventually fail.

In-Person Meetings

It is a good practice to have regular check-ins, during weekly staff meetings or in one-on-one sit-downs. Schedule at least fifteen minutes with each senior staff member each week, to give you a moment to sit together and check in. In the age of tweets, texts, and emails, sitting down together can pay huge dividends in understanding each other and communicating clearly.

Staff Roundtables

Early in my first leadership role at Young Playwrights' Theater (YPT), I needed to inspire a more equitable culture in the staff. Everyone was feeling burned by the previous executive director, and I needed them to feel they could bring ideas and innovations into our staff meetings, because we desperately needed them. I realized we were, at the time, meeting around a roundtable in our tiny office. In the shower one morning it hit me: We needed to rebrand our staff "meetings" as staff *roundtables*. These roundtables would actively shift the meeting culture from one of *reporting* to the executive director to one of *sharing* and *collaborating*, with everyone bringing ideas to the table. I announced this idea at the next meeting to some quizzical looks, as no one really understood what this weird idea might mean. I also shared that the person running the agenda for the meeting would no longer always be me. Instead, we would rotate meeting leadership among the staff, so that the person taking us through the agenda and being "in charge" of the meeting would be different every time, until we had covered the entire staff and started again. This approach underlined the collaborative approach to these meetings, and it allowed different staff members to design the agenda in their own style and with their own priorities. I also suggested that the person running the agenda should add a fun activity for us to do sometime during the meeting, as a way of blowing off steam, bonding as a staff, and recognizing the priority to find joy in our work, even as we worried over every detail. Over the years, this practice proved very successful and especially helped interns and entry-level staff members to learn the company and feel empowered to fully participate and contribute their ideas.

THE BOARD

Developing the Board

Each board member comes with a certain skill set and interest. When you are building or recruiting for your board, first determine what skills are important to the function of your board. Do you need an attorney? Or would someone with marketing experience serve the board? What skills would help the organization? Does the board simply need members with more money and connections to larger potential donors? Create profiles, in partnership with your board chair and governance committee, of the type of people you seek.

Then articulate, with your board, the recruitment process. Can an individual board member nominate a potential new member, or does the governance committee do that? Or is a special nominations committee required? Can there be a regular short list of potential candidates being moved forward in the board candidate "pipeline" all the time?

New member profiles should be created, reviewed, and approved by the governance committee and sometimes the full board. Using these profiles as guides, board members and staff suggest potential nominees. These nominees then have coffee or lunch with two board members, who spend that lunch getting to know the potential candidate and gauging their interest. The candidates should be notified in advance and asked if they are interested in serving on the board, so this is already understood before this meeting.

The two board members then report back to the governance or nominating committee. If the potential candidate seems like a good fit, a second coffee or lunch can be scheduled with the executive director and/or another board member. Assuming this second meeting goes well, the candidate then receives more information from the executive director, including the company's latest audit and annual report and an application for board service. Depending on your organization's size and location, you may skip a formal application and simply ask the candidates for their résumé. In urban areas, candidates will be more familiar and comfortable with an application. In smaller rural areas, candidates may be turned off by the idea of applying.

The candidate sends the application and/or résumé to the executive director. At the next full board meeting, the agenda includes a time to consider new board members. A member of the governance committee will then present information about this person, with their résumé and application having been sent to the full board with other meeting materials, and then nominate them for board service.

After any discussion, the board can then vote on this person's candidacy and vote them onto the board. Ideally, this process includes voting on at least three new members each time, so that a whole "class" of new board members can join the board together as colleagues. This allows new members to feel at ease in their new learning curve, together. After a new class has been voted onto the board, try to schedule a time just before or after a regular board meeting when members can mingle, socialize with some food and drinks, and get to know the new members. Ensuring new members

feel welcome and connected to their fellow members is the first step in helping them to succeed as board members. Every new member should also be asked to join at least one board committee when they begin, so that they are focused on a particular topic, either fundraising, finance, governance, facilities, events, or whatever other topics the board has prioritized by creating committees.

As new members join, you may also have them sign board member agreements. These simple documents ask board members to state their intended contributions to the organization for the current year, including money and effort. They allow the board chair and executive director to quantify how much support they have from the board financially and professionally, and they give the chair a chance to circle back to the other members, midyear, to discuss any shortfalls in their contributions to date, in money and effort. This agreement can be intimidating to some less-experienced board members, but it ultimately provides everyone more freedom and clarity, so that the board leadership and staff are not left to guess how much support they might gain from a member. Contributions in time and professional expertise can be just as valuable as money, and knowing that expertise is available can bolster the staff and help the organization's operations. Again, boards in rural areas will likely be more resistant to signing a board member agreement, in part because they may be concerned with their own ability to donate enough money, or they may simply have less experience with contracts and agreements in their daily lives. Box 10.1 shows an example of a Board Member Agreement. Each board member would decide how much money and effort to offer, knowing that some boards have an established Give and Get policy or a certain number of committee memberships is required as a baseline.

BOX 10.1. BOARD MEMBER AGREEMENT

As a member of the Board of Directors of, I agree to support its mission and programs. I understand that my duties and responsibilities include the following:

1. I have, along with other board members, legal responsibility for oversight of the management and operations of the organization.
2. I am expected to be familiar with the company's programs and policies and to participate actively in strategic planning.
3. I am responsible, with other board members, for the organization's budget and finances. It is my duty to be active in monitoring its income and expense, in planning the budget and in assisting to raise funds to meet the budget.
4. With the other board members, I am responsible for the ethical standards maintained by the company; and I pledge to carry out my duties as a board member with the highest degree of ethics.

5. I agree to treat courteously and with respect all those involved with the organization.

6. I will actively pursue the fundraising goals of the company during fiscal year 2028 (July 1, 2027 through June 30, 2028). Understanding that board members exercise a leadership position in fundraising efforts, I agree to participate in those activities as follows:

 - I will personally donate at least $_____ to general and specific fund drives.
 - I will set a personal goal of obtaining at least $_____ in donations from others, friends, and associates during the next year.
 - I will share names of prospective donors for fundraising activities;
 - I will purchase a season subscription;
 - I will attend and actively participate in programs of the organization when possible;
 - I will talk about the work and the achievements of the company with colleagues and friends;
 - I will participate in the following:
 - Active recruitment of board and committee members;
 - Helping to identify and establish contacts with potential corporate and foundation donors;
 - Identify sources of in-kind contributions;
 - Send letters/requests/personal notes on fundraising appeals to friends;
 - Help to plan, organize, and participate in fundraising events.

1. I agree to serve on and actively participate in at least one standing committee of the board.

2. I will do my best to attend all meetings of the board and any committees on which I serve. I understand that I am required to attend at least three-quarters of the total meetings to remain in good standing as a board member.

3. I will try to attend at least two opening night performances during the season and to bring guests with me to the performance and/or opening night dinners.

4. In addition to the above, I am committed to making any specific additional efforts to support the work of the organization described in the attachment to this agreement.

In turn, the organization is responsible to me in the the following ways:

1. I will be provided with board meeting agendas and other meeting materials in advance, including a monthly financial report.

2. I can call on the executive director and president of the board to discuss the programs, policies, goals, and objectives of the organization.
3. I will be provided with straightforward, thorough, and timely responses to any questions I have during the course of carrying out my fiscal, legal, or moral responsibilities to the organization.

Board member name: (Print) Board member signature & date

ADDENDUM TO BOARD MEMBER AGREEMENT
INDIVIDUAL BOARD COMMITMENT FOR FY28

List your top priorities as you fulfill your board member responsibilities in FY28. (For example: Cultivate and solicit a minimum of five new donor prospects; host a reception/dinner/tea for donor prospects; take a leadership role on a board committee, etc.)

How can the organization assist you in fulfilling board member responsibilities in FY28? (For example: providing additional information, providing sample follow-ups letters, providing special board training sessions.)

Board member name: (Print) Board member signature & date

Knowing the Board

Similar to the staff, find time to talk with board members outside of formal board meetings or emergency situations. Have lunch or coffee and just spend time together. Board members are sometimes the closest thing an executive or artistic director has to peers in the organization. Develop some sense of collegiality with them so that you can trust and like each other, even in the stressful times. Board meetings are usually times of deep, important decision-making. Ensure you at least occasionally schedule a board retreat, so the board can think more freely about the future of the organization, and so that you can get to know each other a bit more as human beings.

VARIATIONS

THE DANGER OF TEXT MESSAGES AND EMAILS

Emails and texts are for information sharing only: updates, data, time and place, direct answers. As soon as an email thread becomes a conversation, meaning more than a few lines, you need to either pick up the phone, meet in person, or at least schedule a Zoom meeting. One reason: The *tone* via email or text can be very confusing. Anger, fear, and even despair can be miscommunicated from something intended to be simple and direct.

We as humans gain thousands of signals from our facial expressions, body movements, and even the way we breathe when we can see and hear each other fully. Email communications rob us of these many natural cues and therefore often lead to miscommunication. In person, on the phone, or even via Zoom, we can process a conversation, change perspectives, and have a natural exchange in real time. We cannot via email. Some individuals also fall into habits of venting and attacking via email in moments of stress, in ways they never would if they were communicating in person.

Some people keep this as a long-term bad habit, with late-night emails to colleagues or friends in moments of frustration and exhaustion. But then they spend much of the next day fretting over what they said, apologizing for what they said, or a mix of both. Those who behave this way will never truly receive honesty from their staff or colleagues, because no one ever knows exactly which person to expect, or which they truly are.

Phone calls at least give you real time and the human voice. Meeting in person, face-to-face, is still the best way to meet about important issues and to indicate the other person's importance to you. But in a pinch, or during a global pandemic, a Zoom call is better than nothing. Again, you can see the person, hear them, and process things in real time. Whenever possible, make the effort to follow up in person as well.

VARYING POINTS OF VIEW

Everyone has a slightly different way of viewing and processing information. Some people learn visually, aurally, or kinesthetically. A combination of introverted and extroverted behavior can live in one person, depending on their environment, health, and even blood sugar. Often what looks like someone disregarding a direction, dragging their feet on an assignment, or simply not understanding a message, can really be a matter of that person processing information differently than you do. Rather than viewing miscommunication as a difference in attitude or temperament among staff, start to see these variations as natural physical and chemical differences. Keep in mind, too, that every person's life is unique and that their current experiences outside of work may be affecting their perspective and abilities. Listen actively to others and allow for a wide variety of communication styles, in order to successfully relate and work with each other. Learn what each person needs to communicate clearly and then practice

translating your message to their perspective. If you are leading an entire staff, engage your senior leaders in this conversation so they can translate for their direct reports.

This may sound obvious. But for me, to actually hear and understand this variety of perspectives as physical differences in the ways we perceive each other was a revelation. It went beyond thinking, "Well, they just don't agree," or "They must have never learned to work this way," to realizing that different ways of working can be as organic and physical as the different ways we look and move through the world—and that one way is not the right or better way. Instead, we need to allow for all these different ways of perceiving the world and figure out how to best translate our intentions to each type of personality as necessary.

DELEGATING, NOT ABANDONING

Micromanagement tends to be a dirty word, meaning a manager is overseeing their staff too closely, checking in on every step of their progress and not allowing each person to independently complete the agreed-upon tasks. It tends to engender fear and stress in most situations and leads to burnout. It engenders fear in staff members that the intense management reflects a lack of trust or belief in them. Delegating tasks and allowing staff to do their jobs without intense observation is one key to having a positive and productive company culture. But at the same time, you want to avoid the sense of ever abandoning your staff to tasks. This is especially tricky when asking staff to innovate.

Some people feel very comfortable going out onto the thin branches of new ideas, trying them out, and not worrying if they fail or succeed. But others can become very stressed when trying new things. These staff members tend to want more supervision when experimenting. You may feel you are trusting them deeply by *not* checking in with them continually on their progress, but they may view this behavior as abandonment. If you can check in via regularly scheduled meetings, you can quickly assess how they are doing on their delegated tasks and offer any and all support they need, while letting them know you believe in their ability to get it done. For some people, a steep learning curve can be scary. But if they know you are there to catch them if they fall, they can learn and grow through the process.

THE IMPACT OF FACILITIES

How your facilities feel and function have a big impact on your staff. If your offices are dark, dreary, and lack fresh air, no amount of positive feedback will completely inspire people to do their best. When Nancy Yao Maasbach arrived at the Museum of Chinese in America (MOCA) in New York City, she quickly realized that their offices were a problem:

> When I first joined, we were only renting the main floor and the basement. And all the staff were in this very small, like 700 square foot space and I knew the air wasn't good in the basement. . . . I almost felt like the space we were working in was like

a human rights violation. So, even though we didn't have money, I just wanted to make sure that we could work in a place that was going to . . . in Chinese, there's a phrase *Chi Ku* (吃苦). In English it means to eat bitterness. Like, you need to suffer. And then slap on top of that, like the arts world, right? Like, let's suffer and suffer. Right? And I was like, "This is not healthy." So that part needed to be fixed.

Nancy expanded their facilities and moved the staff offices for MOCA in order to advance the entire organization. She also increased everyone's salaries, because she recognized the staff was being paid too little to succeed. But she rightly recognized that any staff reforms needed to include a change of space, so that staff members would feel supported by the organization and be able to breathe. Examine your facilities and ask what your space communicates to your staff. Does it communicate support, health, and care for them and their work? If not, figure out how to change it.

FAMILY

Family can pay a price in the amount of time you may miss with them because of your work in the arts. They can also be affected if your income is lower because you have chosen a life in the arts. An ideal work/life balance may prove impossible. More and more experts are dispelling this myth. They instead recommend being *present* in what we are doing now and finding happiness in that (even if it is occasionally working late), so we are not adding additional stress via guilt and regret. But in the end, keeping your family, friends, and loved ones a priority is so important to your health and happiness, and to the health and happiness of your organization and your staff. You lead by example.

HEALTH AND HAPPINESS

If you want your staff to be healthy and happy, you need to be healthy and happy too. If you feel like you cannot find enough space and time to prioritize your loved ones, talk to your board of directors or supervisor. No one wants you to burn out and leave. If they care about you and the company, they will work with you to adjust your workload so you can be sure to take time off and have time for your loved ones. I have gone to my boards and supervisors several times during my career to let them know I was working too hard and that I needed to downshift. By doing so, they were aware and could support me if I chose not to add new programs or expand our operations at that time. They also made sure the rest of the board appreciated how hard the whole staff was working, so they understood that any additions to our workload would need to come with more resources and staffing.

FINAL THOUGHTS

This chapter has explored several aspects of managing people, including the importance of clear communications, the need for a healthy balance between resources and expectations, and some simple steps to help you grow authentic relationships with your colleagues in order to develop a healthy and more satisfying work environment. While there is a mission, programs, payroll, rent, and space, there are always people at the center. Please remember that. There are people at the center. For those people, on both the board and staff, remember to: *be clear; be forgiving; create cycles; set goals for growth in people and the organization;* and *maintain clear policies and systems.* If you can focus on these five steps, remembering that people are at the center of everything you do, your company will grow *and* be a great place to work.

NOTES

1. Author interview with Deborah Cullinan, May 18, 2021. All quotes from Deborah Cullinan that follow are from the interview, unless otherwise noted.

2. American Psychological Association, "Do 360 evaluations work?" Accessed June 22, 2021. https://www.apa.org/monitor/2012/11/360-evaluations.

11

ENGAGING AUDIENCES

I always listen to the audience. At the end of the day, I am creating for the people.
—C. Brian Williams, founder and executive director, Step Afrika!

INTRODUCTION

How can artists and arts organizations engage and grow their audiences? What do audiences want or need from an arts experience? *Engagement* is about deepening our connection to audiences, deepening their connection to the art, and deepening our presence and relevance to our community. Beyond performing, exhibiting, and showcasing art for people, engaging audiences usually means one of two things: *audience engagement* activities or *arts marketing*. These two topics often overlap and interrelate. Arts marketing must be active and continually engaging. Audience engagement advances marketing efforts and spreads goodwill and positive word of mouth. How can we effectively market the arts in the twenty-first century? How can we engage audiences who have so many options for engagement? This chapter explores various approaches to audience engagement and arts marketing, and the value of authentically interacting with audiences, online and in person.

FUNDAMENTALS

FIVE ESSENTIALS FOR ENGAGING AUDIENCES

1. *Have a Strong Presence Live and Online*. Think about both live and online as you approach your season planning. Gone are the days when online or digital content was optional for artists or arts organizations. Today every organization needs to be at least present and somewhat active online (Instagram, Twitter,

Facebook, etc.). Since the pandemic, digital content has grown and shown itself to be a presence for the long haul.

2. *Think about Your Community.* Who is your community? How can you be relevant to the community you serve? Think about those in your physical or virtual "backyard" as well as those who already attend your events, buy your tickets, or engage with you online. Why have a physical presence in a building if you ignore those immediately around you? Even if you have a single office space at home and do everything else virtually, think about how you engage those closest to you. What do they need from you?

3. *Start with the Art, Then Build Out Other Audience Engagement Activities.* Arts organizations sometimes build audience engagement activities to fill the gap between their artistic choices and audiences' interests: "This play may be dated or dense, but we will hold a happy hour for young professionals so they can talk about it and try to understand why we are doing it." Instead, ensure you are programming your main season with clarity on *how* and *why* audiences would *want* or *need* to see it and engage with it. Make the work itself engaging, then build activities online and in person to augment or cement their connection to the work and you.

4. *Avoid Status Quo Marketing.* While some old approaches might be necessary for your stalwart subscribers, including mailed season brochures, advertising the season and subscriptions nine months in advance, etc., *never settle or rest on the tried and true.* Figure out ways online and in person to reach new audiences and tell stories to grab your current and potential buyers and wrap them into your regular marketing maelstrom.

5. *Keep Your Promises.* Keep your eye on developing, building, and sustaining a relationship with your audiences and patrons over time—especially if you are building new audiences, which *everyone should be doing all the time.* Be ready to invest in the long term. Know that new audience development takes time and commitment from the whole organization. Don't just program a play or exhibit for them once and then ask them to engage in all the other stuff you do. Plan on programming with their interests and points of view in mind throughout your seasons. Once you entice them, make sure you keep your promise to them and follow through with programming and events that are relevant to them. Challenge them with new things, but don't assume that dropping a show for them in the season every other year is enough.

AUDIENCE ENGAGEMENT

Traditionally, organizations and artists have offered a variety of events to help engage audiences in their work. These have included post-show talkbacks, online forums, cocktail hours, scholarly publications, opportunities to meet with the artists, or even to catch an insider's view of rehearsals or development workshops. These offerings all aimed for the same goal: to deepen the audience's experience of the work and to

build their feelings of connectivity to the art, the artist, and the organization. Whole new departments have sprung up in theaters, museums, dance companies, and music companies in recent decades, in order to more fully plan and integrate these activities across and throughout their seasons.

ENGAGEMENT PLANNING

In planning any audience engagement activity, start with the art. *What* are you doing and *why*? How will your audience connect with this piece of art? What do they need in order to understand it, engage with it, and carry it with them after the event? What bridges of understanding or excitement need to be built for audiences to be ready to engage with it? Classic pieces, whether paintings, dances, music, or theater, need a different approach from new work. Once you unpack what is vital for an audience to understand, decide who your target audience is. Are these events for audiences who have not connected with you before? Are they for your regular patrons? Are you trying to develop audiences who do not usually attend your events? Are you aiming for younger people? Young professionals? People of color? Other artists? Political elites?

Once you know *what* you are doing, *why* you are doing it, and *who* your target audience is, think about ways you can prepare those audiences before the event, or help them process it after it. These could be pre- or post-show talks, online games, cocktail hours after the show, or expert- or artist-led discussions. Here are key steps toward creating a successful engagement campaign:

Invest Resources

- Allocate the resources you need to succeed.
- Make engagement a priority by dedicating a significant portion of your budget.

Build Your Team

- Develop a diverse team that reflects the audiences you wish to engage, on your engagement team and throughout the organization at all management levels.
- Include a diversity of voices and points of view in your decision-making.

Describe Your Current Situation

- What do you do? (Consider the art as well as efforts to engage audiences.)
- Who's your current audience?
- What are your strengths and challenges?
- What are your goals?
- Are you promoting a single event or program, or your overall organization?

Research the Market

- Decide what you need to know.
- Survey your current audience.
- Survey your potential audience (perhaps using a regional survey within your potential audience travel time).
- Crunch the numbers with an eye to how you can influence behavior.

Articulate Your Target Audience

- Whom do you want to keep? Whom do you want to gain and for how long?
- Think about intersectionality, and all the various nuances of your target audience.

Describe Your Goals

- What will success look like?
- What metrics will you use to gauge success? Increased income, audience growth by the numbers, etc.?

Articulate Your Product and Your Comparative Advantages

- What do you have that's special?

Define Your Strategy

- What change do you seek?

Create Tactics to Achieve Your Goals

- In-person
- Events or one-on-one
- Print (direct mail, programs, brochures, print ads)
- Online
- Email
- Social media
- New staffing
- New programs

Monitor Results

- Gauge any increase in audiences.
- Evaluate whether the audience reflects your targets.
- Is the work stronger for your efforts? Is the organization? Has the audience benefited?

Assess Success and Plan Next Stages

- Assess by the numbers your increased income and participation at the end of a set time period.
- Use the information from phase one to plan phase two of your efforts, to refine them for the next round/next season.

Engagement Tactics

- *Panels.* Usually these are composed of experts, artists or staff sharing special insights into the content of the work and/or the process for producing and presenting it.
- *Talkbacks.* Artists and perhaps staff talk with audiences about the piece, either before they see the show (sometimes during a special pre-event on a separate date) or more often just after an audience has seen the piece.
- *Online Threads.* An organization or artist may start a thread on Instagram, Facebook, or Twitter offering audiences inside information or opportunities to connect with various artists involved before seeing the piece.
- *Invited Online Critique.* Artists and organizations may enlist members of the public to post their own reviews about the piece. A risky strategy, but one that offers more peer review, which audiences now value more than expert-led review. Inspired by online offerings like Yelp and Rotten Tomatoes.
- *Live Social Events.* Either pre- or post-cocktail hours and social hours with snacks, sometimes paired with a panel or talkback on a special date or tagged onto the hour just after a performance. Sometimes for the general public, but more often held back as a "bonus" for subscribers, donors, or at least those who have already purchased a ticket. When these occur for the general public, a push to have attendees buy tickets that day usually also occurs.
- *Workshops.* Sometimes artists or staff will lead guests through an experience that explores the work (a dancer leading a movement workshop in the style of the piece or a playwright leading a writing workshop) or some part of the dramaturgical background of the piece (designers sharing some of their inspirations for the piece's design or a dramaturg sharing history or the process behind the piece). These are most often offered exclusively to donors or subscribers, though sometimes also for the general public, with enrollment limited to a smaller group of twenty persons or less.

- *Literature about the Piece*. These various articles began as printed materials and now more often found on an organization's website. They offer history behind the piece, perhaps bios of the artists involved and often Q&As with the director, choreographer, or writer. Aimed at those attendees who value gaining scholarly views of the piece and like to read background materials before connecting with the piece.

- *Happenings*. In tandem with more online connections, these events are branded as "secret" or "spontaneous" in order to make them special for audiences. They may be last-minute invitations online to meet up with the artists involved at a local bar after a performance. Or a chance to enjoy cocktails and hors d'oeuvres with artists and staff at a special location and time not known to the general public. These events leverage the idea of a whisper campaign among "special" people (again usually higher end donors or subscribers) and use the immediacy of online communications combined with the public's desire for benefits to be more unique and original.

- *Guest Hosting*. A popular way to entice audiences to follow your Twitter or Instagram feed is to have an artist "guest-host" the organization or project's feed for that platform for a day, taking audiences through a typical day in the life of this person and giving them a peek into this person's world. Some shows have even carried this idea across the company of artists, so that a different person hosts the feed per day or week, allowing audiences to watch this thread multiple times and to see more of their favorite artists tied to the project over time.

- *Integrated Activities*. Artists and audiences have also experimented with interacting during performances, with companies like the Shaw Festival in Canada or the New York Neo-Futurists integrating audience engagement into their work, with audience members called up on stage or asked to throw things at the artists as part of the play. These efforts are integral to the pieces in performance and appeal to younger audiences or audiences hungry to experiment. In New York over the past two decades, several shows have enjoyed longer runs featuring dancers and acrobats filling a communal space shared with the audience and the audience milling through the work and sometimes being moved from space to space.

Figure out new ways to reach audiences and deepen your relationships. Try them out, assess how it goes, and let your findings inform what you plan next.

Ballet Austin

In 2015 the Wallace Foundation launched a $52 million *Building Audiences for Sustainability* initiative, aimed at addressing declining audience numbers for some major art forms, including ballet. Ballet Austin in Austin, Texas, began a six-year project under this program in 2015 to determine how they could engage audiences with new ballets as much as their usual classics. They saw that audiences, even loyal subscribers, tended to avoid new works in ballet. With an annual operating budget of $7.5 million but ticket revenue of only $2.8 million, they needed to figure out how to draw

new audiences. They set out to find ways to move loyal audiences to new work while also bringing in new patrons to the form. They conducted months of market research, including a survey with over 1,500 responses, well over their goal of 1,200. They realized that uncertainty about ballet as an art form and a discomfort with attending alone were keeping new audiences away. In response they created a suite of new offerings, live and online, aimed at making Ballet Austin more accessible.

Online videos allowed potential customers to watch rehearsals in action: "Pei-San Brown, Ballet Austin's community education director, and Loignon, director of audience engagement, sales and services, devised Ballet Austin Live!, which allowed more people to get a sense of a production beforehand through a 30-minute live-stream of a rehearsal. The script, which included a brief introduction by Mills with commentary and discussion from others, avoided ballet jargon. The production enlisted both professional and in-house videographers, including an ensemble member who weaved among the dancers on a skateboard while filming, creating a compelling and raw sense of immediacy."[1] When they produced a new work in 2016, *To China with Love*, over five hundred people watched the rehearsals online.

Ballet Austin also created opportunities for more social interaction for audiences, so that friends and family could attend together and experience special connections with ballet before performances. Their program Ballet Bash! created a party atmosphere before performances, with a DJ, live music, and food provided. Their Ballet-O-Mania! program gave audiences multiple opportunities to learn about the work they were seeing that night, while creating opportunities for audiences to connect socially and build positive memories connected to Ballet Austin: "Before one September performance of *To China with Love*, a girl, perhaps eight years old, showed her grandmother how to use a tablet to learn about the featured composers and their pieces. At a table display, people could see such tools of the trade as pointe shoes, bisected to show what dancers' toes are scrunched into. A plastic sound dome enabled visitors to preview the music they would be hearing without adding to the din of the room. At another station, vinyl dance flooring laid atop carpeting provided a smooth surface on which Ballet Austin apprentice dancers taught people basic ballet moves—an especially popular feature with young girls, much to their parents' delight." Within the first fourteen months of these efforts, Ballet Austin's daily ticket sales doubled, from $1,500 to $3,000 per day. They realized they had a long way to go to grow their audiences, especially for new work, but they seemed to be on the right track.

ARTS MARKETING

Marketing for the arts is about building long-term relationships with audiences: *gaining* their interest, *enticing* them with the promise of a good time, *fulfilling* that promise with a great experience, and then *following up* the experience with an offer to reengage. You are also making a promise to *not waste their time*.

Reflecting shared values is equally important. More and more, audiences expect arts organizations and artists to publish their mission and values statements. They want to know you share their values. Avoiding political debate is often a good strategy, given diverse audiences are comprised of diverse political views. But standing with

movements like Black Lives Matter with an organizational statement of support is also extremely valuable, as is ensuring those statements are backed up with actual action by the organization.

In this age of constant media outreach, audiences value authenticity more than anything. Social and earned media, meaning when an outside source comments positively about you, rather than featuring a paid advertisement, is perhaps the most valuable coverage for audiences. Hearing positive reviews from another source is almost *thirteen times more likely* to entice audiences than a paid advertisement.[2]

Arts marketing today relies on a dynamic mix of online, digital, and live content to truly engage audiences. Print advertising is almost completely dead. Print also does not give you the immediate feedback provided by online clicks and digital ads. Banner ads on online news sites or social media give arts organizations a chance to entice audiences with upcoming productions and follow up on their interests, while tracking their clicks. But even though the media landscape has changed greatly, certain fundamentals of marketing remain at the core of every marketing campaign.

The Classic Marketing P's

The classic P's of marketing can help you plan your efforts.[3] The exact meanings and intents behind these terms are evolving, as technology and the ways we deliver our products continue to change:

Product. This is the artistic work and all of your offerings, including audience engagement and arts education programs. If this is not excellent, the rest of your marketing efforts are pointless.

Place. Place can mean your location or where you place yourself in media via paid, earned, and owned media. *Paid media* means the ads and stories you pay for. *Earned media* is coverage from other sources, including features about your work. *Owned media* is what you own and operate yourself, including your e-blasts, website, etc. The emphasis of Place as your *location* is even more important. How your location looks and feels will either attract or repel audiences. Does it look and feel welcoming? Energetic? Abandoned? Place also now implies your online platforms, including your website and streaming platforms. Is the functionality easy to use? Does it look fresh and professional? Does your streaming platform's branding match your website and look contemporary? You can offer an excellent online performance, but if the platform itself looks dated and is difficult to use, audiences will be turned off, especially younger audiences who are digital natives and therefore accustomed to quick excellence.

Price. How you price your products must fit your market, product, and intended audience. Dynamic pricing, in which popular offerings become more expensive as demand rises, has helped to drive earned income in recent years. But the shift to more digital content and the demand for greater accessibility might make this practice rare. One challenge facing the arts post-pandemic is how to earn money or *monetize* digital content, and how to differentiate pricing between live and digital events. If live events are also streamed online, how can organizations price live attendance and online

watching in ways that are clear and attractive to audiences? If the online pricing is much cheaper, what incentives need to be added to draw live audiences?

People. This includes the audience and *who* they are, *where* they come from, *how much* they will pay, and what they *want* and *need* from you. Even more importantly, this includes your staff, box office personnel, and marketing consultants focused on your efforts. Who do you need to execute all of this effectively? Plans need people.

Positioning/Branding. Branding has shifted from being defined by an organization or marketing campaign to instead living within and with audiences. This is how an audience perceives and feels about your organization. All the other P's influence this perception, but the brand is now further defined by discussions on social media, earned media, and a host of other information experienced by the audience and then synthesized by them into their ultimate judgement and perception of you.

Promotion. This is how you distribute your message, via direct mail, social media ads, online promotions, special events, etc. The explosion of social media use has ushered in an era of casual and continual conversation with audiences, in which the Promotion is less a direct sales pitch about a season or product and more a consistent building of a relationship and sense of trust between the organization and audience. Audiences are less attracted by a direct sales push than a sense of belonging and shared values.

Creating a Marketing Campaign

There are three major phases of any marketing campaign: planning, execution, and assessment. The planning grids in Tables 11.1, 11.2, and 11.3 show each of these phases.

Table 11.1. Marketing Planning

Research	
What do you need to know?	
Why do you need to know it?	
Whom will you ask?	
How will you ask?	
When will you ask?	
Audience Targeting	
Whom do you want to gain?	
Whom do you want to keep?	
What will success look like?	
How long do you intend to keep them?	
When will you assess success or failure?	
Comparative Advantage	
What do you have to offer that's special?	
Promise	
What promise are you making?	
Additional Notes:	

Table 11.2. Marketing Implementation

Strategy	What is your overall strategy? (the BIG PICTURE)
Tactics	What tactics will you use to pursue your strategy?
Print	
Online	
In Person (engagement or marketing)	
Programming	
Staffing	
Company Culture	
Additional Notes:	

Table 11.3. Marketing Evaluation

Goals	What will success look like?
Assessments	How will you know if you achieved your goals?
Sales	
Attendance	
Audience Experience (Did you fulfill your promise?)	
How was your artistic work improved?	
How was your organization improved?	
Next Targets	
Next Timeline	
Next Questions	
Next Goals	
Additional Notes:	

These planning grids are also available in the cache of online documents accompanying this book. Once you have *planned*, *executed*, and *assessed* the success of a campaign, keep working on how you can further innovate and keep these communications integrated with your company's *brand*.

Branding

Once upon a time, marketers and advertisers would develop and then sell a brand for a product: "Refreshing," "Reliable," "Fun," "Clean," "Family." Those days are

long gone. Now brands live with the *consumer* instead of the product. Audiences carry brands with them, meaning they decide what a product makes them feel, think, or value. Brands are also more fully experienced. They make consumers feel a certain way (at home in Starbucks, as a "third space" for meetings and work), or they reinforce their identity ("I'm a good person because this brand gives to charity every time I buy it"; or, "I'm an *athlete* because I can *Just Do It*").

When customers attend an event or visit a business, their entire experience adds up to what they experience as the *brand*. If an organization's lobby is warm and inviting, the bar quick and easy, and the restrooms plentiful, audiences leave with a better impression of the art itself and that organization. But if parking is tough, the box office rude, and the space chilly, they may not ever return. An organization's brand is how consumers think and feel about the company. It's *their* definition of *you*.

Each piece of the journey must be attended to in order to avoid negative experiences. When Arena Stage designed the Mead Center for American Theater, they added an additional women's restroom to the lobby space. Anyone who has attended a performance in the past fifty years can attest to the long lines at women's restrooms during intermissions or just before performances. By adding a whole additional restroom to the lobby design, Arena Stage actively alleviated this cultural thorn and improved the experience for audiences.

Finding ways to carry your brand *online* is important as well. Is your website and social media clear, compelling, and easy to use? Do your online events feel special in some way? Have you curated the work online to be exciting and compelling? Or do your performances or exhibits feel like Zoom events? At the same time, given the competition for audience members' time and the prevalence of online activities, live events must be curated even more carefully and robustly.

Global Arts Live

World Music/CRASHarts in Boston had a problem: No one knew who they were. Despite presenting great world music events throughout Boston for over twenty-eight years, World Music/CRASHarts had branding issues. They were engaged by the Wallace Foundation's *Building Audiences for Sustainability* initiative and spent several months studying their problem. Their audiences were growing older, with younger audiences attending their annual festival but not much else, and very few audience members knew their name or who they were. In part because they presented in different venues and different artists each time, their identity was invisible. Even though they were presenting high quality, wonderfully diverse music for their Boston audiences, they needed to raise more money. In order to do so, donors, funders, and audiences needed to know who they were and what they did more clearly. They spent a year working with Mark Minelli of Minelli, Inc., a branding and design firm, to examine results from audience surveys and make a plan to rebrand the entire organization. In

August 2018, after months of internal and external work, they landed on their new brand, changing their name and logo from this:

Figure 11.1. World Music CRASHarts logo. Michael Sullivan Design and Jonathan Jackson at Egg Design, and Fritz Klaetke at Visual Dialogue

To this:

Figure 11.2. Global Arts Live logo. Designed by Minelli, Inc.

Figure 11.3. Global Arts Live event flier. Designed by Zack Guerra. Graphics provided by Global Arts Live.

They would now be known as Global Arts Live. Their event designs would clearly show that Global Arts Live was responsible for bringing these eclectic artists to Boston. While it may take a few years to embed this brand with audience members,

Global Arts Live now had an identity and focus that would help them engage audiences, raise funds, and build the organization for its next great stage of growth.[4]

Telling Your Story

In his brilliant book *All Marketers Tell Stories (Are Liars)*,[5] Seth Godin emphasizes the need to *tell your story* in order to successfully communicate. Human beings listen to narratives. People look for what's different and then strive to make sense of it. An audience's attention may be grabbed, and then it needs to be kept engaged via storytelling. At the core of any marketing efforts, the story needs to be clear: *Who* are you? *What* do you do? What do you *value*? What are you *offering audiences*? What can you *promise* them? Gaining clarity on these story points is critical. Then you need to figure out how best to tell it. Once you know what story to tell, you need to tell the same story again and again, across platforms and mediums, in words, images, actions, and programming. If your messaging and programs do not match, audiences will become confused and unsure about how to engage with your organization.

Social Media

Organizations and artists need to engage in authentic dialogues with audiences on a variety of social media platforms. These can be sparked with posed questions, inviting others to respond; a behind-the-scenes video offering a sneak peek into the work and requesting responses; profiles of involved artists; or even some quotes or critiques from current audiences about the work. Some of these conversations should be directly about the current or upcoming work. But some conversations can also be focused on topics related to the shared values of the organization and audiences, on perhaps other great artists and pieces of history, or even on current events relating to the arts discipline, the location of the organization, or the history of the community. Conversations not directly connected to the work at hand can be a great way to build the sinews of a long-term relationship between an organization and its audience. With all our efforts on social media, here are some key issues:

- *Staffing.* Staffing these efforts is critical to any success. The nature of social media means that staff or volunteers can implement these efforts from anywhere. But a clear staffing plan is the only way to ensure that posts, conversations, images, and stories can be continually updated. A lack of consistent activity usually means doom for any social media efforts.
- *Facebook.* Originally, this platform was a free way to help connect with audiences online. Unfortunately, Facebook now requires the purchase of ads in order for arts organizations and events to be seen clearly by audiences on the platform. These ads are still vastly cheaper than print ads, but their costs can add

up over time. Younger audiences have also stopped using Facebook to communicate, preferring newer platforms.

- *Instagram.* This image and story-based platform has rocketed upward in popularity in recent years, giving participants the chance to quickly share an image-based tidbit about their experiences with large audiences. Artists and arts organizations who continually share images and experiences can build a simple but continual presence in their audience's lives.

- *Twitter.* This short text and link-based platform is a quick, active way to spark conversations with audience members, along with links to more information about ongoing arts offerings. Twitter is perhaps the most active platform as of this writing for constant conversation and *debate.*

- *TikTok.* This quick video app grew tremendously in 2020 and early 2021 during the global pandemic. Millions of people became creative artists, shaping dance and performance videos with quick thirty-second clips. This app also became a major creative outlet for shared projects.

VARIATIONS

DIGITAL ENGAGEMENT

The growth of online activities, especially via robust websites and social media presences on Instagram, TikTok, and Twitter, now allows organizations to continually engage audiences in conversation, backstage peeks at the work, and reminders of exciting events coming up. When the global pandemic took hold in late spring of 2020, digital content became the natural replacement for live events. By winter 2021, it became clear that online and digital content was here to stay, in part because organizations found that some audiences who never attended their shows live were now engaging with them online, perhaps in part due to barriers that previously stood between the organization and the audience's ability to attend, including the price of events and the difficulty in traveling to the organization's space.

A national study conducted by the research firm La Placa Cohen in October 2020 detailed that many people engaging with digital arts content online had *not attended a live event at the organization in the past year.* Moreover, the online audience for events like orchestra concerts included younger people and more people of color. It seems clear that growing the digital space is key. At the same time, one big challenge in transitioning to more digital content is how to pay for it. The same study by La Placa Cohen showed that only *13 percent of audiences* in 2020 were *paying* for the digital content they were receiving from arts organizations.[6] Given that producing high quality digital content will require new investments in staffing, technology, production, and time, arts organizations need to figure out how they can find these new resources or allocate them from elsewhere. They also need to entice these digital audiences to attend live events.

While most organizations might have viewed online content as an interesting but inconsequential side project before the pandemic, the balance between online and

in-person efforts could be closer to 50/50 in just a few years. If the arts field is truly interested in gaining and keeping younger audiences, it must accept that these audiences are *digital natives*, meaning they have grown up with technology deeply rooted in their daily lives in ways that older generations have not. Meeting and engaging them on digital platforms will be important if arts organizations are to remain relevant. They have plenty of other arts content already at their fingertips.

Ratatouille *on TikTok*

In the summer of 2020, one person posted their performance of an original song based on the hit Disney film *Ratatouille*. The song was simple. Heartfelt. Really random. Which was perfect for TikTok. Others were inspired to copy the song with their own performances. Eventually people were creating more songs to add to the idea. Dancers were putting together new dances inspired by the show. Choruses singing songs. Even a song inspired by the style of *Hamilton* and Lin-Manuel Miranda. More and more artists from professional theater got into the act, eventually leading to the formation of a full-length, TikTok-generated new musical based on the film. The new musical premiered online in early January 2021 for one weekend only, as part of a fundraiser for The Actors Fund. This semi-spontaneous explosion from a single song to a full show entirely created across a global group of amateurs and professionals exemplified a new step in online creativity—the chance that entire, full-length artistic pieces could be created via social media and without a team in control of the overall process.

TECHNOLOGY AND LIVE EVENTS

Organizations can also offer opportunities for audiences to take out their phones and engage *during* the event. This is already common in museums with visual arts, as QR codes now exist along with the usual note about the piece and the artist. These QR codes allow audiences to aim their camera phones at them and open a website or online portal with more information or even sound and video about the artist. Extra engagement during an event in the performing arts is still rare but growing. This kind of engagement needs to be developed in tandem with the piece itself, so that the artists have a say in how the online augmentation resonates and connects with the live performance and does not become a distraction from the live event.

A Killing Game

In 2012, a theater company in Washington, DC, dog and pony DC, produced a new show about death and dying, entitled *A Killing Game*.[7] The piece, like a lot of dog and pony DC shows, was totally interactive, asking audiences to speak with the actors on stage from time to time, to move into different spaces between scenes, and even to

stand up and dance and then "die" in a catastrophe. In addition to all these live physi-
cal engagement activities, the company also created and curated a Twitter thread and
encouraged audience members to Tweet opinions, answers, and reactions throughout
the show. This way, each performance was shared in real time with a global audience,
while the live audience of fifty to seventy-five people reflected how exciting and fun
the show was through their Tweets.[8]

ENGAGEMENT STAFFING

Your investment of time, money, and people in engagement efforts will define how
much you can do, how successful it will be, and how sustainable it will be. It is admi-
rable to see an organization further invest in community engagement, but the organi-
zation must ensure resources and expectations are balanced, so the efforts can succeed.
In early 2021, a major theater posted a job opening for a new position as director of
community engagement. As you review this rather long job description, consider these
questions:

- Will this person have a staff to help them?
- What questions would you want to ask if you interviewed for this job? What
 concerns might you express?
- Is it clear from this description who the targeted community is? Or does it seem
 this organization expects this new position to figure this out?

Director of Community Engagement
Full-Time Exempt/Senior Staff
REPORTS TO: Artistic Director
 Olney Theatre Center seeks a spirited, creative, and activist-minded individual
to serve as its first full-time Director of Community Engagement (DCE). The DCE
will be responsible for envisioning, launching, and implementing a strategic array of
activities that cultivate and share the creativity of communities around OTC, connect
them to the makers and artistry on our campus, and position OTC as a leader of civic
conversation at multiple levels. The DCE will work interdepartmentally on both new
and established initiatives to maximize the impact of OTC's programs for every com-
munity around us, demonstrating our belief that OTC should matter to everyone in
our community.
 The Director of Community Engagement will:

- Learn about the diverse range of communities around the theater, with a par-
 ticular focus on those communities that traditionally or historically have limited
 engagement with us.
- Engage with those communities to learn how OTC can be a more meaning-
 ful institution for them, what cultural resources they need and what cultural
 programs they want, and what partnerships we can discover together to unleash
 our creativity and theirs.

- Create deep, engaged, nontransactional relationships with and within those communities to benefit them and ensure OTC's programs are fully inclusive.

SKILLS AND VALUES REQUIRED:

- Investment in OTC's Mission, Vision, and Values, and its Statement on Social Justice and Becoming Anti-Racist.
- Passionate belief in the benefits of connecting communities to the arts, and the arts to their communities.
- Belief in the value of nontransactional, organic relationship-building.
- Strong cross-cultural competency a must.
- Ability to dream up innovative ideas, big and small, and translate them into actionable plans.
- Strategic thinking and planning within a larger organizational framework.
- Outstanding interpersonal, organizational, and communication skills.
- Great collaborative skills to enable cross-departmental work.
- Ability to self-direct and manage multiple projects and priorities.
- Courageous in their convictions, respectful in their arguments, gracious with disagreements.
- Excellent listening skills.

PRIMARY DUTIES:

- Collaborate with other departments, including the Advancement and Marketing teams, to promote the story of and need for impactful community engagement.
- Create and implement new Community Engagement strategies that make our theater matter to more people, from every background, in our community.

These may include:

- Artistic connections to communities in our region with barriers to access
- Partnerships with other nonprofits in appropriate areas of advocacy, and civic engagement
- Civic forums inspired by and in support of the themes in the work we produce
- Community-created arts programs and performances
- Quarterly and/or targeted open house events
- Off-site artistic visits and events to connect OTC and promote its programs
- Collaboration with members of the artistic staff, especially with those who lead the National Players Mobile Unit, SummerFest, and the Just Arts program
- Continuation, alteration, or elimination of current programs.
- Community Partnership program that leverages individual show themes to connect with appropriate groups, associations, and organizations.

- Nonprofit Partner program to provide fundraising or promotional opportunities for local nonprofits, at the same time as adding to OTC's audience development efforts.
- Our Play and My Monologue: building this program outside schools (which is run by the Education Director)
- Engage with the community around Olney Theatre Center, attending events, visiting civic facilities, serving on local Boards as appropriate, etc.

ADDITIONAL DUTIES:

- Work closely with the Managing Director to ensure institution-wide engagement with position goals and priorities.
- Serve on the Senior Staff of the theater.
- Serve on the Artistic Staff, attending Artistic Staff meetings on at least a bi-weekly basis, and all meetings about season planning and other topics particularly relevant to Community Engagement.
- Serve on the theater's internal and external EDIA committees.
- Attend marketing and advancement staff meetings on a monthly basis.
- Provide guidance to all departments as relevant to help the institution achieve its Community Engagement goals.

GEOGRAPHIC RANGE OF ACTIVITIES:
While community engagement activities can happen in any location, OTC is focused on developing relationships within the geographic range below, which includes two of the ten most ethnically diverse cities in the nation (Gaithersburg and Rockville).

THE ART AS ENGAGEMENT ITSELF

The Chalk Room

At the Massachusetts Museum of Contemporary Art (Mass MoCA) in 2017, famed multimedia artist Laurie Anderson installed "a multi-functional constellation of galleries and installations including a working studio, audio archive, exhibition venue, and a virtual reality environment for experiences she co-created with Hsin-Chien Huang."[9] These experiences included an interactive room titled *The Chalk Room*, based on a previous piece created by Anderson but now augmented with virtual reality. Audiences signed up in advance online for twenty-minute slots because physical space was limited to four participants at a time. Upon arrival, audience members checked in with Mass MoCA staff on iPads, and then entered the exhibit. They discovered a beautifully haunting dark room, filled with black light and covered in Anderson's eclectic drawings. They placed virtual reality goggles over their eyes and then entered the totality of the piece.

Once inside the virtual reality, participants found themselves in a vast underworld filled with Anderson's drawings, inviting them to travel at will from one huge room to another. Running water, music, and various figures interacted with them as they went. Beyond walking from room to room, participants could also *fly above the ground*, up to the ceiling if they desired, by pushing their arms down against the air, similar to a dream state of flying. Various instruments appeared as well, inviting the audience to play music on them, in whatever rhythm and melody they chose to create. Some rooms were filled with Anderson's voice reading her own poetry, haunting audiences as they traversed the dark world. After twenty minutes, participants were invited to remove their goggles. Upon doing so, the dark walls of the exhibit mimicked the virtual reality in a way that helped to transition audiences from one reality to another. This piece was massively popular and, nestled among many more traditional arts installations, perhaps a forecast of more to come.

Sleep No More

In this hit adaptation of Shakespeare's *Macbeth* imported from the UK by the British theater company Punchdrunk, *Sleep No More* took over a whole building in Manhattan. Audiences were first deposited in a speakeasy bar and able to enjoy cocktails and socialize before entering the performance. In groups of ten at a time, audiences were then given masks to put over their faces and led by guides into the performance space of several levels and dozens of rooms. The masks turned the audience members into a kind of silent chorus of faces, which added to the dread and dark atmosphere created in the piece, wherever one looked. Audiences were free to roam through the building, able to follow actors playing characters from *Macbeth* at their own choosing and pace. Sometimes audiences would flock together and follow each other—or follow a certain character, like Lady Macbeth. Or they would hear a cry in the distance and quickly move to find out where the cry was coming from.

Over the course of two-plus hours, this "choose your own adventure" approach gave twenty-first-century audiences a kind of spontaneity, free will, and movement they lacked in traditional theater. It also required the strength of a social contract between artists and audiences, as audience members were free to get very close to the actors. While staff were standing by to guide and protect the performers and audiences, the assumed social contract of safe play and care between artists and audience was more necessary and present than in a traditional theater setting, where the audience is clearly separated and distant from the performance. It highlighted that this kind of immediate, close, and spontaneous interactivity also raises some of the inherent risks of live performance. Why would an audience member not reach out and abruptly grab Lady Macbeth? Because everyone understood and accepted the game. You could get close but not touch. You could follow but not lead. You could choose but not mandate.

The performance became an interactive event in real time and involved the audience as much as the artists. Engagement was the core of the art itself.

FINAL THOUGHTS

In this chapter, we have explored how to engage audiences, including:

- Audience engagement planning and tactics
- Creating, implementing, and evaluating an arts marketing campaign
- The importance of branding, storytelling, and social media
- Variations and innovations in digital content, live performances, and staffing

As you continue to pursue arts marketing and audience engagement, remember:

- *Be creative*. Audience engagement activities come in many forms and should deepen an audience's connections to the work and the organization. Successful marketing efforts require clear messaging but also a sense of spontaneity and fun.
- *Build relationships*. Focus on developing conversations with your audience.
- *Keep your promises*. Deliver high quality events. Engage them with messaging but avoid overwhelming them with constant contact.
- *Build your brand*. Know that audiences are building their sense of you, who you are, and what you value every time they connect with you. When they physically visit or attend your event, they are taking in endless information about who you are and whether they like you or not. Attend to that experience and you will reap the benefits.

Marketing and engagement are continually evolving. By *listening* to what your audience wants and needs, *building* your capacity to deliver great content to them in new and exciting ways, and *balancing* your efforts online and in person, you can prepare and plan for any challenge.

NOTES

1. Andrew Decker, "Ballet Austin: Expanding Audiences for Unfamiliar Works," The Wallace Foundation, 2017. Accessed April 18, 2021. https://www.wallacefoundation.org/knowledge-center/Documents/Ballet-Austin-Expanding-Audiences-for-Unfamiliar-Works.pdf.

2. Colleen Dilenschneider, "How Social Media Drives Visitation to Cultural Organizations," *Know Your Own Bone*. Accessed April 17, 2021. https://www.colleendilen.com/2015/09/02/how-social-media-drives-visitation-to-cultural-organizations-fast-fact-video/.

3. National Arts Marketing Project, "Mind Your Marketing P's," Americans for the Arts. Accessed April 18, 2021. https://www.americansforthearts.org/sites/default/files/documents/practical-lessons/lesson_5.pdf.

4. Sarosh Syed, "World Music CRASHarts Tests New Format, New Name, to Draw New Audiences," The Wallace Foundation, March 2019.

5. Seth Godin. *All Marketers Are Liars* (London, England: Portfolio/Penguin, 2009).

6. La Placa Cohen, "Culture and Community in a Time of Crisis," La Placa Cohen, October 21, 2020. Accessed June 28, 2021. https://culturetrack.com/research/covidstudy/.

7. Peter Marks, "Dog & Pony DC's 'A Killing Game': Killing you softly, and smartly," *Washington Post*, December 3, 2012. Accessed June 27, 2021. https://www.washingtonpost.com/entertainment/theater_dance/dog-and-pony-dcs-a-killing-game-killing-you-softly-and-smartly/2012/12/03/6de3cb56-3d70-11e2-8a5c-473797be602c_story.html.

8. Ramona Harper, "'A Killing Game' at dog and pony DC," *DC Metro*, October 7, 2013. Accessed June 27, 2021. https://dcmetrotheaterarts.com/2013/10/07/a-killing-game-at-dog-pony-dc-by-ramona-harper/.

9. Massachusetts Museum of Contemporary Art, "Laurie Anderson." Accessed April 19, 2021. https://massmoca.org/event/laurie-anderson/.

12

INSPIRING STUDENTS

You're showing our students that each of them has something to contribute to this life. You're opening their eyes to a world of possibility that awaits them: one work of art, one relationship, one lifetime at a time.

—First Lady Michelle Obama, the White House presentation of the
National Arts and Humanities Youth Program Award to
Young Playwrights' Theater, October 10, 2010[1]

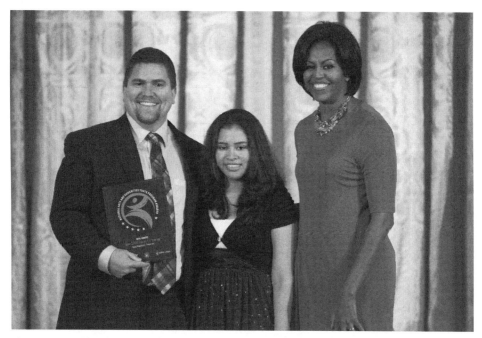

Figure 12.1. The author, Mariana Pavon Sanchez, and First Lady Michelle Obama.
The White House.

INTRODUCTION

Now more than ever, students need to be able to think for themselves. Beyond basic reading, writing, and arithmetic, they need to be able to imagine, envision, and explain. They need to be able to stand up, put their ideas forward, and defend them. They need to understand—not just know, but understand—what they're learning and why. And they need to be able to inspire and be inspired. After all, how will students compete in the global arena if they cannot communicate their ideas with passion and conviction? And how can they envision their future if they are not given the opportunity to dream? If you meet students where they are, engage their creativity, and help them realize their potential, they will be able to express themselves and live with a sense of imagination and power.

Arts education and community engagement programs developed in the 1980s and 1990s, when arts organizations realized that a) they needed to strengthen their ties to their local communities in order to justify their presence and government support; and b) they could raise vast sums of money in the name of "arts education" or "community engagement," money that could also contribute to the company's bottom line, general operating, and even production costs. Since then, arts education and community engagement departments have worked diligently to build programs that enhance student learning, reach students with a variety of learning styles, and augment traditional education systems. This chapter explores how to develop strong programs in arts education in order to authentically inspire students, deepen your community connections, and strengthen your organization. The next chapter will dive more deeply into models of community engagement.

FUNDAMENTALS

FIVE CORE PRINCIPLES FOR ENGAGING AND INSPIRING STUDENTS

Students should be at the center of this work. Before exploring building strong arts education programs, here are five basic principles for authentically engaging and inspiring students:

1. *Never Underestimate Students.* They have a lot to learn but also a lot to share. Students quickly realize when adults are condescending to them. It's death to any workshop. Whether you are engaging fourth graders or graduate students, prepare high quality content that challenges them at their highest learning levels. Make it smart, quick, and funny whenever possible, and with at least one "aha!" learning moment in each session.
2. *Think Outside the Box.* Plan activities and lessons that will surprise and inspire students. Let them bring their own ideas to the work. Imagine how this content might be traditionally taught (spoiler: often it's spoken *at* them and that's

it), and then flip it around. Find ways to give them tasks each lesson. What can they do to pursue this lesson *actively* instead of receiving it passively?

3. *Activate and Empower Students.* Think about their multiple learning styles and approaches. Offer content, then spin an activity out from it that asks them to think and create based on that content. Start the session with a fun warmup, followed by the content, the activity exploring the content, and then wrap up. Get them on their feet whenever possible. Have students work in teams if applicable and then gather them together to report.

4. *Allow Time for Questions, Answers, and Discussion.* Ensure you have enough time to hear from everyone and explore points they may contribute. Establish a mechanism for sharing what they've observed and learned. Find ways to engage everyone while a specific person is sharing, so everyone stays invested.

5. *Honor Student Contributions.* Through positive feedback and by bringing professional artists into the process to engage in their work, treat students like professionals and show them that what they have to say and what they create truly matters. Make it clear from the start that their participation will be valuable and that their work will be honored as professional. If you discover students having trouble staying focused, figure out ways to shift tactics during the workshop in order to keep them engaged. Reexamine your content and approach to see if something's missing.

I have spent much of my career working with students or leading organizations that serve students. From fourth graders through graduate students and teachers with decades of experience, I've taught a wide array of learners, in courses of acting, playwriting, Shakespeare, arts management, and on and on. During my years at the Shakespeare Theatre Company, I worked with high school students and teachers in a wide range of public schools, from those in the wealthiest communities in the United States to those in the poorest inner-city schools in our nation's capital.

Regardless of their setting or their resources, I found students to have a deep hunger to learn and be seen. Many of them did not flourish in a traditional learning mode, by sitting at desks and having to listen to lectures all day. But when given the chance to learn actively, and interactively, through an arts-based approach, they thrived. One core value we articulated at Young Playwrights' Theater (YPT) was that we would "meet students where they are." For me, this is a core value in working with anyone, but especially with students. It is vital to try to understand each person's perspective while engaging them as learners, since each student comes to learning with a different learning style, a different background, and different perspectives on the content they are seeking to learn.

ARTS EDUCATION AND COMMUNITY ENGAGEMENT

In addition to regular season programming, most arts organizations engage their communities with offerings in arts education or community engagement. These terms are

sometimes used interchangeably, depending on the organization. Community engagement generally denotes programs and projects that *reach outside the organization* to participants of all ages in a community, sometimes creating special arts projects in collaboration with community members, as explored in the next chapter. Arts education usually means programs offered to school-age students, either in school as enhancements to the regular classroom, after school as extracurricular offerings for students, as professional development workshops for teachers, or as additional workshops either before or after students come to see a show. Arts education and community engagement programs are also used by arts organizations to develop the next generation of audiences.

Organizations with active arts education departments eventually develop in-school programs with detailed curricula, citing the required learning standards for that class. This level of professional arts integration better enhances students' intended learning in the classroom, and it allows classroom teachers to show school principals and superintendents that these programs are fulfilling the required learning standards and not just "filling time" with "fluffy, artsy stuff."

APPROACHES TO ARTS EDUCATION

There are three prevailing approaches to arts education.

1. *Arts Learning.* This is the learning of an arts skill, as when a student learns to act.
2. *Arts Experiences.* This is when a participant experiences the arts, as when a student attends the performance of a Shakespeare play and sees professional acting.
3. *Arts Integration.* This is when the arts are used to enhance learning of a different topic or skill set, as when a student deepens their vocabulary, understanding of literary characters, and reading skills by rehearsing and performing scenes from Shakespeare.

FIVE COMPONENTS OF SUCCESSFUL ARTS EDUCATION PROGRAMS

Strong programs often feel inevitable. They are tied authentically to your mission and vision and serve a real need in the community. They build a bridge between your organization and the community, and ideally entangle your work in the lives of those you serve, for the better. They also help your organization raise funds, improve public relations, and serve as a feedback loop to help the organization assess its relevance. Having well-laid-out curricula, learning objectives and outcomes, clear ties to the learning standards, and assessments capable of demonstrating the program's impact on student learning are all ways that arts education programs have grown to prove their worth to the standard public education system, beyond being "art for art's sake."

Here are five keys for planning successful engagement and education programs:

1. *Dedicated Personnel.* The teaching artists and managers running programs are the ones who best articulate what the program does and how. They work on the front lines of the classroom while also taking time to then digest and

articulate how the program works. Without a skilled, dedicated team focused on the program, it is almost impossible to implement let alone improve strong programs.

2. *Clear Learning Objectives and Outcomes.* Whether you intend students to a) learn about Shakespeare's use of rhythm and symbolism (*outcome: students will appreciate some of Shakespeare's use of rhythm and symbolism*), or b) realize their ability to write creatively (*outcome: students will appreciate their ability to write creatively*), having clear objectives (*what they will do*) and outcomes (*how they will be changed by what they do*) is essential for rigorous programs. Teaching artists will be much clearer on *what they are expected to teach*, and classroom teachers will better understand *the intention of the workshop*. Without this clarity, the goals of any workshop become mushy and too broad, teaching artists teach too many topics at once, and students can become overwhelmed or disconnected from the white noise.

3. *Organizational Support.* Although many arts organizations gain funding and public support through these programs, the programs need to be supported and prioritized in order to succeed. Company resources, including staff, supplies, and consultant fees, need to be committed in order to support the program. If a program is not an organizational priority, it clearly shows and undercuts the energy behind it. If those running the program do not feel supported, they will sit back and not worry about whether the program truly works or not.

4. *Partnerships.* Strong arts education programs become intertwined with and relied upon by public schools and classroom teachers. You must deepen connections with specific educators and school systems, who can be strong advocates for the program with their students, administrators, and funders. Take the opportunity to pitch the program as a potential sponsorship for corporations or business entities looking to raise their profile with the local community.

5. *Care for Students.* Excellent programs ensure they are serving students well. Assessment tools can reflect some of student learning. Following up and checking on student progress with their teachers, even after the program has wrapped up, demonstrates the program's investment in student learning. Treating all participants with the respect of being well-prepared, planned, and intentional will help grow the program's reputation among students, teachers, parents, and the community at large.

ARTS EDUCATION PROGRAM PLANNING

In Table 12.1, you will find an example lesson plan from YPT for their *In-School Playwriting Program*. This first workshop was designed to introduce students to the idea of a play and how a play is different from a written story.[2] Notice the instructions for the teaching artist included, so that each teaching artist can refer to the lesson plan for guidance on how to implement the lesson. YPT would hold a weeklong training each year for teaching artists, so everyone teaching the program would be well-versed in these workshops and could provide feedback on them before they were finalized for the year.

Table 12.1. Workshop One: What Is a Play?

Young Playwrights' Theater

Workshop One: What Is a Play?
Inspiration Phase (Prewriting)

Enduring Understandings
• Plays are expressions of personal perspectives that can teach and entertain audiences.
• Dramatic writing requires imagination and creativity.
• Plays are written to be seen by an audience.

Key Questions
• What is a play?
• What is the value of writing a play?
• What does a play look like?

Programmatic Objectives
• To provide students the opportunity to see a play before writing a play.
• To introduce students to the role of the playwright.
• To demonstrate the value of playwriting.

Participant Objectives
• To experience a play.
• To identify the role of a playwright.
• To assess the value of playwriting.

Outcomes
• Participants will make connections between the role of the playwright, the performer, and the dramatic form.
• Participants will discover how self-expression translates into public performance.
• Students will identify potential play ideas from their own experiences and perspectives.

Vocabulary
• **Playwright:** one who writes plays; dramatist.
• **Playwriting:** the act of creating the plot, theme, characters, dialogue, spectacle, and structure of a play and organizing it into a script form; the ability to imagine the entire production scene and to put it into written form so that others may interpret it for the stage.
• **Actor:** a person, male or female, who performs a role in a play or entertainment.
• **Play:** the stage representation of an action or a story; a dramatic composition.
• **Audience:** the group of spectators at a public event; listeners or viewers collectively, as in attendance at a theater or concert.
• **Stage:** the area where actors perform.
• **Character:** a person, animal, or entity in a story, scene, or play with specific distinguishing physical, mental, and attitudinal attributes.

DC ELA Standards Addressed
• 11.LD-Q.2. Analyze differences in responses to focused group discussion in an organized and systematic ways.
• 11.LT-C.1. Relate literary works and their authors to the seminal ideas of their time.
• 11.LT-T.3. Apply knowledge of the concept that a text can contain more than one theme.

DC Arts Standards Addressed
• HSP.1.7 Collaborate on the development of original dramatic pieces leading to performance.
• HSP.3.3 Document observations and perceptions on how a specific actor used theater techniques to convey meaning in his or her performances.

- HSA.3.2 Assess the intent, structure, and quality of informal and formal theater productions.
- HSA.4.2 Compare and contrast a traditional and innovative interpretation of a play.

Preparation for Class
- **Communication with Actors:** Before class begins, you should make sure to communicate with the actors who will be helping out in this workshop and ensure that they have all the materials they need.
- **Scripts:** Enough copies of *My Date with Kara* for every student, plus actors, classroom teacher, and yourself.
- **Groups:** Near the end of this workshop, you will split the students into three groups. If you need help choosing groups of students or rearranging the room, communicate with your classroom teacher.

Activities:
- **Introduction:** Introduce yourself and let the students know you work with YPT: Young Playwrights' Theater teaches students to express themselves clearly and creatively through the art of playwriting. YPT believes that each person has a story worth telling and works with students to help them discover the power of their own voices. Explain that you will be visiting their classroom once a week for twelve weeks and in that time they will develop an original play.
- **What Is a Play?** Ask the students this question. Write down their responses. (They will be able to revise their definition later in the workshop.)
- ***My Date with Kara:*** Tell the students that before they begin writing their own plays, they are going to watch a performance of *My Date with Kara*—a play written by YPT. Begin the performance. Actors perform the play until it ends abruptly (at the climax).
- **What Happens Next?** You "Write" the Ending: Ask, "How do you think this play should end?" Have the actors play out a few of the students' suggestions. Discuss each suggestion after the actors perform it, encouraging the student to explore multiple possibilities. Now explain that the students have been acting as playwrights!
- **What Is a Play? Revisited:** Ask if there is anything the participants would like to add to the definition of a play. Share the final definition with the students. At this point give a copy of the script to each student. Take a few minutes to have the class identify the major difference between a script and other kinds of writing (character names, stage directions, etc.) The students will learn the proper script format in a later workshop.
- **Giving Voice to a Character:**
 - **Character Discussion:** Lead a discussion about character. A character is a person, animal, or entity in a story, scene, or play with specific distinguishing physical, mental, and attitudinal attributes. Characters carry out the action of the play. Plays are built around characters in conflict. As an audience watching a play, we identify with characters based on their position in a conflict. We usually side with certain characters because we want what they want. Ask, "Which character(s) in *My Date with Kara* did you want to cheer for? Which character(s) did you want to fail? Why?" The intention here is to begin to steer students toward the idea that when we see characters in conflict, we often cheer for one and against the other based on our personal experiences and observations. This is why characters in conflict are essential to dramatic writing.
 - **Character Work:** Explain that the actions a character takes define the character and tell us who they are. Divide the class into three groups and assign one of the actors to each group. Ask each group to list actions that the character took in the story of *My Date with Kara*. The actors playing that character should write down all the actions on the board or large Post-it Note. Next, ask the groups to write down adjectives describing the character while the actor writes it down.
 - **Giving Voice:** Finally, have the groups write a speech for the end of *My Date with Kara* for the actor in their group that: 1) tells the audience more about this person, and 2) suggests

(continued)

Table 12.1. *(continued)*

an action s/he could take to end the play. The actor should work with the group to develop an original monologue. When all the groups are finished, have the actors perform the monologue. Encourage groups to surprise us with what they show us about the characters.
- **Why a Play?** To answer this question, tell the students that there is an innate human need to tell stories. From ancient civilizations who acted out their daily life (the hunt for food) around a campfire to the modern-day phone calls we all make to tell each other about our lives, human beings have built communities through common experiences and the sharing of stories. The playwright's role is to dramatize stories they believe will be compelling and influence the world around them. Plays are a great way to reach an audience because they feature live actors and an audience in the same space and create a communal event. You may also want to add something personal about the power of theater in your own life to excite the students about the project they will undertake.
- **Homework—Observing My World:** Tell the students that over the next week they should observe their environment in search of something that sparks their interest. This could be a person, a mural, a fight, something in nature, etc. Instruct them to look for something that might inspire them. They should briefly describe whatever they choose to observe in writing and be prepared to think further about it at the next workshop.

Notice in the lesson plan the objectives, outcomes, enduring understandings, and learning standards articulated for the workshop. These terms are examined below to guide your understanding of the plan:

- *Enduring Understandings* are what you intend students to remember or understand long-term from the workshop experience.
- *Key Questions* ask the essential topics being explored or interrogated by this workshop.
- *Programmatic Objectives* are what the program intends for students to experience or learn.
- *Participant Objectives* are what the students themselves intend to do during the workshop.
- *Outcomes* are the resulting learning you expect to achieve through the lesson.

The company implemented this first workshop when it realized that many students had not seen a play before or weren't entirely clear on what playwriting meant. This fun, interactive workshop gave students the chance to experiment with creating actions on stage and having live actors play those actions out. Developing this curriculum took years and helped YPT demonstrate what students would learn from the program. Do not worry if this seems intimidating at first glance. You will need *time* to grow your programs. It took me four years to grow my first program.

VARIATIONS

BUILDING A PROGRAM FROM THE GROUND UP

The *Text Alive!* program brought Shakespeare into the classroom and made it real for students by giving them the opportunity to read a Shakespeare play, learn about his text and history, and then rehearse one scene from the play for a festival performance held at the theater on the set of the latest production of this play. Students would spend a full semester rehearsing their scenes and then come together on a single Saturday to perform their scene of the play, in tandem with fourteen other public schools. The result was a fun performance of the full play, with each scene transporting us to different times, places, and interpretations of the play.

Only in Our Dreams

When I arrived as a manager for the first time to run the *Text Alive!* program at the Shakespeare Theatre Company, I was told how beloved this program had been. I was told how much teachers and students relied on it. I was told how successful and rigorous the program was.

But when I started at the theater and fired up my desktop computer for the first time to peruse the *Text Alive!* program files, I found only a handful of theater games. No curriculum. No full workshops articulated. No learning standards, objectives, or outcomes. I was dismayed that this program seemed to only exist in people's minds.

Like a lot of programs, including the playwriting program I would inherit four years later at YPT, *Text Alive!* was a great *idea* that relied on *each teaching artist* to define and implement it in their own way. *Teach students how to perform Shakespeare* seemed to be the program's intent, without anything else mentioned. I realized I would need to put muscle on the bones of this idea.

Getting Real

I spent the first year teaching the program while trying to figure out how to articulate what we intended to accomplish. I practiced lots of experimenting with workshops: one on text, one on history, one on production, etc. I engaged teaching artists to help and teach parts of the program. We met and discussed what we were learning. We started to examine the DC Public Schools learning standards and pull them into workshop plans. We started to create an actual workshop plan for each visit, which eventually grew into eight workshops (four focused on skill learning and four on exploring and rehearsing the text on its feet).

BOX 12.1. SHAKESPEARE'S WORLD

Early in my tenure at the Shakespeare Theatre Company, I was faced with the fact that we needed a new way to teach students in our *Text Alive!* program about what life was like during Shakespeare's time, without just lecturing them about it. In the weeks just after 9/11, I was working hard to develop the program. I was tired and stretched too thin. I decided to try a new game I called simply *Shakespeare's World*.

I wrote short descriptions of a variety of character types from Elizabethan England—the Nobleman, the Beggar, the Baker, the Priest, the Journeyman Actor. Each student would gain a slip of paper with their character description and one short line of dialogue they could use. The Baker: "Buy some fresh bread, sir?"

After playing a brief character status game with playing cards (with 2s being low, Aces high, and students having to find their peers based on how everyone behaved, with their cards hidden), I distributed the slips of paper and gave them a situation. They were now these characters and had to embody their status somehow—a tall and open stance for high status, low and cowering for low status. They were now on the streets of Elizabethan England. Their goal was to communicate who they were while trying to figure out who everyone else was. Students had one minute to read their slips and then dive into the scenario. The first time I played this game, 7:30 am, blurry-eyed, at Fort Meade High School in Maryland, the students *dove in*.

Bingo! The game, even in this early rough form, worked. Students understood status. The card game gave them practice at embodying status. The character slips were simple enough to quickly read and remember. The game was fun. They were able to create their characters however they liked and play with each other in a free form improvisation. At the end of each round of the game, we would have students share who they were and what they did. We would play two or three more rounds, giving students the chance to switch characters each time. At the end of the workshop, we discussed how these characters and their social status would help us understand the characters and story in whatever Shakespeare play we were studying that semester.

Over the years *Shakespeare's World* has been refined and improved. But the basic ingredients have stayed the same: simple but strong content, a well-defined and fun game, and then the chance for students to apply their own ideas and creativity to a session of active learning. No more boring lectures. A chance to play and learn with their whole selves in ways that will stick in their memories, because they fused the presented content with their own new ideas and discoveries.

Getting Help

Gradually, as we further articulated the workshops, I was able to hire more teaching artists, train them in the burgeoning curriculum, and then do feedback sessions after each semester, when we all met and discussed how the curriculum worked and made adjustments. By year three, we were able to engage a professional researcher and evaluator, Dr. Barry Oreck, who came from New York City to help us further develop the curriculum, and we could build assessments and evaluations to capture lightning in a bottle and see what impact our work was really having on students.

Writing the Program

With Barry's help, we discovered that, in order to build authentic assessments, we had to be very clear on what we intended students to learn, with laser focused objectives, outcomes, and expectations for workshops. We spent a year rebuilding the curriculum yet again with Barry, while piloting new assessment and evaluation tools. By the fourth year, we had a strong program, articulated in detail with a curriculum that detailed the learning standards, objectives, and outcomes pursued by each workshop and the program overall. We also had activities completely described for each workshop and proven transitions from one activity to the next.

Assessing Our Work

We had performance assessments for students to do, at the beginning, middle, and end of the program, so we could gauge their progress. We were able to hold teaching artist trainings twice a year, when we brought current and new teaching artists together to train in the curriculum and again offer any adjustments they thought would improve the program. We were able to hand the program to anyone, in printed form, and show them exactly what *Text Alive!* was intended to do and *how* to do it. The results were tremendous.

The Resulting Program

In *Text Alive!,* students in fifteen public high schools would study a particular Shakespeare play with us, whichever one we were doing on stage at the time. We would provide free texts. Their teachers would commit to teaching the play in class, participating in a series of four professional development workshops with me on teaching Shakespeare and this play in particular. In exchange, we would implement eight weeks of workshops, one per week, including an introduction, the history behind Shakespeare and his life, Shakespeare's text, and the language of this play, and then

shifting into rehearsing one scene. We would cut the play down into fifteen semi-equal scenes and assign each school classroom a scene. Then the students would decide what time period and location the scene would take place. Either a student or the teacher would direct the scene. Finally, at the end of the semester, they would come downtown to our theater to dress rehearse and tech their scenes on our stage and then, that Saturday, to perform them in order.

It was always a fun but nerve-rattling morning of Shakespeare. It was as if you were seeing this one play but in many different time periods and with many different casts and approaches to the language. Often it was even better than the production we were presenting professionally, in part because you learned a lot about the play and what worked and what didn't when you applied a certain point of view of time and place on it. It also worked because if you did not like a certain approach, it would change in five minutes with the next scene. As opposed to going to a Shakespeare play and knowing within the first five minutes that you are trapped facing a bad adaptation for the next three hours, the *Text Alive!* Festival let you sample many different approaches, like a feast of tapas that quickly moved along.

Pencils Down

I had fulfilled my vision when I first began managing the program. It now stood as a sustainable model for an arts education program. It was also replicable. We could hand the curriculum to another organization in a different part of the country, and they could implement it. The test for sustainability of this kind of program is: if everyone here disappeared tomorrow, would the next people know how to do it? With *Text Alive!* now clearly articulated, it could be handed on to others. It could also be clearly improved, adapted, and evolved, because the starting point was clear.

WHERE TO START?

It may seem daunting to consider the time, staffing, and focus it takes to truly develop a sustainable program like this. The scale of effort can be adjusted as well. If you are a tiny organization, with just one or two people implementing these programs, you will want to build programs in a way that makes sense for you.

- Maybe you keep things simple and cite just two or three learning standards for the whole program.
- Maybe you choose just one or two learning objectives for each workshop.
- Maybe you first simply create a bulleted list of activities for each workshop, so you are clear on what you intend to do and how.

In whatever way makes sense for your situation, find a way to map out your workshops. What's the beginning, middle, and end? Is there a warmup, a main lesson,

and a wrap-up? And over the course of the program, is there a natural flow between workshops? If you have just two workshops planned in the process, is one clearly a beginning and the other the end? Or, with three or more workshops, is there a sense of how the program begins and ends?

ASSESSING YOUR WORK

Finally, do you have any way to assess if students learned from your workshops? Is there a quick Q&A at the end, when students can respond with raised hands or quick responses to your answers? Or is there a performance assessment you can use to gauge how much they have grown during the workshops? Or, at the least, is there a short survey you can give their teachers after the program, to hear from them about the impact of the program, either immediately or shortly after you wrap things up? What have students gained and how can you see it? Be strict on how you capture these insights and keep trying until you get it just right. Being humble about what you can truly see and assess will help you focus on what's really possible.

All these steps will start to grow your programs beyond being beloved, anecdotal offerings based on whatever each person does, to being sustainable, reliable, and clear on the impact you are having on students' lives. In the online cache of documents accompanying this book, you will find some example assessment tools to help you begin.

NOT ASSESSING THE ART

Barry Oreck and I spent a few years creating assessments for the *Text Alive!* program. We had two in-school workshops we used to assess students' use of language, creation of character, and understanding of vocabulary. The Saturday morning performance always brought a ton of energy into the theater and some truly inspiring performances by students from all kinds of backgrounds, from the richest suburban school to the poorest inner-city charter school. We attempted to develop a performance assessment, trying to create a rubric and checklist to capture how much the students learned and reflected the desired learning in their performances. We implemented these during dress rehearsal earlier that week and then during the actual performance. Levels of commitment, energy, and use of language skyrocketed on performance day. But we were having trouble gaining any kind of baseline for this assessment or showing any kind of clear bridge between the classroom learning and what we saw on stage that day.

Some class performances seemed entirely disconnected from their classwork, with some classes who never focused or seemed to engage in the class suddenly showing up with an amazing performance of their scene. Other classes, who had worked hard and seemed to learn a lot in the classroom, were mediocre in their performances. Then we realized: We were trying to assess the art. And art, in most cases, eludes assessment. It can be inspired, trashy, simplistic, or brilliant. It comes from moments of inspiration, when painters, dancers, musicians, or actors lift us beyond their normal experiences and dare to dream themselves into a new reality. Because of the energy, nerves, inspiration

caused by live performance, we could not relate it to their learning in the classroom, strictly speaking, so we stopped trying. We could not assess the *performance*, but we could assess the *learning*.

FINAL THOUGHTS

By offering rigorous, student-centered arts education programs, you can enrich the lives of your students and communities, while substantially growing financial and communal support for your company. Remember to stay focused on your students. Combine your artistic expertise with their abilities to create unique learning experiences. Plan rigorous programs that challenge them and your organization to deliver excellence. Meet them where they are, in their learning style, abilities, and strengths. Specify what you intend to teach them and what they can gain from the program, and then find ways to assess if you are accomplishing that. Celebrate student success. Thank the parents, educators, and administrators who are helping make the program happen. Relish the opportunity to work with some students over the course of several years, as repetition and consistency support their continued growth as individuals and artists.

In the course of exploring arts education, this chapter examined:

- How to inspire students and build authentic arts education programming;
- The three major approaches to and five fundamentals of arts education;
- How to develop a lesson plan;
- How to build an existing program from the ground up;
- Getting started; and
- Assessing learning and not art.

Many of these programs began simply as a means to generate income. But with the right focus and time, arts education programs can become authentic, rigorous, and relevant offerings, worthy of your students. Through in-depth planning, substantial investment, and a pursuit of excellence, vibrant arts education programs can enhance lives, strengthen connections, and deepen the delivery of your mission.

NOTES

1. Young Playwrights' Theater, "whYPT?" November 29, 2010. Accessed June 23, 2021. https://www.youtube.com/watch?v=0lYO9NkJ7WY&t=1s.

2. YPT's curriculum has evolved and changed since this lesson was first designed.

13

ACTIVATING COMMUNITIES

Who's actually doing the work in the community? Where is there a need?

—Karen Zacarías, founder of Young Playwrights' Theater[1]

INTRODUCTION

Community engagement denotes programs and projects that *reach outside the organization* to participants of all ages in a community, sometimes creating special arts projects in collaboration with community members. This chapter offers concrete steps for developing and implementing community-based projects and workshops, along with several examples of successful projects, including partnerships with the U.S. Department of Justice, the Fannie Mae Help the Homeless Program, the Smithsonian Institution, the Kennedy Center, the City of San Francisco, and the White House.

FUNDAMENTALS

COMMUNITY ENGAGEMENT

If community engagement programs are authentic and prioritized by organizations, they can deepen the organization's ties to their neighbors, enrich lives, and strengthen the health and well being of the communities themselves. In addition to offering programs before and after performances, in schools, online, and in after-school settings, some organizations engage their constituents with larger community engagement projects, especially if the organization is able to make these projects central to their mission. In these *community-based special projects*, organizations engage communities in a creative process centered on a topic *important to the community itself* and with the goal to create work for the organization to feature.

Over the years I have created multiple community-based projects aimed at deepening community connections and creativity. These special projects focused on one or two relevant themes. They gave us a chance to spend time developing a piece while growing deeper roots. They helped us establish partnerships, new sources of funding, and opportunities to build our brand and our case for support with the general public.

FIVE GOALS FOR BUILDING
SUCCESSFUL AND AUTHENTIC COMMUNITY-BASED PROJECTS

By focusing each project with five basic goals in mind, you can build projects that will serve your organization *and* community:

1. *Seek relevance.* Focus your project on an issue or segment of your community that needs your attention *now.* Center the work on something that needs to be discussed, seen, and understood better.
2. *Engage your community.* Wrap your community into the project. Rely on their participation. Seek their input and guidance. Find community members of all ages and walks of life to work with you. Honor their time, contributions, and points of view. Thank them for doing the work with you.
3. *Be ambitious.* Reach for goals you normally might not achieve on your own. Think big and plan boldly. Assume this project and process will stretch you and your organization. Plan on being tired, proud, and better at the end.
4. *Build partnerships.* Seek help from other organizations. Focus on what you do well and invite others to bring their A game to the table. Be humble but clear on what you need and want from your partners. Tap into their resources and networks. Offer them something they cannot achieve themselves. Seek something from them you cannot gain on your own.
5. *Demand excellence.* Honor your students, artists, and audiences with the best possible work you can do. Set the bar high and meet it. Conclude the process with excellent production values, performances, and post-show discussions. Close the loop by honoring those you served and laying out a path for how you can work together again.

COMMUNITY-BASED ARTS ORGANIZATIONS

Some arts organizations are focused entirely on community engagement, aimed at improving lives and making the world a better place through art. The Yerba Buena Center for the Arts (YBCA), Life Pieces to Masterpieces, and Young Playwrights' Theater (YPT) are three such organizations.

Yerba Buena Center for the Arts

The YBCA in San Francisco, California, is a community-based arts center. According to their CEO Deborah Cullinan, YBCA focuses on empowering artists and

arts organizations with an eye to improving the community: "YBCA is a laboratory and platform that is shifting resources and power to artists and arts organizations working to advance equity, health, and wellbeing in their communities. We have three focus areas: *YBCA Create* moves away from top-down curatorial structures and discrete transactions with artists and toward deep, game-changing relationships with artists in the form of fellowships, residencies, and experiments that provide the space, time and resources to pursue moonshots that have the potential for great impact. *YBCA Champion* encompasses all the work that we do to advocate for the role of artists and the arts in a more equitable society. This includes policy advocacy and also the work we are doing to gather the evidence of impact and grow demand for art and creativity in other sectors. *YBCA Invest* includes all the work we are doing to address the economic insecurity and systemic inequity in our sector. This includes our Guaranteed Income pilot for artists, with the City and County of San Francisco. It also includes our CultureBank initiative and our Artist Led Giving Circle."

YBCA was opened as part of a community redevelopment project in 1993, according to Cullinan, so community engagement is at the heart of the organization: "YBCA is part of the former redevelopment agencies—one of their redevelopment projects in San Francisco. It was a project that started as sort of urban renewal and it was focused on what was considered by some to be a blighted part of San Francisco. Lots of empty parking lots, etcetera, but was also thriving for others. It was home to seniors. There was a significant labor presence. There was a significant Filipino presence. There were lawsuits and struggle around this big development project.

"YBCA is just one of the pieces of the Yerba Buena Gardens, and it was the result of community collaboration in order to heal and to put the arts at the center of a new path forward. It's one of these many, many projects that has a complicated history and to think about what it was built on—it also is on Ohlone burial grounds—and so to really think about like what it sits on, what its legacy is, what kind of institutional harm we may have done over the years, and to try to address that and manage forward—it's hard. I mean, it's really hard."

However, with Deborah's leadership, YBCA continues to innovate and find new ways to empower artists and its community in order to change the world: "We have transformed the curatorial structure. There are no longer curatorial silos, you know, performing arts, visual arts—this kind of thing. We have one big program and engagement team. A lot of the work we're doing now is instead of transacting with artists and then presenting the object or the performance, we are actually getting into deep relationships with artists creating the conditions for them to pursue game-changing ideas—really focused on process and what it means to share the process of creativity, the process of inquiry with the broader community in order to actually try to change things. *And we believe that art can change things*, we believe that if you create the right conditions for people, they can think really big and really outside of the box and that we can execute on those things. And that's the role of YBCA."

Life Pieces to Masterpieces

Located in Ward 7 on the east side of Washington, DC, Life Pieces to Masterpieces (LPTM) works with young black men in their community to "ensure that every child in our community has a strong support system and the prospect of big dreams and a bright future. In 1996, Larry Quick, an artist born and raised in Ward 7's Kenilworth Parkside & Kenilworth Courts public housing community, decided Black boys needed a space to express themselves. LPTM was co-founded in the Ward 7 Lincoln Heights public housing community by Larry together with Mary Brown, a highly regarded advocate for youth, and Ben Johnson, a skilled fundraiser. Over the next two decades, Life Pieces has evolved from an after-school arts engagement activity for seven boys to a comprehensive nonprofit organization recognized as a leading model for the development of African American boys and young men living in marginalized communities."[2]

LPTM engages dozens of young men in Northeast DC each year to provide them with a safe, loving after-school environment, help them with academic tutoring, and inspire them with the ability to express themselves through art. They lead these students to create beautiful portraits about their lives. But more importantly, they help them know their own worth and make the world a better place by leading positive lives. Their students are with them from eight years old through their high school graduation and beyond. Many of them return to work at Life Pieces to mentor the next generation.

Young Playwrights' Theater

In addition to teaching thousands of kids the art of playwriting and how to produce their plays each year, YPT, the company I led for seven years, also focused on special projects to create exciting new work that drew great press and support. Special projects were special commissions we would pursue to create a new play with a larger group from the community and/or another organization focused on issues of social justice in some way. These groups could be comprised of two hundred public school students from various grades throughout the city or from organizations including the U.S. Department of Justice, the Kennedy Center, and even the White House.

During my first few months at YPT, we produced a new play in collaboration with the Smithsonian Institution titled *Retratos: Portraits of Our World*, a play centered on students' reactions to a new exhibit at the Smithsonian of the same name. The play was developed by YPT working with dozens of public-school students, who explored and wrote about the paintings on display. In this kind of process, YPT would create a series of workshops for each classroom, which partially presented content and then gave students a chance to react to that content via their own writing. For example: "Choose one of the provided portraits. Take about five minutes to really examine the person in the portrait. Who are they? How old are they? What's their job? Where do

they live? What do they love or hate? What annoys them or makes them happy? Now take some paper and pencil and write down a page of what this person might say if you asked them *who* they are and *why* they are the way they are. Keep looking at the painting. If they stop talking to you, take a moment and go back to the painting and see if you can learn more from it, then continue writing."

Then YPT took their writings (monologues, dialogues, poetry, and prose), read them all, examined them, and imagined what kind of story might encompass all this writing. The students' writing then became material for a lead artist to stitch together, along with a coherent narrative or construct, in order to create a one-hour play. In this model, the resulting play provided audiences with insights into issues, in this case about some of the heritage and history contained in portraiture, while also being organically created with students and educators. Students came to opening night at the Smithsonian and were honored for their work. They heard their words and ideas on stage, seeing that their words, ideas, and interests mattered. They experienced that what they had to say mattered and was appreciated by audiences and organizations as renowned as the Smithsonian Institution. This project laid the groundwork for several more community-based special projects.

PLANNING PROJECTS

At YPT these special projects would sometimes take us the better part of two years to plan, develop partnerships, fundraise, implement, and then ultimately produce. These projects would give us a chance to tackle a big central issue important to our community, while partnering with larger organizations and raising our profile via good press and associations with the larger organization. Often, we would benefit from the additional fundraising made possible by the project, or even some commissioning fees.

Each project began with the idea to do it, which could arrive from many different places. Sometimes a staff member would suggest it. Or an opportunity to pursue a commission would present itself, as when the Kennedy Center wanted to commission artists to write plays about the White House. We convinced them to hire YPT instead to engage hundreds of kids to write it. Once the germ of an idea solidified into something that felt real and actionable, we needed to map out all the necessary partners, including the other organizations participating and the schools, teachers, and students who might work on it with us.

We reached out to classroom teachers to pitch the idea to do a series of workshops with us, in order to create the play. We figured out if and how many students would be able to participate and attend the opening night. We began to write workshops aimed at giving students the tools needed to write, and then pivoting to exploring whatever relevant content we could bring into classrooms and writing monologues, poetry, dialogues, and even song lyrics in response. We set up a timeline to get us from the first week of planning through the final stages of creating a finished script.

KEY QUESTIONS

When planning community-based projects, the following questions should guide and inform your planning:

- *Who?* Who will do this? Who do we need as partners? Who is our audience?
- *What?* What are we proposing to do? What components do we need to succeed?
- *When?* When will we do this? When will it begin and end?
- *Where?* Where in the community will this happen? Where will it serve?
- *Why?* Why are we doing this now? Why do we need to do it? Why will this benefit our community and our organization?
- *How?* How will we plan, fund, and execute this project? How can we maximize its impact and success?

ENGAGEMENT WORKSHOPS

Part of the magic of any series of workshops is to ensure that students can have fun, be inspired, and write freely. Sometimes we worked with students as young as fourth graders or as old as elder community members, from ages ten to ninety. We always had to plan workshops that were flexible enough to engage students with a wide variety of reading and comprehension levels. We were never sure exactly what we would find in the public-school classrooms, and so we needed to plan for any contingency, and make the workshops as compelling and adjustable as possible in order to succeed.

Prompts, examples, and the amount of writing we expected were all adjusted depending on the amount of time we had with each group, their expected reading and writing levels, and the goal to always have time to wrap up and reflect on the work accomplished in each workshop. In every scenario, we required the staff or teachers onsite to actively participate and help us focus and coach participants throughout the workshop. If teachers or staff instead used this time to grade papers, take breaks, or otherwise shift their focus away from the workshop, we would reiterate to them the need for them to stay focused and participate. Their focus would go a long way to coding to participants whether this work was important or not. Typically, any workshop would contain the following transitions.

- *Introduction.* Why are we here, and what are we hoping to do together? On the first day this section introduced the entire project. Each subsequent workshop would recap what we did in the previous session and introduce this session's central idea or theme.
- *Sharing of content.* What can we learn about this topic in order to inform our own writing? This section sometimes offered a story, visuals, or even video content relating to the topic.
- *Brief discussion.* What do we think and feel about what we have just seen or heard? Each workshop would offer specific questions relating to the content, leading to a brief warmup discussion with the teaching artist.

- *Writing prompts.* Worksheets distributed to the participants would pose specific prompts or questions for them to address with their writing. For example, in *The Susan B. Anthony Project*, one workshop asked students to imagine they were Susan B. Anthony speaking to an audience today. What would she say? What might she fight for if she were alive today? What might surprise or dismay her?
- *Sharing of writing.* Students would be given a chance to voluntarily read some of their writing with the class. The teaching artist would reflect what was strong and interesting about each piece shared.
- *Final thoughts and questions.* The teaching artist would briefly recap what had been explored in this session and invite any questions or final comments on the work from participants.
- *Collection of writing.* Teaching artists would collect all of the student writing, with the promise to return them to students after we had copied or transcribed them for the final project. Often, we would return the writing at the next session or within a few weeks of their writing. Sometimes classroom teachers would request copies that day or soon thereafter so they could review them and use them to evaluate students' progress as part of their class grades. In some instances, when working with students in the DC Juvenile Justice system or those experiencing homelessness, we would not see the same people at each session, or we would lose contact with one of the writers. We made every effort to return their writing, so that they would be able to remember and own their accomplishment.

VARIATIONS

COMMUNITY-BASED PROJECTS

These examples answer the key planning questions and describe how and why the project happened, including how each project affected the company's finances, fundraising, staffing, community relations, and marketing. These examples deal with theater, visual arts, and even healthcare, but the same principles of organization and management apply to any discipline.

Chasing George Washington

Project: In 2006, the Kennedy Center, the White House Historical Society, YPT, and DC Public School students celebrated the history of the White House by creating a new kid-centered musical, while asking, "Whose house is it, really?"

Who? The Kennedy Center, the White House Historical Society, and YPT, and DC Public School students; more specifically, three teaching artists, twenty students, one classroom teacher, and a team of Kennedy Center artists.

What? The purpose was to create a new musical about the White House with DC Public School students, to be produced by the Kennedy Center.

When? The whole process would take about a year and a half, with in-school workshops for six months, then a few months for script development, and then six more months for the production from beginning to end.

Where? We planned to engage students at a DC public charter school we knew well, with a classroom teacher we trusted. This project was a big deal for YPT, so we wanted to engage students and teachers we knew we could count on to complete the process.

Why? We decided to do this project because it gave a new, higher profile way for YPT to feature DC students and their points of view. At the same time, the project gave us a great opportunity to raise our profile as a company by working with the Kennedy Center and the White House. Ultimately, it was a unique opportunity to serve our mission and our students and grow the organization.

How? We gained just $5,000 from the Kennedy Center to create the play, but we committed hundreds of additional hours in staff, teaching artists, and artists' time to the project because we knew we would gain in donations and funding for years to come. The project provided us with stories, images, and professional credit, and each partner provided value to the project. YPT developed and implemented the play development process with students and provided the final script. The White House Historical Society provided background information on the history of the House along with access and a private tour for students. Then the Kennedy Center produced the play and ran it there for three sold-out weeks.

Notes: The script and music took about a year to finalize. In the fall of 2008, the Kennedy Center fully produced the world premiere for three sold-out weeks. The students who wrote the piece were honored at opening night at the Kennedy Center and able to see and hear their words on this national stage. The show then returned to the White House for a showcase performance hosted by First Lady Laura Bush, and then it went on national tour for six months in 2009. By the time the Kennedy Center published a children's book based on the show, President Barack Obama was in office and First Lady Michelle Obama wrote the foreword to the children's book.

What started out as an idea to involve DC students in the writing process of a play became a major moment in their lives and the life of YPT. The project involved two presidents and first ladies, gained great press for YPT, and gave us new opportunities to fundraise with individuals and foundations. At the beginning of the process, YPT had only gained about $5,000 in a commissioning fee from the Kennedy Center. But we gained perhaps hundreds of thousands of dollars in indirect donations in future years based on this work, along with great stories to help us pitch more educators and leaders on our work. Being associated and recommended by our partners, the Kennedy Center and the White House, was a huge win, as was the quality of the resulting work. We were all very proud.

Choosing Change

Project: In 2009, the U.S. Department of Justice and YPT examined the pitfalls and reforms of the DC Juvenile Justice System.

Who? YPT, the U.S. Department of Justice, the staff and students of the Oak Hill Juvenile Detention Center, and the DC Juvenile Detention System leadership and staff.

What? To create a new play about life in the DC Juvenile Justice System, in order to tour this play to schools and community centers to teach local youth about the system. YPT provided the teaching artists, workshops, curriculum; the U.S. Department of Justice provided the funding and professional association; Oak Hill and the DC Juvenile Detention system staff, teachers, and students provided access, writing, and insights.

When? The whole process would take about a year, with three months of workshops at Oak Hill, two months of script development, and then another six months to complete the production and tour.

Where? We were to engage classroom teachers and students in the Oak Hill Juvenile Detention Center in Maryland, the center for DC-detained youth. We would then produce the play in our rehearsal hall and tour it to public schools and community centers throughout Greater Washington, with an opening night at the GALA Hispanic Theater.

Why? We had successfully completed a program with the U.S. Department of Justice three years before. In 2008, the department sought proposals for projects to educate local youth about the DC Juvenile Justice system. Based on previous projects, YPT submitted a proposal to create a play with students detained in the system. This project would serve our mission to teach students to express themselves and reveal the power of their voices while serving our community and adding to our company's capacity with greater funding and press from working with the Justice Department.

How? We gained $30,000 in funding, which helped support staffing the project and paid for the tour. We committed three staff members to the project as teaching artists and writers. We had the capacity to do the tour (and would do a tour that spring regardless), so we had the capacity to implement each part of the project.

Notes: The most nervous I have ever been to present a play of mine was when we toured *Choosing Change* back to Oak Hill. Would the students hate it? Would they be bored by it? Would they even pay attention? As the first music played to start the piece, and the students erupted in raucous applause to their music, it felt like we were on solid ground. They listened, enraptured, drawn in by themselves as characters. As I watched standing in a side aisle of the audience, the wall between reality and art dissolved, as the audience and play looked, felt, and sounded exactly the same. There was no barrier to belief. No need to suspend disbelief. It simply was true, even for those living it. We hoped seeing some of their words, and their reality, on stage would further empower them to get out of the system. Unfortunately, because the necessary privacy

of the system could not allow us to stay in touch with these students, we would never know. But we hoped it had an impact.

The Good Neighbor

Project: In 2010, YPT and the Fannie Mae Help the Homeless Program investigated issues of homelessness in the nation's capital.

Who? YPT, the Fannie Mae Help the Homeless Program, DC Public School students and teachers, five community-based nonprofits, and dozens of DC residents experiencing homelessness.

What? To create a new play on issues of experiencing homelessness in Washington, DC, as a way of increasing understanding and dialogue on these issues, in tandem with the Fannie Mae Help the Homeless program.

When? The whole process would take about eighteen months, with six months of project and curriculum development, four months of workshops in schools and nonprofits, three months of script development and then another six months to complete the production and tour.

Where? We were to engage classroom teachers and students in DC public schools, as well as residents experiencing homelessness and staff at five nonprofits who serve those experiencing homelessness.

Why? The Fannie Mae Help the Homeless program was looking for ways to improve their existing workshops on these issues, deepen the dialogue, and develop a curriculum for doing this work they could then publish and disseminate nationally. This project gave YPT the first opportunity to develop and publish a national curriculum while gaining more exposure by partnering with a nationally recognized program. It also gave YPT a chance to serve community members we had not reached before and engage DC public school students with these important issues.

How? We gained approximately $60,000 in funding, which helped support staffing the project and paid for the tour of this project. We committed three staff members to manage the project and one to serve as the lead writer. We invested months of time in developing the curriculum.

Notes: We pitched Fannie Mae on an idea based on the other special projects we had completed over the previous four years. We would create a curriculum for students in schools and community members in nonprofits serving those experiencing homelessness to explore themes and issues related to experiencing homelessness in the nation's capital. Residents experiencing homelessness and public-school students in grades seven, nine, and eleven would write monologues, short scenes, and poems inspired by these discussions. We would then take these writings and shape it into a play about homelessness, which we would then produce and tour throughout the Greater Washington region to schools and community centers. Fannie Mae loved the project and the pitch, so much so that, after we had written and tested this new curriculum and

workshop series, Fannie Mae would produce it as a printed set of workshops, which would then be disseminated nationally to partner schools and offices of the Help the Homeless Program. Fannie Mae had implemented various workshops around their walks across the country over the years, but they had never been able to develop a single, streamlined, and effective workshop series in support of the program. Our work with them would give them that opportunity and would let us disseminate a program nationally for the first time.

We spent a few months developing the workshops, which would ask participants to explore what it might feel like to experience homelessness and what a community might do to help. Our program associate Nicole Jost was assigned as the lead artist on the project and created a brilliant play from participant writings titled *The Good Neighbor*. The premise of this interactive play was a town meeting to discuss whether to allow a homeless shelter to be built in their community or not. Five characters from the community debated the issues with a facilitator, revealing multiple points of view, and eventually engaged the audience in the discussion. Audience members were allowed to ask questions, make points, and really be a part of the debate. Eventually, the "meeting" wrapped up with an announcement that the shelter's fate would be considered and announced at a later meeting. When we toured this play, students actively engaged in the issues. For the official opening night of the play, we invited students and the clients of the five nonprofits serving people experiencing homelessness to attend. Similar to our experience with *Choosing Change*, the audience got lost in the reality of the piece and some of those experiencing homelessness thought we were in a debate about a real potential shelter, with real community members. We were heartened by the fact that it felt like an authentic debate to those *living* the debate at the very same time.

Woodlawn

Project: In 2010, YPT engaged elders and students in Northeast DC to explore and learn the history of Woodlawn Cemetery and those interred there.

Who? YPT would partner with the Woodlawn Cemetery Board of Directors, the nonprofit LPTM, and DC public school students to create an original play about Woodlawn and those interred there. Stone Soup Films would also create a short film about the process and LPTM would create pieces of visual art for the production.

What? Two months of in-school and after-school workshops with DC public school students aimed at raising awareness, sparking a dialogue about Woodlawn Cemetery and those interred there, including the first African American U.S. Senator, Blanche Bruce, and one of the first African American Congressmen, John Langston, and creating an original play. The play would be featured at GALA Hispanic Theater and via a tour of staged reading performances at several schools and community centers.

When? The process would take approximately two years, including one year of fundraising and planning, three months of workshops, and six months for production.

Where? YPT engaged students in a variety of public schools and after-school programs. We then developed the final script and produced the show at YPT and on tour to GALA Hispanic Theater and to several schools.

Why? Woodlawn Cemetery is in Ward 7 of Washington, DC. The cemetery has largely been abandoned since the 1980s, even though it contains thirty thousand people, many of whom were elected leaders, professionals, and immigrants from all walks of life. Implementing this process and creating this piece gave YPT a new opportunity to serve students and our community with another important exploration of our history, while advocating for greater support for this hallowed ground. The first African American Senator, Blanche Bruce, was buried there, as was a black Congressman and one of the founders of the Howard University Law School, Congressman Langston, uncle to Langston Hughes. Thousands of important people were buried in Woodlawn Cemetery, some of them in mass graves, having been relocated there from other cemeteries.

How? We gained a few smaller grants in support of this project. We dedicated one staffer part-time to support and implement this project. Our partnerships with schools, LPTM, and the board of Woodlawn helped us greatly to prepare and implement the project successfully over a limited amount of time. The touring staged readings of the piece did not require any setting or sound design, instead using some of the visual artwork from Life Pieces and having the cast appear in simple contemporary clothing.

Notes: The production toured throughout Greater Washington to schools, nursing homes, and community centers. The project also facilitated the cleanup of Woodlawn Cemetery in partnership with Greater DC Cares; the activation of education programs; tours of the cemetery by local DC students; and the creation of multiple pieces of original visual artwork by the DC students and the staff of LPTM in Washington, DC. Stone Soup Films also created a feature about the cemetery and the project, helping Woodlawn to tell their story online for the very first time.

The Main Street Banner Project

Project: In 2016, Hubbard Hall engaged local students in a yearlong process to create new visual arts decorating Main Street in the village of Cambridge, New York.

Who? Hubbard Hall staff and teaching artists engaging public school students in grades four through nine at Cambridge Central School, in partnership with the school and the Village of Cambridge.

What? Hubbard Hall initiated a project to have local public-school students create artwork based on the prompt "What is Cambridge?" This artwork would then be reviewed and twenty of the designs would be chosen to be made into banners to be hung on the streets of the village for two years. The artwork not chosen for banners would still be honored and exhibited for a month at Hubbard Hall.

When? The process would take eighteen months. Six months for planning, six months to hold the after-school art workshops for participating students, and six months for the production and installation of the final banners. The banners would hang in the village for two summer seasons.

Where? Students would be engaged in after-school workshops at Cambridge Central School. An exhibit of the produced artwork would be held on the Hubbard Hall campus, and the final artwork would line the two largest streets in Cambridge: Main and Park Streets. See Figures 13.1 and 13.2 for examples of student artwork.

Why? The existing banners on Main Street in Cambridge were wearing out. At the same time, the village needed to highlight its strong arts presence more clearly for visitors and residents. Hubbard Hall was inspired to offer a solution: to have local students create artwork based on their lives here, which Hubbard Hall would then produce as banners and the Village of Cambridge's Department of Public Works would hang throughout the village for two years.

How? We engaged the school and the village to gain their support of the project, then hired a teaching artist to teach painting and drawing workshops for the creation of these banners. We sought business sponsors for each banner, gaining a $400 sponsorship for each banner, which only covered the cost of the production of the banner. The graphic designer volunteered their time for the project. Hubbard Hall, the Village, and the school all donated staff time to plan and implement the project. Hubbard Hall donated funds to pay the teaching artist for the workshop series. The project cost the Hall just a few thousand dollars in staff and teaching artist fees, but it gained the organization a major public relations win, with our local children's artwork being celebrated and advertised all across our streets and the village being filled with local artwork for residents and visitors to see every time they entered the village for two years.

Notes: This project was implemented during Hubbard Hall's 2016–2017 season. It gave us a chance to inspire students by teaching them to express themselves in a visual art form, and then celebrate their work with an exhibit and a series of street banners beautifying the village with their paintings. The project also celebrated our community, its children, and life in the village from a child's perspective. It also served our need to increase local tourism and business development, by emphasizing the strong arts presence in the village. The project gained us no additional income or funding, but it deeply served our mission to develop, sustain, and promote the cultural life of our rural community and allowed us a chance to innovate while serving that mission. We were also able to surprise our community with its own creativity.

The Farming Plays Project

Project: In 2017, Hubbard Hall engaged local farmers to explore the history of farming and issues of farming in today's world.

Who? Hubbard Hall staff and teaching artists engaging approximately twenty farming families and two hundred local public-school students. Local youth and art-

Figure 13.1. Christian Carroll's *Veggies*. Art by Christian Carroll.
Graphic design by Sara Kelly.

Figure 13.2. Robin Carroll's *Flowers*. Art by Robin Carroll.
Graphic design by Sara Kelly.

ists would perform and produce the final play and workshop dialogues as part of the mainstage season. Local schools, teachers, and students would partner with us for the in-school workshops.

What? Hubbard Hall would lead a process with local farmers and students in Washington County, New York, to create a new play and engage the local community in a dialogue about farming. Hall staff would serve as teaching artists in the classroom and interviewers at farmers' homes. Oral history interviews with local farmers, writing created by the students, and research into local history would form the basis for creating a new play on these issues. Three months of workshops with students in grades four through eleven would generate poems, short scenes, and monologues toward the creation of the final play.

When? The process would take approximately two years from beginning to end. We would plan for a year, implement the workshops in the fall, draft a script by mid-season, and then produce the final play in January 2017.

Where? We engaged students in three different school districts and farmers throughout the community. The final production took place in our black box Freight Depot theater.

Why? Farming is still the number-one employer in Washington County, New York, where Hubbard Hall is located. We were not engaging this particular part of the community in any direct way, and it seemed important to do so. This hardworking part of the local community rarely attended Hubbard Hall events. For this production, every audience included a large portion of farmers and farming families, because the piece was relevant to their lives, reflected their experiences, and was created by and for them.

How? We gained $5,000 from the Champlain Valley National Heritage Partnership in support of our workshops with students. We allocated enough time from two staff members for two years to manage and implement the project. The design and production team were paid. The youth actors were all volunteers because they believed in the project and gained valuable professional experience.

Notes: For Hubbard Hall, this project engaged the farming community in new ways and made the organization more relevant for our local community. We had farmers in the audience at every performance, many of whom had helped to write the piece. Several of them wept after the show. We held talkbacks after every performance to gain their feedback, which we would then bake into the show, sometimes for the very next performance. They would tell us about how long their family had farmed their land, their happy memories, and their regrets. One mother shared that she regretted her son had decided to continue the family farm, as debts and stress ate up his life. For weeks and months after, community members would approach me about how much this play meant to them, as something *about them* and their community. *The Farming Plays Project* was another reminder that being relevant and compelling to your community always starts with the art. If you do work that is deeply *about* and *for* your audience, they will come.

The Susan B. Anthony Project

Project: In 2019, Hubbard Hall engaged local students and artists to examine the legacy and local history of Susan B. Anthony and the Women's Suffrage Movement.

Who? Hubbard Hall staff and teaching artists working with local public-school students in grades four through eleven in three different school districts; a company of artists in the production, including a composer, two vocalists, and a cast of three adults and seven youth.

What? To create a new play with music about Susan B. Anthony, the Women's Suffrage Movement, and the Right to Vote in 2020. Hubbard Hall would conduct

research into the Hall and Susan B. Anthony's presence at Hubbard Hall in 1894, then lead a writing process with local youth to explore the Women's Suffrage Movement and Susan B. Anthony, those left behind by that movement, and global feminism today. The resulting scenes, dialogues, and monologues would be used toward the creation of a final script with music. Composer Bob Warren would be commissioned to create four new songs for the piece.

When? The process would take almost four years from beginning to end. We would research and fundraise for two years, plan workshops and the process for six months, then implement the workshops in the fall, draft a script by midseason, and then produce the final play in the spring. Note: The global pandemic would delay the production for six months, from May to October 2020.

Where? We engaged students in three different school districts. The final production took place on the main stage of Hubbard Hall.

Why? In 2017, we unearthed published evidence of Susan B. Anthony leading a Women's Suffrage Convention in Hubbard Hall in February of 1894. We also found research showing that Susan B. Anthony was a friend of one of the founders of Hubbard Hall, Mary Hubbard. We also found that very few local community members knew any of this history. As the centennial of the Women's Right to Vote in 2020 approached, funders began to offer special funds in support of events and projects aimed at celebrating and commemorating the Women's Right to Vote. Therefore, an opportunity to celebrate our authentic history while teaching this history to our community and examining the legacies of Susan B. Anthony and the Women's Suffrage movement presented itself.

How? We gained $30,000 from the New York State Council on the Arts in support of this project. We planned an in-depth curriculum for students in the classroom and engaged three school districts to plan these workshops. We then implemented these workshops in grades four through eleven and generated hundreds of pages of monologues, dialogues, and speeches for the final piece. At the same time, our commissioned composer created four original songs. We then compressed all the writing into a draft script and engaged three professional actors to read this script, which was then redrafted. Finally, a small group of artists (a director, stage manager, three actors, seven students, and two vocalists) rehearsed the final play for two weeks and performed six shows over the course of three days.

Notes: We successfully engaged over 220 public school students in this process to study Susan B. Anthony, the Women's Suffrage Movement, those left behind by the movement, and global feminism today. Students in grades four through eleven engaged in three to four writing workshops each and wrote poetry, monologues, and scenes toward the final script. A diverse group of professional and student actors were engaged for the final production. Press coverage in the *Times Union* of Albany raised awareness of the project throughout our region. This project also helped us gain a historical marker from the William G. Pomeroy Foundation to designate Hubbard Hall as an important Susan B. Anthony site. Some of the students who wrote in the classrooms

Figure 13.3. D. Colin, Christine Decker, and Vivian Nesbitt in *The Susan B. Anthony Project.*
Katie Veltum.

Figure 13.4. D. Colin, Christine Decker, and Vivian Nesbitt in *The Susan B. Anthony Project.*
Katie Veltum.

ended up performing in the piece. Bob Warren was commissioned to create original music, and created songs for Susan B., Mary Hubbard, and Sojourner Truth that told their stories as well as a collective song sung by the entire company at the end urging everyone to "Rise Up" and vote in 2020.

The play called up images of Ruth Bader Ginsburg, Sylvanie Williams, Harriet Tubman, and Amy Coney Barrett, as the characters dove into the history of women's suffrage in this country. It reminded us of Mary Hubbard, the leader of Hubbard Hall for twenty-five years who established the Hall as the village town commons, where rallies, lectures, performances, and graduations took place every week. It challenged us to remember our history while fighting for a better present and future. The opportunity to highlight our history with Susan B. Anthony also raised our profile as a historic destination, while reaching new audience members and community members not yet familiar with Hubbard Hall. We celebrated the important work of the Women's Suffrage Movement and the fact that this history lives within the Hall and our community.

The Creative Corps

Project: In November 2020, the YBCA and the city of San Francisco engaged artists to help communicate how to stay safe during COVID-19 while also beautifying parts of the city with artwork.

Who? YBCA and the city of San Francisco, with the city providing funding and YBCA engaging the artists.

What? Artists were engaged to travel and perform outside in specific areas of the city, spreading information about being safe during COVID-19 while enhancing the quality of life of residents with performances.

When? The project was initially focused on the December holiday season, with the opportunity to extend the program if it proved successful.

Where? Specifically targeted parts of neighborhoods in the city were designated by the city, based on the greatest need to communicate with older and impoverished residents.

Why? The city needed help to communicate how to safely behave during the global pandemic with residents who were hard to reach, and artists needed work. The mayor was publicly supportive of getting artists back to work. This project satisfied multiple needs while serving the public good.

How? From the mayor's press release: "The City is funding the SF Creative Corps with $250,000 from the Office of Economic and Workforce Development (OEWD), and is working with YBCA and Paint the Void to administer the program. YBCA will administer the Community Health Ambassadors component of the Creative Corps program. YBCA will select artists in partnership with three local performing arts organizations: San Francisco Bay Area Theater Company, Dance Mission, and SF Carnaval. The San Francisco Parks Alliance, in partnership with OEWD and the City's COVID-19 Command Center, will assist with assigning Ambassadors to specific locations."[3]

Notes: The YBCA describes more of what makes the Creative Corps such a special project: "In partnership with the City of San Francisco, YBCA has been piloting the San Francisco Creative Corps, a program that puts artists to work in service of the health of our communities. We have been working alongside San Francisco Creative Corps partner Paint the Void, an organization paying visual artists to promote COVID-19 public health messaging through city-wide public art. We are also partnering with key performing arts organizations, including San Francisco Bay Area Theater Company (SFBATCO), Dance Mission, and SF Carnaval—organizations led by and serving BIPOC and LGBTQIA+ communities—to engage over 30 performing artists to be Community Health Ambassadors.

"Since fall 2020, our artists have been reaching out to their neighborhoods both in person and online, sharing critical pandemic safety messages that help protect our community and inspire them through the performing arts. Our Community Health Ambassadors are now creating a series of short videos encouraging community members to get vaccinated and to continue practicing COVID-safe behavior. Their dance, music, and performances speak authentically to the challenges of living through the COVID-19 pandemic and how we can work together to keep our communities safe.

"Through our Community Health Ambassadors, we hope to encourage and inspire people to care for themselves and care for others throughout the COVID-19 pandemic, and to provide joy and inspiration when and where we need it the most. This program is one of many ways YBCA is investing in artists who support the well-being of their communities, including the YBCA 10 artist cohort and the Guaranteed Income Pilot."[4]

Deborah Cullinan, CEO of YBCA, says these kinds of community-based projects are all about partnership: "The core strategy is partnership. It's finding whether it's the philanthropy, whether it's individuals, whether it's like a corporate entity, but finding folks who have a shared interest and getting into partnership. And so the Creative Corps, for example, is a partnership with the mayor's office of Economic and Workforce Development. The shared interest in San Francisco is really about, 'How do we re-awaken our streets? How do we reach people where they are? How do we bring joy and inspiration? How do we bring that in a culturally, contextually sensitive way? How do we spread health messages so we could come together and be of service to one another?'"

FINAL THOUGHTS

Community engagement can enhance an organization's connections to its community, mission delivery, and even fundraising. This chapter has explored how to authentically and successfully engage communities, including:

- The five goals for building community-based projects
- Examples of community-based arts organizations
- How to plan projects and workshops
- Examples of successful community-based workshops

As you plan and implement projects, remember to focus on the five main goals: *seek relevance, engage your community, be ambitious, build partnerships,* and *demand excellence.* Listen to what your community wants and needs, and let ideas pour in from multiple sources. Plan projects that will benefit the community more than your organization. Be mindful of participant intersectionality and issues of equity, diversity, and inclusion as you plan. Build projects that are bold, are exciting, are meaningful, and spark long-term relationships between your organization and community.

NOTES

1. Author interview with Karen Zacarías, April 23, 2021. All quotes from Karen Zacarías that follow are from the interview, unless otherwise noted.

2. Life Pieces to Masterpieces, "Our History." Accessed June 2, 2021. https://lifepieces.org/who-we-are/our-history/.

3. Office of the Mayor of San Francisco, "The San Francisco Creative Corps pilot program will provide economic opportunities for 60 visual and performance artists, while also promoting public health during global COVID-19 pandemic." Accessed June 2, 2021. https://sfmayor.org/article/mayor-london-breed-announces-san-francisco-creative-corps-support-artists-and-promote-public.

4. Yerba Buena Center for the Arts, "San Francisco Creative Corps." Accessed June 2, 2021. https://ybca.org/san-francisco-creative-corps/.

14

ADAPTING FROM CITY
MOUSE TO COUNTRY MOUSE

I'd rather have barley and grain to eat and eat it in peace and comfort, than have
brown sugar and dried prunes and cheese—and be frightened to death all the time!

—The City Mouse and the Country Mouse[1]

INTRODUCTION

Audiences and funders tend to think of "the arts" as one big industry across the United States, but the arts function differently in different environments. Urban and rural environments, for example, pose different challenges and opportunities for arts managers. Beyond the clichés of country and city, understanding the differences in staffing, fundraising, board development, and programming can help an arts manager be ready to adapt and understand their colleagues in different regions. This chapter compares the role of the arts in rural and urban communities and explores strategies in how to approach fundraising, staffing, board leadership, programming, and organizational development in urban and rural environments.

FUNDAMENTALS

In February 2021, the Rural Policy Research Institute and the National Endowment for the Arts (NEA) published a new framework for studying the rural arts in the *Rural Cultural Wealth Research Priorities*, including some assumed differences between urban and rural areas based on previous research. Table 14.1, recreated from the report on the next page, reinforces some common assumptions about rural and urban environments.

In November 2017, the NEA released *Rural Arts, Design, and Innovation in America*, an in-depth study of where and how many arts organizations exist in the rural and urban United States.[3] Some of their findings were surprising, including:

Table 14.1. Potential Differences Between Urban and Rural Environments.

Characteristics	Urban	Rural
Relationship between place and culture	Culture creates place (e,g., architecture)	Place creates culture (e.g., geography, agriculture, and forestry)
Cultural infrastructure	Architecture, historical districts	Natural features, cultural heritage, nature parks
Investment in cultural infrastructure	Conservation of heritage assets Investment in complementary architecture	Tourism facilities, conservation of natural and heritage assets, investment in assets complementary to nature
Amenities	Urban, built amenities	Natural amenities, quality of life, Indigenous artistic concentrations, Indigenous cultural systems, less pollution, less congestion and crime, walkability
Tourism	Cultural, heritage, or art tourism	Cultural, heritage, ecotourism, natural tourism
Tourism	Mass tourism	Niche tourism
Social capital	Weak social bonding	Strong social bonding
Social networks	Global	Local
Civic leadership from arts orgs.	Less	More
Cultural clusters	Art districts: e.g., Broadway, French Quarter, Hollywood	Wine regions, ski resorts, wilderness areas, college towns
Cultural diversity	More diverse	Less diverse
Cost of living	Higher	Lower prices of land and housing
Cost of studio space	High	Low
Small art business venues	Largely away from home	Many rural artists work in home
Part-time employment	Less need, more opportunities	More need, less opportunities
Culture-related data	Archival data generally available	Archival data often not digitized

ARTS PRESENCE

- Roughly the same number of museums and theaters exist in rural and urban counties.[4]
- Music venues, dance companies, galleries, etc., and independent artists are *much more present* in urban counties than in rural counties, with 23 percent in urban areas and just 7 percent in rural counties.

BEAUTIFUL SETTINGS

- Most rural counties with arts organizations also offer some kind of scenic beauty or park land. A rural county is 60 percent more likely to have a performing arts organization if it also has a national park or forest.

QUALITY OF WORK

- Rural and urban arts organizations are equally shown to be "substantive innovators," with 30 percent of arts organizations in each environment creating new work, worth distributing elsewhere and being led by data-driven decision-making.

DISTANT AUDIENCES

- Rural organizations draw audiences from farther away, with 31 percent of audiences reporting they travel "beyond a reasonable distance" to attend versus just 19 percent of urban audiences. Given the challenge of winding, dark roads in rural settings, this perception of traveling *far* might relate more to the *traveling conditions* than to actual miles driven. Forty-five minutes across dark country roads can seem much longer than forty-five minutes down a well-lit highway.

IMPORTANCE OF BROADBAND AND ACCESSIBLE ROADS

- Two of the largest challenges facing rural organizations are the *lack of strong broadband internet* and *poor roadways and bridges* for audiences to travel.

FEEDBACK

- Thirty-eight percent of rural organizations highly value their audience's direct feedback, while just 26 percent of urban organizations do so. These numbers reflect the fact that rural organizations rely on a tight-knit local community for their support, and so are naturally even more beholden to their local audience's opinions than their urban counterparts.

INCREASED INCOME AND EDUCATION

- Individuals in rural counties with arts organizations earn an average of $3,500 more per year than their counterparts in rural counties without the arts. In rural counties with at least one arts organization, the number of college-educated adults is greater by 6 percent, and the population growth is higher than the national average for rural counties.

WORKFORCE VARIATIONS

- Arts workers tend to earn less in rural settings, with an average wage of $12 per hour versus $16 per hour in urban counties. There are many more workers available in urban counties, making it tough to find the right skilled workers in rural counties.

LOCAL LEADERSHIP

- Finally, 36 percent of rural organizations provide "a lot" of civic leadership in their communities versus 24 percent of their urban colleagues. Rather than reflect a lesser degree of devotion to civic leadership by urban organizations, as suggested by a brief on the study created by the NEA, these numbers seem to reflect the fact that civic participation is more possible and necessary for arts leaders in rural environments, where the potential to serve as mayor or a town council member exists more readily than in a major city where professional politicians thrive.[5]

These findings reveal a more vibrant arts scene in rural settings than one might expect, but they also reinforce the fact that most independent artists live, and arts activity happens, in urban settings. Depending on what state, what county, and what local municipality an artist or organization is in, the levels of activity, support, and opportunities can be very different. Some of these differences are obvious, but others are subtle and not always recognized across the field.

Being specific, avoiding clichés, and listening deeply to your community and audience are all keys to succeeding in either rural or urban settings. To help clarify, here is a deeper dive into some of the subtleties on how the arts differ in rural and urban settings.

EIGHT VARIATIONS BETWEEN CITY MICE AND COUNTRY MICE

1. *The Scale of Service.* In cities, you are serving sometimes hundreds of thousands of people. In small towns, you maybe serve a couple thousand. This means there is naturally less activity and less income in rural environments, which translates into smaller staffs, more modest facilities, and continually lower capacity than the larger, city-based arts.

2. *Individual Donors.* Donors exist everywhere and are the largest contributors to the arts, in both cities and the country. Again, the scale is what is different. In the city you may have some top donors at larger organizations giving millions of dollars. In the country, your larger donors give in the $5,000–$15,000 range, if you are lucky. Philanthropy and giving are more celebrated in the *culture* of cities as well. Large donors like to be seen and recognized for their gifts. In rural settings, donors with the resources to give significantly often want

to remain anonymous, because they fear the focus and ire of their neighbors if their wealth is displayed prominently.

3. *The Amount of Government and Corporate Support.* Businesses are smaller in rural areas, and the home offices of most major corporations are located in cities, so corporate sponsorships in rural areas tend to run in the $100–$1,000 range, with a select few hitting $2,500. At the same time, government support tends to be much less in rural environments than in urban settings, in part because local municipalities in rural environments have very little extra cash and rare capacity to support their local arts. Big cities, however, have larger arts councils and city funding dedicated to the arts. In cities, many arts organizations serve students with in-school programming or enrich student lives with active after school or summer programs, which cities often help to fund. At the same time, small rural school districts will actually fund an arts organization's in-school or after-school offerings, in part because the school needs the organization to provide arts programming and partially because there are so few organizations in rural settings that the school can afford to contract with the organization. In cities, the larger ecosystem of arts organizations means competition for school funding is intense and school districts will rarely contract with an organization, in order to not alienate any of the rest of them.

4. *Availability of Artists.* There are some rural areas with lots of artists, especially visual artists and sculptors, or older retired performing artists. Musicians also sometimes land in rural areas, though many need to become educators to pay the bills and can seldom find a way to earn a living via performances. In cities, artists are much more abundant, making it easier and more affordable for any arts organization to engage them. In rural areas, a lack of local talent means hiring, transporting, and housing artists from elsewhere for most projects. Between these extra costs and the lower amount of income available, rural organizations tend to barely scrape by if they want to offer their community high-quality work.

5. *Mindset.* In cities, the abundance of people usually means an abundance of viewpoints. Arts organizations can take great risks with their audiences and maintain a strong artistic aesthetic, having found their core audience among the many different viewpoints and tastes in their population. In rural areas, the limited population can mean a more limited amount of risk taking. Organizations need to be careful when trying new things. If they lose their core audience, they may not be able to find a new one. At the same time, rural organizations tend to have some very committed audience members, donors, and volunteers, who will stick with the organization no matter what, even if they need to defend it to their neighbors.

6. *Diversity.* There is obviously greater diversity in cities, racially, socioeconomically, age-wise, gender identity, sexual orientation, mobility, etc. The diversity of the population and the ability for artists and organizations to strongly express their artistic vision also leads to a diversity of work in the arts in many cities.

A variety of aesthetics and a strong ecology of museums, dance companies, theaters, music venues, and galleries all inspire and support more work in the cities. In rural settings, diversity does exist, but it tends to be diversity by age, politics, socioeconomics, sexual orientation, or gender identity. Some racial diversity does exist, though gathering people from diverse racial backgrounds can take more effort in rural environments. Doing so is well worth the work required. Promoting a safe space for diverse views and backgrounds is vital in rural settings, while it usually seems a more assumed priority in cities. Communities in rural settings are often deeply politically divided as well, and so finding ways to engage both ends of the political spectrum can be important.

7. *Transportation.* In most cities, there is some kind of public transportation. There is parking. There are well-lit streets and highways to travel in the evening. There are several options to get from point A to point B for artists and audiences. But in most rural areas, a car is required. Street parking is the norm. It can be very dark and treacherous on winding country roads, sometimes taking much longer to travel a short distance. With any kind of weather, the journey may be too daunting for most audiences and even artists. Most performances happen in the evening in both cities and countryside. The country lacks the rush hour traffic of most cities, meaning getting to performances might be less stressful in the country. But the dark hours after a show are more easily traveled in cities than the country, leading many rural audiences to not venture out for an evening event. Traveling forty-five minutes by car in the country can feel like a big hazard.

8. *Food.* Urban locations, especially those with thriving arts scenes, tend to offer at least a couple choices for eating and drinking before and after arts events. In smaller towns, there might only be one restaurant. Because of this, rural audiences often must eat at home before they come to an event, meaning they must travel to their homes after work, eat, then drive to the venue. Most restaurants in rural areas close by 9 p.m., meaning choices for after the show can be scarce. Rural audiences therefore cannot easily go from work to an arts event like urban audiences. They often cannot socialize or process what they have just experienced with drinks or dinner after the event, which lessens the evening's impact and their enjoyment of the event.

THE ROLE OF THE ARTS IN CITY OR COUNTRY LIFE

What about the *role* the arts play in cities versus the country? What do audiences and communities *value* about the arts in these varied environments? Ideally, artists and arts organizations in both environments find ways to truly entangle themselves in the life of their communities. In cities, this entanglement might manifest in:

- Vast, robust arts education programming in schools;
- Enriching the quality of life somewhat for hundreds of thousands of people of all ages across the city;

- Affecting discussions of social justice, equity, and equality at the local and national levels;
- Serving as national leaders in the arts;
- Large lavish facilities, which help revive neighborhoods and inspire additional business development and economic activity in their neighborhoods;
- World-class artists and projects, which help raise the profile of cities and add to the attraction for visitors, corporations, and business travelers;
- A home base for local youth and artists, who see the organization as their artistic or community home;
- Serving as an employer for several staff members and artists year-round, encouraging people to live in their city;
- Contributing countless full-time equivalent jobs to the regional economy;
- Major cultural events that bolster the city tourism and calendar and increase civic pride; and
- Partnerships with other local businesses, including restaurants, bars, and hotels, aimed at drawing customers for all of them.

In rural environments, communal entanglement can result in:

- Thriving arts education programs offering hundreds of students each year their only arts-based experiences;
- Supporting the local economy by generating jobs and economic activity with events and classes;
- Serving as a home base for local retired seniors who serve as volunteers for the organization; and for local students and families who rely on the organization for their only arts experiences;
- A few full-time and part-time jobs, with many more opportunities for participation, including robust volunteerism;
- Deep long-term relationships with smaller groups of individuals, including donors, board members, and volunteers, who feel a deep sense of ownership of the organization;
- Rare performances, exhibits, events, and classes;
- Deeply held partnerships with local schools and municipalities;
- Significantly raising the quality of life for thousands of people who rely on the organization for some of their only local arts experiences; and
- Funding provided by local school districts to support in-school and after-school programs.

BOARDS

In a city, board members tend to be busy professionals who can provide networks of other supporters, donations, and expertise in business, education, banking, law, etc. Board members view their membership as a feather in their professional cap and a new networking opportunity.

In the country, board members tend to be a mix of local retirees, working professionals, and parents whose kids are involved in the organization. Members give of their time and expertise, with more time to volunteer and roll up their sleeves to help than their city counterparts. They have less money and fewer networks, but more time and personal care to offer. They gain personal and communal pride in participating, more than any professional gains from the organization.

STAFF

In a city, there are usually more candidates to choose from for every position, more advanced skills in technology, social media, and program planning, and more young people who can afford to work in entry-level jobs in the arts. The workforce is more diverse racially, but it still tends to favor staffers with at least college degrees and on the younger side, due to the lower salaries found in the arts.

In the country, the workforce has less experience in tech, programming, social media, and the arts themselves. The workforce is older and less able to afford entry-level wages. A lack of diversity in the local populations and a lack of resources for training and "on boarding" new employees has kept employees less diverse, though that is changing. With just enough resources to operate and without a locally diverse population, tiny rural arts organizations are especially challenged when seeking to advance diversity, equity, and inclusion in their workforce.

FUNDERS AND DONORS

In the city, there are many more funders focused on inner-city needs such as education, food scarcity, and youth safety. It may be easier to draw the support of the NEA and other national funders, while city governments often maintain their own arts councils and therefore funding streams. More donors tend to have deeper pockets to give bigger gifts, because they may be connected with major industries and businesses based in the city.

In the country, it may still be possible to gain the support of the NEA, but the smaller local population inevitably leads to serving fewer people than in the city, which translates to less interest from major funders, who traditionally want to have big impacts based on numbers served. Now that *diversity*, *equity*, and *inclusion* are buzzwords for funders, the same bias away from whiter, older, less-populated areas may persist. State funding therefore is very important to rural organizations, as are local donors. Donors in rural areas tend to have less money than their city counterparts, however. Local municipalities (towns, villages, etc.) tend to have no money in their budgets for supporting the arts, because they are barely able to plow the roads, clean the streets, and secure the community with the small amount raised from a much smaller tax base.

TAXES

Culturally, farmers and other independently minded residents of rural areas *despise* being taxed by their local governments, since they spend the vast majority of their time and work on their own land far from anyone else. Increasing taxes for things like supporting local culture is a nonstarter. Cities, on the other hand, highlight the arts as a value-added for their local businesses and residents, and so they fund those arts, however meagerly. Tax rebates are sometimes offered to arts organizations constructing new buildings in a city, knowing that the new building will generate greater income for the city through gentrification and business development.

FUNDRAISING AND FINANCIAL MANAGEMENT

In the city, arts organizations have staff members or whole departments devoted to the company's financial management. Systems are complex and continually managed. Funds are raised for general operating costs and specific programs and projects. Budgets are created and finances managed with an eye to fundraising, and how outside stake-holders might view an organization's finances.

In the country, because of a lack of resources, fundraising tends to focus on what is needed *right now* for immediate projects. General operating expenses tend to be severely underfunded, in part because there are fewer places to raise them, but also because donors and local funders are less interested in funding them. There is a *cultural value* of an organization or artist needing to *make their own way and not rely on others so much*. Matching campaigns aimed at special projects and improvements to facilities tend to do much better than general fundraising. At the same time, financial management tends to be cash-based, even when accrual accounting is used, and less with an eye toward demonstrating programming needs for the donor and funder base, in part because the donor base does not want to hear the need for greater support. Local donors tend to set in their minds how much they give each year and stick to that amount for years. In the country, use of debt or credit to finance new growth in an organization is feared and avoided because organizations tend to operate on a shoestring. In cities, vast amounts of credit and debt are often embraced in order to build new buildings or expand programming beyond the organization's current means.

PROGRAMMING

In a city, arts programming tends to be a mix of professional and amateur arts, with an arts ecosystem of locally grown offerings mixed with exhibits, performances, and events brought in from elsewhere. A mix of traditional, classic, and "family-friendly" offerings fill the calendar, with new and more experimental work in the mix as well.

New York, Chicago, and Los Angeles have the most thriving arts ecosystems in the United States, while other midsized cities have been growing quickly, and even smaller cities are developing a healthy mix. In the coming years, it will be interesting to see how the mix of locally grown versus imported arts changes, while digital content

continues to grow. In some ways, locally grown arts may be more successful because of the costs and risks of productions or exhibits traveling across the country for longer periods. Flexibility and adaptability will be the key to any successful growth.

In the country, locally grown and amateur arts are more prevalent, with some professional arts in the mix. For the professional arts, artists from elsewhere often need to be brought into the community for the duration of the work, requiring housing, travel, and living stipends in addition to pay. Locally grown arts come from retired professionals, lifelong dabblers, amateurs, and recently relocated professionals from cities. New and risk-taking work is less prevalent than in the cities, because smaller resources and populations make producers and presenters more risk averse. Without a larger arts ecosystem, risks and failures stick out more visibly and may taint a rural audience's willingness to try an organization or artist again. With fewer touring professional offerings in the future and a trend of city populations moving to the country, local offerings might become more professional and higher quality in the wake of the global pandemic.

AUDIENCES

In a city, audiences with enough time and money often rely on the arts as part of their regular lives. They attend more than one arts event each month. They sample work from all kinds of artists and institutions. They enjoy a mix of free and paid events. They often subscribe to one or more arts organizations, because they attend so frequently. Audiences with less time and money, especially those in poorer neighborhoods, may connect with the arts online and via for-profit arts offerings, including movies, streaming services, television, and YouTube. But they may feel disengaged and even shut out from most arts offerings, because the artists or organizations have not built bridges for them to access the work.

Audiences are large in urban settings, but they are divided. Age, socioeconomic status, race, education, and many other factors can prescribe whether an audience member feels welcomed or connected to the arts. Many arts organizations invest in arts education and community engagement programs in order to try and bridge these gaps with varying success. Until issues of programming, costs, scheduling, and capacity are tackled more fully, divides in who attends, how they attend, and whether or not they attend will haunt the urban arts. The era of Black Lives Matter and the global pandemic has invited and required arts groups to rethink all their assumptions, including who their future audiences will be.

In the country, audiences are smaller because the population is smaller. A lack of decent broadband and internet access means that many audiences still need printed materials mailed to them in order for them to know about upcoming events. A lack of public transit means that audiences need a car or a friend to bring them to events. A lack of public parking and major roads means that, even with a car, traveling to the event can prove difficult. Weather and a lack of sufficient lighting at night means that audiences may be wary about driving in the dark, especially after the event. Work

schedules, especially those of farmers and other seasonal workers, mean that a regular 7 or 8 p.m. event is not possible to attend. Artists and arts organizations need to rethink when and how they offer their work to better suit these challenges.

A lack of racial diversity in the community might make audiences of color even less comfortable attending an event if they know they will be less represented in the audience or onstage. Rural audiences have less access to other arts events than their urban counterparts, meaning they have less of a habit of attending the arts and must be convinced that these events are worth their time. Because rural populations rely on the same limited resources (one grocery store, one library, one public school) together, the population is less divided physically on a daily basis, and therefore extreme poverty can be less obvious than in the city. The same barriers of cost, relevance, time, and travel exist as in the city, but they can be less obvious and therefore even more insidious to blocking access to the arts. At the same time, the fact that rural audiences might have less access to arts offerings can make those few offerings even more valued and cherished by audiences.

VARIATIONS

CONTRACTING IN THE COUNTRY

When I arrived at Hubbard Hall in Upstate New York in 2014, there was no understanding of the differences between *Presenting* and *Producing* work. *Producing* means you were responsible for all the resources needed to do the project. You must provide the money, staff, supplies, space, promotion, etc., for the show, event, or exhibit. You therefore also have control over what is being produced: what artists, what show, and how they will show the work. Producing gives you artistic control of the project and a chance to generate work of your own, for your community. It also puts all the financial risk on you, since you have to pay for everything and hope your box office income and donations can more than cover the costs.

Presenting means that you are showing someone else's work as part of your season of offerings. Someone else chooses what and how it will be done. They hire the artists, rehearse it, design it, and build it. You host that work in your space, promote it, and manage the audience's experience of it. In this model, you contract the company doing the work and agree on a box office split or a basic fee for presenting their work. Presenting means the work is coming in from elsewhere, so it's not your work (though you are identifying with it by presenting it), but you also take on much less financial risk. With either an agreed-upon box office split or a base fee, you can control the cost of the project for you and even better guarantee that you will at least break even on the project.

Hubbard Hall had been presenting a chamber music series for decades and guaranteeing the group a payment of $1,000 regardless of the box office, which often meant the Hall lost a lot of money on this series, since it was providing space, utilities, tech, and staff time for every concert in addition to the financial guarantee. Recognizing

this series was a presentation and *not* our production, I insisted on negotiating a new contract with the group, one that split the actual box office so that the Hall would always gain 30 percent of the net box office, plus we would first take the costs of our staff time out of the gross box office total. This new deal ensured we wouldn't lose money on staff time, and sometimes we would even gain some funds to help pay for the space and utilities used.

Because this group had never been faced with professional contract negotiations, they were largely outraged the first year or two for having to sign such a contract. Even the Hubbard Hall board failed to understand why this was so important and complained to me about these contracts. But to their credit, they did not stop us from renegotiating and implementing these new contracts. For decades, the focus had been on simply getting the work up and done, while our general operating costs kept being underfunded, and therefore our capacity was being eaten away. After the first two or three years, the chamber music group gradually settled into this new reality and accepted it. It caused me a lot of stress, but it made the organization healthier in the end.

LONGER RUNS VERSUS SINGLE EVENTS

Another difference between urban and rural arts events can be *when* and *for how long* they occur. In general, urban settings can afford and will demand an arts offering to be available for a longer period of time. A hit exhibit, dance show, or theater piece might run for months in the city in order for larger audiences to gain access. They may be offered on the weekends and in the evenings, but also on weekdays and at times more suited for seniors, students, and young professionals. The bounty and demand of urban audiences means that arts organizations can experiment with many opportunities to share their work. Evening access to museums and midday Wednesday performances are two examples of ways the arts have tried opening access to more audiences in recent years.

Rural audiences are smaller and need fewer weeks of offerings. They may be wary of the more traditional times of arts offerings, with evening performances at 8 p.m. presenting challenges because of weather, roads, a lack of lighting at night, and an older population less inclined to be out at night. Artists and arts organizations in rural environments often benefit from offering limited runs or single events, with times and days offered to better suit a rural environment. For example, at Hubbard Hall, concerts on Sundays at 6 p.m. became a big hit, because they were late enough to allow families to spend their Sundays on other projects during daylight hours but early enough to be over by 8 p.m., thus making getting home easier and safer. Saturday offerings at 5 p.m. also worked well, as did open-door exhibits available during weekdays and weekends.

Flexible and limited scheduling seems to lead to fuller audiences in the rural arts, though these limited runs also require robust marketing efforts well in advance so that audiences can be aware of and prepared to attend the event. Offerings of popular titles (hit musicals) with local talent included also seem to do especially well. For rural audiences, having friends and family in the cast is the best way to guarantee a portion of audience attendance. The draw to see friends and family perform is sometimes

the best way to overcome the hurdles of cost, transportation, and time. An unknown show filled with performers from elsewhere would seem to be appealing to audiences without a lot of variety in their lives. On the contrary, the risks of spending money, time, and travel on something unfamiliar can be too great a barrier for rural audiences, however great and different the offering.

SMALLER NUMBERS, DEEPER IMPACT

In cities, artists and arts organizations may serve hundreds of thousands of people each year with high quality, risk-taking, and extraordinarily relevant work. In rural areas, an artist or arts organization might serve hundreds or a few thousand. The work will be fewer and farther between, more of a mix of classics and new work, and produced with a mix of amateurs and professionals. But because the work is rare and local, audiences may remember it more deeply and for a much longer time. The fact that their friends and relatives were involved in the project makes it relevant to their lives. When the work is centered on topics relating to their lives as well, such as farming, the work resonates in an even deeper way. For example, here are two projects, one based in the city and the other in the country, each deeply relevant to their audience:

The Good Neighbor: 2008, Washington, DC

At YPT in 2008, we engaged our community in Washington, DC, to create a new play about people experiencing homelessness in the nation's capital and issues related to serving those experiencing homelessness. It toured throughout Greater Washington and was deeply relevant for those who saw it.

The Farming Plays Project: 2016–2017, Washington County, New York

In 2016 and 2017, Hubbard Hall Center for the Arts and Education in Upstate New York, engaged our local farming community to create a new play about issues of farming in twenty-first-century America and the lives of those who farm and have farmed for generations. It performed for and resonated deeply with a rural audience.

FINAL THOUGHTS

The arts function a bit differently in urban and rural settings. The amount of money, time, community influence, and social impact differ slightly. There are fundamentals and variations in each setting. Paying attention to your environment is half the battle.

Ultimately, how you engage urban and rural communities can be based on the same key principles:

- Listen to the community. Who are they? What do they want and need?
- Invite that community. How can you meet them where they are? How can you entice them to try you out?
- Serve that community. How can you serve their needs? How can you challenge them to grow?
- Repeat.

NOTES

1. Bygosh.com, "The City Mouse and the Country Mouse," https://bygosh.com/kids-classics/the-city-mouse-and-the-country-mouse. Accessed May 17, 2021. Based on *Aesop's Fables* by Aesop, circa 620 and 564 BCE.

2. The Rural Policy Research Institute and the National Endowment for the Arts Research Labs, "Rural Cultural Wealth Research Priorities," Rural Policy Research Institute, February 2021.

3. This study defined "urban counties" as areas deemed "metropolitan areas" by the U.S. federal government's Office of Management and Budget as thus: "A metro area includes one or more counties containing a core urban area of 50,000 or more people, together with any adjacent counties that have a high degree of social and economic integration with the urban core."

4. An equal number of theaters being present in rural and urban counties is a surprising finding. It seems important to note that the report does not distinguish between summer/seasonal and year-round theaters. Given the report found that the performing arts were much more likely to exist where beautiful parkland exists, it might be safe to assume that a good number of rural theaters are summer theaters and not year-round. A more substantive comparison might be the number of productions in urban and rural counties each year or the number of artists employed each year.

5. National Endowment for the Arts, "Rural Arts, Design, and Innovation in America," NEA Office of Research & Analysis, November 2017.

15

REBUILDING AN ORGANIZATION

Any director comes in and starts to find out what people think, what's going on,
who's doing what, and what's working and not working. It's about a culture
shift, and getting everybody aligned around a vision.

—Mary Ceruti, executive director, Walker Art Center[1]

INTRODUCTION

Rather than *grow* a new organization, you might need to *rebuild* an existing one. If you arrive at an organization in crisis, you will need to quickly triage and manage multiple issues. The organization might have developed significant debt, drifted far from its mission, or lost most of its staff and board—but it could still be worth saving. Established arts organizations have their 501(c)3 status, a track record for programming and fundraising, a board of directors, and some semblance of staff or volunteers. They might still have supporters and donors who believe in the organization's mission. But rebuilding an organization takes time. This chapter explores *how* and *why* to rebuild an existing arts organization.

Rebuilding is a process of doing and not doing. Taking action but listening. Looking to long-term change but also reacting daily to new learning, and seeking out lessons on what works and what doesn't, what is valuable in the organization and what isn't. The rebuild needs to be organic and touch on all aspects of the organization at once. You cannot come up with a strategic plan over a couple days and then force that plan into action. Any effort to increase fundraising probably includes changes to your programs, operations, and even staffing. You will need to question everything, including your mission, and whether you are delivering something valuable to your community: Why does the mission matter? What are you doing for the greater good? And how can you do it better? Once you agree it is worth saving, how do you begin?

FUNDAMENTALS

FIVE REASONS TO REBUILD

Rebuilding organizations can be tough. Their missions may be unclear. Their staff might be gone. Their board may be dazed and confused. Their programs may be next to nonexistent. But even in the worst of circumstances, if the organization can still serve a purpose, it's worth trying to rebuild. Here are five reasons why:

1. *Starting a New Organization Is Harder.* It's tough to gain 501(c)3 status, it's tough to gain donors for an unknown cause, and it's tough to start programs based on no organizational history. Rebuilding an organization is usually just a tiny bit easier than starting something brand new.
2. *People Trusted You.* Okay, maybe not *you*, if you're new to the struggling organization. But at some point, donors, staffers, board members, students, and audiences trusted this organization to deliver. They gave you money. Money given to the organization was tax-free and therefore in the public trust. Recovering and rebuilding that trust is important. For every arts organization that collapses, donor trust erodes.
3. *You've Got Nothing to Lose.* If an organization is already ready to collapse, any progress is a win. With the organization already legally established and with a track record (albeit maybe a bad track record at this moment), you can focus on building programs and a mission that can truly serve your community.
4. *Funders and Donors Want You to Succeed.* People who have invested in you in the past would rather see you succeed than fail. They already have a vested interest in your success. Rebuild their trust. Show them that things are turning around, and you may be able to quickly rally their support.
5. *You're Free to Try Almost Anything.* When an organization is ready to collapse, people are more open to trying new things to help it succeed. The status quo is gone, because the old model failed so completely. You have a golden opportunity to innovate, experiment, and try new ideas. Play. Dare. Risk. This is a great opportunity to learn and build new practices.

KEY CONSIDERATIONS

If you decide to rebuild an organization, you might begin with a S.W.O.T. analysis to unearth key issues and priorities for the organization. As you begin working to transform the organization, there are several key considerations to keep in mind in growing each component:

The Board of Directors

The key relationship for any staff leader is with the board and, most importantly, with the board chair. You will need to develop your relationship with your board

chair, even if you think they may not be the right chair for you. Coffees, lunches, and phone calls can help you and your board chair get on the same page regarding the challenges and opportunities facing the company. Hopefully, via your interview process or your previous years at the company, you have at least a partial bond and similar point of view to your chair. If you find yourself in the worst-case scenario, with deep disagreements between you and your chair, you will need to quickly find other members of the board with whom you can work and begin a plan to perhaps transition those members to board leadership. Or you may need to face your inability to make significant changes and therefore resign your position, eventually. But again, listening to everyone's concerns and finding common cause with wanting to improve and grow the company will usually provide a positive path forward.

Budgeting

You will need to ensure you have a budget that is clear enough for you and your board to understand, along with both summarized and detailed versions to share with people outside the organization. You also want to ensure you are budgeting in such a way as to reflect the complete cost of what you do so that funders, donors, and sponsors can support both direct and indirect costs of what you do. Revising budgets to clearly reflect the true story of what you do is vital so that, as you begin to meet with donors, funders, and board members, you have clear budgets and updated numbers to show how you are growing as a company, refining your practices, and better articulating how you do what you do, and why you need their support.

Staffing

Do you have the staff you need to do the work? Is your staff the right size? Does your current staff have the skills and mindset to grow the organization? Are there people and positions to pursue fundraising, financial management, programming, and operations?

Assessing your staff and making changes might take at least a year after you arrive. You cannot afford to make too many mistakes, so choices should be made quickly but carefully. You need time to see how things work, find places where pieces are missing, and reimagine staff portfolios, in line with a vision for how things can change. Hopefully you find people there who already realize the need for the company to grow and change and are hungry for that change. They can be allies and advocates in this work.

Be open with the whole staff about the company's need to change in order to survive and thrive, but consider keeping some changes under wraps until you hit a natural time of the year for evaluations and staff changes (often toward the end of the fiscal year). You don't want to scare the current staff away by signaling that they may be fired soon anyway. Find a few trusted allies on the board or staff to help you think the matter through, but otherwise keep the question of staff turnover to yourself until firm decisions have been made and are ready to be shared.

Policies and Administration

If an employee handbook does not exist, develop one. There are many examples online. You can also ask colleagues to see theirs as an example. If staff members need to ask random questions about time off, official holidays, hours, and compensation throughout the year, it can engender a feeling of unease about their security in the company. Not having a handbook also means the leader needs to constantly communicate expected policies, from those governing sexual harassment and drug abuse to email, social media policies, and intellectual property issues. Having all of these policies articulated in one place, as well as providing it to new employees before they begin work, helps to keep everyone informed and safe in their work.

Bylaws and Board Policies

Similar to the need for clear, compelling job descriptions for staff, the board needs clear bylaws, policies, and committee structures. A big part of growing the board and rebuilding the organization can be the rewriting of bylaws and establishing clear policies. Term limits create a structure through which members of the board can be limited in how many years they can serve, which also ensures that new members must be recruited on a regular basis. Continual recruitment requires more work for the board and staff leadership, but fresh candidates and new members also bring fresh blood and new resources to the organization. If existing board members have served for more than six years already, and are not contributing significant effort or funding, set up a process with your chair to gracefully begin rotating these board members off the board. Develop a list of specific skill sets, professional backgrounds, and networks you hope to gain for the board, then activate a nominating committee to pursue those types of candidates.

Committees that serve specific purposes and meet between the main board meetings can focus members' work on specific goals and objectives. Board members are always donating their time, so honor their service by being *as specific as possible* in what you ask of them. What do you want them to do? How much money do they need to give or get? Work with them as partners to determine, given your specific situation, the best role of the board and how it can help, while delivering on its responsibility to oversee and protect the organization.

Programming

Your programming may or may not be delivering on your mission. If the organization has been short on staff or funding, some programs may have been loosely implemented. Mission drift may also have allowed programs to spring up that are unrelated to your core mission, either because someone on staff thought it was a good idea or because a funder or donor wanted it to happen. These programs have little to do with

your mission or do not serve enough participants to be sustained. Gain the support of your board chair and then cut them as soon as you can.

You may still be programming based on what your audience wanted twenty years ago, without an eye to growing or engaging new audiences, or without challenging the company and its audiences with new ideas. Take time to observe which programs work and why. Hopefully you have staff who can help in this effort and can begin making small changes in year one, with the aim of adjusting things further in year two. If you rely on subscribers or attendees to specific events, you may need to let them know in advance of changes in order to get them on board with the new direction, assure them of your continued commitment to them, and ask for their support and bravery in trying new things.

Facilities and Technology

When you start to rebuild your company, look around at the physical plant and see if you have what you need. You may or may not own your facility. You may rent your office or performance space. Regardless of how much physical plant you maintain, you will need to figure out if you have what you need, if you can afford it, and how to maintain and grow it.

When I arrived at Young Playwrights' Theater (YPT) in 2005, the company did not yet have a computer server, so none of its files were regularly backed up. Over the course of seven years, YPT implemented a series of new computers, along with a hard drive server and eventually an online server in the cloud. These technical improvements helped us develop our programs by creating new curricula and assessments, and it improved our marketing, with enhanced in-house graphic design and video capability. Without the correct equipment, these improvements were impossible. We were also able to pursue and win new grant opportunities, which provided us with much-needed funds for infrastructure, including these computers and servers.

When a board, donor, or volunteer balks at spending any money on equipment or facilities, they miss the point that a decent desk chair, air conditioner, or desktop computer can make the difference between delivering on your mission or not. Too often not having enough funds leads to bad decision-making and cutting costs until it's impossible to succeed. As management guru Michael Kaiser often points out, you cannot cut your way to success. Even if you find yourself in a fiscal crisis, figure out what you need, convince your board and staff that it is necessary and will pay dividends, and then spend it.

Fundraising

Fundraising can be one of the biggest challenges after a leadership transition. The previous leader may have had connections and relationships to donors and funders you

do not yet have. Or they may have dropped the ball on deadlines and reports and damaged these relationships before they left. Hopefully your predecessor sets you up well and even introduces you to their contacts. But if they do not, all you can do is reach out and invite these funders and donors to coffee, lunch, or just a meeting, to share with them your new vision for the company, your current activities, and to listen to any of their concerns or questions about the organization.

This simple olive branch lets funders and donors know that you care and that you want to have a positive relationship with them, beyond always guaranteeing that your applications and reports will arrive on time. Of course, your time is limited. You will need to choose how much time you can spend on each funder and donor, partially based on their support of you. But make a plan to reach out to everyone in some way (even a semi-personalized e-blast to smaller donors helps) so that everyone gets the message that a change has happened, the future is bright, and you want to thank them and engage them as partners.

Never miss a deadline. You are one of thousands of people asking donors and funders for their support. Missing an application deadline usually means you cannot be considered for that opportunity. Missing a report deadline means the funder may not accept any further applications from you, or at the very least will not prioritize you in the next round. Missing a thank-you letter for a donor after they have given a gift means they may see you as unappreciative and sloppy. They may also have doubts about your use of their money.

Relationships also improve when you care for them in between the deadlines. Invite donors or a representative from a funder to lunch or coffee. Hold a special event to talk with several donors at once and give them some exciting insider info about company plans. Let them know you are not asking for anything right now. You just want to honor the relationship and update them on your progress. Then, at a later date, you will ask for their support.

Marketing

Marketing tools and policies may be severely outdated when you arrive. Figure out where you are lacking and how to update operations as soon as possible. Your messaging to the outside world is one of the quickest ways to broadcast change and improvements. Look to your website and social media presences first. Figure out how to make them more engaging and user-friendly.

Marketing can function as a tool to sell tickets or raise money, but it is also your voice to the community, your calling card, your image. Ensuring it is positive, professional, clear, and compelling is a key to rebuilding any organization. Find ways to involve others in the decision-making process. Engage early-career innovators who understand social media and the value of having a strong online presence, and who are looking to create cool content while supporting a good cause.

Reputation

How you are viewed is often tied to how you operate. Are you and your programs reliable? Is your organization pursuing a compelling mission? Do you communicate that mission clearly? Do you have a history of excellence? Do people care about you and speak well of you, your staff, your board, and your programming?

This is one area you cannot fix on your own. Focus on fixing everything else and delivering *more* for *less,* and your reputation will grow. Market yourselves clearly, behave professionally and with the utmost care for everyone involved, and your reputation will be repaired. Similar to how your brand affects your impact on the public, your reputation lives inside others. When they *see* you doing better, they will *say* you are better.

VARIATIONS

FIXING THE LEAKS

When Anna Glass first arrived at Dance Theatre of Harlem (DTH), it was as a consultant. She would eventually become the executive director of the organization and spend years rebuilding what felt like a startup organization with a huge existing brand:

"I was brought to DTH by Darren Walker, with the Ford Foundation, and Anita Contini, with Bloomberg. They had asked me back in 2014 to do an assessment of the organization because at that time, the organization was financially struggling. And I did the assessment, and presented it to Darren and he said, 'Great, that's exactly what I thought was happening. Now I need you to fix it.' I was consulting, I had just had my daughter, I was independently producing, and it was not my plan to become a full-time executive director."

Anna took on the role as a consultant and brought in Sharon Luckman, who had just retired from the Alvin Ailey Dance Company.

"And Sharon was great, I learned an immense amount from her in that short period of time that we were working together. It was maybe four or five months that we had the consultancy gig. And together, what she and I learned was that it wasn't *what* Dance Theatre of Harlem was doing, it was *how* Dance Theatre of Harlem was doing what it was doing. That was the problem."

After Sharon Luckman fully retired, Anna was convinced to stay on as DTH's full-time executive director: "I stayed on because it was just very clear that all we had to do was fix how the organization was executing what it was doing; that that would be the source of sort of switching things, moving things forward. It was several years of intense unearthing, intense putting the pieces together. DTH was a leaky ship and it had leaks all over the place. Those first twelve months were just patching up the holes, so that we could then assess, what do we need to fix?"

But even after patching the leaks, the organization was running a little wild: "I described DTH at that time as like, if you were on a stagecoach, it was like, every single

department, every single division of DTH was going in a very different direction. You had one horse that just wouldn't move. One horse that was moving too quickly. One horse that was moving in a different direction. I mean, it was just like, the wrangling of these pieces, really was the focus of my energy for those first several years. And I was really, really intentionally focused on fixing our foundation. Even though we had this big name, we had just brought the company back in 2012. *And so, it was a startup company, but with this huge brand.*

"Virginia Johnson, the company's artistic director, was focused on honing the artistic quality of the institution. And simultaneously, I was like, 'Okay, I've got to take this department, and I've got to focus my energy on this department.' And it meant that there were other departments that just didn't get touched; that they just had to be Wild West for a while, because I needed to focus on one thing at a time."

Slowly but steadily, Anna and Virginia turned the company around: "The company had better brand awareness, people were saying good things about what they were seeing from an artistic output. We were just beginning to see administratively that things were tightening up. . . . And we had a lot of people paying attention to who and what we were, who we are, and what we were doing."

Anna brought in financial consultants as well, to help her analyze how to set DTH on a firmer path financially: "I was really doing the grunt work in sort of getting this institution administratively back on its feet, I had been working since day one with a consulting group, a nonprofit finance consulting group that really focuses on sort of strategy, big level conversations around sort of capitalization of nonprofits. And we had been working very closely on sort of a lot of analysis work on why we were struggling. What were the parts of our business model that were creating the structural deficit that this institution had historically had? And we'd finally gotten to the end of all this work."

All of this hard work made DTH ready for new opportunities and new levels of support: "We had a fabulous memo pulled together that I turned into a PowerPoint presentation. And I went in front of the Mellon Foundation. And they had been asking me for years, 'When are you going to put an application in?' and I was constantly like, 'Not now, not now,' because I didn't want a project gift. We were not in the space of wanting to do a project." Now the organization was ready. "I knew that I had one shot to request a significant transformative gift. And that was what I was aiming for, not some crazy six-figure gift that was only going to be patchwork."

"I presented this proposal to the Mellon Foundation, and timing was everything. And they came back and said they wanted to make a $4 million gift to us, which was the largest gift that DTH had ever received, historically. It really took just a drastic upward turn for us in 2019 with that gift. And despite the pandemic, we've still been trending upward. And I think it's just largely because we've been working so hard at fixing the problems that we've had institutionally."

RAISING YOUR LOCAL AND NATIONAL PROFILE

If you can tell a clear and compelling *story*, while pursuing your mission, you will raise your profile. Find ways to do your work in partnership with other organizations, and with *such relevance* that you merit being covered for free in the press with *earned media*. Think about how new projects or programs might help your organization to be covered in the mainstream and national-level media. A little national-level coverage can still help a great deal with local media, funders, and donors.

At YPT, early in my tenure, we decided to shift our In-School Playwriting Program from a few classrooms across the city to the entire eleventh grade at Bell Multicultural High School in Columbia Heights. Instead of thinly serving several schools, we would serve all the students in one grade at one school with a fully integrated standards-based curriculum. This shift to deeply serving one entire grade level, and serving as their English class every Wednesday, gave the company a *great story*, while also being cheaper than spreading out to multiple classrooms throughout the city. The model also gave YPT an in-depth partnership with one school, where the company could develop a rigorous program and practices. It became the cornerstone for YPT's profile throughout Washington, DC.

At the same time, YPT created special projects and partnerships, working with the Smithsonian Institution on several new plays, including *Retratos: Portraits of Our World*. Partnering with the Smithsonian Institution gave YPT a chance to leverage the Smithsonian's good name, even though YPT only received $5,000 from the Smithsonian for several months of work. But the project gave YPT something much more valuable: higher-profile coverage in the media, and an official association with the Smithsonian, further building YPT's brand in providing excellent arts and education programming. The company gained hundreds of thousands of dollars in donations and grants for years because of the association.

CREATING PARTNERSHIPS

You can grow and expand your capacity immediately by forging partnerships with other organizations. Think about how you might partner with a larger organization, either a larger arts organization or a corporate entity, on a specific project. Maybe *you* have wonderful programs and approaches to engaging students, as YPT did. And maybe *they* have a larger profile, reputation, and a larger stage, like the Smithsonian Institution did.

Together two organizations were able to combine forces and create something impossible for either one. Working with the Smithsonian Institution led YPT to working with the Kennedy Center and the White House. Those projects in turn led the company to be sought after by the Fannie Mae Help the Homeless Program, and ultimately to working with the U.S. Department of Justice. YPT's partnership with Bell Multicultural High School led to other schools and school districts seeking to partner with the company.

Step Afrika! at Arena Stage

In May 2021, Arena Stage in Washington, DC, announced an exciting new partnership with acclaimed DC dance company, Step Afrika!, via Facebook: "We are excited to announce a three-year partnership with Step Afrika!—the first professional company in the world dedicated to the tradition and cultural heritage of stepping—beginning Fall 2021. The partnership will include three productions, presented and produced over the course of three years, beginning with "Drumfolk"—a rhythmic storytelling of the history of African American percussive by the Stono Rebellion of 1739 and the Negro Act of 1740.

"As part of our commitment to championing diverse voices and engaging audiences, this partnership will further enhance collaboration, experimentation and build upon our combined strengths in serving our community."

"This is a fantastic partnership. . . . Step Afrika! is a distinctive and explosive dance company and a powerful part of Washington's artistic community," wrote Arena Stage artistic director Molly Smith. "This partnership will be an incredible opportunity to develop one-of-a-kind productions that can then tour the world," wrote Step Afrika! founder and executive director C. Brian Williams.[2]

For years Arena Stage did not host or partner with other local arts organizations in DC, especially not with other arts disciplines. So, why now? The partnership presented an opportunity for Arena Stage to align themselves with a distinguished African American dance company and save significant expenses by giving Step Afrika! a slot in their regular season for three years. For Step Afrika!, the company gained their first major venue in DC, with the extra marketing afforded by Arena Stage, while increasing their national profile and their reputation by aligning with such a larger, renowned regional theater. This partnership was a win for both organizations and something that should have happened years before. With the pressures caused by the global pandemic and recession, the time was right for collaboration.

FINAL THOUGHTS

Given how many nonprofit arts organizations already exist, rebuilding an organization is often smarter than starting one from the ground up. You will, however, inherit a history with any existing organization. Some of this history might be negative and provide obstacles to moving the organization forward. Listening to each aspect of the organization and figuring out how to move things forward quickly and organically is key. Find partners in this work, on the board and among the staff. Refocus the mission and let that help to refocus every aspect of the organization. Interrogate everything. Keep what works. Jettison what does not. Stay in it for the long haul.

NOTES

1. Author interview with Mary Ceruti, May 7, 2021. All quotes from Mary Ceruti that follow are from the interview, unless otherwise noted.

2. Arena Stage, "We are excited to announce a three-year partnership with Step Afrika!," Facebook, May 11, 2021. Accessed June 23, 2021. https://m.facebook.com/story.php?story_fbid=10159829591217638&substory_index=0&id=6277352637.

16

FOLLOWING A FOUNDER

Sniff the fire hydrant before you pee all over it.

—Anonymous

INTRODUCTION

There are many issues when a founder leaves a company. The organization up to that point has been, in some way, *their* project, their passion, their kingdom. They built the organization from the ground up, often with a bit of trepidation on whether it was worth all the investment and time because it was *their* idea and purpose. This humility or natural ambivalence about the organization sometimes leads founders to not treat their companies as institutions, even after running them for decades. They stay focused on the immediate needs of the organization and putting out daily fires. They therefore fail to invest in long-term planning, infrastructure, facilities, or even sufficient staffing. Which is why there can be so many issues to address when a founder leaves.

Usually, the first attempted transition from a founder to a new leader is a disastrous failure. Often a board of directors or new leader approaches the transition as if the organization can immediately switch from being the way it was under the founder to a new, "more professional," and institutional model. This dramatic shift from being one organization to a completely new one, with new expectations of fundraising, staffing, and programming, puts too much stress on the organization and causes all kinds of system failures, which are often then blamed on the founder's successor. Following a founder is therefore a tricky task, but one that can succeed with a combination of patience, vision, and strategic changes. This chapter explores how to successfully follow a founder and examines four examples of successful transitions.

FUNDAMENTALS

FALSE EXPECTATIONS

The expectation is that new leadership will be able to instantly raise more money, improve efficiencies, dynamically increase programming, improve staff morale, and on and on. But what this attitude ignores is that organizations are living, breathing entities, filled with people who are used to working in a certain way. They cannot and will not change overnight. At the same time, there are often huge hidden issues left behind by the founder. Not necessarily because the founder ignored or actively hid these issues, but because the founder was focused on beginning and birthing the organization and therefore didn't see (or wasn't able to care about) a myriad of issues, from debt to operational deficits.

Oftentimes the first big goal of any successor is simply to get the organization to a place of sustainability and stability. If the new leader or the board of directors doesn't allow for the time and resources needed to fix things—or if they face (or trigger) huge resistance to necessary changes—they can hit a wall that cannot be overcome, and their tenure leads to an organizational implosion. Here are five recommendations on ways to make it work.

FIVE KEY STEPS TO SUCCESSFULLY FOLLOW A FOUNDER

1. *Sniff the Fire Hydrant Before You Pee All over It.* Your instinct may be to change a lot of things immediately. Don't. *Take time* to listen to the organization and the community. Change what you must to make things run a little better, but take the first year to really learn and assess how things work. Note: Many people, especially the board and staff, might expect or want you to make a lot of changes fast, if they see you as the rainmaker or the savior of the organization. But if you make changes too fast and things do not work, they will also be the first to dig in and blame you, because part of them wants things to change and *part of them does not.*

2. *Honor and Involve the Founder.* Your views and ways of working will probably differ *greatly* from the founder. Many decisions they made, or did not make, might still be making your daily life difficult. Now that they are out and you are in, many stakeholders may view the founder's tenure with rose-colored glasses—and view you as a big problem. That's okay. It's also okay for *you* to be *frustrated* with the founder. *Do not badmouth them.* If you complain about the founder, you may do irreparable damage to how others view you, and you set the precedent for others to complain about you whenever they face challenges with the organization. Keep doing your work, speak well of the founder, remember they are the reason the organization exists, and just keep moving forward. Eventually you will be viewed as the leader of the organization. Your grace and kindness will endear you to others. Finally, find ways to involve

the founder for a while, if at all possible. You could ask for their advice (and even have coffee occasionally), invite them to your events, or even hire them as a staff member or artist, as I did in both my founder transitions. Do what is useful and not confusing for them or others. If you can involve them in some way with grace and kindness, their long-term supporters will love you for it, and your confidence in doing so will make you look stronger. We often fear that having a founder around makes us look weak or incompetent, as if we are leaning on them for help. On the contrary, we appear strong and at ease when we can give the founder the gift of having easy access to their long-term home. Having said all that, some founders or previous leaders can prove hostile if they were not ready to leave or regret doing so. In those cases, communicate your concerns directly to them and find ways to manage and limit their access to you and the organization as needed.

3. *Be Optimistic. Be Patient.* The first few years are really challenging. Keeping your head above water and continuing to focus positively will help the board and staff relax and know that you're in it for the long haul. Sometimes frustrations can lead a new executive or artistic director to become pessimistic and confrontational. Sometimes the pressure to deliver change can push leaders to start making ultimatums to their board or staff: "This will only work if you give me x." Stay positive. Even if the board and staff are frustrating, keep everyone thinking positive and feeling like you are all one team, because you are. You don't need absolutes. You need more time and help to get things done. Often these transitions fail because of *fear* and *impatience*. Everyone fears that the organization won't succeed under a new leader. This fear drives them to become impatient to see drastic changes and success. This *fearful impatience* drives one or all of them to pull the plug on the new leadership before it's too late. Ironically, they will have pulled the plug too early, before the relationships and organization had a chance to succeed.

4. *Promise Less. Deliver More.* Be cautiously ambitious with your staff and board, but work hard to deliver some wins in your first year. Once you win that first new grant, or start a widely successful new program, or increase staff satisfaction and functionality, or end the year with the first budget surplus in years, the organization will start to truly become yours.

5. *Remember It's an Evolution More Than a Transition.* When a founder leaves and a successor arrives, many people expect the organization to drastically change on the very day the leader arrives, as if the new leader just flips a switch and transforms the company. They imagine the organization changing like when the ball drops in Times Square and we declare it's a new year at midnight. But the organization is a living, breathing organism, with much of the same staff, board, programs, donors, etc. Growing the organization takes time and is filled with dangerous pitfalls. Everyone involved needs to understand that the organization will change and grow, but it will take *years* to do so. Choices

and changes made in the first six months may take years to play out and show success. External forces will affect how the organization grows and how fast. Part of the importance of the founder-transition is shifting the organization's viewpoint from the short term to the long term, from a simple startup to a true institution aimed at longer-term impact and service to the community. *Shifting the organization's view of time simply takes time.*

VARIATIONS

ANNA GLASS AND DANCE THEATRE OF HARLEM IN NEW YORK CITY

As mentioned in the previous chapter, Anna Glass was first engaged as a consultant to help DTH address its challenges in 2012. The company, founded by the legendary dancer Arthur Mitchell in 1968, had been through some tough times in recent years and had suspended its dance company temporarily due to financial issues. Since then, Anna has helped to lead a renaissance at the company, resulting in the largest grant ever given to the company, a $4 million gift from the Mellon Foundation in 2019. I talked with Anna about her journey to turn around a company that felt like a new, struggling startup organization, burdened with a legendary brand, while honoring and involving their founder, Arthur Mitchell. I asked her about a video posted online by DTH during the global pandemic. It was a beautiful piece, featuring DTH dancers dancing throughout Harlem. The video had been one of the best pieces of digital content I had seen in 2020, with clear messaging, featuring the beauty of Harlem; the beauty of the dancers and their expertise; mask wearing; ballet with a modern twist and a bit of a playful attitude. It all added up and somehow still embodied the spirit of Arthur Mitchell. I also asked how the passing of Mr. Mitchell in 2018 had affected the organization. Anna responded:

> I always say, when you are posting something or creating something for social media, you want to believe that Arthur Mitchell is looking at that piece of material. We always want to have a contemporary lens, right? So, we don't want to feel dated, but we also want to feel like we're Dance Theater of Harlem. That we're going to produce content that Mr. Mitchell would be proud of; that he would feel good about, that he wouldn't feel offended seeing. And so, I can't take credit for that beautiful video, it was the creation of two of our dancers, who used an iPad to film it. But they understood and they all understand who we are, very clearly, and they understand what they're representing.
>
> When Mr. Mitchell passed away, we were going into our fiftieth anniversary. . . . We'd had a very challenging relationship with Mr. Mitchell, the institution had. . . . There had been some challenges that when he stepped down from his role, it was not necessarily what he wanted to do. It was not the way he wanted to go down. And so that summer was the first time that Mr. Mitchell had actually actively been engaged with the institution since he left. So, it was a really big turning-point year.
>
> I think we were definitely showing signs that we were beginning what I would call the upswing that this institution has been on for the last several years. So, when

Mr. Mitchell passed away, it was really devastating, for a number of reasons. We had planned a fiftieth anniversary celebration that involved him in it. We were starting to think about, what did our world look like, with him actively involved? And now we had to begin thinking about a world where he wasn't in it at all. And who were we going to be? And so fortunately, we had already planned that that year. . . . We decided that we were going to celebrate our fiftieth anniversary over two years, over two fiscal years.

And that first year was really going to be about looking back. And we had brought back a ballet that Mr. Mitchell had created in the seventies. He was in the studio with us twice before he passed away, but the intention was that he was going to take this project all the way to the stage. But we were able to get it up on its feet and on stage, and we had other ballets that we had done. Then I would say again, we were still on this sort of upward trajectory. We had had sort of this burst of energy coming out of Mr. Mitchell's passing, I think. It was sort of a real awakening for many people of Dance Theatre's problems. And we had a lot of people paying attention to who and what we were, who we are, and what we were doing.

Today DTH is again a nationally respected institution, leading the way for the dance community and the arts overall with their excellence, their empowerment of artists, and their successful transition from the founder stage.

SARAH CRAIG AND CAFFÉ LENA IN SARATOGA SPRINGS, NEW YORK

Sarah Craig's first job in the arts is still her only job in the arts. In 1995 she took over the legendary Caffé Lena, where Bob Dylan and many others developed their craft. The founder, Lena Spencer, had died suddenly in 1989, and the company had limped along ever since. Sarah faced huge disagreements between the board, staff, and volunteers about what the organization's mission should be, along with severely aging facilities and little to no infrastructure. But she rolled with the punches and kept making decisions and moving the organization forward. As Sarah says, she found the place in a bit of disarray:

It had been Lena Spencer's private small business and she had run it very much like a nonprofit. Certainly, there was no profit, that's one thing you know, that's obviously not a requirement of a nonprofit but there was *no profit*. She ran it like a mission that she was utterly dedicated to. Most of the people who helped her around here did so on a volunteer basis or for maybe you know, five dollars or something like that. *There were people who lived here in the building.* She lived here with her cats in the back room. I mean, it was her whole life, and she was beloved.

She was obviously, you know, not an ace businessperson, but she had a tenacity that enabled the place to survive for twenty-nine years. And she died suddenly. The place had absolutely no succession plan whatsoever, and there was actually a fairly widespread feeling that it should just close. There was nobody who was qualified to carry on what she had done. It would be best to just close it, and frankly, if she hadn't died, it probably would've closed within the year anyway. So, this was a place that was honoring its founder and hadn't really found its new identity as a nonprofit.

And so, it had this nonprofit status. It had some volunteers. It had been run just by its board of directors for a couple of years, then it went . . . it tried out some managers that just didn't work out. Didn't really know how to book shows.

And so, when I came there was somebody booking shows and he lasted maybe about four months after I came. I started writing grants. I started meeting the customers. I started getting to know kind of what this place was. Why was it such a legend? It was so kind of decrepit, and it seemed to be just barely hanging on, but yet there was some kind of absolute unbreakable loyalty that people had to it, and it did have this status of being the longest running, you know folk club in the country. So, there was something there and just the degree of love that people had for it overwhelmed me.

What was your first day on the job like?

I'll tell you, the first day that I showed up for work here. This was an organization that was not in good shape, okay, and it had a board of directors that was kind of *fried* . . . all totally done with showing up to put on shows on weekends. They didn't want to think about it. They just wanted to put it on somebody else. And so, I walk in, and you know, I've never booked a show in my life, never run a show, been to a few shows . . . and so, the first day I come in. It was an office day and a quite elderly member of the board met me at the office and gave me a key and said: "Here's a desk. Telephone. There is a filing cabinet that has some information about performers, and do you have any questions?" And knowing that there would be no answers, I said, "Nope. I got this. You go. I got this." And you know, probably a lot of people would've been, like "Are you kidding me? I need a training program. Good-bye!" You know?

The fact that Sarah stayed, dug in, and taught herself what she needed to know to do the job probably saved the organization. She began, very smartly, by asking everyone involved what *they* wanted the place to be. She discovered, while doing so, that what the board of directors had decided to make the organization was diametrically opposed to what the audience and volunteers wanted.

It was the volunteers probably that I connected with first and I sat them down and I said, "Tell me. Tell me about this place. What's working here? What's not working? What was lost when Lena died? What is the most important thing to hang on to? What do you think Caffè Lena could be?" Just asking those kinds of questions and realizing that the ideas and visions that the board had hired me to fulfill were actually *terrible fits for the organization*. Didn't make any sense. Nobody wanted that except for them, and I told them so. I was like, "You don't have this right. This is not what this place is. I already know. I already met the volunteers. We're not doing that." They said, "We want it to be kind of an after school drop in place for troubled youth." *Nobody wants that except you.*

After Sarah heard from the volunteers, audience members, and donors, she realized that Caffè Lena's mission needed to stay as focused as it had been under their

founder, Lena Spencer, as it is today. Their mission, simply put, is: "Caffè Lena presents extraordinary music in an intimate setting steeped in history."[1] By listening and responding to the organization *as it was*, rather than shifting it to something *someone else wanted it to be*, Sarah kept the venue on solid footing while she worked hard to improve not *what* they did but *how* they did it.

YOUNG PLAYWRIGHTS' THEATER (YPT)

Unlike Sarah Craig's first day at Caffè Lena, no one met me when I arrived at YPT for my first day. I only found the receptionist there, whom I had never met. She pointed me to my desk and said, "So, you're the new guy, huh? Well, good luck!" I sat at my desk and began reading all the files I could find.

I arrived after the organization had almost imploded, which I did not learn until years later. The company had hired a professional executive whom they assumed would be able to improve the company's fundraising and professional practices. Unfortunately, because he was completely new to the city and had no experience in the kind of work the company did, he spent nine months hiding in his office and inflicted the company's first major deficit, reducing YPT's restricted cash reserves by more than 50 percent. Besides his own shortcomings and the board's incorrect hiring of him, he also faced intense resistance from the staff leftover from the founder's time, including someone who believed they should have been hired as the new leader instead of him.

This staff resistance also kept the new leader from making significant changes in how the company operated and how programming worked. He probably pushed for some ill-advised and too quickly considered changes, given his short tenure. Luckily for me, his tenure was so disastrous and the company so close to death by the time I arrived, that the founder and board were completely ready and open to change. They had refocused their priorities in the new search for leadership, prioritizing connections to DC and to arts education over longer-term executive experience, which is how they stumbled upon me.

One thing to note about starting as a new leader: Be prepared to discover problems that the board and search committee never told you about. *Because even they did not know about them.* Or at least did not appreciate how problematic they were. Both times I took over for a founder, for at least the first five years in the job I was still discovering issues no one had previously warned me about or even articulated as issues. I often think of this as continually discovering rotten floorboards under your feet. Just as you think you have ripped out all the rot, you discover another one. Try to have a thick skin and a sense of humor. Avoid throwing up your hands and walking out. Leadership transitions often fail because the organization decided they did not like their new leader, or the new leader got fed up quickly with awful surprises and said, "This is not what you promised me." Remember that the board and staff were probably also in the dark. Keep going. It gets better.

The Freedom of Limitations

By the time I arrived at YPT, the resistant staff members had decided to leave, barely overlapping with my start at the company. This meant that I started with basically zero staff and little to no guidance on how the company had operated before. But it also meant that I faced little internal resistance to change. I was severely limited because we had no money, debts to repay, and one ill-advised staff position that I could not eliminate for at least nine months. But I was in it for the longer haul, and besides the need for cash in order to continue the company, I didn't feel rushed. I *did* need to innovate and find more efficient ways to operate.

Luckily, Karen Zacarías, the founding artistic director of YPT who was still on staff when I arrived, continues to be a close friend and an amazing artist and activist. She was very open to my leadership and my deciding where to take YPT next. She did sometimes step in with sharp questions, though she never went to the board directly with any concerns and was always completely supportive of my work in board meetings. She stayed on the board during my tenure at YPT. That meant I had a real partner in my corner. I also made sure we discussed major changes *before it went before the board*, so she could express concerns to me in private and I could answer questions before we discussed them in front of the board. We were always publicly on the same page and ensured the board wasn't getting mixed signals from us.

One of the big ways Karen helped YPT was by involving the company in a project she was doing with the Smithsonian entitled *Retratos: Portraits of Our World*. This project was a huge game changer for YPT, giving us a higher-profile project when we needed it. Karen would repeat this kind of opportunity again with *Chasing George Washington* with the White House and the Kennedy Center. She also continually served as my guide and mentor, as I led YPT to greater growth and success. In the meantime, Karen was secure in her own artistry, and busy with a playwriting career that would continue to soar.

HUBBARD HALL

By the time I arrived at Hubbard Hall in Cambridge, New York, Benjie White, the founder, had led the organization for thirty-seven years. Having helped to raise the money to buy and reopen the Hall in 1977, Benjie had been with the company since his midthirties and now was in his seventies. He had done little else in his professional life in the intervening time. To his credit, by the time he was approaching seventy, he also approached the board about the need for a succession plan. Unlike at YPT, I was entering into an initial founder transition with someone who seemed ready to retire, but who was also asking to stay with the organization for a bit longer.

Organizational Gaps

Often operational deficits in a founder-driven organization only become apparent after the founder leaves, because the founder has largely either donated their time, their own resources, or a mix of both to help the company operate. They see it in some way as their own project and responsibility. So even after thirty-seven years, their personal devotion and investment in the organization leads them to give their own cash, time, and materials. This investment is rarely quantified by any staff or founding board, and so a resource deficit automatically occurs when this person leaves.

Successor Salaries

A founding director also often earns a lower salary than their counterparts at similar organizations because they are accustomed to lower wages in order to help the company. This was definitely the case at Hubbard Hall. By the time I arrived, Benjie White had been earning $40,000 a year as executive director for the past few years. What I didn't learn until years after I arrived was that his salary was only increased to $40,000 from about $25,000 two years before they conducted their search for a new executive director. The board and Benjie knew they could never attract decent candidates with anything less. The board knew that, since the organization had been historically underfunded and paid below-standard wages, they needed to raise special funds to cover a new executive director's salary for three years. With a goal of $150,000, they ultimately raised just over $120,000, meaning that by my third year, the regular operational budget would need to cover my salary.

Swept under the Rug

In the two years prior to my arrival, the company had once again needed to cut staff. They did so in part by eliminating the facilities manager position and having Benjie manage facilities. Some former board members would eventually characterize this as Benjie's strategy for job security. If he was the only one who knew how the four historic buildings functioned, we would need him indefinitely.

I'm not sure if this insight into his actions rings true or if he was simply needing to make cuts and realized he could take on more tasks and save the company money, as he explained it to me. Regardless, when I arrived, he was the only person on staff familiar with the four historic buildings we owned and operated.

Founder as Staff Member

During my hiring process and negotiations with the board, Benjie expressed a desire to stay on staff as a facilities manager. This seemed like a horrible idea on the

face of it. But both successful transitions I have managed with founders have included a little time with them on the regular staff after I arrive. While it can be tough to manage, these situations allow the founder to stay involved and feel valued while providing some invaluable institutional knowledge. *Sometimes the sheer trauma of a founder being removed from an organization they have created leaves a knowledge gap so wide that it becomes impossible for the leadership transition to be successful.*

Having a founder on staff can complicate things, to say the least, especially if they are now a peer with staffers whom they previously supervised. Frankly, Benjie's offer seemed both generous and naive. He was offering to help me by staying on to manage facilities he knew so well, while I needed to learn the job and tend to so many other issues. But he also was offering to stay in the organization in a way most founders would realize would be untenable, as their presence might distract or even undercut new leadership. When I visited the campus a few months before I would begin in earnest and we toured the facilities, I realized that I was really going to need Benjie—or someone similar to him—to oversee facilities while I got up to speed.

Too Much to Tackle

With an 1878 opera house with two stores on the ground floor, a black box theater, dance studio, visual arts studio, multiple staff offices, and a multipurpose warehouse, the facilities and their maintenance far outweighed the tiny five-person part-time staff I was inheriting at Hubbard Hall. I needed Benjie to keep his metaphorical thumb in that dike while I triaged everything at the organization, assessing our facilities needs without spending my days fixing problems in them continually. But by the time I was starting, Benjie was unsure whether he should stay on, given my misgivings. As we looked up into the rickety ladder that led to the attic above the Hall (a space I never wanted to see), I said, "I don't know how I do this without you, Benjie."

Benjie ended up staying on as our facilities manager for three and a half years because he provided invaluable support to me, while overseeing four historic buildings still in need of lots of repairs and care. Similar to Karen's presence at YPT, Benjie would serve as a treasure trove of institutional memory. And perhaps the secret to my success in both of these transitions was in keeping the founders actively around for the first few years of my tenure.

The Value of the Founder Sticking Around

Having founders remain with the organization helps in several ways:

- It provides the new leader with invaluable information about the history of the company, the *how* and *why* of past decisions, and sage advice about new ideas when asked. *Often a founder transition fails because the founder takes all the institutional knowledge with them when they leave.*

- It also reassures people inside and outside the organization, including donors, board members, and staff, that the new leadership isn't simply ignoring or discarding the past, but instead honoring it and working organically to transition to the future.
- It lets new ideas be implemented in the full context of the past, so new leaders know if something has been tried before—and why now may be a good time to try them again. Or to see why a totally new idea might be necessary to overcome obstacles.

The Downside

There were times when Benjie would genuinely express concern or dismay at a new idea—or one that had been tried before—during staff meetings. These moments would naturally undercut any momentum for these ideas, and I would need to assert the idea or effort as necessary and explain *why* in more detail to keep others on board with the effort. This in part forced me to be a better leader by requiring me to explain to Benjie and others why I thought these were the right decisions. But over time, this tendency for him to live in the past and express doubt about new efforts became problematic.

One other downside to Benjie's advice: He was perhaps the slowest talker I have ever met. Once you asked a question, you'd better have at least ten minutes for the answer to come out. He was so accustomed to keeping his own counsel over the years and dealing with people in a village of just 1,900 people. So, speaking quickly was not in his wheelhouse.

Time to Go

By the end of 2017 at Hubbard Hall, we finally hit the point where the founder's presence seemed to hinder our growth more than help. He had trained another staffer on most facilities systems. His own work had seemed to slow to a crawl. He more often than not seemed unwilling to make changes in the way things worked. For example, when I arrived in 2014, our production shop in our basement was stacked to the gills with old furniture and leftover wood from previous set builds. The costume shop was so overstuffed and filled with old, unused clothing that it was hard to see what we had or to even enter the room. This tendency to hoard and never clean house came from Benjie's history of needing to beg, borrow, or steal to even *have* an organization. When things were dropped off as donations, including old, dirty clothing or worn-out furniture, they were gratefully accepted, until the place was overrun with stuff we never used. Only after he left were we able to spend two summers renting dumpsters to clean house and reorganize, to the still-persistent dismay of some longtime staff members who also preferred to hold on to everything, just in case.

Freedom

First, we spent a summer gutting and reorganizing the costume shop, until we found the mold we always suspected in the rear of the room, caused by rotting wet clothes. By the end of the summer of 2018, our costume shop was clearly organized, clean, with clothing we could actively use in the coming seasons. Then in 2019, we cleaned out the production shop, donating piles of wood, clearing out old broken furniture, props, and still more old wood. We reorganized our prop storage and kept more than enough wood for future builds and only a few period chairs and tables. This newly cleaned and organized storage set us up for greater success and safety, given how much mold and risk of fire existed when they were so overstuffed by decades of neglected donations.

Being Crystal Clear

Benjie always expressed gratitude for being able to stay on staff for a few years after his "retirement" from the company. He and I would check in every six months about his progress and staying with the company, given the dynamics of having a founder still on staff. We made plans several times for him to transition out, only to continually kick those plans down the road, because it seemed to work well, and we needed him. But we had discussed his ultimate transition from the company as happening in 2017, once he had trained a successor as facilities manager. So, it surprised me when we discussed it again in fall of 2017 and he seemed genuinely caught off-guard. Had he not heard me when we'd discussed it before? Or had he simply been in denial that the change was finally happening? He accepted his being let go peacefully but sadly. This sadness may have just been inevitable after forty years in one place.

At the same time, we had a program manager leaving her position to move to New York City. We held our traditional staff holiday lunch in December and used it in part to celebrate both their tenures and thank them for their service. Unlike Karen, once Benjie left the staff, he *really left*. He still lived in Cambridge, but we rarely if ever saw him again on campus. I think it was his way of giving me space.

When I would see him at shows and on campus for other meetings, it always made me happy, which I guess is the ultimate good sign for how these transitions went. I continue to be friends with both Benjie and Karen, in different ways. I see them as positives in my life. I continue to be grateful for what they built, which allowed me to also have a rich life while leading the companies they started. I hope other arts leaders are as lucky as I have been.

FINAL THOUGHTS

In this chapter, we have explored how to successfully lead an organization after a founder. There is no magic formula for doing so, but some of the key elements include:

- Approaching the transition as long-term change for the organization.
- Listening to what the organization is and staying true to its mission and purpose.
- Involving internal and external stakeholders in creating the new vision for the organization.
- Respecting, honoring, and possibly involving the founder in the organization after they leave.
- Being ready to deal with more issues than you ever expected, for at least the first few years, with a sense of humor and humility.

If you can approach the job as a long-term project, worthy of your time and effort, and treat everyone involved with kindness and respect, you can succeed.

NOTE

1. Caffè Lena, "About." Accessed May 18, 2021. https://www.caffelena.org/about/.

17

LISTENING TO THE FIELD

Getting people whose opinion you trust is really, really, really important.

—Karen Zacarías, playwright

INTRODUCTION

Hearing how a successful arts manager began, how they have sustained a career, and how they view arts management today can help guide your own path. In this chapter, arts leaders working in various arts disciplines throughout the United States talk about how they began as arts managers, what they have learned over the years, and how they see the arts changing. These are some of the best and brightest artists and arts administrators working today. The following dialogues are fragments of our full conversations, delineated by individual questions to guide you.

FUNDAMENTALS

BEN CAMERON

The primary concern, going forward, if you are a manager, should be less about stability than it should be about resilience and adaptability, and how is it you build a resilient organization and a flexible organization that can respond to periodic disruption.

—Ben Cameron, president of the
Jerome Foundation, Minneapolis, Minnesota

Ben Cameron was program director for the arts at the Doris Duke Charitable Foundation from 2006 to 2015, where, during his tenure, the Foundation created the Doris Duke Artists Awards and received the National Medal of the Arts from President

Barack Obama. He previously served as the executive director of Theatre Communications Group, as the senior program officer for the Dayton Hudson Foundation, and manager of community relations for Target Stores, and as the director of the theater program at the National Endowment for the Arts. He received an MFA from the Yale School of Drama, received a BA with honors from UNC-CH, and is a recipient of three honorary degrees.

Ben Cameron.
BFRESH Productions.

Ben, you have had a hugely successful and impactful career in the arts. How did you begin?

I wish I could tell you that it was a more deliberately and strategically planned event than it was. To be quite frank, for personal reasons, I had left full-time theatrical practice and had entered teaching full-time, and really realized, had a sort of come-to-Jesus moment in my midthirties, where I thought, I don't think I'm ready to really be tenured at this point in my life. I think, with all due respect, I experienced some lovely people who were tenured too early for both their sakes and their students' sake. And I was worried that if I accepted a tenure job in my thirties, I might freeze myself, rather than continue to grow.

And so, at that point, not knowing what I wanted to do, I applied for what was then called the Art Administration Fellowship at the National Endowment for the Arts, where they would make three-year commitments to people to come be part of the NEA. Ironically, of course what happened was I arrived there in the fall of 1988. While I was there as a fellow, we heard the words *Andres Serrano* and *Robert Mapplethorpe* in the context of big NEA controversies. There was a slight expansion of staff to deal with a lot of the controversy, but there was also a fair attrition of staff. And I went from being the fellow to being a program specialist, to being assistant director, to being the director in *a compressed period of time*. I've often said it was kind of like the Fifth Act of *King Lear* when the stage was streaming with bodies, and the fool was on the throne. So, I just happened to be at the right place at the right time.

What skills or traits helped you succeed as an arts leader?

What has been really important to me is, in addition to the opportunistic timing, has been knowing when to say yes, but also the number of times I said *no*, when I looked at opportunities, and thought *I'm not a fit for that job*. I don't have the right skill set, or the questions aren't engaging enough to sustain my interest.

My dramaturgical training really taught me to think about taking global views, looking at systems, looking at dramatic structure, looking at architecture. I'm able to look at that sort of 30,000-foot view at a field or at a movement, or at a discipline, and

discern both the architecture and the impulses at work, and an architecture for helping that move forward. And I think I do that well, and I think that's dead center to what my dramaturgical training was about.

I think what I *don't do well*, I recognize in myself that when the work pressure accelerates, or when there are deadlines, my default mechanism is to say "I'll get the work done," and move into sort of an *isolation mode*, where I'm doing a lot of reflective thinking and a lot of self-scrutiny and a lot of self-work. But I think a really good manager actually in that moment presses in the *opposite* direction to say, "We need to animate the whole team in this moment." And so that's an impulse that I don't have, that I think is an important impulse.

I'm not good at the microdetail, as anybody who's ever worked with me will tell you. So, I make a mess, and I'll often say like, okay well, what if we tried this, and then everybody else figure that out. I think a good manager is far more attuned to the minutiae of detail than I am.

The primary concern, going forward, if you are a manager, should be less about stability than it should be about resilience and adaptability, and how is it you build a resilient organization and a flexible organization that can respond to periodic disruption.

Who did you admire early in your career?

Peter Coleman was the manager at Baltimore Center Stage. Peter was about a depth of transparency and a depth of spiritual purpose, and at the same time, was the most practical person I've ever seen in my life.

I'll never forget one meeting when somebody said, "How is it you run that complex so well?" And Peter said, "Well, I go to a different bathroom every time I have to go to the bathroom during the day." So, during the day, I found myself in the costume shop, and then I found myself in the set department, and then I found myself in the marketing. So, by the end of the day, everybody has seen my face, and I hear things otherwise I never would hear. That's the smartest thing anybody's ever said to me. Peter was deeply granular, but he was profoundly spiritual. And the way he invited artists in transparently. There are still directors, I'm sure, whom you could find who would say their first day at Baltimore Center Stage. that they'll never forget is: Peter Coleman called them into the office, made a pot of tea, and said, "Sit down, I'm going to explain the finance of this place to you. We're a $7 million theater. Here's your show. On your show, this is how much we're going to spend on marketing, and this is how much we're going to spend on salaries, and this is how much is going to be spent here. . . ." They said no one had ever shown that to them before. And Peter would say, "So, if we want to make changes, we can do it, but we need to understand the context in which, if you need more for your set, we're going to have to figure out where else it comes from." With that sort of trust and transparency. Who does that?

How do you see arts structures and management changing going forward?

I've always been curious about, and always responsive to the idea that real innovation typically comes from outside of a field rather than from within.

I think the arts organizations who are going to survive—who are likely to have the greatest chances for economic survival—are those who are as or more articulate about their *civic* agenda than their *artistic* agenda. It's not like I'm saying you shouldn't have an artistic agenda, you need one. But if you've got a civic agenda, the opportunity is a very different opportunity about how you think about who your partners are and what your place is.

I think there's about to be a profound shift in philanthropy that's going to be really critical. Institutions of philanthropy are going to be challenged more strongly about the origins of their wealth, and what it means for where they dedicate their money. And I think that there are communities that have long been undercapitalized for whom that conversation will be an important win for them. It's going to pull stilts out from under the beach houses.

One of the things I've thought about a lot recently is the essential structural disconnect between the typical art's workforce and the audience. That we basically say, "Okay, everybody, you're going to work, 9 to 5, the audience is going to get here at 7:30 tonight, so we never overlap." So, if I were hiring right now, I would be saying to my development staff, "you may work 9 to 5, four days a week, but there's going to be one day a week, you're going to work 2 to 10, because I need you to be in that audience. I need that audience to see you. I need you to feel what the audience feels when they're in the house. I need that texture."

And of course, the other thing we're learning is an incredible amount about racism and structural racism, and what our role in that has and hasn't been, especially because we're here in Minnesota. And so, the George Floyd Memorial is a mile from my house. And the unrest is right outside our bedroom window. So that's been a *huge*, *huge* dimension of our learning, probably the most important learning that's not COVID related. That's racism and anti-racism related.

I also think an emerging workforce is not interested in the lives of poverty in which many of us early in our careers were willing to adopt ourselves. And I think the expectations of a humane level of compensation is going to increasingly be an important point for those emerging into the field in a way that's going to test organizational commitments in resources, first of all. And that has a lot of consequences you can imagine about how you divvy up budgets, and what that looks like.

I hope there's going to be a different level of thoughtfulness about alternatives in ways in which resources are deployed. It's interesting that when you look at *Theatre Facts*,[1] you see a consistent shrinking of marketing budgets. Every year, the marketing budgets are getting smaller and smaller. As people are getting smarter about virtual marketing, they're letting go of paper. That's a good thing.

If I were running a theater now, I wouldn't want a building. I mean, at this point in time, a building permanently ossifies a configuration between an audience and an artist that may have been appropriate to the nineteenth century, but I'm not sure what the relationship even wants to be for the twenty-first century. If I were running a theater, I'd say give me the Cirque du Soleil tent. *I think where sources are spent is going to be very different.*

I think that more and more arts organizations are going to be reliant on individual generosity, and part of the urgency around this right now is the philanthropic priorities of the younger generation are rarely art oriented. I mean, they're about the environment, yeah. They are about voting rights, absolutely. They're about anti-racism, yes. But when you look at where young people are investing, charitable resources, the arts typically are not high on that equation list. And so, I think that we're about to go into a period of profound reorganization both in terms of our values, our missions, but also in terms of our philanthropic structures that will demand people think about themselves, communicate about themselves, and define themselves very differently than they have in the past. Otherwise, they're going to be part of an intensely, exponentially more competitive sector that is shrinking, that has less control over the destiny of the arts, etcetera. And then I think we'll still survive.

KAREN ZACARÍAS

Everyone has an opinion, but that doesn't mean that every opinion is what your work needs.

—Karen Zacarías, playwright, Washington, DC

Karen is one of the most produced playwrights in the United States. She was one of the inaugural resident playwrights at Arena Stage in Washington, DC, and a core founder of the LATINX THEATRE COMMONS. She is also the founder of Young Playwrights' Theater (YPT), an award-winning theater company that teaches playwriting in public schools in Washington, DC. Karen lives in Washington, DC, with her husband and three children. Her plays include *The Copper Children, Native Gardens, Destiny of Desire, The Book Club Play, Just Like Us, Legacy of Light, Mariela in the Desert,* and *The Sins of Sor Juana.* Her work has been produced at the John F. Kennedy Center for Performing Arts, Arena Stage, Oregon Shakespeare Festival, the Goodman Theater, Round House Theater, the Denver Center, Alliance Theater, Imagination Stage, GALA Hispanic Theater, Berkshire Theater Festival, South Coast

Karen Zacarías.
Liza Harbison.

Rep, La Jolla Playhouse, Cleveland Playhouse, San Jose Repertory Theater, GEVA Theater, Horizon's Theater, People's Light and Theater, Walnut Street Theater, Arden Theater, Milagro Theater, Teatro Vista, Aurora Theater, and many more.

Karen, you are a very successful artist as well as a founding artistic director. What advice would you give to artists on managing their own careers?

Think like an entrepreneur both in the content of your work, but also in how you approach everything. First of all is the idea of looking around to see where there's a *need*. If everybody's writing the same kind of play, why should I throw my hat in that arena when they're already dominating it and they're doing it so well? What skills do you bring to it? Where is there a need?

For me, as an immigrant who came here at the age of ten, I really, really remember the idea of how vulnerable it felt to be a ten-year-old here, and so being a kid is something I've always had access to, those kinds of feelings. I started by volunteering at Hardy Middle School. I knocked on the door and said, "I'm twenty-four. I'm here to teach playwriting. I've never done it before, but I'll do it for free." The teacher handed

me ten students, and I did the same at Bell Multicultural. I knocked on the door, and I taught a high school class.

Second of all is the idea of networking, and I don't like the word *networking*, but the idea of building *allies and friendships*, and representing yourself in a way that you always want to be treated. I think it's really important to be a good team player, right? You establish a family of people who understand your aesthetic and all that. Getting people whose opinion you trust is really, really, really important. Everyone has an opinion, but that doesn't mean that every opinion is what your work needs.

I had big failures in that early on. I listened to too many people. I rewrote too much. The idea of building community is—people forget how important that is for opportunity.

How did you get started?

I always wanted to be a writer, but I went to college in international relations because I was like, I need to have some other job that I can rely on. My college did not have minors, but I did an equivalent of like a minor in creative writing, but who's going to make a living from creative writing? So, I came to DC, and I started working at the National Endowment for Democracy using my economics, and Latin American policy, and all of that. I took a playwriting class at night at Georgetown, so that became my outlet while I was working this kind of stressful political job. I don't know if you remember this feeling, but that feeling with your first job is like, "Oh my God, I can always escape if I go to graduate school," so I decided to apply for graduate school in playwriting. I got into Boston University, which was a one-year writing program. I'm like, "Oh, how hard could it be?" So, I went and did my graduate work there in playwriting.

Because I had this background in working in international relations and working with nonprofit groups in Latin America, I wrote a pretty impressive grant proposal about using playwriting as a form of conflict resolution, as a form of arts empowerment and literacy in schools, thinking that I would do it on weekends in a community center somewhere. And they so liked the proposal that they turned around and they said, "If we give you some small amount of money—$20,000—to kind of pay yourself something and start the program, would you come back to DC and do it?" So here I was—with a playwriting degree, but I got this job. I was like, "Sure, I'll come back," and that became the beginning of Young Playwrights' Theater. And it felt to me that reaching out to kids and hearing their point of view was always really important.

How did you first get an agent? How did you turn a "no" to a "yes"?

I used to mail so many plays to so many people. I can't go to the Post Office anymore because I'm so traumatized by sending so many paper scripts with return envelopes. In 2003, the Public Theater in New York was doing a reading of a play of mine, and so I sent several invitations out. One agent wrote an email back, saying "Thank you very much for your invitation, but your play doesn't sound like anything that I'd be interested in." [laughs] Super direct. Super direct. "Yours sincerely, Earl Graham." I showed it to Rett, my husband, and I go, "Look, an agent wrote back

to me." He goes, "Karen, that's a pretty resounding no." And I was like, "No, no, no, but he's the only one who's written back. I've written like twenty-five letters to people and he emailed me." So, I spent all day in my pajamas, trying to think of how to write back. So, I wrote back, and I said, "Dear Mr. Graham, thank you for your very direct response. I just have one question for you: When you go to a restaurant, do you always order the same thing off the menu? Yours respectfully, Karen Zacarías." [laughter] And I just send it, right?

And the next day, I had three paragraphs from him. He was incensed. He wrote, "I do not order the same thing off the menu, but from your description of your plays, they sound like kitchen sink dramas, and I'm not interested in any kitchen sink drama." blah, blah, blah, blah, blah, "I get three hundred scripts a week or a month or whatever and you know and I have to be discerning about what I do. Yours sincerely, Earl." and I was like, "Oh my gosh. He's already spent more time on me!"

I wrote back, "Dear Mr. Graham, you seem to be a victim of your own. . . ." I remember this so well, "You're a victim of your own success. I understand, you're getting all these emails because people want to be represented, and let me assure you that neither one of my plays are kitchen sink dramas." And then I described them a little bit more and sent it off the next day. No response. And suddenly I get an email. "Send me your script. Federal Express. If I don't have it by tomorrow at noon, I won't read it. I'll read it and I'll let you know what I think."

Rett and I were running around, photocopying the play. We drove down to the Dupont Circle Federal Express and sent it for like a million dollars. The next day at one o'clock in the afternoon, I get a phone call. "I read the script. I love it. I will be at your reading Saturday. It'll be an honor to represent you."

So, it was all about how "no" is *not* the end of a conversation. The idea of treating other people not like gatekeepers, but thinking of them as humans—and what makes you stand apart—and finding the right kind of sassiness that doesn't insult someone but makes them kind of have to rise up. It worked this time, but I use that story a lot because a lot of people get a rejection and I used to too. I'd get rejections and all I could hear was the no. If you sometimes read the rejections, there's a lot of really lovely things that are being said. If someone has had to turn people down for things—that are really talented promising things—there are reasons. I urge people to read between the lines and not take no. Take no as a beginning of a conversation. It doesn't mean the door is closed.

You have always been what I consider an artist activist. How do you think about the need for greater equity in the arts?

People have to change—give up something to gain something. It's really interesting where the values lie and who's willing to give up something, because that's what's going to need to happen.

It's very comfortable to talk about justice when you don't have to give up anything, right? And I understand. If I was making a million dollars, I'd be like, "Ooh I don't know."

I personally would feel very uncomfortable with that degree of disparity. When I find out how much people have been making working at certain jobs, I'm like, "Oh my God." The nonprofit has been getting out of control. It's been subsidized by young people who are—well not even young people—by people who are willing to not own a home in order to do what they want to do.

There's been a lot of exciting new leadership that's coming up, but boy do they have a lot of work to do, between funding and getting a theater back up. I think there's been a reckoning, but as everyone starts getting busier and busier, I wonder how that will manifest itself. I hope that there's going to be more awareness of who's been left out and who's been left in in the decision-making, in theater making and how anti-Blackness has become part of a lot of different layers of society even in a liberal theater moment.

Some of the questions are bigger. Why are health benefits connected to work, when a lot of times you can't work because of your health? There's some deeper, deeper societal questions that I think need to be answered. That I hope in our rush to go back and hug and go back to some kind of normalcy, that it's not the old normalcy. That there's some kind of thoughtful change. It's an opportunity, but it's going to take some thinking and some people being brave to slow down and turn around. It's going to be challenging, but it's an opportunity if people are brave enough and willing and find a way.

ANNA GLASS

Don't you want this beautiful art form to reflect the diversity of this country?

—Anna Glass, executive director of Dance Theatre of Harlem,
New York, New York

Anna Glass has been involved in the performing arts as both an artist and arts administrator for over twenty-five years. She currently serves as the executive director of the Dance Theatre of Harlem where she co-launched a collaborative initiative addressing racial inequity in ballet. Anna has also served as a consultant providing strategic planning and fundraising guidance to various nonprofit arts organizations across the country and has served as an advisor for the DeVos Institute of Arts Management supporting New York City nonprofits. She is also a licensed attorney in the State of New York. Anna lives in Harlem with her husband and their daughter.

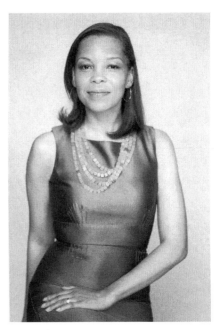

Anna Glass.
Dance Theatre of Harlem.

Anna, how did you make the leap from dancer to lawyer to arts manager?

When I was in law school, I was dancing for a company called Dayton Contemporary Dance Company in Dayton, Ohio. And it was my intention to continue pursuing a career in dance. But I was interested in a lot of things and really not sure where I wanted to land. And at the time, I was not aware of this thing called arts administration, frankly. When I was in law school, I knew that I did not want to pursue a career in law. And I was really enjoying being a performer, and I made the decision to move from Ohio to New York, thinking that I would continue dancing.

I temped for a while and then Dayton Contemporary Dance Company (DCDC) reached out to me, and they asked me, would I become their booking agent? And I didn't know anything about being a booking agent. I knew intimately about the company because I had just spent my last three years performing with them. And honestly, I got into arts administration, not because it was what I wanted to pursue, I was curious, and I knew I wanted to be in the arts. But I didn't really know how and what that would look like.

When the opportunity presented itself to become a booking agent, and the way that we set it up, I had just moved to New York, so I wasn't moving back to Ohio. I was embedded in a booking agency in New York called Pentacle, which represents a lot of mostly contemporary modern dance companies and artists. And I represented

Dayton Contemporary Dance Company, but I was embedded in this other company so that I could learn the industry. And it was great. I did that for three, four years. And really started kind of feeling like there was more to this world, even though my job was booking agent, because I was situated in New York; I had my ear to the ground, I knew what was happening.

I'd just done three years of law school, so I wasn't going back to get a master's in arts administration. I learned about the fellowship program that Michael Kaiser had at the Kennedy Center, and was asked to apply, which I did. And really, Michael Kaiser and that fellowship program is actually where I got my arts administration education. Where I learned conceptually, how these pieces all fit together and how do you approach marketing? What do you see when you look at a budget? What does it mean to raise money? What does it mean to produce a massive project?

You are clearly a brilliant leader and manager. What skills or traits have served you well?

I think the biggest key to my success is that I don't believe I know everything. And I'm constantly in some level of inquiry and understanding whatever it is that I'm challenged with. I try to find people, the smartest people that understand the particular topic. I'm really focused on consensus building. I feel very strongly about listening to others' opinions. The buck always stops with me. I have learned the hard way to follow my instincts, to not doubt myself, and to be willing to take risks when it comes to delving into things that are unfamiliar.

I find that if I listen to my instincts, nine times out of ten it's probably right, even though I may not know what I'm talking about or doing. But I think it's a number of things, I think, always being willing to be in the unknown, to being willing to be transparent around what you do and do not know. I think also, a big piece of my leadership has been being willing to be vulnerable, as well.

How would you describe your management style?

What I work very hard at is ensuring that, particularly our company, that they really understand the ethos of the institution. That they understand what is important. That they understand who we are, and they understand, from me, how I see who we are. So that everyone is on the same page as to what we say about this institution, what we say about ourselves. The empowering piece is really important. I do not like to micromanage.

And I always tell my staff in the company, the moment I have to get involved in something, we're in trouble, there's a problem. "You don't want me involved," because I say, "Look at my persona as mean mom. If mean mom is showing up, we've got a problem. So don't have mean mom show up. Here are the things that you know that I'm going to be looking out for. Make sure that you're working together, you're checking each other's work. That you're working as a team, and sort of vetting what you're creating." But I don't want to micromanage, I don't want to get in the weeds.

I want to have people understand enough of how I see the world. Those who have been with me long enough, they know without a shadow of doubt, "This is what

she's going to want to see. This is how she's going to want to approach it." My new folks that come in, it does require a little bit of hand holding, but I also say, "Make mistakes. I'll show up and tell you where you slipped up, but at least try something. You can't learn how to do your job if I'm telling you how to do your job."

How is Dance Theatre of Harlem changing?

We are about to begin a strategic planning process, where we are going to really be in conversation around who we are in this new world. Who do we want to be? What size institution do we want to be? I think the best way to describe what my priorities are is when you think about nonprofits, the nonprofit structure, I sort of describe it as a house. And everybody's building the same house with four walls and a pitched roof. And for some institutions, they've got really just jazzed up homes with Jacuzzis and saunas, and all sorts of stuff. DTH had from the exterior a lovely home, a beautiful home, but our interior, our basement flooded every year. We had cracks in the foundation. We just were never on a solid footing. We were always playing catch up. We were robbing Peter to pay Paul.

My big priority as an institution, the challenge that I am giving to us is: let's not build another house. Everybody's scrambling, coming back to normal, rebuilding the same house. I want to think about this completely differently than where we have been before. What would it look like if we reimagined the role of an artist and had multiple income streams, paying for those individuals versus what we've had before? Touring revenue has somewhat covered the expenses associated with the company, but not a hundred percent. And the revenue from the school covered the instructors, our teachers; and the revenue from our community engagement work covered our teaching artists. What if it was one group of people doing that work and all those sources of revenue were paying for that one group of people? So those are things that we are really sort of delving into. I don't have answers to any of it but I know that we're not going back to where we were before.

Dance Theatre of Harlem and its founder, Mr. Arthur Mitchell, embodied and helped to trailblaze greater diversity in dance. How do you relate to the current conversation about diversity, equity, and inclusion?

I feel that we have to be active participants in the conversation. I think there are varying degrees of intention around the conversation. But I think if we are to see real change, we have to be active participants in the leadership and the teaching of what all this means. And so, one way in which we have done this, and that was prior to the pandemic, back in 2017, Virginia and I, we convened fourteen dance companies, executive and artistic directors, to have an open and honest conversation around diversity, equity, and inclusion.

Was there an appetite to have honest conversations with the intention of moving the needle, moving this conversation outside of just panel discussion? There was an appetite. There were varying· degrees of cluelessness, but there was an appetite. And so, what then took place is a three-year initiative that we did in collaboration with

Dance USA and the International Association of Blacks in Dance, where we created a program called the Equity Project, which was about specifically increasing the presence of Black people in ballet. And the group grew to twenty-one companies, and it was a learning community. The intention was that it would be a safe space for people to stumble through this work. We hired consultants that sort of built a program. We convened once a year all together. And I don't think they began really seeing the necessity of the work until the George Floyd murder. And ballet artists in particular, were speaking out about their experiences in their sort of predominantly white spaces.

A colleague of mine, who runs a ballet company said, "Oh, you know, Dance Theatre of Harlem really should lead this diversity, equity, and inclusion conversation. That should be your thing." And I said to my colleague, "Well, it should be everybody's thing," and I said, "Don't you want this beautiful art form to reflect the diversity of this country?"

And that is true. I still wholeheartedly believe that and nobody's going to raise their hand, right? And so, DTH had to be the one to raise their hand and sort of lead this field in this particular direction. Otherwise, we would have been navel gazing, and nothing would have been done. And the George Floyd incident would have happened, and we would have been responding to that versus having had these conversations for the last three years. We had actually started planting those seeds three years prior. So that's really my take on it. I'm hopeful and skeptical. But neither of those things matter really. Because what's important is my role as a leader in demonstrating what's possible.

SARAH CRAIG

The important thing is to keep moving. Keep moving. Make decisions.

—Sarah Craig, executive director of Caffè Lena,
Saratoga Springs, New York

Sarah earned her BA in psychology and women's studies from the University of Vermont, where she developed organizing skills as an activist on campus and in Burlington. Before taking the reins at Caffè Lena in 1995, she served as a fundraiser then executive director for the Massachusetts state branch of Peace Action, a nationwide, grassroots citizen's lobby. Sarah seeks to carry forward Lena Spencer's dedication to community service through music, creating friendships, careers, and harmonious connection. She has contributed articles to national music publications, freely offers herself as a mentor to emerging artists and presenters, and shares her experience as a panelist at conferences in the United States and Canada.

Sarah Craig.
Sarah Craig.

Sarah, you have led the legendary Caffè Lena for over twenty-five years. How did you begin?

I never envisioned pursuing a career in arts management. That was not what led me into this. You know, the world of folk music is very intertwined with grassroots movements that are political, that have been anti-war, and anti-racism and that . . . you know, folk music has always been part of those movements. I started in the Labor movement, but I found that kind of frontline activism was just not a good fit for my temperament, my personality, the way I feel about people. It was much too fractious and full of winning and losing. And what I really wanted to do was find ways to help people to be their best selves. A place where people could share an experience that was emotional and intellectual and feel the walls evaporating around them.

And so, even though I didn't really know that live music was necessarily going to do that, when I started being around Caffè Lena, I realized that I had found. . . . I don't want to call it the tool that I was looking for but more like the niche that was the right fit for me where I could do the work and bring the gifts that were mine to give and bring.

What do you think makes you a capable manager?

I think maybe the thing is simply a willingness to make decisions. You know, I see a lot of people out there *weighing the pros. Weighing the cons.* Getting more information. Taking it *slowly* and I'm afraid that the world just went right by them, like a freight

train you know? And I am a person who can . . . I always know that whatever it is, I can live with the consequences. If I got it wrong, I can solve that later. *The important thing is to keep moving. Keep moving. Make decisions.* Keep moving and keep everybody around me moving. And so, that I think is probably what has served me best.

What motivates you?

In addition to being committed to the world-changing possibilities of this work, I've also fully adopted the place as one of my children. I didn't plan to do that; I just kind of woke up to the reality that it had happened. I celebrate its triumphs, I swing into action when there are failures, and I always believe in its potential for greatness. I'll take calls from it at any hour, and it's the first thing I think about in the morning and the last thing I think about at night. That's probably not *healthy* according to any kind of industry standard, but I think it's the reality for a lot of nonprofit executive directors and, frankly, I don't think there's any other way to get this job done.

It's so consuming to run a nonprofit like this. For a couple of years leading up to the renovation that we did in 2016, there was a tremendous amount of fundraising that needed to be done. There was much higher-level financial management required, so we brought in a second staff person so it wasn't just me anymore. And then you know, when we actually went through the renovation, it was like seventy- and eighty-hour weeks for about a year and a half. And that really started to make me crazy, that was really unhealthy. And I'm sitting in the green room right now and I remember sitting in here with my executive committee and we were having one of these meetings you know, and I was so burned out. I just like lost my cool. I mean, I was just . . . just sobbing and saying, I just want to die. I just want to die. I'm so burned out and there was no escaping it. You know, it had to be seen through. People had given us millions of dollars. And you know every thank you, every dollar donated was like tightening a noose around my neck. Like I don't have that much gratitude in me to meet the outpouring of generosity that we're receiving. Stop!

Caffè Lena has dramatically increased streaming performances online. How has that affected the organization?

We had been streaming since 2012, but we didn't make much of it until the pandemic and then it became the thing that we did. It was the way to survive, to serve our audience, to serve our artists. The growth was exponential. We went from just under a thousand subscribers to our YouTube channel to now we have more than five thousand subscribers. The views on the videos went up 800 percent. Exponential growth. So, what I don't want to do is to say "That was awesome. Thank you everybody, now good-bye." We all go on with our lives.

A lot of what I'm thinking about right now is how do we really erase the concept of walls? And erase the concept of there being a difference between the livestream audience and the in-house audience? How do we just make it our community that supports our mission? So, we've created a new kind of membership for people who never come to the venue but that want to go beyond supporting us on a show-by-

show basis and you know, really inform them about the core mission of the place. You know, the Caffè Lena school of music. The community outreach that we do. We send music out to the soup kitchen and the nursing homes and all these things that we do. And these commitments we have to cultivate the next generation of artists. So, we're trying to really educate people about that kind of stuff and show them that it's not just a TV channel that you turn on but it's a real place with a mission and a community.

How has the music industry changed in recent years?

In the early part of the global pandemic, the booking agencies were just dissolving. They were laying off all of their agents and just disintegrating. And then during the second and third quarter of the pandemic you started to see new agencies popping up. There was this huge kind of kaleidoscopic shake up of the whole structure and now I'm getting to see rosters that they've put together and suddenly, those rosters are a lot more diverse than they used to be and they're a lot of people of color available to me to book who I had never heard of before the pandemic. Like they said, "We want to right this wrong. We want a better roster in terms of diversity, and we have an opportunity to do it because we're starting over again." And they're finding great artists and those artists are going to be all over the stages. I mean, I think this is going to happen a lot faster than we thought it might.

What does the future look like for Caffè Lena?

I think it's really important to know that I don't hold the whole vision for the place, and I don't want to hold the whole vision for the place, because what makes my heart warm is maybe not what is the greatest potential of Caffè Lena. I would say a few different things. One is that more and more we have become a home for creative community. So, what does the art have to offer to the community conversation? You know, it's not about just entertainment. It's about opening eyes and creating understanding and creating those shared experiences and how far can we take that? I run something now called a community classroom, where there's no art involved. There's nobody playing a guitar. There's nobody reading a poem. But it feels like a natural extension of folk music because what we're talking about are things like the opioid crisis. Homelessness. Mass incarceration. Racism in community policing. And these are the things that have informed folk ballads forever. The little guy versus the big guy. Folk music takes a position in this world.

My dream come true would be to have people floating in here, you know during the after-school hours. Sitting in a circle. Playing songs. Having conversations. Having a pot of free coffee going and then the artists roll in for the night and we put on a concert that's sold out. Saturday morning, we'd have a bluegrass jam. I really want this place to be so that the artists of the future look back and say, "I felt so encouraged when I went to Caffè Lena. I discovered that you actually can be a professional musician, and this is how you can tour, and I got to meet these musicians and it really inspired me. So, I decided to go to Berkley, and you know, now I'm doing it." The other thing I want to see happen is for somebody to say, "Well, I just like banjo, and

you know I used to hate those commie liberals, but now I like playing my banjo. And so, I sat down and I found out they weren't so bad after all." You know, so that's kind of my dream, is world peace through music.

Now, the other thing, though, is that we do have this kind of special role in the arts world of the United States because it is this . . . you know, very historic place. Our archives are held at the Library of Congress. The Grammy Foundation gave us a big honor around 2015, around our fiftieth anniversary. It's a nationally and internationally known little place that's one of the gems of American music. It really is. And so, it needs to be honored as such and so, I really do think that streaming is just an entrée onto a national stage and that we really need to do right by that potential. So, I want our content to keep streaming for free, but I want it to be watched by a lot of people and at this point, it's being watching by you know a hundred people. And there's no reason why it can't be a thousand people. So, I think there's huge growth potential there.

ROBERT BARRY FLEMING

I think the job of the artist is to go ahead and radically say, "Racism, misogyny, classism, prejudice doesn't align with natural laws."

—Robert Barry Fleming, executive artistic director of Actors Theatre of Louisville, Louisville, Kentucky

Robert Barry Fleming.
Jonathan Roberts.

Robert Barry Fleming is the executive artistic director of Actors Theatre of Louisville and previously served as associate artistic director at Cleveland Play House and as Director of Artistic Programming at Arena Stage. World premieres commissioned, developed, and championed during this tenure at Arena include the 2017 Best Musical Tony Award winner *Dear Evan Hansen*, Karen Zacarías's *Destiny of Desire*, and the 2017 Pulitzer Prize winner, *Sweat*, by Lynn Nottage. Fleming was also a tenured professor and chair of the University of San Diego Theatre Arts and Performance Studies Department. Live event directing and choreography credits include *Are You There?* and *Once on This Island* (Actors Theatre of Louisville), and productions at Cleveland Play House, Oregon Shakespeare Festival, and Tantrum Theater.

Robert, you are a rare quadruple threat: actor, director, educator, and arts administrator. When and how did you realize you were destined to be a manager, producer, and educator, as much as an artist?

I'd say right from the start I was a generative artist. As a kid I got exposed to a lot of different disciplines from opera to music to ballet to drama. I think there's something about having all of those different disciplines at a really early age that make you have a relationship to visual arts, performing arts, all kinds of artistry that is different than if you just started out playing the piano at three and that you were just drilling and practicing that thing.

The first play I did was at Kentucky State University, *A Raisin in the Sun*, and the director of that was also an administrator within the college. She ran the program. She was an educator as well as a practitioner. I watched her navigate students. These were college students, Black college students at a land grant institution. So, it wasn't like, I'm just directing actors and we're trying to find the play. She was shepherding young Black people as an educator as well as a practitioner as well as someone who was managing a whole program, picking this particular play.

And so, I think I was just getting that real global thing and then having parents who also ran programs or initiated programs. My mother was a part of the PhD nursing program at the University of Kentucky. My father was a research coordinator at Kentucky State. My orientation never was myopically discipline specific because while she was a nurse and while he was a biologist, they have hyphenated identities. I think it was going to be kind of inevitable that I was never likely going to be a really focused practitioner solely.

What skills or traits do you think are important to sustain a career in arts management?

We heard that thing growing up of "those who teach can't do." But that's not true. The first time that got disrupted for me was when I went to Shakespeare and Company I was like, "Well, these people are great actors." But they're also teachers and some of them are directors and fight choreographers, etc. They were great at both. I really needed that image because somehow the narratives were not matching what my orientation or even what I felt my strengths were. I'm just some hybrid. There's a different way of thinking about it.

As an arts manager, you can't be a specialist in every single intersectional piece of what makes an organization run well. But you can certainly have a global overview, hire the right people, so that you create teams that can work effectively together toward a central goal that might be identified in your mission or your value statement. Or understanding globally what the business is trying to achieve and what service it's trying to provide effectively. But one wouldn't confuse that with "I have expertise in every single one of the areas that comprise that."

One's job is ultimately to say globally, "Here are the areas that need certain kinds of support to effectively meet that mission, meet that goal." Because I think the big difficulty and one of the most common mistakes is you'll hear people often say, "Well, you know they're good but they're a micromanager," and you hear that from staff and faculty and artists in the project. It doesn't mean that you don't have certain areas of expertise but it may not be your job to do it. It's like yes, I have a large musical knowledge but if I'm working on a musical, I'm not going to try to do what the musical director does or the vocal arranger. Even if I've taught singing, that's not my function in that circumstance. You want to keep thinking globally and strategically and it's working with a board and helping them to do a similar thing keeping people engaged and onboard.

The Actors Theatre of Louisville has produced some great shows as digital content online. What do you think about the relationship between online and live performances going forward?

I can go back to trying to do a thirty-person *Christmas Carol*, but I can tell you that it's not going to be sustainable. If we're going to talk about what might sustain you, you might want to think about this emergent technology piece. Because it's not really all that different from the evolution of computers or the evolution of TV or any other technological evolution. People who are investing in it, if they can hang on, are going to see a more democratized opportunity to share stories and ideas and ideologies and creative exploration.

That's the exciting part for me is we're going to keep exploring forming content partially because that's always been something that I think has been interesting in our field, like moving from candles to actual electric lights. A really beautiful artist said, "You know the minute you start moving the camera it's no longer theater. That's the dividing line." And while I had great respect for this artist I was like, "If it's a play, isn't it still theater?" It's not a movie, and it's not a TV show.

I think we're going to have a big rush back into the live event reopening thing and a lot of sighs of relief that we're in spaces that we're familiar with, practices we're familiar with. And then we're going to be reminded about the economic and business continuity challenges of things that were not working prior to these disruptions that still persist. And people are going to have to figure out how to navigate back. I think some of this conversation of working digitally as well as in person, and the hybrid nature of that, is going to really resonate for many of us. We don't know that we've already created entirely new habits of engaging stories. It's done. It's already changed. It's just going to take a couple of years for us to realize the level of how deep that goes.

How do you see money relating to issues of diversity, equity, and inclusion? How do we pursue true equity given the economic disparities in the arts?

If you can conceive of an unsolvable question, then there must be an answer. There must be an answer or answers to address that in some way. I think that's the big thing; what do you do with a country that established itself on conquest, enslavement, misogyny, and the establishment of a system called capitalism?

So, I think for our industry when we have that conversation of, "Well, we can at least get rid of racism in the theater," I'm like, *really*? How would you do that when you are part of a system that is inherently racist, misogynist, classist. How do you think you're going to do that? That seems very childlike to think that. We can delude ourselves collectively on a large-scale. I think the job of the artist is to go ahead and radically say, "Racism, misogyny, classism, prejudice doesn't align with natural laws."

The most progressive environments are the environments that are the most economically viable. So even if you're trying to just do it from a capitalistic transactional business model it pays to create a more equitable system, a more diverse system, because those are the systems that thrive in science and economics. Really what you're doing is continually shooting yourself in the foot by framing a binary of saying, "Well, I can either do social justice or I can make money."

Actually, by continually trying to exploit in a capitalistic way, you continually undermine your long-range sustainability and ability to fully flourish. Man keeps getting in man's way but the artists are going to be the ones to say, "This is how you keep getting in your own way. Here's another option, I know you're not going to take it, but for anybody who wants to take a little bit of it and innovate, here it is."

Understand these are not mutually exclusive, your profitability lies in social justice. Justice is the pathway to more fully flourishing in every aspect, for social capital, for fiscal capital. But right now, we have a system that rewards disparity. So, we just keep planting the seeds, we keep telling the stories, we keep showing that when we work in the interest of all humanity, we all flourish more fully.

Recognizing that that's something that's not going away and will continue because man has always worked opposite its own interest. So, no need for despair, business as usual. We'll keep telling the story and we'll keep not listening to it. And somebody else down the road will say, "Yeah they've been trying to have this conversation for thousands and thousands of years and somehow we're not getting the message."

NANCY YAO MAASBACH

I get a phone call, and there's a five-alarm fire. You can't make this stuff up.

—Nancy Yao Maasbach, president of the Museum of
Chinese in America, New York, New York

Nancy Yao Maasbach.
Museum of Chinese in America.

Nancy Yao Maasbach has served as the president of the Museum of Chinese in America (MOCA) since 2015. As the president of MOCA, Nancy has the unique privilege of combining her experiences in managing organizations, promoting arts and culture as a bridge between peoples, and executing research focused on redefining the American narrative by examining the role of Chinese Americans in U.S. history. Prior to her time at MOCA, Nancy was the executive director of the Yale-China Association, one of the oldest nonprofit organizations dedicated to building U.S.–China relations. Nancy has over twenty years of leadership experience at nonprofit organizations and for-profit management, including staff and board positions at the Community Fund for Women & Girls, International Festival of Arts and Ideas, Tessitura Network, Goldman Sachs & Co, Council on Foreign Relations, CNN, the Center for Finance and Research Analysis, and Aberdeen Standard Investments–managed closed-end funds. Nancy received her MBA from the Yale School of Management and her AB from Occidental College. She was an original member of the Here and Now Theater Company. She is a lecturer at the David Geffen School of Drama at Yale. Nancy is a member of the Council on Foreign Relations.

Nancy, how did you first know you were not just going to be an artist but also going to be an arts manager?

That's really a great question. I'm going to give probably a different answer than other people. I think less than 1 percent of Asian Americans go into arts and culture. There's a legacy of exclusion and doing certain types of professions for Asian immigrants in this country. It's not something that I was ever encouraged to do, although as a young person I definitely had a passion for theatre, and I was a piano player, but at the time they wanted me to play the piano for whatever school production it was. I said, "Well, I'd rather have a role rather than being a pianist." I never got one, I was just the piano player, and I was a good piano player, a solid piano player. I think on my own volition I always trained and played for myself. In the back of my mind, I was calculating the way to success. By 1994, I thought, "I'm never going to be able to do this and it's not practical and my parents will have a fit."

So, I've done a ton of theater secretly. This is my personal rebellion. I've done theater productions every year of my life since I was twenty-two. I'm forty-nine years old. I played the lead in *The Jury* in Hong Kong. I was the lead in *The Golden Child* with David Henry Hwang in Hong Kong. I remember there was even a *South China Morning Post* headline that said, "Almost Famous." There's a picture of me, and I'm looking at it and my boss at Goldman Sachs says, "Oh this person looks just like you," and I'm like, "Oh yeah, what a coincidence," and it *was me*. There were two lives I was leading. I remember when I was forty or forty-one and I started an arts scholarship at Yale-China and I let out this huge sigh of relief. Because this is something that I never thought I'd be able to do as a paid position.

I write now and I teach at Yale School of Drama. I think it's been a very long and circuitous road for me. But going into arts management is something exciting but still different. Going into arts and culture in a museum combines storytelling and presentation. It's just great. I have the best job. But it's the most difficult job I've ever had. But I have the best job.

The arts and culture are such a big part of the fabric of New York City, and yet people who are in arts and culture are getting paid so poorly. I think that's a little bit shocking. How is somebody supposed to have any semblance of quality of life in New York City if they're getting paid but they can hardly pay rent? For people who have a trust fund or with parents who have an apartment, that's fine. But for anyone who has $200,000 of debt after school, like I did, it's impossible. But there is a self-righteousness about "I'm in the arts so I don't need money."

You have led MOCA since 2015. What's changed since you arrived there?

A lot of things have changed, I think, in the last six years. For one thing, MOCA is forty-one years old. And before I came, it reopened in this new location in a rented space designed by Maya Lin. That was 2009. And between 2009 and when I started in February 2015, there were nine different leaders of MOCA. And I've been here six and a half years, and I've been holding on for dear life. Like, literally, I feel like things are around my ankles. And it's, again, been the hardest job I've had. People say, "Oh,

you worked at Goldman Sachs. That must have been so hard." I was like, "So easy compared to this. . . ."

When I first joined, we were only renting the main floor and the basement. And all the staff were in this very small, like 700-square-foot space, and I knew the air wasn't good in the basement. I was like, "We can't do this." So those were the two things I recognized right away. One is the salaries aren't fitted correctly. And I almost felt like the space we were working in was like a human rights violation. So, even though we didn't have money, I just wanted to make sure that we could work in a place that was going to . . . in Chinese, there's a phrase Chi Ku (吃苦). In English it means to eat bitterness. Like, you need to suffer. And then slap on top of that, like the arts world, right? Like, let's suffer and suffer. Right? And I was like, "This is not healthy." So that part needed to be fixed, and then also thinking about really doing the work, fully and well. And they did it well before but again, it was sort of like, we need to tap into scholarship. One of the problems around museums and MOCA's content is that there's not enough scholarship in the area.

When I first started, I had about twenty-four full-time staffers getting paid ridiculously below market. And now I have twelve. I've been able to increase people's salaries. What I've learned is that prioritizing is a tactic. Until you can get an organization properly resourced, you need to make sure that you're aiming to go somewhere, and you've just got to prioritize. Everything you want to do just cannot get done. But it's hard because you're juggling opportunities. Contributed revenue made up about 90 percent of our total revenue, and only 30 percent of that repeated year on year. Then you have to not only cultivate all 100 percent of your donors but then find another 70 percent to make up of the difference. Ticket revenue was less than 3 percent of total revenue. But it's more important to get people to see the museum than it is for me to ask you for $20, if you decide not to come in.

How has MOCA's fundraising changed since you arrived?

Early in my tenure, we kept getting denied grant funding. And I said: "Wait a second, this is the best grant I've written. This is amazing. We're showing that we can do it, that we're going to do anything we can to get this project done. And we keep getting denied." I had a big revelation when I was a grant reviewer. Organizations were writing things like, "We're going to close if we don't get this grant. We need this development person because we don't have any money, and we don't know how to do it." And I said, "What the hell is going on here? That is the antithesis of how Asian Americans are," or at least how I grew up, right? Like, the culture of writing grants was the opposite. All the other grants were like, "We can't do it. We need you to help us. We need your help now." And we kept saying, "We can do it, we won't sleep. We can get this done." And I thought, "We are not being honest because we cannot get this done. We might get it done, but we might not sleep or eat for six months." I said: "Time out, team, we've got to be honest with ourselves. And we have to be honest, because people don't want us to die and be martyrs in the process." And once we started saying, "We can't do this, and we actually need your help. And this is how

we need your help," we started getting grants. It's crazy. But that's a cultural difference, you know?

Philanthropy is so yucky these days. There's just a sense people just want the money. Development people are like the investment bankers of the eighties. And you need philanthropy to build out the larger culture. We have to build it properly and not just look for the dollar. Even today we're doing a 128-million-dollar capital campaign, and too much of it is often focused on getting the gift and not about making people feel good about *giving* the gift. Once they commit to a gift, I feel like they fall off our way.

In January of 2020, MOCA experienced a huge fire. Can you talk about that experience?

Yes. The cofounders of the museum, Jack Tchen and Charlie Lai, started MOCA forty-one years ago, by looking into dumpsters where people were changing generational shops. And they saw these signs, like hand laundry signs, things that people obviously didn't think had any value, and they started keeping them. And that was the basis of our collections.

So fast-forward forty-one years, we had the largest collection of Chinese American artifacts, oral histories, newspaper collections, the first Chinese typewriter, a real rich combination of items. And you cannot make up this story. We all happened to be in New York City in downtown Manhattan at the time. And I rushed over, and I'm actually at dinner with these two people who wrote the book about the *Farmer's Almanac*. And every year they do this prediction about the upcoming year. And they had just given a program at the museum. I'm taking them out to dinner. And literally, I'm asking them, *"Is it really going to be as bad as you said it was going to be?"*

And I get a phone call, and there's a five-alarm fire. This is two days before lunar New Year, and I was like, "You're kidding me." I'm running over there. Most of the staff happened to be in Chinatown that night for dinner. And the roof comes down on the fourth floor. Fourth floor goes down on third floor, third floor goes on the second floor. Sixteen hours of water going into the building, the entire first floor is flooded and destroyed. The only floor that survived was the second floor, and *our entire collection was on the second floor.*

Wow.

We got 98 percent of the items out of that building. Nothing else came out of there. Burned to a crisp. So, the fate and the destiny of this. "Okay, I guess we have to get this thing done," the new museum done, because our museum needed a permanent home. But, for me, watching the fire until midnight, and then going home. And then coming back at seven in the morning, I was just like, "Can I take this?"

You can't make this stuff up. And then we finally got everything out. And it's in truckloads. When there's water, everything goes off and everything comes out and items don't land in the same place where they were. Like, it just kind of gets all taken apart. We ended up putting it in four different locations, two stabilized freezers. One in Pennsylvania, Western Pennsylvania, another one in Westchester. And then another massive surface area in our current building where we're just borrowing space and laying things out. And then another facility. It was just a total mess.

And then COVID hit. We were already seeing cancellations, like in early January, because I think people thought the Chinese virus was going to be in Chinatown. I went to my director of education and said, "Do you think this is racism?" She's like, "No, you don't think so? Why would they think that?" I was like, "Chinatown. They think Wuhan flu." This is people already making the correlation, "Oh, it must be in Chinatown."

In this moment of finally recognizing and combatting AAPI hate, do you have thoughts on what the role of the museum should be, in this national conversation we're finally having?

It's Asian American and Pacific Islander Heritage month. We've been giving corporate presentations on just about every day, this month, as well as to schools and PTAs, and churches. This is the same issue that we dealt with dramatically last year with Black Lives Matter. I mean, the Chinese American journey is about systemic racism, and the great need to redefine the American narrative. It's the same story, it's just different faces. And if we don't get it right. . . . I'm looking at your image here, it's like folks with dark brown curly hair and facial hair. You guys might be the victim next year in a moment, right? Because we might not like you for whatever reason, or red hair, auburn eyes, whatever, like Irish American women.

This is the same problem where we can't seem to fixate ourselves beyond labeling a color on a person and compartmentalizing our understanding of what the American dream is. And it's unfortunately a moment, if we can't see beyond the fact that this is the same problem. And so we talk a lot about, there are a lot of loud voices right now, and there often are around things when they flare up. And those voices are necessary in voicing around advocacy and sort of like telling what happened. But places like MOCA, our history museums, and our social history museums, it's just like this idea of like, there's a broken bridge and people are kind of like falling through the hole in the broken bridge. MOCA has to fix the bridge, right? So MOCA has to tell the history, it's got to get into textbooks. We've got to make sure that teachers are coming to the museum until the textbooks are rewritten.

People said, "Hey, you've gotta go protest. Why aren't you protesting?" I said, "Please, let's time-out on this. What is our mission? Let's make sure we're doing our work." So then, we all said, "Oh, wow, our mission is to *record* what's happening." It's to record the advocacy groups, it's to record what's not being done. It's to record all of this. To make sure people know this happened. And we've done that throughout our work, whether it's Vincent Chin getting murdered by Richard Evans, in Detroit in 1982, and how he was mistaken for a Japanese auto worker. Whatever those instances might be, we need to record it.

What does the future look like for MOCA?

Holding on for dear life, taking deep breaths every day. And we're definitely going into a permanent home scenario. And Maya is redesigning the museum, Ralph Appelbaum Associates is designing the museum exhibitions with us. We're hoping that this will forge a greater interest in scholarship, so that we can look at things more ob-

jectively, because right now, I feel like objectivity and scholarship are really important. Because, especially with social media being used as a tool, sometimes not always for productive means, we're in a very dangerous space right now.

People think the Museum of Chinese America is by Chinese, for Chinese. It's not at all. MOCA is a U.S. history museum, but it's telling the stories through the Chinese lens, stories that you don't know. But we're hoping that you have a greater sense of yourself, after you experience the fact that this history is so unknown. I am hopeful, if we can get this done, that it will actually contribute to the great need for other marginalized groups, and also mainstream groups to have a fuller, more nuanced presentation of its history. And we're always simplifying in America. It's the weirdest thing to me. Like, assigning colors and making things simpler. We're a sophisticated, intelligent country, I don't know why we keep doing this.

LISA RICHARDS TONEY

You must be confident but confident with a base, confident with a reason, confident with something under you, some weight. Showing up, being ready, being prepared. Because when the door opens, you're going to walk through it. But can you stay?

—Lisa Richards Toney, president and CEO of the Association of Performing Arts Professionals (APAP), Washington, DC

Lisa Richards Toney has more than twenty years of experience leading a range of small and large arts and humanities organizations, managing change, and building stability. Prior to leading APAP, she served as the executive director of the Abramson Scholarship Foundation, the deputy director and later the interim executive director of the DC Commission on the Arts and Humanities, as well as other leadership roles at the Pen/Faulkner Foundation; the American Place Theatre, and as the first executive director of the Debbie Allen Dance Academy. She received her Bachelor of Arts degree in drama and English as a Presidential Scholar from Spelman College, a Master of Arts degree in Arts Education from New York University, and a Vilar Arts Management Fellowship with the John F. Kennedy Center for the Performing Arts.

Lisa Richards Toney.
Lisa Richards Toney.

Lisa, you have had an extraordinarily rich career as an arts leader. How did you begin?

I grew up in Washington, DC, and my first, I would say, real comprehensive performing arts experience was through the DC Youth Ensemble. One of the things that was very clear to me is that I came into the arts a little late, especially as a dancer. I think I always knew that, but I still pushed myself because I actually really enjoyed it. But I had a wondering that, "I don't know if I'm going to be physically able to do this for such a long period where it's my life and career. Maybe I should also think about what else I like." So, I started teaching, and as an assistant teacher in drama classes at DC Youth Ensemble. And I continued to do that for years and years and over the summers, ended up running an entire summer program.

And I will always credit Carol Foster, because *she let me sit at her desk.* You know what I mean? She made space for me. She said, "Okay, this is what you want to do. These are the things you need to do so that you can achieve it. You need to figure out within this budget, how you're going to divvy up what this program looks like. You need to figure out how much it costs, how much you can afford to pay your teachers."

I'm just listening. "Are you going to have to buy costumes? Do you need to hire any tech people?" Learning about production budgets, learning about the administrative, the company management side of things, contracting artists; it was all very much in front of me, and I would sit at her desk. In fact, I used to keep a picture that she took of me, it was a black-and-white photo of myself with all these notebooks stacked up. Now, all the notebooks were kind of subject matter on what I was just telling you, contracts or schedules or whatever it could be. I took that very seriously and she liked that about me.

What advice might you give to someone who is just starting out?

I would say, the word is listening, but it has something that's active with it too. Sometimes people think of listening and they think it's passive. But I see listening as a very active space to be in as a young person. I remember Debbie Allen, another one of my dear mentors and my old boss. Before I worked for her, I sat in her rehearsals quietly and watched her like a hawk. Just watched her. I wasn't on her team in the same way that others were. I was a Vilar Institute fellow at the Kennedy Center. But I wasn't someone she knew and trusted. So, you can't have this expectation that you're coming in and running stuff. You know what I mean?

Humility is *really important*. So, I would just come in, acknowledge her, acknowledge my presence, and sit down. And I would watch, and I would take a lot of notes. And at one point I'm looking at her and I said, "Ms. Allen, I would really like a chance to meet with you, because I've been watching and I really appreciated the opportunity to do that. And I have some questions that I think you could answer." She was very receptive to that. And so we met. Then at one point, she really liked my questions, and we had such a nice communication going on. I would ask her questions, all the time. Then I became more daring and confident.

And so, as a student and early career professional, you must be confident but confident *with a base*, confident *with a reason*, confident with something under you, *some weight*. Meaning you have observed, you try to learn, you're trying to bring something to the table, you participate, you're on time, *don't be late*, you know how it is. And so all of those qualities are important: showing up, being ready, being prepared, because when the door opens, you're going to walk through it. But can you stay?

And it takes time. It takes time. So, I don't underestimate any position. I think the strongest position someone could take is as an executive associate or assistant under a CEO. If you're lucky and play your cards right, your boss will tell you a lot. They'll share with you.

How have you sustained a career in arts management?

It's an art form in the sense that it takes courage and vision, like none other. Tenacity has been absolutely central to it. Not giving up. Following the dots, because when something opens, finding opportunity in that and jumping in that, that's very much a creative way of working.

I came always from dance first and so I watched dance. I'm not watching it as a businessperson, I'm watching it as a lover of dance. And so, when I think about, "What does that industry need?" I'm coming to it half in my head and half my heart. And that's what I think keeps us going, even in spite of the very, very challenging times that this art community can face and has faced.

How have you seen the field changing and growing in recent years?

I think we finally have really understood that we actually are stronger together. Meaning that our ecosystem, the ecology of the performing arts, is actually quite large. And when we band together and really support one another, we actually have a prominent place at the center of the public square. And all of us, I mean, people who have never done that before, are raising their voice. That's very important.

I also think that we are learning really how to think about our business in a very serious way, where issues of equity, diversity, racial inclusion, all these things and other aspects of inclusion and diversity, that our business, just like any other business, must be really solid in those ways. And if they're not, we need to work toward it. We're not an exception to anything. Actually, we are just like everybody else. We are businesses full of people that need to have a very, very strong representation of who we are. To be fair, the concept of equitable business practices has been, I think, a sore spot within our field. It's always been, "Well, who has the work and who needs the job?" And so, it's that dynamic that has really disempowered many.

How have you experienced empowerment in your own career?

I mean, if I didn't have Black arts organizations and Black arts professionals who hugged me, who brought me up when, honestly, not all but some white arts teachers were not really very supportive. Telling me that I should be in more of an ethnic dance, as opposed to trying for ballet. It happened on a particular audition that I went on. I'll never forget it. Or when I raised a question about my tights. I preferred we should wear brown tights, you know, kind of just being ignored.

If it wasn't for the confidence building that came in tandem with the opportunity, because that confidence comes from being given a chance to do something and succeed at it, I don't know if I'd be sitting where I am. So, I don't take this opportunity to expand what it means to have justice in this field, I don't take it lightly. I'm a direct recipient of it. And yes, I worked hard. I worked hard and I was ready to go through any door and anybody's door, and that's okay. And I don't discriminate. I will go through any door. I'll try. I love people, and I want to explore and be the best that I can be.

However, light doesn't come from just looking at the light. Light comes from when you see it in the darkness. Right? Sometimes you have to kind of really take a step back and dig everything up and go, "What is it that we really do again?"

How has the global pandemic changed your organization? How do you envision its future?

It's not that APAP was in any way out of mission or out of line. But it is an opportunity to realign and be creative about what we now can do. So, you've got on

one hand crisis management, shrewd management, and on the other hand, you have, "Wow, what an opportunity. Who could we be and where do we need to align?" We were doing what we were doing, just marching by orders. So, everybody's had a chance to kind of unwind a bit, take a step back and figure out, "Is this working? And if it's not working, why are you holding on to it?" Stop it.

I see APAP as an important leader to carry the field forward, now and into the future. Very simply, we are the large tent. But the needs are vast and different. And so, we have to hold all that. Now, in order for us to hold that, we need people to step up and help us hold that. We know that we're going to have to carry this field forward.

People need to be together. They need our conference; they need to do business. And they need to continue that network that will keep us solid and strong because we're the big tent. There are lots of tents. There's lots of service organizations, they're discipline-specific, region-specific, you know they're all out there and they're all my colleagues. And they do a great job. APAP is the big tent, though, and so we have a breadth of information that others may not always have, because we service the field in that kind of a way. Our opportunity for new business models is being interrogated as we speak, because we have to also understand that that is a big piece of our identity and our sweet spot. And so how do we maximize what we know to be our sweet spot to make sure we're servicing the people the way they need to be serviced? And that does not allow us to shrink. And no business should, by the way, right?

CHAD BAUMAN

You're always going to have to balance pros and cons of multiple different areas and make the best decision that you possibly can, knowing that every single decision you're going to make is going to probably piss off somebody.

—Chad Bauman, executive director,
Milwaukee Repertory Theater, Wisconsin

Under Chad's guidance, Milwaukee Rep has grown from a $9 million to $14 million organization. Before moving to Milwaukee, he was the associate executive director at Arena Stage in Washington, DC, where he was instrumental in opening the Mead Center for American Theater, a 200,000-square-foot, three-theater performing arts complex dedicated to American voices and playwrights. Bauman is a graduate of Harvard Business School's Strategic Perspectives in Nonprofit Management program and has a Master of Fine Arts in producing from the CalArts. He and his husband, Justin, live in Whitefish Bay and have been host parents to AFS Exchange Students from Norway and Germany.

Chad Bauman.
Michael Brosilow.

How did you get your start as an arts manager?

I had just graduated grad school, and much like a lot of graduate students, I sent my résumé out to like a hundred different people. I got a couple of good interviews. One was with a theater in Norfolk, Virginia, called Virginia Stage Company. I interviewed with them a couple of times, and I guess I talked my way into getting an offer for a director of marketing job. I got back to Los Angeles, and I knew I had to move cross-country, and I was like, "Oh—by the time I get to Virginia, they're going to think I'm going to know something about marketing. I'm going to actually have to do this now." And so, it was a five-day drive. I remember I would drive eight hours during the day, and at night I would read *Marketing for Dummies*. By the time I did get there, I knew enough from the *Marketing for Dummies* to fake it until you make it, and that's what I did.

What advice would you give to a new manager?

I think being curious and inquisitive and figuring things out is a key to be an arts manager. You're going to be faced with different situations. The one thing I love about my job is that I never really know what I'm going to get in any different week. A year ago, I had no clue we were walking into a global pandemic and what it was going to take to navigate. Everything else is going to be interesting and different. In this case, I

had to learn about marketing. I had to pour myself into learning about marketing, and it ended up being a very good part of my career for ten years.

I will say every single job that I've ever taken has scared the crap out of me. I think about the analogy of the goldfish growing into the size of the bowl that it's in. I think what holds a lot of people back is being scared or timid about not being able to flourish. I think a lot of people have the capacity to flourish and they just don't embrace that.

How has the growth of digital content changed your organization?

I think how we deliver our mission has significantly changed this past year, and I think it's going to be really difficult to put the toothpaste back in the tube. We were able to make a lot of really significant changes in terms of digital delivery of artistic content, particularly with the unions that we work with that we hadn't been able to do for a decade or more. Then all of a sudden, it was the only way you could deliver artistic content. I think, at this moment, we're going to have to come to terms with how we use it in the future, where previously we weren't using it at all. Then, we were using it exclusively. There is something that is always going to remain magical and interesting about live performance. There's no doubt in my mind about that.

I'm not one of these people that believe that digital content is going to erode live performance. It's not. But there is a really interesting opportunity for us to bring our work and Milwaukee Rep all over the world for people to see. If we're trying to reach rural populations in the state of Wisconsin that just will not be able to travel to Milwaukee, we can serve those populations. We can serve donors that get to a certain part in their life, and they just don't feel comfortable coming into the building any longer because of physical limitations. We can now livestream content right into their homes. So, I do think there's a really exciting opportunity. I think that's not going to change. I think it's going to permanently make some adjustments to the way we deliver product.

What are your concerns about the future?

The pandemic has made the wealthy wealthier by a lot. I don't think we should be naive about this. "Who pays the piper calls the tune." There are these great ideas and plans out there about what to do in terms of reaching broader people, being more inclusive. When the rubber hits the road with a huge donor that completely disagrees, and let's just say, their bankrolling 10 percent of your company, 20 percent of your company. How do those decisions get made? I am concerned about the concentration of wealth, because with wealth comes power and I think a lot of donors use their wealth very generously and are amazing, and I think some don't use it as well. The more that's concentrated, the more decision-making is put into fewer hands at a moment where there's a call from the field to be more populist and more inclusive. Those two things at some moment are going to collide, I think.

The other thing that's sort of on my mind: Commercial real estate is having massive problems because the pandemic has allowed everybody to work from home. They've sort of spread out all over the country. You're seeing booms in really odd places like Idaho, and you're seeing a mass exodus out of cities like New York.

Our organizations work right now because of the high concentrations of people in a very small, geographic area. The only reason why you can have Milwaukee Repertory Theater is that there's a million people within—I don't know—ten miles, fifteen miles of us. If that population starts to shift significantly and your entire business model is on live attendance at your venue, you've got a big problem, because you don't have the people there any longer. If this continues to happen, I think Broadway won't have a problem because tourists will continue to go, but I think the major regional theaters will have a problem. Maybe those theaters will branch out and will do more digital content that will help them have it do a new business model. Maybe we'll do touring more across the country. I think it's going to cause us to really take a look at things. I think the cities that have a mass exodus—I don't think they're going to be able to support large, artistic institutions.

How has Milwaukee Rep embraced diversity, equity, and inclusion?

In 2015, we changed the mission of the company at Milwaukee Rep, which is highly unusual for a company that's been in operations for more than sixty years. But we put two things into our mission statement that hadn't previously existed. The first was that it now calls for us to create positive change in our community. The second was that we were called to be reflective of Milwaukee's rich diversity.

Milwaukee has a lot of positive things about it. I love living in the city, but it's also got a lot of areas to improve. It's pretty well known as the most segregated city in the United States, and it's palpable. It's palpable when you're here in the city. And so, if we're looking to create positive change in our community and be representative of the rich diversity of the city, then it really meant that we had to focus on equity, diversity, and inclusion in almost every single thing that we did.

In 2017 and 2018, we created a new strategic plan that centered on equity, diversity, inclusion. We ended up having a board committee for it. We brought in consultants to help us. We had a road map, but we made a lot of mistakes along the way. And one of the mistakes that we made was that we tried to put diversity, equity, and inclusion (DEI) efforts on the plate of a current staff member that wasn't an expert in DEI work, and they weren't trained in it. They had a passion for it. They might have had lived experience in that area, but they didn't come at it from a strategic perspective. I say that not to denigrate any of their work. It just—it was an error on our side.

Our strategic plan called really for three priorities. The first was a real commitment to new play development. The second was upgrading our physical facility. The third was equity, diversity, inclusion. At this point last year, I was starting to notice that for new play development, we hired on an associate artistic director, who was an expert in new play development, that's all she did. She drove our new work development program. We hired some experts in building infrastructure, and we started to really think about capital campaigns and driving that. Our third focus area, which is DEI, we didn't hire on an expert. We tried to do it internally with resources that were not adequate.

We went back to the board about maybe a year and a half ago now, and we said, "Okay, we really need a senior leader that is going to focus on this, that's going to be strategic in their approach, that this is all that they do. This is their career to come in and really give us a high-level guidance and steer this program." And so, that's when we ended up hiring a chief diversity officer and it's been a game changer for the company. Her mantra is: "Acknowledge the joy." She brings joy to this work, which, I think a lot of times we're told that this work is tough and it's difficult and it's hard. She brings a completely different approach to it.

If you're trying to create an environment that is welcoming and inspirational to all that is more just, that is more kind, then this is a joyful process. She's coached our entire company through a lot of DEI work and continues to do so. She's involved in our highest strategy discussions. She's involved in all of our HR discussions. You name it. She's involved within our community relations and she's a really great addition to the team. It was a mistake not to go in that direction earlier.

Milwaukee Rep is one of the very few arts organizations to create a senior level chief diversity office position. How were you able to do that? What power does your chief diversity officer have to affect the organization's decision-making?

The thing that made her really effective almost immediately was that I have a near decade-long professional relationship with her. I met her when I moved here, and she was a marketing and brand consultant at the time. Everybody in the community knows her. Her personal brand is very well respected. We brought her on as a volunteer. She volunteered to help us with our community outreach, and I just sort of fell in love with her and her personality and everything. She had worked with us for seven, eight years in multiple different positions—as a volunteer, as a consultant, you name it.

I called her one day and I said, "Listen, I know you have a very successful company, but you know Milwaukee Rep. You know me. You know where we need to go. You know this city really well. You're the perfect person. This is the first time creating this position. We don't really know what we need, but I know you're smart, I know you're not going to pull any punches, and I know you're going to come in here and do some change." She said, "Let me think on it." Later she called me back and said, "Yup, I'm in."

Because of that relationship—she had it with our board, she had it with our staff, she had it with executive leadership. She immediately came into the company with a lot of buy-in. People trusted her. They knew her. They respected her. And I said to her, "I know that if this is a priority for the company, then it's going to have to be well funded at some point. Tell me what you need." About five or six months into it, she came back to me and said, "Here's my budget. This is what I need." I took it to the board, and we got it approved and that was that.

She has her own budget. She creates company-wide trainings and company-wide opportunities, and celebrations, and lots of different things that she guides and it's across all departments. She works a lot with marketing. She works a lot with engagement.

She works a lot with our donors. She has access to basically anything she wants, but this is also a finite period for her. We knew that she would come in, help us establish this role, what this role would do, and the last part of her work with us is to recruit the next chief diversity officer as a permanent officer. So, she's going to be with us in this capacity for a year and a half to two years, and then we're going to ask her to join the board. She's gotten a lot of respect on the board. She'll be an amazing trustee when that time comes.

MARY CERUTI

Museums are in a moment of real evolution. I don't know if I'd be willing to call it disruption yet. Museums don't disrupt that easily. But I think we are in a moment of real opportunity for evolution.

—Mary Ceruti, executive director of the Walker Art Center, Minneapolis, Minnesota

Mary Ceruti.
Bobby Rogers.

A Cleveland, Ohio, native, Mary Ceruti has over two decades of experience as a curator and arts executive. Prior to leading the Walker Art Center in January 2019, Mary served as executive director and chief curator of SculptureCenter in Long Island City, New York. Before joining SculptureCenter in 1999, Ceruti worked as an independent writer and curator with various arts institutions and agencies, including the San Francisco Arts Commission through which she organized three public art projects by Bill Viola. From 1992 until 1998, Ceruti served as the director of programs at Capp Street Project. She started her career as a curatorial assistant in the Twentieth-Century Art Department at the Philadelphia Museum of Art. Ceruti holds a dual BA in philosophy from Haverford College and in art history from Bryn Mawr College. She received her MA from the Inter-Arts Center at San Francisco State University after pursuing an in-depth study of community-based public art projects.

Mary, you have had such an impressive career. How did you begin?

I grew up in Cleveland and the Cleveland Museum of Art offered the AP Art History class. My mom is an artist, so I had spent time at museums, and I love museums. The thing about that class that was so great was that it was taught *at the museum*. And because it's an encyclopedic museum, one day a week we were in the classroom doing slideshows and a lecture and the other day we were in the galleries looking at real objects and paintings and sculptures, which is not the way a lot of people study art history. So, I feel that was really important and formative for me.

I knew I wanted to work with contemporary artists. I really was interested in the way that art could witness, reflect, imagine the world and that seemed important to me, to be part of that conversation about the world we're living in. Perhaps informed by the past, but really about the present and the future. That was compelling to me. While I was in college, I studied at the Philadelphia Museum of Art with Mark Rosenthal, who was the curator of Twentieth-Century Art and taught a seminar. He then hired me for a part-time contract research job that summer. I was able to work at the Philadelphia Museum for about eighteen months. But then I realized I didn't want to be

in a big museum. [laughs] Because, of course, watching a curator putting up contem-porary art at the Philadelphia Museum, which has an amazing collection, seemed like the *dream job*. Then I saw that what it *really means* is you spend your day in meetings, and then you go to a cocktail party and chat up some donors. If you really want to read and write about art, you have to get up at five in the morning and stay up late at night. That really wasn't part of the core of your job. When I moved to San Francisco, I looked at alternative spaces and thought I want to be in smaller, artist run spaces. Of course, there's a lot of administration and meetings that happen at those meetings too. So, part of that is just growing up, right?

How did you develop your management style?

Working in those smaller spaces did, I think, shape the way I approach museum work in a whole different way than if I had come up through a larger institution where you're siloed into different departments. I had the great fortune when I was in San Francisco to work for Capp Street Project, which was a residency program committed to basically inviting an individual artist to make a large-scale work of installation art, this was in the mideighties. And we were dedicated to realizing the artists' vision and it was a small team. I think when I started there were four or five full-time staff.

I started as an intern. Then when the admin job opened up, I got that, then I became a paid administrative assistant. Then I don't even remember exactly what the sequence was, but the executive director really enjoyed developing talent and the team was so small. Basically, when somebody left it was like, "Okay, what do you want to do? We'll rearrange the job." So, I thought, "I want to learn how to do that, so I'll take on that." It was sort of a constant process of mentorship and professional development in this very small space. I'd be the grant writer. I was the bookkeeper for a while. I wrote the press release, whatever. Until I worked my way up, until I was a program director and curator and then eventually, I came to New York and became the director of the SculptureCenter. But I feel that training of doing a little bit of everything in that small environment was really important for me.

What traits or skills do you think helped you sustain your career in the arts?

The ability to shift perspective is really important. I may have learned that partly from being in those different roles in a smaller organization. Understanding what you need for the press release versus what you need for a grant proposal versus what you need to have a conversation with the artist. Or what your audience members needed.

But also, I think working with artists so directly informs that too. And being able to shift perspectives or understand how other people are experiencing something which I suppose is in terms of managing people but also in terms of how you think about audiences and how they're going to approach something and multiple audiences that are going to have different approaches and need different entry points.

I'll be perfectly honest: the other trick is you have to get people not to be afraid to make mistakes too. To be able to maintain that aggressive experimentation and be will-

ing to take risks when you've been through a really dramatic failure. If you get people to commit in that way. It's about building trust and that doesn't happen immediately.

How do you view the role of museums today?

Museums are in a moment of real evolution. I don't know if I'd be willing to call it disruption yet. Museums don't disrupt that easily. But I think we are in a moment of real opportunity for evolution. The pandemic, from my perspective, I think really just laid bare some things that were obviously already there. Then the racial reckoning layered on top of that also even furthers that. But I think any of these issues around racial equity, inclusion, and how museums are or are not integrated in their communities and function as civic institutions: Those were questions that the field has been grappling with for a long time. I think they've just become a little bit more urgent and maybe more visible to boards and people outside of certain parts of the field.

Which is why I think of it as a little bit of an opportunity because I feel like these issues of inclusion, community engagement, how museums serve their communities and speak to their communities and respond to what communities might need from them. Those are all things that people have been talking about for a long time now. And some museums have done some really great things and been successful and others have kind of talked about it, acknowledged it, maybe made some steps, but not enough to get them there. Like how a museum operates in terms of expertise and dialogue with the community.

There's a lot of debate about whether museums should be allowed to deaccession their core collections, meaning sell part of their collection in order to purchase other art. What do you think about deaccessioning and the debate around it?

I'll start by saying that the Walker has the reputation it does and the collection it does because of deaccessioning. Of the original T. B. Walker collection that formed the original Walker art galleries, there's one bust of the founder. That's all that's left out of eleven thousand objects.

Everything else was either deaccessioned or given away. Because at various moments, the institution decided its purpose and function was different. So, the Walker Art Gallery was founded in 1878, T. B. Walker was a timber baron. He was very, I would say, probably very typical although extraordinarily philanthropic. He started the libraries in Minneapolis, he started the science museum. He was committed to education in all its forms.

But the collection was typical jade from Asia, and antiques, and old masters, and a little bit of everything. Basically, it became a regional arts center under the Works Progress Administration. So, our multidisciplinary program that incorporates performing arts programming and moving image and music, and to focus on art of our time, all of that dates from that moment. So that began that shift. That was the beginning of shutting some of the older collection but there was a lot of it still there.

Over time there were a series of deaccessions. The biggest one, I want to say around 1980 or maybe it was 1985, where they sold this group of Hudson River

School paintings at auction, and I think it was eight or nine million dollars. It was a huge sale. It made a lot of news mostly just because it was a record-breaking sale, not because it was controversial. It was a record-breaking sale and that provided endowment funds to collect contemporary art. I think that is integral to our DNA, that we have reshaped our collection by deaccessioning and acquiring. But there's a difference between that kind of deaccessioning and deaccessioning to pay the bills, and that's what I think most people are concerned about is this thinking about the collection as something that can be monetized and transferred to something else.

I'm not going to advocate that everybody should be selling their collections, but I do think we have to be honest about what it costs to preserve and maintain a collection when lots of it is never going to be seen. And all the resources that go in to taking care of a collection and who that's really serving. It is part of a museum's role to be that steward and caretaker of these things. But I also think there's probably examples where our resources, how we allocate those resources, is worth thinking about.

As someone who is an expert in contemporary art, do you have an opinion on NFTs?

Right now, digital art itself, I guess there's two things, there's NFTs, which are around, and they exist for all kinds of things that have nothing to do with art. There's art NFTs and that mechanism of NFT and whether it has value as art are unrelated. I think there are digital artists that are probably doing some interesting work, but I think the speculation and the attention right now is really over the tool or the container rather than the artwork itself. So, I think there may be things, ways in which, that the tool, the NFT, might embed itself within the art market and the way we work with art. But I think that's kind of a separate conversation from whether artists are really making fascinating art that only lives online in that way.

How has the Walker developed its online content in recent years? What do you think will be the balance of live and digital content going forward?

I'm really proud of my staff. We were, I would say, really underinvested in digital infrastructure and capacity. That pivot to digital was hard for us but they did it fast and really well, I think. The live virtual programming was a pretty quick shift for us, as I think it was for everybody. I think people figured out kind of quickly what they could do digitally that they couldn't do otherwise. Like last week we did a studio visit with an artist in Seoul, and we're doing a collection visit in Sao Paulo next week. So, things like that we've been able to take advantage of that.

I can remember not that long ago hearing from people: "I've been invited to do a conference in Hong Kong but I have this other thing so I'm going to fly for two days to Hong Kong to do a conference and come back." That's insane. I would hope we won't do that anymore. That there might be a way that we can have global conversations and utilize these platforms that we've developed and have that combined version. And yes, we might be able to bring audiences from outside our immediate geographic area to participate in programming. But I feel like we were already doing stuff like that with recording these things and putting them on YouTube, so that content is available.

I'm not sure being live with that content is so much better. Once we're out of this moment then having it online later and people can look at it if they want, but that the event itself was considered a live event.

But I think ultimately, I will never watch anything online if I can go out and watch a live performance. We knew that and we still know that and it's going to be true in the future too. But I think there are specific things like certain kinds of panels or lectures or things that yes, we'll be able to include people without flying them around the world, which is great.

What's next for the Walker Art Center?

We're finishing a new strategic plan. We were just about to start that when everything got shut down. We put that on hold. But we restarted it in the fall, so we are now just to the end of that process. The pillars of that are very similar to what I was describing before about the realignment, it's about programs and collections, it's about engagement and how we interact with and integrate with our multiple communities, and then it's about sustainability.

And how do we create? What are the models and what are the ways that we operate that are going to be sustainable moving forward? And now that we're kind of toward the end I'm realizing I went into this saying it needs to be a five-year plan because we need to be able to see past this moment. This is such an odd moment to try to envisage our future when we're just trying to figure out if we can be open to the public.

Our income is down 25 or 30 percent, and next year I think our expenses will come back almost to where we were before the pandemic, because we'll be doing live programming again and we're filling vacant positions that we were able to keep on hold until we could see the light a little bit. But expenses are going to come back a lot faster than income. So that's the challenge, how do you bridge to that point where we're building back? But I think we're getting there. Will it take more than five years, I don't know. I feel like we were on a path and doing some good work and I think it's also one of those things it's a little bit about a culture shift in getting everybody aligned around that vision. As I was saying its uneven, but once we all start to get aligned and some things start to happen, I think it will then happen faster.

C. BRIAN WILLIAMS

It was wanting to bring the idea into the world, and having to do whatever it takes to get it there. I didn't know anything about art administration. I didn't know anything about grant writing. I didn't know fundraising. None of that. I just knew I just had to figure out how to get the idea in play.

—C. Brian Williams, founder and artistic director, Step Afrika!, Washington, DC

C. Brian Williams is a native of Houston, Texas, and a graduate of Howard University. He first learned to step as a member of Alpha Phi Alpha Fraternity, Inc.—Beta Chapter, in the spring of 1989. While living in Southern Africa, he began to research the percussive dance tradition of stepping, exploring the many sides of this exciting, yet underrecognized American art form and founded Step Afrika! in 1994. Williams has performed, lectured, and taught in Europe, Central and South America, Africa, Asia, the Middle East, the Caribbean, and throughout the United States. He is the founder of the monumental Step Afrika! International Cultural Festival in Johannesburg, South Africa. Through Williams's leadership, stepping has evolved into one of America's newest cultural exports and inspired the designation of Step Afrika! as Washington, D.C.'s official "Cultural Ambassador."

C. Brian Williams.
Drew Xeron.

Brian, how did you start Step Afrika! and your career as an arts leader?

The arts were always a huge part of my life. But when I arrived at Howard University, I didn't major in the school of fine arts, I chose business. I studied marketing. I joined my fraternity, Alpha Phi Alpha Fraternity Incorporated. And as a part of joining the fraternity, I was forced to learn a traditional art form called stepping. Stepping is this folkloric dance form that was created by African American fraternities and sororities, and it's a way to express love and pride. We started performing in step shows. We shared it on campus, at Howard University, kind of informally, and there were formal presentations called step shows where we would compete against other frats and sororities for prizes. It was performance, and it was dance, even though we didn't want to call it dance then. And it was a lot of fun. It was an art form that wasn't really acknowledged or celebrated by the larger environments. It was very much a closed circle.

So, I'm playing with the art form at that time while I'm in college, looking at it, studying it, and kind of knew there was something to it. But when I graduated from Howard, I decided to go on a fellowship to Southern Africa. This is in 1990. I go to Southern Africa, and I'm assigned to a country called Lesotho, small country within South Africa. And this is at a time when South Africa is raging with the anti-apartheid movement. White South Africans are voting to see whether or not Black South Africans will be allowed to vote. It's just a crazy tumultuous time and country. And while there, that's where I first got exposed to the South African gumboot dance. Gumboot dance is a percussive dance tradition created by men who worked in the mines of South Africa. The mining industry is big in South Africa. I see that art form for the first time, and I'm kind of shocked because it's so similar to stepping. Just something just feels right. Like, goodness gracious, I'm going to bring these two art forms together.

I see some small business guilds in Lesotho, in the capital city. And one day after class, I told my students, I said, "There's this art that I saw this little boy doing this dance. Can someone tell me what it is?" They're like, "Oh, that's the gumboot dance." And I was like, oh, well. Okay. I said, "Look, after class, I'm going to show you some steps, and I want somebody to show me this dance." It's totally organic, like informal artistic exchange. And so, they showed me some steps. And then I showed them some steps. It was like this huge synergy that came about. Once that happened, from that little small exchange, is where I had the idea to create Step Afrika!, so stepping would meet the continent of Africa for the first time. We'd bring the dance forms together, and people together, through artistic and creative exchange. So, Step Afrika! was born from that experience.

Was it always your understanding growing up that you wanted to be a manager, to move mountains, put things together, or when did that become clear to you?

The Black fraternity and sorority system can be a little leadership proving ground, if you will, where you practice leadership quite honestly as a young student, how to manage, how to connect, how to get ideas through a group. I really think I'd practice a lot of those skills in the fraternity, to be honest. And that's when I started to see that I enjoyed putting things together and moving things toward the end goal. So once I had that initial idea to start Step Afrika!, I first wanted to create a traveling troupe across the continent of Africa. And then that's when Step Afrika! really became a thing. Then I started working to figure out how I was going to bring stepping to the African continent. Took me about three years from the initial idea to make that happen.

You became a manager and artistic director based on your ideas more than any specific desire to be a manager or producer?

It was the project. I've always said that there was the idea that sparked that led me to become an arts administrator, a manager of project. It was wanting to bring the idea into the world and having to do whatever it takes to get it there. I didn't know anything about art administration. I didn't know anything about grant writing. I didn't know fundraising. None of that. I just knew I just had to figure out how to get the idea in play.

Can you say what your management style is today?

Management by objective. Which can be frustrating for long-term planning, because I'm really focused on one thing. It's always, "What's the objective, what are we trying to do?" And as long as no one messes with that, I'm okay. I'm not going to say I'm an amazing manager. I'm probably a strong leader. I really just set the goal and try to make sure that the goal I set everyone feels. I try to sense what motivates people. So, standing room only, sold out shows—motivation. We're touring the world. We have a four-week run at Arena stage. I'm trying to get there, and now, let's get it. Let's all have fun getting there. The goal is there, let's go get it.

You are the rare founder who has kept your organization dynamic and growing, even though you have been running it for twenty-seven years. Can you talk about how you've kept Step Afrika! fresh over the years?

Largely because I understood almost immediately that I could not do it alone, as a founder, as a leader. That was just clear. So, collective management and engagement, and bringing other ideas and concepts into the space, and giving them room to grow and create was almost like in the DNA of the organization.

I'm in a fraternity, and traditionally stepping is just the men. You never see frats stepping in sororities. You wouldn't see different fraternities stepping with other ones. So, we were very fratty, very stuck in our fraternal ways for a couple of years with South Africa. Only the guys, nobody else.

I'll never forget one day: we're doing a workshop out on a plaza here in DC. This girl took our class, a little kid. And normally, we didn't step with any girls, just the frat. But I invited her to be onstage with us. And we went onstage, and the girl started stepping with the frat, and the crowd just went berserk. And I thought, "Oh my God!" That's when I recognized it. And that's when the transition to a dance company started to happen. Step Afrika! started to do work in the United States. Started this path toward a dance company. So, long way to answer your question. Other ideas have always been coming in, and they keep coming in.

Can you talk about how you raise money and how that has changed over the years?

When we first went to South Africa in 1994, I copied the model of most marathons at the time, where a marathoner had to raise their own money to do the marathon. So, each individual that wanted to go on the trip was responsible for their own support. Our board of directors were going to their own communities, with this little form letter about the individual, and raising money, and bringing it to the pot to create the larger project budget.

Step Afrika! slowly started to become an entity, and performing. Then we almost shifted almost exclusively to earned income. We got an agent very young in our development, so that allowed us to start booking performances. So for most of my experience in Step Afrika!, we've had an agent trying to bring in our earned revenue, so that's been a huge part of my existence in the performing arts industry.

We're now about 60-40, earned and contributed income. It's resulted in a balanced, strong organization that doesn't rely only on contributed, doesn't rely only on earned, but all together. So, we're not overly reliant on the individual donor. We're not overly reliant on earned income. It all works together, hopefully.

Step Afrika! does not own a facility. How has that helped the company?

I'm a huge believer in shared space. First and foremost, we're a touring company. What I built was an organization to go all over the world and all over the country, so that wasn't congruent with having space. We have a home to rehearse, but the essential operation were the dancers. The hugest investments Step Afrika! makes is in its artists, providing full-time employment to dancers, and they are one of the largest, longest dance contracts in the country, an eleven-month contract. We've been doing that for a long time. We've been able to provide consistent employment to artists for many years. That has been the center. And so, since the focus of my work with Step Afrika! is to employ artists, and that's where the money goes, we haven't focused on a building. Now, I will say, and I don't think we ever will focus on a building for Step Afrika!, but we do need a permanent home at this point. I don't think we need to *own* that home.

Step Afrika! was hardwired from the beginning to be more relevant and equitable than many other arts organizations. How can the rest of the arts world authentically pursue diversity, equity, and inclusion? Are you hopeful or pessimistic about their ability to do so?

I have nothing but hope, to be honest. What we need, I think, in the broader arts ecology is more vibrant and stronger support of organizations of color going forward. There's a problem with distribution of resources. You know what's interesting about this? In this moment, I don't care how well another organization wants to do this work. You can't serve it better than I can. You can't do stepping like I can. I'm centered around a tradition deeply rooted in the African American community. It will be inauthentic for the Washington Ballet to now try to center stepping. Take Gala Hispanic Theater, for example. The way Gala Hispanic approaches what it does creating productions centered around the Spanish language as native speakers, traditional speakers. Sure, Arena Stage could do a play once a year in Spanish, but it won't do it every time as their mission. So, we need to support an organization that centers that work. And it's okay for larger white American theaters to center a broader range of work. I think we need to have strong organizations of color that are vibrant and can survive in the space.

It's such a competitive world anyway. Everybody's fighting for space, so it's not personal. People are just fighting for space, fighting for audience, fighting for donors, just fighting. Kind of a negative vibe, but try to fight it to survive, and keep an organization alive and strong. And in that fight, stronger people with more money can win.

How do we create space, and recognize that we have to share the resources? I don't need all the resources. I need what I need to make it happen, but I don't have this crazy aggressive growth thing. I know what I need to be able to serve and create, and it does not require all the money. I can play in the sandbox and exist. And I just want others to do that. Some people need more money. Some people need less money.

Step Afrika! has created some acclaimed digital content. How did you all begin doing that?

We made for the medium. One of the artists is a videographer. Next thing you know, we just start creating for the digital platform. And that's been what we've done for the entire year. We just started creating different projects and works, but we created our first dance film, *Stono.* That became a successful project and was reviewed by the *New York Times.* Penn State commissioned us to do a work called *No Justice, No Peace.*

This is how we can go directly to our audience, and create for them, that doesn't require anything else. It's kind of fascinating. When we did our holiday show, we brought in almost two thousand new individual donors of varying degrees, because people all over the country have watched our holiday show. I don't want to lose those people who are now connected to us, who might not ever see us in person. It's one thing to create a great stage show. It's a different thing to create great film. So, I like the challenge. I think the artists enjoy the challenge. The hard thing will be how do we create time for both.

DEBORAH CULLINAN

My trajectory has been rooted in a sense of purpose around the role that art and artists can play in helping us to build a better world.

—Deborah Cullinan, CEO of the Yerba Buena Center for the Arts,
San Francisco, California

Yerba Buena Center for the Arts (YBCA) CEO Deborah Cullinan is one of the nation's leading thinkers on the pivotal role that artists and arts organizations can play in shaping our social and political landscape, and she has spent years mobilizing communities through arts and culture. Deborah is committed to revolutionizing the role art centers play in public life and during her tenure at YBCA, she has launched several bold new programs, engagement strategies, and civic coalitions. Prior to joining YBCA in 2013, she was the executive director of San Francisco's Intersection for the Arts. She is a cofounder of CultureBank, co-chair of the San Francisco Arts Alliance, vice chair of the Yerba Buena Gardens Conservancy, and on the boards of the Community Arts Stabilization Trust and HumanMade. She is a field leader in residence at Arizona State University's National Accelerator for Cultural Innovation and a former innovator in residence at the Kauffman Foundation.

Deborah Cullinan.
Yerba Buena Center for the Arts.

Deborah, how did you begin working in the arts?

I have a history of activism, and I had worked very, very early in my career in community service, social service, social activism. My mother was in community theater. I was constantly reminded about and reminded by artists of the power of art and creativity in people's lives. Though it may not look this way, my trajectory has been very rooted in a sense of purpose around the role that art and artists can play in helping us to build a better world. I was actually working in a community service organization. I had zero experience formally in the arts. I dabbled. When I lived in Prague, I helped create an art center in a squat building. I was always in the mix running with poets and writers, all this kind of stuff.

I was a development director and interim executive director at a very young age for an organization that was working to support and serve people who were formerly homeless, and I really started to consider what it means when nonprofits inadvertently or sometimes advertently exist to perpetuate the problems that we're supposed to be

trying to solve. There was just something about the kind of role of the imagination of art and creativity, and I saw this job in the ads, when there used to be such a thing, to be the executive director of an organization called Intersection for the Arts and I just—I applied and who knew?

And that was it?

That was it. I stepped into the interview. I was surprised to even get a phone call. It was clear that this was a very venerable organization that had undergone a pretty rapid decline, or maybe not rapid, but had declined. It was referred to as the near-death experience. And it was very intriguing to me to understand in my own naive way that arts organizations often thought of art and community as some kind of separate thing. And that an organization that meant so much to that many people, had launched that many careers, could be so vulnerable and so closed off from its community, was really interesting to me. I think that my naivete was actually a great strength because I just didn't get it, you know? So, all I could do was ask questions.

What's your management style?

I'm highly collaborative. I think that for people who I get to work with, it may be maddening because I like process and I'm interested in people's input. But I'm also willing to put a stake in the ground and make a decision. When I think about Intersection for the Arts and even Yerba Buena Center for the Arts (YBCA), it's very much about *listening* and trying to understand and *evolve*. You have to understand that you only come with the strengths that you come with, and that you need people around you who have strengths that you don't have, and you need to create the conditions for them to be successful.

How did Yerba Buena Center for the Arts (YBCA) start?

So, YBCA is part of the former redevelopment agencies, one of their redevelopment projects in San Francisco. It was a project that started as sort of urban renewal, and it was focused on what was considered by some to be a very blighted part of San Francisco. Lots of empty parking lots, etcetera, but was also thriving for others. It was home to seniors. There was a significant labor presence. There was a significant Filipino presence. There were lawsuits and struggle around this big development project.

So, YBCA is just one of the pieces of the Yerba Buena Gardens and it was the result of community collaboration in order to heal and put the arts at the center of a new path forward. It's one of these many, many projects that has a complicated history and to think about what it was built on—it also is on Ohlone burial grounds—and so to really think about like what it sits on, what its legacy is, what kind of institutional harm we may have done over the years, and to try to address that and manage forward—it's hard. I mean, it's really hard.

How has the organization changed since you arrived?

When I arrived, there were a couple of people on board who had already been doing work to transform the organization—to open it up to include people that maybe

haven't been included and to rethink the way we approach being an art center in downtown San Francisco. Over the years, we have transformed it radically and the COVID-19 pandemic certainly propelled us and enabled us to do the boldest version of what we've been trying to do, which is really exciting. For me, the changes are about the fact that art centers of all shapes and sizes can reorient their resources in order to be in service of their communities, that we can better support artists by centering artists and building their capacity to help advance health equity and well-being in their communities.

We have transformed the curatorial structure. There are no longer curatorial silos, you know, performing arts, visual arts, this kind of thing. We have one big program and engagement team. A lot of the work we're doing now is, instead of transacting with artists and then presenting the object or the performance, we are actually getting into deep relationships with artists creating the conditions for them to pursue game-changing ideas, really focused on process and what it means to share the process of creativity, the process of inquiry with the broader community in order to actually try to change things. *And we believe that art can change things*, we believe that if you create the right conditions for people, they can think really big and really outside of the box and that we can execute on those things. And that's the role of YBCA.

What's the thing that's stopping most organizations from authentically doing that?

I think there are a lot of things. One of the big things that I've learned over the years is it's really hard to change, and especially to realize something that *you have not seen*, that you have not done before, if you actually don't know what the path is and you don't see your own value, right? And so, it's like any kind of big change in a sector or a field, we can hold each other back because we create binaries; we create tensions.

There seems to be a belief still that you can't be of service to the community—a community-based organization—and also have "excellent art." You know, it's this or that. Is it a community center? Is it an art center? People are still asking those questions. I think that the economic systems in the arts, which we know are historically, systemically inequitable have put the power in the hands of the people with the wealth and the resource. Therefore, the decisions that are made, are made for a very small number of people. How do you shift that, especially if you're in an organization that depends on it? I think there's a lot of that kind of stuff that we have to deal with. For me—I mean, I just don't get it, because in my mind we're all interdependent and if someone else is not wealthy, then neither are you, you know? To put it simply.

We've taken some steps back and we take steps forward, and some things we do—you know, we try, we fail. There's all of that stuff. I think for YBCA, the biggest challenge among them—and we have quite a few right now, but the biggest challenge for us is that we have not *told the story of what we're doing*. If you're researching it, you might be able to put the pieces together. If you're deep in it, you can put the pieces together. But we have not stopped and shared with our community how we've transformed, what it might mean for them, how all of these things hang together. The risk we have right now is that it doesn't make sense to people, and therefore, they don't like it because they don't understand it. So, there's that.

I think also YBCA is unique. I'm not sure if this is true of other organizations as much, but it has struggled since its beginnings because it was built on strife, and a lot of displacement, and harm; because, as a community give-back, it was promised to be everything to everyone. It is not a museum and we're not really a presenting arts organization. We're much more like an incubator and a laboratory, and we're a venue. There are people in the world that are spending all their time, expecting it to be what *they* think it is, and it's failing them over and over again. So as a result, we then have decades of dissatisfaction that we have to work with to try to put a stake in the ground, make sure people know who we are and what we do, and they know what to expect from us. And hey, if it's not for them, they can make that choice. They don't have to be disappointed by it.

There's also a continual tension around affordability and equity in the city for sure. We are looking for simpatico partners, folks who see what we are trying to do and want to be part of it. Especially during the pandemic, the tension that I'm experiencing is that the inequities were so deep and so long held that those who were struggling before are—it's like, "We have to fix this." And that's going to require a lot more than organizations like developing community engagement strategy. It's about shifting resources, and shifting power, and creating opportunities for people, and supporting those leaders who've been in communities doing the hard work forever.

Do you feel like the way we're financing the arts, can change?

Bottom line is, it has to. And we've already proven that we can, because we all got shut down for a year, many of our venues. Even if things like the Shuttered Venue Operators Grant, or the PPP loans, these kinds of things, even if those things are in place, there are still shifts in the revenue model that everyone has to experience; and it just feels like you have to. It has to be dynamic, and it has to be accessible to people.

What do you think about the new movement for greater diversity, equity, and inclusion, and how to do this work authentically?

I think that's the big question. Right? You don't just check boxes. It's got to be about "No, actually, we need to transform." I think of Octavia Butler, "All that you touch, you change. All that you change, changes you," and *it's about change.* You're not inviting people in to behave the way you behave or whatever; you're actually changing. I do worry that our field will struggle with being authentic about it, but I also think it's great that it's a mandate. People have to do the work.

When do you feel like you've had the effect you want to have in the community?

I can only answer that broadly because a lot of the initiatives that we're undertaking right now are so new. But to me, I think success is multifold. Success is that we've created conditions for artists and communities to thrive, that we are proving, we are sharing the evidence of artists' impact, that artists are really essential for a more equitable future. I think we're successful if we've transformed as an organization.

Arts organizations can be very good at *neutralizing.* The idea that if you put something up and then you take it down, it's literally *gone* and there's no imprint. And so,

there's something about success related to "What's the imprint? What's the change that's happened?" If society is going to change, the organization has to change, and if the organization has to change, the people have to change. *It's change all the way.*

What do you think is next for Yerba Buena Center for the Arts?

I think next for us is just to be that thriving kind of platform and laboratory for community change that centers artists and arts organizations. We're focused on trying to help the ecosystem here in San Francisco and it is challenging. It's a really tough time. There's a lot of tension. There's work to be done.

What are you concerned about?

I see a lot of opportunity, and I worry that YBCA won't be able to scale to that opportunity and not only just meet it, but knock it out of the park and change things as a result of it. Yes, I think there's that. In San Francisco, we're doing a guaranteed income pilot right now and there's a lot of controversy about it. There are people that are really mad that we got the grant and there are so many people that wanted to be in the program. It's only 130 artists as of right now. We're dealing with some pretty heavy controversy, and I worry about the team. I think that is applicable to organizations that are authentically trying to change because you really have to get thick about it, and be willing to take the criticism, and really listen to people, and try to work collaboratively. It's very hard work, and I don't think our sector is necessarily trained for that.

NOTE

1. Daniel F. Fonner, Zannie Giraud Voss, and Glenn B. Voss, SMU DataArts, with Teresa Eyring, Adrian Budhu, and Laurie Baskin, Theatre Communications Group, "Theatre Facts 2019," Theatre Communications Group, December 2020. https://circle.tcg.org/resources/research/theatre-facts?ssopc=1.

18

LOOKING FORWARD

There's work to be done.

—Deborah Cullinan, CEO of Yerba Buena Center for the Arts

INTRODUCTION

Arts organizations are evolving. Global disruptions, social awakenings, and digital breakthroughs continue to push the field forward quickly. A mix of digital and live events is the new normal. Diversity, equity, and inclusion are finally priorities. Safety is a continual concern. Relevance and value are necessities. "Adaptability and flexibility" have replaced "sustainability and growth" as important markers. New leaders and artists are forging their own paths for collaboration, community, and excellence. Experts say the global pandemic pushed our use of online platforms several years into the future in a matter of months.[1] The arts ecology is forever changing.

The last time the U.S. arts sector faced these kinds of drastic changes may have been in the 1950s and 1960s. The U.S. Internal Revenue Service established the 501c3 tax-exempt status for nonprofits in 1954, giving arts nonprofits a financial advantage by allowing them to not pay taxes on most of their income. In 1955 the Ford Foundation began to donate multiple millions of dollars to arts organizations throughout the United States, in hopes of growing the arts outside New York City. Then President Johnson established the National Endowment for the Arts and the federal government's funding for the arts in 1965. These multiple new streams of support combined to cause a massive growth spurt in the U.S. arts sector.

"From 1965 to 2010, the number of professional orchestras increased from 58 to more than 1,200 (including community orchestras); opera companies from 27 to more than 120; dance companies from 37 to 250; and professional resident theater companies from 12 to more than 1,500."[2] This huge injection of fuel meant that the

arts grew quickly but not strategically. This growth also meant that many arts organizations developed huge buildings, large and wealthy boards of directors, big orchestras, expansive dance companies, and other structural necessities now seeming outdated and more difficult to fund in the post-pandemic age. Disruptions like the Great Recession and the Global Pandemic can be viewed in retrospect as horrendous moments of course corrections for the arts; as opportunities to reflect and reengage our values, rather than focus on growth for growth's sake.

In the wake of two recessions in just over a decade, large, lavish facilities for the arts are being reconsidered and partially replaced with robust digital spaces and simpler buildings with cutting-edge technology. Arts organizations are quickly trying to figure out how to offer audiences live and digital experiences that are relevant, entertaining, and safe—and somehow special enough to compete with all the other entertainment immediately available to audiences. In order to survive, arts organizations are also redefining their roles in society, entangling themselves more than ever with efforts in social justice, education, and even healthcare. This final chapter explores innovations and evolutions pointing us toward the future. It also articulates some key elements for any arts manager, arts organizations, and arts management in the future.

FUNDAMENTALS

The global pandemic was devastating for the arts in America.

BOX 18.1. IMPACT ON NONPROFIT ARTS AND CULTURE ORGANIZATIONS AND THEIR AUDIENCES[3]

Nationally, financial losses to nonprofit arts and culture organizations are an estimated $17.5 billion, to date; 99 percent of producing and presenting organizations have canceled events—a loss of 543 million canceled ticketed admissions impacting both arts organizations and audiences. Additionally, local area businesses, such as restaurants, lodging, retail, and parking, have been impacted by canceled arts and culture events with a loss of $17.2 billion in audience ancillary spending. Local government revenue losses are $5.9 billion and 1.02 million jobs have been negatively affected because of canceled events (Americans for the Arts Survey).

- Approximately half of organizations with in-person programming remain closed to the public.
 - Fifty-one percent have targeted a 2021 reopen date. Forty-nine percent have no target date.
 - Forty-two percent lack the financial resources needed to restart in-person programming. Sixty-seven percent of those report it will take

three-plus months to assemble those funds, and 15 percent are not confident they can do so at all.
- BIPOC organizations are more likely to report that they currently lack the funds they need to return to in-person programming than non-BIPOC organizations (55 percent versus 38 percent).
- Forty-six percent of organizations laid off or furloughed staff. Of this group, 35 percent had more than half of their staff affected; 49 percent expect to return to pre-pandemic employment levels, though not until 2022 or beyond.
- Audiences are increasingly ready to return. Fifty-seven percent of vaccinated attendees say they are ready to return to cultural events, up from 25 percent in February 2021 (AMS Audience Outlook Monitor).

In fact, the U.S. Census Bureau's Small Business Pulse Survey reports that "arts, entertainment, and recreation" businesses are among the most likely to take longer than six months to recover from the pandemic.

Artists, and especially artists of color, seemed to suffer the most:

BOX 18.2. IMPACT ON ARTISTS AND CREATIVE WORKERS[4]

Artists/creatives remain among the most severely affected segment of the nation's workforce, having lost an average of $34,000 each in creativity-based income since the pandemic's onset. At the height of the pandemic in 2020, 63 percent experienced unemployment (Americans for the Arts Survey).

- Thirty-seven percent have been unable to access or afford food at some point during the pandemic, and 58 percent have not visited a medical professional due to an inability to pay.
- Ninety-five percent have lost creative income. Seventy-four percent had events canceled.
- Alarmingly, BIPOC artists had even higher rates of unemployment than white artists in 2020 due to the pandemic (69 percent versus 60 percent) and lost a larger percentage of their creative income (61 percent versus 56 percent).

Johns Hopkins University reports that, as of April 2021, the percentage of job losses at nonprofit arts organizations is *four times* (emphasis added) the average of all nonprofits, as a whole (-24 percent versus -6 percent).

SIX ESSENTIALS FOR ARTS MANAGERS

So, what should an arts manager do in the face of global disruption?

1. *Throw out your assumptions.* Realize your experience and plans are probably outdated. Be ready to adjust.
2. *Take a good hard look at what you should do next.* Many arts organizations have been limping along for years, with barely enough support to keep going. Take a good, honest look at your organization and ask, "Why should we still exist? Is our mission necessary?" If you are not essential, it might be time for you to wrap up and help others elsewhere. It's really okay to admit irrelevance and take action to end the organization.
3. *Collaborate and consolidate.* It's absolutely critical. Find ways to collaborate with other organizations, schools, funders. Look for opportunities to merge and consolidate your operations.
4. *Cut strategically.* Find ways to proactively cut costs. Try to find ways to cut things other than your people, if you can. Can you suspend a building's use or part of a building? Can you cut your utilities bills by becoming more seasonal in programming? Find ways to downshift costs, so your funding can go to programming and people.
5. *Create.* Create new models for sharing the arts. New models for staffing an office. New models for rehearsing, building new work, collaborating. Find ways to ask people to be creative. Offer a bit of beauty and inspiration.
6. *Tell your story.* Take photos, videos, and write up descriptions. Articulate your value proposition. Ask for support. Thank donors and funders immediately. Thank them, thank them, thank them.

PRIORITIES

The need for art is greater than ever. Human connection, creativity, and communion are as necessary for life as food and water. While we are figuring out how to fulfill these needs, we need to be generous with our work—and quick about it—or we risk becoming irrelevant.

Disruption is the new normal. Streaming and screentime have exploded. Live events are changing. Online content continues to grow, as live events suffer from the drawbacks of traffic, ever-increasing prices, unproven value, and the simple inconvenience of leaving one's home. How can arts organizations compete?

FIVE KEY ELEMENTS IN ARTS ORGANIZATIONS GOING FORWARD

1. *Flexibility.* Organizations need to be able to listen to their communities and the rest of the world more actively and turn their programming and operations on a dime when necessary.

2. *Freedom from Debt.* Large debt, meaning more than an organization can comfortably pay off in three to five regular years, keeps arts organizations rigid, afraid of change, and unable to take risks.

3. *A Commitment to Diversity, Equity, and Inclusion.* It took a global pandemic and multiple murders on camera, but the arts are finally awake to this conversation. Policies, practices, and programming need to be entangled with commitments to these foundational truths.

4. *Deep Community Connections.* Organizations need to involve their local communities and community members in their work and offer value in service to their community.

5. *Extraordinary Programming.* The arts need to offer extraordinary experiences, online and in person. To pull people away from their screens, and have them glad they did so, requires all arts organizations to deeply consider why they need audiences to engage with them, make a promise to those audiences on what they can expect, and then overdeliver on that promise. This promise does not require expensive production values. But it does require authentic risk taking.

To grab an audience's attention away from their social media, streaming services, and texts, arts organizations need to ensure that their live and online programming is offering audiences something they cannot get anywhere else. Here are a few important aspects of live and online programs that will ensure audiences engage and maybe even return to your organization.

SUCCESSFUL ARTS PROGRAMMING

Live Events

- *The Path to Attend Must Be Clear.* Where can I find directions? How do I get there? Where can I park? What public transit exists and where? How can I get tickets? Where do I pick up my tickets? How long is the event? When will it end? Will food be available?
- *The Price Must Be Reasonable.* Does this ticket price seem fair and reasonable? Is the work well worth the money?
- *The Place Must Be Inviting.* Does your building and space look and feel welcoming and energetic—or abandoned? Audiences need to feel welcome, safe, and excited to be there.
- *The Event Must Feel Safe.* This is incredibly important since the pandemic. Do you have clear safety protocols in place? Are they clear on your website? Does it seem that you have done your due diligence to ensure everyone's safety?
- *The Work Must Be Excellent.* Coming out for an event is now a big deal. Audiences need to feel the event was special, substantive, relevant to them, and high quality. For live events, the performances, production values (lights, sound,

setting, costumes, makeup), script, direction, designs, choreography, and even seating all need to be excellent. For live visual arts events, the artwork must be well lit and compelling, while the setting for the work is easily accessible and comfortable.

- *Audience Follow-up Needs to Be Quick and Sincere.* Is there a follow-up email or text sent to attendees after the event for their feedback and comments? Is their feedback heard and answered?

Online Events

- *The Platform Must Be Fresh and Fast.* The digital space includes your social media, website, and streaming platform. Are they easy to use? Do they look fresh and professional? Does your streaming platform's branding match your website and look contemporary? You can offer an excellent online performance, but if the platform itself looks dated and is difficult to use, audiences will be turned off, especially younger audiences who are digital natives and accustomed to online excellence.
- *The Path to Attend Must Be Clear.* How and where can I purchase tickets? How many clicks does it take to secure tickets? Can I watch on my phone? Must I watch at a particular time?
- *The Event Must Feel Special.* Will audiences learn about this event through friends? Or through some kind of text that makes the event feel special and maybe exclusive? You will need to break through all of the online white noise to make your event stand out.
- *The Work Must Be Excellent and Relevant.* Because these offerings are online, audiences expect excellence in digital design and innovation, in addition to an excellent script, performances, costumes, makeup. For online visual arts, the artwork must be clearly visible, well-lit, and close to the true colors of the original. Offerings must be relevant to their targeted audience. What does this work have to do with them?
- *The Work Must Be Concise.* Calibrate the length of the offering in relation to its value and excitement. Plan the work to fit into a succinct time frame, ideally ninety minutes or less. Offer content that is much shorter as well, so new audiences can more quickly sample your work, similar to TikTok.
- *The Work and the Organization Must Feel Fresh.* Is the video shot and streamed in ways that feel fresh and fun? Are the organization's mission, vision, and values easily accessible online tied to the event, so that audiences can quickly learn more? Is there an obvious and easy Donate Now button available?

VARIATIONS

Artists and arts organizations are innovating in ways that can point us toward the future.

ARTISTS

In June of 2021, comedian, writer, director, and performance artist Bo Burnham released a new one-person comedy special on Netflix titled simply *Inside*. The piece was written, rehearsed, filmed, recorded, edited, produced, and performed by Burnham, alone at home during the pandemic. This "comedy special" was filled with angst, insights, innovations, and inspiration. It showed Burnham rehearsing, setting up his cameras, sound equipment, and furniture before or just after a bit of comedy, song, or tirade. It was Burnham raging against the pandemic, but also against his own sense of uselessness. It was also Burnham showing the world how it is now possible for a single artist to write, rehearse, film, record, and sell their own work, independent of any movie studio or streaming service (though Netflix presumably paid Burnham well to stream the piece after it was complete). This individual artistic freedom assumes that the single artist has access to the necessary money, space, time, and technology to do the work, as Bo Burnham clearly did. Obviously many if not most artists do not enjoy the privileges Burnham enjoys. But technology has still flattened previous power dynamics and granted more people better access than ever before.

Because of advances in technology and online platforms, artists are now free to create and disseminate their work without waiting for large institutions to tell them when they are ready to be seen or heard. They are also able to advertise their work on social media, and gain services like insurance or retirement accounts online. Organizations are no longer gatekeepers for success. Arts organizations do offer, however, the space, time, and funding to develop work and collaborate with others. Arts organizations can provide artists with live and online audiences interested in the artists' work. Organizations like museums can feature an artist's work over a longer period of time, even decades, to allow the art to exist in a relationship with people over time.

Given that artists have more options than ever to develop and share their work, arts managers will need to be very specific about what their organizations can offer. Meanwhile, artists will need to develop their entrepreneurial skill set, with an eye for budgeting, planning, producing, and even managing people, if they are to succeed as independent artists.

MUSEUMS

Museums are becoming more exciting than ever, as traditional spaces create new ways to engage artists and audiences, and whole new approaches to art in space become possible. From the Metropolitan Museum of Art in New York City to the Dali Theatre-Museum in Figueres, Spain, museums have created opportunities for audiences to visit their spaces and artwork online. During the global pandemic, the *Met 360 Project* provided audiences with the ability to visit the Metropolitan Museum of Art from anywhere in the world via four interactive videos posted online. But while these videos gave visitors a chance to pivot and look around, the journey through the museum's spaces never stopped or gave the viewer a chance to focus on a chosen artwork. The Dali Theatre-Museum, however, offers a more visitor-centered experience, with the

ability to travel through the museum in a way that mimics Google Maps functionality, allowing visitors to move and focus at will. Popup markers give viewers the chance to learn more about the art and history of the museum, including the kinds of anecdotes usually only shared by seasoned docents. Beyond how these traditional museums are using technology to engage visitors, some newer organizations are focused entirely on technology, science, and holistic audience engagement.

ARTECHOUSE in New York City is built for experimentation and dedicated to innovation, as stated in their mission: "We are on a mission to stimulate interest in the limitless possibilities of creative innovation and to push the boundaries of what is possible." Their focus on how art, science, and technology relate seems especially aligned with our times and the need to break down silos between art and technology: "We believe in the transformative power of art, science and technology and are committed to: *Inspiring* a new generation of genre-pushing artists to create with technology. *Educating* the public about these new, exploratory mediums. *Empowering* artists and partners with tools and platforms that support and amplify their work." They also express no need for their own building. They instead embrace the many ways they exist, as articulated by one of their founders: "ARTECHOUSE has no walls, we are a constellation of spaces, people, platforms, ideas, products," says Tati, cofounder and managing director.[5] In recent years, too many arts organizations have grown to see themselves as their buildings, rather than seeing themselves as *what they do*.

The installation *Geometric Properties* by artist Julius Horsthuis at ARTECHOUSE in 2021 invited audiences to enter a blank space and move around at will while the space transformed around them into a vast variety of beautiful, dynamic realities, as described by ARTECHOUSE:

> Through the creative digital expression of the endless iterations and multiple dimensions of fractals, Geometric Properties explores fundamental mathematical patterns to stimulate existential self-reflection and emphasize the pure wonderment of being. Embark upon a cinematic journey where the sheer beauty of mathematics, nature and architecture coincide to inspire introspection and awe.
>
> This audio-visual installation created with artist Julius Horsthuis presents a new existence: an immersive, eternal reality removed from the complexities of the everyday. Within this reimagined world, we are free to visualize ourselves within the larger whole. Visitors are taken on an exploration through our recent past and Horsthuis's ideal future, one that returns to the intersection of nature and math as our source of inspiration.[6]

The artist himself is an interesting hybrid of visual artist and computer programmer: "Julius Horsthuis is a Dutch visual and fractal artist who combines his years of experience with visual effects and passion for computer graphics to create cinematic animations. With a background in film, his passion for fractal art and artificial intelligence allows Horsthuis to be the creator of his own world. Horsthuis works with the software mandelbulb3d to uncover iterative complex formulas that are generated by the computer to produce the unmeasurable structures that are fractals."[7]

This artist's background in computer programming echoes that of the artist Beeple, whose digital piece *Everydays* (featured in a case study later in this book) sold for $69 million at Christie's in March of 2021. Computer programming might be a necessary tool in a visual artist's toolkit from now on, as much as brushes and palettes once were.

THEATERS

In the wake of the global pandemic, theater went online. Zoom performances became common and controversial. Companies around the world experimented with creating theater on screens that still somehow felt like theater and not just another streaming service. Critics debated what made theater "real theater" and the ways the form might change for the better because of these new pressures, including the elimination of intermissions, subscriber bases, and even season planning.

As live theater reemerged from the pandemic in 2021, it became clear that the extraordinary nature of being together in real space and real time is absolutely necessary, perhaps more than ever, and that live events will need to continue to be special, substantive, intimate, and safe. With *A Thousand Ways (Part Two): An Encounter* by the experimental theater company 600 Highwaymen playing at UCLA's Center for the Art of Performance in Los Angeles and then again at the Public Theater in New York City, two audience members at a time attended the performance and *were* the performance. Guided to their seats on stage by ushers' instructions at the door, the two audience members sat, read cue cards with instructions on what to say and do with their scene partner, and then proceeded to have a sweetly simple but intimate theater experience with another stranger, who somehow was no longer a stranger after the show. Yet even though she seems to have had a deeply theatrical experience, *New York Times* critic Laura Collins-Hughes doubted its theatrical pedigree:

> But is this theater? Not really, though the script has a beautifully solid structure and the ending is both startling and powerful. Rather, this piece uses tools of theater—text, storytelling, the agreement to gather at an appointed time to have a collective experience—to achieve goals of theater, foremost the stoking of empathy and compassion. How extraordinarily "An Encounter" does this struck me only afterward. . . . It sounds weird, and it was, but "An Encounter" left me in an altered state, keenly aware of these many people around me whom I did not know, and who seemed so alive with possibility, complexity, depth. Any one of them might have sat across from me at that table and been my stranger. I made my way through the throngs, trying to imagine the contours of their humanity.[8]

It may not be what this reviewer expected, but this form of theater certainly seems relevant. Live events may not be what we expect or recognize, but that may be a big part of their value.

Actors Theatre of Louisville is one of the most innovative theaters online. They produce digital theatrical works that take place in specific spaces, embrace new ways

to create in the digital space, and lift up diverse artists and stories to ensure relevance. *Where Did We Sit on the Bus?* by Brian Quijada starred Satya Chávez and was directed by Matt Dickson, listed as a "digital creation" by Satya Chávez and Matt Dickson: "During a lesson on Rosa Parks, a Latinx kid begins searching for her own people's place in American history. Performed by a dynamic actress/singer/musician, and infused with a mix of rap, hip-hop, and spoken word, this energetic exploration delves into the experience of growing up in an immigrant family and finding identity in making art." The play had been originally performed live by the playwright. But in the hands of Chávez and Dickson, *Where Did We Sit on the Bus?* became an online romp through identity and culture, shifting through various settings while mixing music and visuals to create a digital theatrical experience not possible when sitting in a theater.[9]

Robert Barry Fleming, Actors Theatre of Louisville's executive artistic director, described his view of theater in the digital space going forward: "A really beautiful artist said, 'You know the minute you start moving the camera it's no longer theater. That's the dividing line.' And while I had great respect for this artist I was like, 'If it's a play, isn't it still theater?' It's not a movie and it's not a TV show.

"I think we're going to have a big rush back into the live event reopening thing and a lot of sighs of relief that we're in spaces that we're familiar with, practices we're familiar with. And then we're going to be reminded about the economic and business continuity challenges of things that were not working prior to these disruptions that still persist. And people are going to have to figure out how to navigate back and I think some of this conversation of working digitally as well as in person and the hybrid nature of that is going to really resonate for many of us. That we don't know that we've already created entirely new habits of engaging stories. It's done. It's already changed. It's just going to take a couple of years for us to realize the level of how deep that goes." The various forms of theater are in flux and up for debate.[10] As *Los Angeles Times* critic Charles McNulty points out, we'll "know it when we see it."[11]

As Robert Barry Fleming says, arts management and arts managers will need to be focused on accepting the ways the arts have changed and managing *how* they change continually.

MUSIC VENUES

Music venues like Caffè Lena have had to figure out how to become more accessible to larger audiences, in order to cover their costs and reach audiences who cannot or will not travel to their spaces. They also realized that digital streaming allowed them to reach new audiences with music they might otherwise not hear or explore on their own. Smaller venues like Caffè Lena have a long history of discovering and sharing rare talents with audiences before they are famous, like Bob Dylan and Spalding Gray, both artists supported by Lena before anyone knew them. Now that almost all music and musicians are discovered in the digital space before they are seen or heard in any three-dimensional performance space, places like Caffè Lena can still play a vital role in discovering and featuring artists who do not break through easily in the digital realm.

Years before the global pandemic, Caffè Lena outfitted its space with the cameras and sound equipment necessary to stream its content live online. At the time, digital streaming was a nice addition to the live venue and more of a curiosity than a core strategy for the future. The pandemic then supercharged their focus on digital streaming, as live audiences in their tiny space became temporarily impossible. By 2021 Caffè Lena was upgrading their technology once again, as they planned for digital and live offerings to continue as core parts of their programming.

Sarah Craig, Caffè Lena executive director, reflected on the changes and the need to educate their largely older audience to what the online venue can be: "A lot of what I'm thinking about right now is how do we really erase the concept of walls? And erase the concept of there being a difference between the livestream audience and the in-house audience? So, we're trying to really educate people about that kind of stuff and show them that it's not just like a TV channel that you turn on but it's a real place with a mission and a community."

But while she is rightly focused on developing Caffè Lena's work in the digital space, Sarah Craig also has a vision for the organization to be a center for the community: "My dream come true would be to have people floating in here, you know during the after-school hours. Sitting in a circle. Playing songs. Having conversations. Having a pot of free coffee going and then the artists roll in for the night and we put on a concert that's sold out. Saturday morning we'd have a bluegrass jam. I really want this place to be so that the artists of the future look back and say, 'I felt so encouraged when I went to Caffè Lena. I discovered that you actually can be a professional musician, and this is how you can tour, and I got to meet these musicians and it really inspired me. So, I decided to go to Berkeley, and you know, now I'm doing it.' Or you know, the other thing I want to see happen is, for somebody to say, 'Well, I just like banjo and you know I used to hate those commie liberals but now I like playing my banjo. And so, I sat down, and I found out they weren't so bad after all.' You know, so that's kind of my dream, is like world peace through music."

Sarah's vision for Caffè Lena is a good reminder that arts organizations need to develop digital strategies while also deepening their ties to the community and expanding their presence as a third space for community members. Simply focusing entirely on the digital or entirely on the communal is no longer an option. Organizations that do both will be much more likely to succeed.

DANCE COMPANIES

Dance companies have been forced to evolve, as the costs of traditional dance coupled with reduced live audiences have made it more and more difficult to survive without relying entirely on old dusty classics and constant productions of *The Nutcracker*. Companies like Step Afrika! are finding ways to partner with larger and very different organizations, including Arena Stage, to produce and present their work. The company's long tradition of touring throughout the United States and Africa, while relying largely on earned income and sales from tours, also means the company is

accustomed to operating within a mostly earned budget and not as at risk as some of its counterparts that rely on contributed income to break even. Step Afrika! also does not own a facility or maintain significant debt. The company therefore is able to focus on paying artists rather than spending on overhead. This priority on artists has always been purposeful for Step Afrika! in ways that are only now becoming priorities for other companies.

Brian Williams, Step Afrika! artistic director, speaks about their values: "I'm a huge believer in shared space. First and foremost, I'm a touring company. What I built was an organization to go all over the world and all over the country, so that wasn't congruent with having space. We have a home to rehearse, but the essential operation were the dancers. The hugest investments Step Afrika! makes is in its artists, providing full-time employment to dancers, and they have one of the largest, longest dance contracts in the country, an eleven-month contract. We've been doing that for a long time. We've been able to provide consistent employment to artists for many years. That has been the center. And so, since the focus of my work with Step Afrika! is to employ artists, and that's where the money goes, we haven't focused on a building. Now, I will say, and I don't think we ever will focus on a building for Step Afrika!, but we do need a permanent home at this point. I don't think we need to *own* that home."

Dance companies must also find more ways to reach audiences online—and the artists themselves might show them the way. As mentioned in the previous chapter, during the global pandemic Dance Theatre of Harlem (DTH) posted a video online that communicated so much about the company's values: the beauty of the dancers; the vibrancy of Harlem; the glory of the ballet; the dancers wearing masks during the pandemic. At one moment, the dancers pivoted away from the camera and did a subtle *snap* with their fingers, communicating DTH's joyful panache. It was gorgeous content, made a beautiful, bold statement, and spoke well of the whole history of the company.

Perhaps most impressive was the fact that the video was the brainchild and project of two of DTH's dancers, who envisioned, produced, and then presented the video. According to executive director Anna Glass, the key to the video's success was the strong sense of vision carried across the entire company: "I always say, when you are posting something or creating something for social media, you want to believe that [DTH Founder] Arthur Mitchell is looking at that piece of material. We always want to have a contemporary lens, right? So, we don't want to feel dated, but we also want to feel like we're Dance Theater of Harlem. That we're going to produce content that Mr. Mitchell would be proud of; that he would feel good about, that he wouldn't feel offended seeing. And so I can't take credit for that beautiful video, it was the creation of two of our dancers, who used an iPad to film it. But they understood and they all understand who we are, very clearly, and they understand what they're representing."

DTH demonstrated that risk taking and innovation in the arts can—and maybe should—be led by artists themselves. But risk taking and innovation also rely on a strong company culture and deep understanding of a company's mission, vision, and values. Arts managers will need to balance how to embrace more decentralized, artist driven projects while still holding fast to organized principles and values.

UNIONS

Artist unions have protected and served artists for many years. In exchange for working regularly and paying annual dues, artists could expect their unions to generally advocate for their rights with employers, ensure their safety, give them a path to healthcare, and even help them save money for retirement. Before the existence of artist unions, artists everywhere had to fight for their rights on a case-by-case basis and accept bad behavior from their employers, like unsafe working conditions, awful or nonexistent pay, and no path to a decent life. But the pandemic called into question the reliability and purpose of some of these artist unions, including Actors' Equity Association (AEA).[12]

Unions were seen through a twentieth-century lens as godsends for artists. But historically artist unions did little to nothing to address issues of diversity, equity, and inclusion in the arts and artist hiring. Many argue that unions did not do enough to promote and help artists with varied mobility or ability issues. After the pandemic hit, some unions revealed themselves to be too rigid, too large, and too afraid of innovation to serve their members. Rather than interrogate what was happening and then innovate to get their artists back to work safely, the AEA simply shut down all work for actors for over a year, causing a vicious cycle in which actors could not work and therefore unable to pay their AEA dues; the AEA then suffered financial losses and had to cut its own staff and operations, leading to the AEA being less able to represent its member artists, and so on. As theaters, dance companies, music venues and organizations, and museums began to reactivate, the need to reimagine how unions work hung in the air. As a new normal in the arts continues to develop, arts managers, arts organizations, and the artists themselves must reimagine the role of the unions and ask the question: What is the purpose of any union? How can we help unions evolve in order to serve artists better?

THE FUTURE OF ARTS MANAGEMENT

All these changes in the arts and arts organizations beg the question: Whither arts management? How will this profession evolve and change as the arts, artists, and arts organizations change?

- *Rotating Leadership.* Artistic, managing, and executive directors should come and go from arts organizations more often. A ten-year limit might make sense. By rotating leaders more often, organizations will gain fresh perspectives, be more adaptive, and become more tolerant to risk
- *Greater Equity.* For far too long the arts field has pursued and pointed to diversity on its stages and in its spaces whenever possible but ignored the complete lack of diversity in its boardroom, staff offices, and funding sources. Now that the need for greater equity has been recognized, arts managers need to keep pushing their boards, funders, audiences, artists, and community partners to never forget and to make radical change whenever and however they can. The status quo must be gone.

- *An Increase in Contract Positions.* An emerging strategy to access great talent while cutting costs is for arts organizations to contract temporary employees focused on specific topics (marketing, fundraising, production, education). This development in the arts can be positive if it allows for more people to work with greater flexibility and a variety of exciting assignments. If more contracts mean fewer full-time positions, worse pay, and no benefits, arts managers should push against this practice.
- *Shared Responsibilities.* Traditionally only smaller organizations were able or willing to have staff members work on marketing and artistic projects, or fundraising and production, out of necessity. But larger organizations should try to dissolve some of the corporate silos that have developed, so that arts managers can web across topics, share information, learn more, and better serve the organization by helping to integrate these efforts better. Greater collaboration across departments would lessen turf wars and flatten power struggles across the staff.
- *Independence.* A corporate hierarchical power system, along with a white dominant culture, have led managers too often to micromanage those reporting to them, and to be micromanaged by their supervisors. The global pandemic showed us the value of working online, at home, and independently when possible. Arts managers should empower others to work independently as much as possible.
- *Collaboration Across Disciplines.* Hopefully dance companies continue working with theaters, and museums with musicians. The strict separation of disciplines between museums, theaters, dance companies, and music organizations has weakened the entire field and created unnecessary competition for dollars, spaces, and audiences. Drop the walls between art forms and find commonalities rather than differences. Share buildings, staffs, budgets. Become stronger united.

FINAL THOUGHTS

Arts organizations are changing so quickly. Arts managers will need to create new ways to support artists with the time, space, and money they need to do great work, in person and online. Arts managers will need to figure out how to balance online and in person programming. Arts managers will need to demonstrate how diversity, equity, and inclusion in the arts help organizations prosper and succeed. Great management invites creativity. Vibrant artistry welcomes strong management. The future of arts management is bright. It's exciting. It's necessary. Creativity is needed now more than ever, in all aspects of our lives. We need the arts. We need joy, laughter, inspiration, and redemption. We need you.

As arts managers, you will meet and work with some of the most caring, conscientious, and passionate people on the planet. You will also work very hard, while helping make the world a little bit better. As Nancy Yao Maasbach says, "I have the best job.

But it's the most difficult job I've ever had. But I have the best job." I hope you will find the most difficult job you will ever have, but also the best job.

I hope you find your way into a career in arts management. I hope you get the opportunity to serve and inspire others. I really hope this book has been helpful. As for the future, all we can do is serve, adapt, and survive. We all must do so. In that order.

NOTES

1. McKinsey & Company, "How COVID-19 has pushed companies over the technology tipping point—and transformed business forever," McKinsey.com, October 5, 2020. Accessed June 22, 2021. https://www.mckinsey.com/business-functions/strategy-and-corporate-finance/our-insights/how-covid-19-has-pushed-companies-over-the-technology-tipping-point-and-transformed-business-forever.

2. Joanne Scheff Bernstein, *Standing Room Only: Marketing Insights for Engaging Performing Arts Audiences* (New York, NY: Palgrave Macmillan, 2014), 12.

3. Americans for the Arts, "COVID-19's Pandemic's Impact on The Arts: Research Update June 21, 2021," Americans for the Arts, June 21, 2021. Accessed June 28, 2021. https://www.americansforthearts.org/node/103614.

4. Ibid.

5. ARTECHOUSE, "About." Accessed June 22, 2021. https://www.artechouse.com/mission/.

6. ARTECHOUSE, "About the Exhibit—Geometric Properties." Accessed June 22, 2021.

7. Ibid.

8. Laura Collins-Hughes, "Review: The Compassion of 'A Thousand Ways (Part Two),'" *New York Times*, June 13, 2021. Accessed June 28, 2021. https://www.nytimes.com/2021/06/13/theater/thousand-ways-encounter-review.html.

9. Actors Theatre of Louisville, "Where Did We Sit on the Bus?" Accessed June 22, 2021. https://www.actorstheatre.org/shows/2020-2021/where-did-we-sit-on-the-bus/.

10. Charles McNulty, "Coming to an L.A. stage: Proof we're in a golden age of American playwriting," *Los Angeles Times*, June 16, 2021. Accessed June 22, 2021. https://www.latimes.com/entertainment-arts/story/2021-06-16/theater-reopening-branden-jacobs-jenkins-octoroon-fountain.

11. Charles McNulty, "Commentary: How to define theater in the digital era? I'll know it when I see it." *Los Angeles Times*, January 25, 2021. Accessed June 22, 2021. https://www.latimes.com/entertainment-arts/story/2021-01-25/future-theater-covid-digital-streaming.

12. Michael Paulson and Katy Lemieux, "'Why Are We Stuck?' Stage Actors Challenge Their Union Over Safety," *New York Times*, March 23, 2021. Accessed June 22, 2021. https://www.nytimes.com/2021/03/23/theater/actors-equity-health-safety.html?searchResultPosition=3.

Appendix

CASE STUDIES

INTRODUCTION

The following case studies provide real-world examples of how management can enhance or detract from the health of an organization, artist, or art itself. Three cases are based in the world of museums or the visual arts. The other five cases focus on a small-town municipality, a theater, an arts service organization, an arts education nonprofit, and a multidisciplinary arts center located in a rural community.

THE CASE OF THE INDIANAPOLIS MUSEUM OF ART

It's a great start, but honestly they all need to go.

—Dr. Kelli Morgan, former associate curator at the
Indianapolis Museum of Art[1]

THE STORY

The Indianapolis Museum of Art was looking for a new executive director. Charles Venable, the museum's CEO, was set to become the new CEO of the overall campus where the museum sits, Newfields. In January of 2021, Newfields and the museum posted a listing online seeking candidates to become the new executive director of the museum. As part of the posting, they said they were seeking a new executive director who would not only attract a more diverse audience but also work to maintain its "traditional, core, white art audience."[2]

Strangely enough, the posting went fairly unnoticed, until February, when social media and the mainstream press caught on and began to spread the word. On February 13, the *New York Times* covered the story. Shockingly, Venable did not apologize for the statement emphasizing white audiences. Instead, he apologized for the *way it was*

stated: "I deeply regret that the choice of language clearly has not worked out to mirror our overall intention of building our core art audience by welcoming more people in the door," he said. "We were trying to be transparent about the fact that anybody who is going to apply for this job really needs to be committed to D.E.I. efforts in all parts of the museum."[3] This incredible response only added fuel to the fire.

In the same article, the reporter revealed that Malina Simone Jeffers and Alan Bacon, cocurator of an upcoming exhibit by artists of color, had decided to resign and not curate the exhibit in the wake of the news of the job posting, saying that this work by artists of color could not be produced in "this environment" created by Venable. What's more, the article said that Dr. Kelli Morgan, a former associate curator at the museum and an African American woman, had resigned from the museum the previous July due to a "toxic work environment."[4] At the time of her resignation, Morgan described feeling ignored by Venable and mistreated by the board of directors at the museum, to the point of crying and cursing at a board member after a contentious meeting regarding a new piece of art featuring NFL player Colin Kaepernick. Katie Betley, the chair of the board at the time, declined to comment for the press about this incident.[5]

THE FALLOUT

By February 15, just two days after the initial *New York Times* article, over two thousand culture workers and community members in Indianapolis signed a letter demanding Venable's resignation.[6] By February 17, Venable had resigned.[7, 8] The same day, the board of trustees issued the following statement:

> LETTER FROM OUR BOARD OF TRUSTEES AND BOARD OF GOVERNORS
> WEDNESDAY, FEBRUARY 17, 2021
> We are sorry. We have made mistakes. We have let you down.
> We are ashamed of Newfields' leadership and of ourselves. We have ignored, excluded, and disappointed members of our community and staff. We pledge to do better.
> For those expressing outrage and frustration—we are listening. We are taking action immediately in the following ways:
>
> - This morning, we accepted Dr. Charles Venable's resignation as president of Newfields. We thank him for his service and agree that his resignation is necessary for Newfields to become the cultural institution our community needs and deserves. Chief Financial Officer Jerry Wise will serve as the interim president of Newfields.
> - We will engage an independent committee to conduct a thorough review of Newfields' leadership, culture and our own Board of Trustees and Board of Governors, with the goal of inclusively representing our community and its full diversity.

- We will review and expand the current admission policy to include additional free or reduced-fee days to increase access to Newfields and ensure that Newfields is accessible to all members of our community.
- We will form a citywide community advisory committee consisting of artists, activists and members of communities of color whose primary function is to hold leadership accountable to these goals.
- We will expand curatorial representations of exhibitions and programming of/for/by Black, Latino/a/x, Indigenous, Women, People with Disabilities, LGBTQIA, and other marginalized identities.
- Our Boards, Newfields' full staff, and volunteers will participate in ongoing antiracist training using a developmental approach and assessment.

As we guide the organization through this crucial process, we will listen to and partner with members of the community. Newfields is yours and we pledge to make the necessary changes to ensure we can regain your trust and respect. We commit to being held accountable, as we hold the institution accountable, to ensure that Newfields is diverse, equitable, accessible and inclusive.

In the next thirty days, we will publicly share a detailed action plan, with specific deadlines, for each of the commitments made above.

Sincerely,

The Newfields Board of Trustees and Board of Governors[9]

WHAT WENT WRONG

How did the Indianapolis Museum of Art get it so wrong? And how could this have been avoided? Looking back, since his arrival in 2012, the executive director Charles Venable was trying to retire the museum's debt and draw in new audiences with several changes. Unfortunately, many of these changes drove the organization away from inclusion and toward elitism. The museum had been struggling to settle its debts since the 2008 Great Recession, when it lost $100 million from its endowment.[10] An expansion to their building in 2005 put them in debt, and in 2007 the then director Maxwell Anderson eliminated the admission fee of $7 to make the museum more accessible. The museum also maintained a core collection that had grown way too large to be useful, with explosive growth of 265 percent since 1970.[11] It had grown to a size, including in property, which demanded huge crowds to be sustainable. In fairness to Venable, he had his work cut out for him.

CHANGES AND INNOVATIONS

When Venable arrived, he eliminated twenty-four positions as an extra cost cutting. He reinstituted a fee for admission of $18 per person to the museum and, for the first time, required this fee to be paid to enter the museum's vast parkland grounds. "A museum staffer told attendees at the Museum Next conference in 2016 that, after the $18 admission was instituted, visitors dropped and 'our population became older, whiter, richer, and less families.'"[12]

Venable established a miniature golf course on the museum grounds,[13] a teahouse, and an annual holiday light installation, titled *Winterlights*, which was a big hit with crowds but had critics howling.[14] Venable also created a new position: director of culinary arts, to help bring food and drink into the museum's purview tied to exhibits or festivals. He eliminated costly high profile exhibits of famous artists, which historically seemed to spike admission temporarily but kept the museum in debt. He also renamed and rebranded the Indianapolis Museum of Art as "Newfields: A Place for Nature & the Arts," in order to highlight the organization's grounds (which now cost money to enter) and offerings beyond the arts. All in all, critics and the community seemed to view these changes as shifting away from the museum's focus on art to one of being more of an "amusement park" atmosphere. Given that the museum is located in a socioeconomically disadvantaged neighborhood with a largely Black population, the new admissions fee and the shift away from localized community engagement seemed to underline the museum's elitism and set the stage for what came next.

CONSULTANTS

Perhaps most disturbing about the museum's publicly stated desire to protect its "traditional, core, white art audience" is the fact that Venable and others at the museum clearly considered and actively chose this language as a communications strategy. m/Oppenheim, a recruitment firm, had been hired to run the search for the new executive director of the museum and crafted the incendiary language of the listing. *Artnet News* noted in an online article on February 25, 2021, that employees of the museum had warned Venable and the consultants that this language was inappropriate, but Venable and members of the board decided to go forward anyway.[15] At the same time, the museum had engaged Pink Consulting in an equity initiative for over six months when this language was chosen, showing a clear disconnect between the board and staff and conflicting priorities. As this same article noted, museums have become especially and sometimes most disturbingly reliant on corporate consultants to guide and inform their decision-making. Often these corporate consultants, unaware of or simply unconcerned with the consequences of their advice, lead museums astray and negatively impact the culture of the organization.

A PREDECESSOR SPEAKS

In the wake of the scandal, something unusual happened: Maxwell Anderson, Charles Venable's predecessor at the museum, spoke out about Venable's tenure in an online article: "The many failings of the Indianapolis Museum of Art during the tenure of its recently departed chief executive stemmed, in my view, from one fundamental misunderstanding: the museum is a charitable, educational, and civic organization, not a commercial attraction."[16] Anderson went on to attack Venable's leadership, including his handling of the organization's drive for greater income. Anderson pointed out that under Venable, the museum's growth of its endowment was "anemic," from $325

million to just $335 million from 2011 to 2021, and that the earned income Venable sought via admission fees could have been raised by producing more exciting exhibits and charging fees for them, instead of charging everyone admissions fees to enter the campus. Anderson expressed hope that the "Newfields nickname" will be retired soon, and the organization refocused on its community. He also pointed out that, during his tenure, he would have lunch regularly with a local pastor to discuss ways the museum could serve the local population better. Anderson also expressed hope that the museum can find its way back to serving its community.

CHANGES

After accepting Venable's resignation and posting their mea culpa statement, the board of trustees, board of governors, and staff at the museum created a new action plan aimed at increasing diversity, equity, inclusion, and access to the museum. It formed a Community Advisory Committee to engage community stakeholders as advisors and expanded its Free First Thursday program to give community members a chance to visit for free every first Thursday of every month. The board chair was also replaced by Darianne Christian, a business owner and entrepreneur, as well as the first Black woman to lead the board of the museum. The museum also published more steps it is taking to improve, including the establishment of a $20 million endowment to support the works of underrepresented and marginalized artists, DEIA training for all board and staff, and the establishment of a senior-level diversity executive on its senior staff.

"Building a stronger relationship with the people of Indianapolis is a priority. This begins with communicating regularly about the progress we make in implementing the plan and actively seeking your feedback. While we know there is still so much more to be accomplished, we are working every day with the shared mission of making Newfields a place where everyone feels welcome, and where all our guests, no matter who they are, feel a deeper connection to our institution and what they experience here."

QUESTIONS ON THE CASE

How could the disaster at the Indianapolis Museum of Art have been avoided?

- *Clearer communications across the staff, board, and consultants.* There were different levels of understanding throughout the organization, leading to a bit of chaos.
- *Paying heed to warnings.* Dr. Morgan's resignation in July of 2020 should have sent shockwaves throughout the organization but seemed to be quickly forgotten. Given she was hired in 2018 to diversify exhibitions, her clear dissatisfaction with the "toxic culture" should have been taken seriously.
- *An adherence to mission.* While they seemed satisfied with the results, the board of trustees and governors should have monitored Venable's mission drift more closely. As he changed the organization, they should have focused on the community as much as on the bottom line. Their drift toward elitism was predictable and alterable.

FINAL THOUGHTS

This case reminds us that systemic racism is all around us and can affect everything, including seemingly straightforward job listings. Luckily the IMA took swift action and has implemented several initiatives and changes in leadership to open itself back up to its community. Hopefully in the coming years they can reach their new diversity goals and continue to improve the museum's financial outlook, all while offering Indiana audiences dynamic, world-class, and diverse artistry.

THE CASE OF BEEPLE AND BREONNA TAYLOR

*This painting and exhibition embody the idea of art for justice and demonstrate
the potential power of art to heal.*

—Darren Walker, president of the Ford Foundation[17]

*Art is no longer about a relationship with an object. It's about making money.
I feel bad for art.*

—Sylvain Levy, art collector[18]

THE STORY

A non-fungible token (NFT) is "a tool for providing proof of ownership of a digital asset. Using the same blockchain technology as cryptocurrencies like bitcoin—strings of data made permanent and unalterable by a decentralized computer network—NFTs can be attached to anything from an MP3 to a single JPEG image, a tweet, or a video clip of a basketball game."[19] NFTs are basically digital files entwined with strings of data that make them one of a kind.

In March 2021, two events demonstrated diametrically opposed paths in the visual arts: the *Promise, Witness, Remembrance* exhibit at the Speed Museum in Louisville, Kentucky, featuring Amy Sherald's portrait of Breonna Taylor, and the sale of an NFT by the artist Beeple for over $69 million at Christie's. One event, the exhibit at the Speed Museum, showed a new path toward relevance, access, and inclusion for museums and the visual arts. The other, the sale of the digital file for $69 million, gave us another glimpse into spiraling prices for artwork (this one paid for with the cryptocurrency Ether) and reminded us how the sale of art at such high prices to collectors, who wish to own a piece for their private viewing, keeps pushing art into the hands of the super wealthy and away from audiences.

BREONNA TAYLOR AT THE SPEED MUSEUM

Amy Sherald was a little-known portrait artist based in Baltimore, Maryland, when she was tapped to do the official portrait of First Lady Michelle Obama. That opportunity—and the fact that Sherald's painting of the First Lady now hangs in the National Portrait Gallery—catapulted her to fame in 2016. Then in 2020, Sherald was commissioned by writer Ta-Nehisi Coates to create a portrait of Breonna Taylor for the September issue of *Vanity Fair*, a special edition edited by Coates and focused on social activism. After painting the piece, Sherald instinctively wanted the portrait to live out in the world and not just be sold to a private collector. She managed to connect the Speed Museum with the Smithsonian's National Museum of African American History and Culture in Washington, DC, and to convince them to co-own the portrait, paid for with $1 million provided by the Ford Foundation and the Hearthland Foundation. Sherald plans to use the fee in support of a program founded by her to support students

pursuing their degrees and interested in social justice. In the *New York Times* on March 7, 2021, the museums expressed their appreciation of having the portrait available to the public:

> "The killing of Breonna Taylor and a year of protests have really changed the course of Louisville, and we're struggling," said Stephen Reily, the Speed's director. "Our goal and ambition is to use the work of great artists to help process what we've been through and collectively find a way forward."
>
> Lonnie G. Bunch III, the founding director of the National Museum of African American History and Culture, who is now the Smithsonian's secretary, said Sherald's painting of Taylor "captured both the joy and the pain of this moment." "This is a story that needs to be told and needs to be retold," Bunch added. "If it went into a private collection, it might get a little attention and then disappear. This way, generations are going to understand the story of this woman and the story of this period."[20]

CONSCIENTIOUS CURATION

Sherald also managed to gain a $1.2 million grant from the Ford Foundation in support of the exhibit *Promise, Witness, Remembrance* at the Speed, which allowed them to engage an advisory panel for the exhibit, including artists of color, and to feature an array of prominent Black artists, including Sam Gilliam, Lorna Simpson, Kerry James Marshall, and Glenn Ligon.[21]

By engaging artists and advisors of color to curate the exhibit focused on Black artists, Sherald and the Speed Museum guaranteed that the artists would be engaged with support and respect. As we have seen, when artists of color are curated by white institutions or white curators, they often must fight to be treated equitably. In the summer of 2020, the Whitney Museum in New York City got into trouble when it was revealed that the artwork by artists of color exhibited at the Whitney in support of the movement for Black lives was purchased by the Whitney at bargain prices at a charity event, where the artists had donated their work in support of a charitable cause. Many of the involved artists were also not notified they were being exhibited at the Whitney. Embarrassed by their actions, the Whitney shut down the show early, rather than pay the artists equitably.[22]

MUSEUM RELEVANCE

When *Promise, Witness, Remembrance* opened at the Speed Museum, it was lauded by Holland Cotter in the *New York Times* as ushering in a potential new age of relevance for museums, if other museums would follow this example. With Sherald's portrait of Breonna Taylor as the cornerstone of the exhibit, artists engaged in moments of social justice in 2020 and 2021 were also featured in video installations, visual arts, and sculptural work. The entire show seemed to sizzle with relevance, installed in a museum known for its usual glacial pace. By installing an authentically curated, vibrant show

focused on current events, the Speed Museum injected new reasons for audiences to care and visit their museum. As Holland wrote:

> Conventional encyclopedic museums like the Speed, the largest and oldest art museum in Kentucky, are glacial machines. Their major exhibitions are usually years in the planning. Borrowing objects from other museums can be a red tape tangle. "Historical" shows, by definition, are usually confined to events and cultures of the past. *Promise, Witness, Remembrance* revises all of that. It speeds up exhibition production, focuses on the present, and in doing so reaches out to new audiences vital to the institutional future.[23]

Holland also wondered how this example could inform other museums in their bid to survive and thrive: "In a social media century, attention seems increasingly focused on the 24-hour news cycle. How can that new consciousness be reflected in classical museums, which pride themselves on being slow-reacting monoliths. Only by staying limber, being ready and able to adjust, absorb and adapt, can our art institutions thrive."[24]

By painting Breonna Taylor's portrait, then ensuring it will be available for public view in perpetuity while also supporting an authentic exhibit centered on social justice, created and curated by artists of color, Amy Sherald showed a path for the visual arts and museums to become more accessible, relevant, and equitable.

BEEPLE AND THE NFT

Unlike Amy Sherald, the artist Beeple (whose real name is Mike Winkelmann) was not focused on sharing his work publicly. A trained computer programmer who never studied art, Winkelmann began experimenting with creating digital artwork in 2007 with images from other sources. He would buy or pull images from elsewhere and create a new piece with these pieces every day, first posting them to a website only viewed by his family and a few friends. Gradually, more and more people started to watch his work, with nearly two million people following the Beeple Instagram account by 2020.[25] By 2021, he had created a collage piece of his first five thousand days of creations, aptly called *Everydays—the First 5,000 Days* and made this into an NFT. On March 11, 2021, the piece sold at Christie's for more than $69 million in Ether cryptocurrency, making Winkelmann's piece the third-highest payout for a living artist's work ever, just behind Jeff Koons's *Rabbit* and David Hockney's *Portrait of an Artist (Pool with Two Figures)*.[26] The buyer of *Everydays* was an NFT fund called Metapurse, led by Vignesh Sundaresan, a Singapore-based blockchain entrepreneur, meaning that the potential second sale value of the art probably drove the buyer's decision to buy, more than any artistic value.[27]

The sale of a digital file for $69 million rocked the art world, as critics debated the piece's merits and buyers ballyhooed the worth of the piece and predicted it would climb much higher in the future. The essential questions, in part, were: Is this art? And are we all just insane for paying this much for art? At the same time, NFTs

require tons of energy to generate, meaning their creation is bad for the environment.[28] Winkelmann quickly transferred his winnings from Ether into U.S. currency, because cryptocurrencies so often fluctuate wildly, not based on anything of substantive value.

The desire to own *Everydays—the First 5,000 Days* for such an extravagant sum also shone a light on ludicrous art prices and how the economic value of art is often based on the whims of the wealthy. Surely the real value of art is in sharing it with an audience and having that audience assess its value with their interest and excitement. By buying art at astronomical prices, then claiming it as one's own and potentially hiding it away from the public, are we not taking away the art's real value and power? The price of the NFT also seemed to reveal that other artwork bought for that kind of price is likely overpriced and overvalued. At the same time, coming a year into the global pandemic, the $69 million fee for one digital file seemed almost tragic, with many museums and established artists struggling to survive. Ultimately, a computer programmer making $69 million from a digital collage of artwork based on copied content was a suitably ridiculous reflection of the times.

FINAL THOUGHTS

Happening within a few weeks of each other, the lauded exhibit of *Promise, Witness, Remembrance* and the sale of *Everydays* for over $69 million demonstrated some of the tensions in the visual arts today. Do museums engage in deep thinking and collaborative curation to create new, more relevant exhibits? Or do they concentrate on gaining new, expensive singular pieces to draw in audiences, as they have for generations? Should art be accessible for all, as Amy Sherald believes? Or should art be expensive, exclusive, and commodified? As museums and artists chart their paths forward, they must grapple with what value we place on art, and how we can make art more accessible, relevant, and authentic.

THE CASE OF *SCAFFOLD* AT THE WALKER ART CENTER

You couldn't have a better test case of white ignorance in one place.

—Sam Durant, artist[29]

THE STORY

In May 2017, the Walker Art Center in Minneapolis, Minnesota, installed a large sculpture created by artist Sam Durant in the newly renovated Minneapolis Sculpture Garden. The piece was titled *Scaffold* and represented seven gallows from historic U.S. executions, including the largest mass execution in U.S. history, of thirty-eight Dakota men in 1862 in Mankato, Minnesota. The sculpture resembled large gallows towering over the rest of the garden, and it cost the Walker $450,000. It was shocking and powerful but also strange. Designed to resemble a gallows, it also invited visitors to walk up the structure, almost as a casual viewing platform or a playground, as described by Durant in the *Los Angeles Times* shortly after the piece was dismantled: "It was designed so that visitors can climb the staircases and go up on the platform."[30] In retrospect, the idea that visitors to a beautiful garden space might want to climb up the symbol of a mass execution against Indigenous people seems heartless. As soon as the sculpture was visible, even before the gardens had opened, protesters began to gather and demand the piece's destruction.

Dakota tribe member Tom LeBlanc expressed his dismay at the piece: "I was shocked that it ever appeared," LaBlanc said. "It's like Indians are supposed to be invisible. I want to tell everybody we are alive, and we are gonna speak up, and we are gonna correct this stuff," he said.[31]

Although the piece had successfully been exhibited elsewhere, it had never been shown in the United States. It had never been installed on Dakota land. It had never been shown in the home of so many who had suffered from hundreds of years of this kind of violence against their people. As soon as the sculpture was visible, the protests began. By June, the sculpture was dismantled and removed. The artist signed his rights to the piece over to the Dakota people. And the Walker Art Center was in disarray. How could the harm and offense caused by this piece have been so blindly overlooked by the Walker and the artist Sam Durant? Why did they never think to engage the Dakota people and the broader community in a conversation about this piece prior to building, buying, and installing it? How could this happen?

THE BLIND SPOTS

Scaffold had been presented several times in Europe without incident, never hitting a nerve like it would in Minnesota. Buoyed by *Scaffold*'s previous success, Sam Durant was excited for his work to be joining the collection in the newly renovated Minneapolis Sculpture Garden and did not think twice about how the piece might affect its local audience. Given the local history, the seeming lack of self-reflection from Durant

and the Walker prior to the piece's installation is shocking. The insular focus of the artist is equally upsetting: "I made *Scaffold* as a learning space for people like me, white people who have not suffered the effects of a white supremacist society and who may not consciously know that it exists," Durant wrote in a statement. "In focusing on my position as a white artist making work for that audience I failed to understand what the inclusion of the Dakota 38 in the sculpture could mean for Dakota people. I offer my deepest apologies for my thoughtlessness. I should have reached out to the Dakota community the moment I knew that the sculpture would be exhibited at the Walker Art Center in proximity to Mankato."[32]

Olga Viso, the Walker's then executive director, had seen the piece previously installed in Europe and stated that only one Walker staff member had expressed concern to her before the opening, which either reflected a mass delusion across the staff or an inability for staff to speak up to Viso. "As executive director, I have to make tough choices that will, of course, not please all," Ms. Viso wrote at the time.[33] But Ms. Viso also admitted her oversight in not engaging the community sooner about the piece:

"Sam Durant's *Scaffold* examines numerous events and injustices against diverse cultures spanning a century and a half of U.S. history," she said recently. "This is why we did not single out individual communities for outreach, which in hindsight was a misstep that I have publicly acknowledged."[34]

DEPARTURES

In June 2017, Sam Durant and the Dakota people engaged in discussions with the help of a mediator. Durant and the Walker Art Center quickly agreed that the sculpture should be dismantled and removed. Durant signed over all rights to the piece to the Dakota people, ensuring that *Scaffold* would never be installed again. Eventually the sculpture was dismantled and buried in an undisclosed location by the Dakota people.[35] Although Durant and Olga Viso actively engaged in conversations with the Dakota people and took swift action to remove the piece, the damage was deep and long lasting to the Walker and Sam Durant. Olga Viso would eventually step down as the leader of the Walker Art Center in November of 2017, in the ongoing wake of the controversy.[36]

THE FALLOUT

In an interview in 2021, Mary Ceruti, the Walker Art Center's executive director, talked about the state of the organization when she arrived in 2019:

> I think the Walker had been through a rough stretch before I arrived and there had been leadership transitions among the senior leadership team in years prior. I'm sure you're aware that there was the installation of *Scaffold*, it's a public sculpture that was dismantled because the Indigenous community found it quite harmful. I think it is not an overstatement to talk about it in terms of trauma and trauma for the Indigenous population, trauma for Sam Durant as an artist whose career has just completely

been upended by it, and trauma for the institution and individual staff members. I think that creates a lot of scarring. We're still working on that. It's taken a little bit to get the institution in a place where we can be a trusted partner again. I guess one of the things that's really hard about it is that it's not an even process. You may do one project that's going really well and develop a really good relationship in this area and then something else happens and people are like, "Oh, haven't you learned anything?" It just doesn't all progress on this even slope that you just get better and better and at some point, you're woke and a great community organization. I think that it takes a long time to rebuild trust and relationships and we're in the process now of doing an institutional acknowledgement which when I arrived everybody was like, "Can't we just do a land acknowledgement?" I said, "I'm not sure even the Indigenous community would look favorably on that at this moment. That would seem a little performative."

REBUILDING RELATIONSHIPS

The search to rebuild trust has been a long and winding road, including facing the history of philanthropy and concentrated wealth, according to Ceruti:

It's taken a while to figure out what do we need to be doing to build that trust, to make that a genuine action. We've done a lot of research into the founding of the institution, not just the land, but the wealth accumulation of the original collection. And we're doing some reflection on that, which in certain ways I don't think there's a whole lot there that people didn't already know. . . . People accumulate wealth in all kinds of ways and do philanthropic things and that's actually the system we exist in, right?

We're dependent on philanthropy to exist. That means that the wealth gets accumulated and if that makes you uncomfortable there's—I mean it's no surprise there's an unequal distribution of wealth, we know this. But I think to be honest about how that, what that really looks like in terms of our history and not just *Scaffold* but a whole history of programming and acquisitions related to the Indigenous community. And how has that evolved over time? How have we thought about it differently? How do we think about it now? I think it's just about changing that consciousness. . . . I was not at the Walker when *Scaffold* was acquired or installed. But I think that it's kind of easy to say, "Oh, these people weren't paying attention or they had blind spots and isn't that awful." When in reality there's a lot of powerful forces that when something goes into motion people that may recognize something as problematic still don't necessarily put the brakes on something, right? There are power dynamics within the institution about who feels comfortable speaking up. There are a lot of things that go in to play on who speaks up and in what forum and who gets listened to even.

DEALING WITH CONTROVERSY

Ceruti was also mindful that Olga Viso and Sam Durant did deal with the controversy when faced with it: "I just feel a lot of institutions could have done the exact same

thing, lots of people could have made that mistake. I think a lot of people would also agree that Sam and Olga, my predecessor, really stepped in and dealt with it. Once it was recognized, they dealt with it really well actually. I think that is probably not acknowledged to the degree it could be. It's like everybody wants to talk about the initial failure of the institution but nobody quite wants to talk about what happened after that. Then it's just taken a long time for me to get the institution to a place where we can really grapple with it in order to rebuild these relationships. So, it's just a slow process."

REARRANGING THE CHAIRS

As Ceruti correctly pointed out, the failure to recognize the harms caused by *Scaffold* did not happen in a single moment or with a single person. It was a combination of:

- An unintended, ill-considered artistic statement.
- A view of earlier European installations as endorsements applicable to the Walker's audiences.
- A lack of communication across the Walker staff to recognize what should have been obvious concerns in the community.
- A total lack of communication with the Dakota people before green-lighting such a massive and provocative project.

What could have saved the artist and the institution from this disaster?

- A stronger curatorial process, aimed at engaging the community in conversation about the piece and recognizing the museum's responsibility to think about and engage with its community about its work.
- A more collaborative staff structure, through which staff members were encouraged to share concerns and discuss the curation of pieces openly, while considering all aspects of a piece's impact on the museum and its community.
- A community advisory board, which could bring community concerns to the organization and strengthen the museum's ongoing ties to its community.

Since Mary Ceruti's arrival, she has been building processes and new staff positions to better communicate across curatorial and community-focused senior staff members. As she describes, the organization was ready for change by the time she arrived in 2019:

> They really recognized what they needed to grapple with, the board and staff. That it wasn't just a crisis that they had to manage through and then get on with their work, it was really much deeper than that. To me that struck me as this is a place that is actually ready to do some real work and think differently about this. I think that's true but it's a much harder process. But I think some of it's cultural. This is hard work, it's really hard work because it's not just coming up with community engagement programs. It's really a lot of self-reflection about how the institution operates, how we budget, how we structure things, who we hire, what the hiring practices are. It

goes to all those parts. It is also basic community responsiveness and being in dialogue and being integrated in your community and understanding what they're looking for from the institution. Which we're still working on, it's not so easy to determine that.

A NEW DIRECTION

A new strategic plan and some restructuring of staff positions were Mary Ceruti's first steps. Upon her arrival in 2019, she immediately began meeting with staff, local artists, and international artists:

> Like any director comes in and starts to find out what people think, what's going on, who's doing what, and what's working and not working. Out of those conversations I drafted an interim plan. The first priority of which was to basically lay the groundwork for change and prepare us to do an actual strategic plan. And a big part of that was hiring some of these senior positions. So, I hired a chief curator and deputy director of cultural affairs. I hired a director of strategic communications and marketing because that was also a vacant position. Then we did a big reorganization which was about partly understanding that one job and reorganizing that whole area of the organization. I elevated the director of education and public programming to the head of public engagement, learning, and impact, and made that person a senior leader equivalent to the director of cultural affairs and chief curator. And the third leg of that pillar is the position which is no longer a marketing position but content and communication.

The Walker is developing a new staff structure, as a means of improving the curatorial process:

> The way I think about it is that they have three areas of responsibility and I work closely with all of them, and we think about the program with someone who's thinking about public engagement and learning at the table and someone who understands how to communicate that in all of its forms. We're not where I'd like to be, but a lot of it was laying that groundwork about thinking "this is how we're going to go about our program now." It's still going because as much as I've explained this and talked through this with the whole staff I don't know if they understand what that shift is yet. How that's going to change the way they have to be working and how they think about their timeline. How they think about who they need to be having conversations with as they plan for things. It is basic change management, it's hard, and people need to be brought along the way.

FINAL THOUGHTS

In this case, many little missteps added up to one big mess, while shining a light on systemic failures and cultural blind spots in a revered arts institution. Luckily, it seems that the Walker is on the path to healing wounds and better supporting artists of color.[37] Hopefully, with Ceruti's leadership and a renewed focus on serving others, the Walker and its community will continue to recover.

THE CASE OF RITA CRUNDWELL

I think something is terribly wrong.

—Kathe Swanson, Dixon Illinois Town Clerk[38]

THE STORY

In 1970, high school student Rita Crundwell began an internship at the city hall of Dixon, Illinois, birthplace of President Ronald Reagan. Rita worked her way up and eventually, in 1983, she was named the treasurer and comptroller for the town, a position she would hold until her arrest in 2012. You see, Rita became really comfortable in her job. She worked hard. She gained respect. She eventually became very chummy with the city's outside auditors, who would audit the town's finances every year and never found anything amiss. They never even noticed the secret bank account opened by Rita on December 8, 1990, titled the RSCDA (Reserve Sewer Capital Development Account), which she set up to look just like another city account. Rita needed money to support her hobby of showing horses around the country. While some residents assumed her wealth was coming from this horse showing business she loved, it was the other way around. Her horses—and Rita—relied on the millions of dollars she would embezzle each year, at an average of $5 million per year during her tenure.

JUSTIFICATION

Why do people steal? How can they justify it to themselves, especially when it lasts for over twenty years? Recent studies have shown that people are very good at convincing themselves they *deserve* more. Maybe they work long hours, or they get paid less than their peers. Maybe they have worked somewhere for a long time, with few raises in salary or no extra perks offered over the year. Somehow, deep down, they believe, as Rita did, that they deserve more—and it's okay to take it. *If it were so wrong anyway, wouldn't they find out? If they're so stupid to be fooled, let's fool them!*

THE HURT DONE

While Rita celebrated and bought herself jewels, furs, and many more horses, she kept a tight rein on those in city government who wanted to spend money on serving the people of Dixon, Illinois. The department of public works would ask and ask for much-needed new equipment, to no avail. They would try to fix potholes, to no avail. They would fight to keep their people employed, to no avail. Rita's stealing even cost many people their jobs, as the city's budget was tightened to try and stem the bleeding—not knowing it was all from self-inflicted wounds. During the Great Recession in 2007–2009, some in the Dixon government began to suspect Rita's stealing, as they looked more closely at how the city's income wasn't matching the amounts they were allowed to spend. But the city's auditors backed up Rita with the mayor, convincing

him to not believe the rumors. Rita would be able to continue her schemes for two more years, until she went on vacation in 2011.

EXPENSIVE VACATION

One of the worst things you can do for yourself, after you've started to steal money through financial fraud, is to go on vacation. This is because while you are away, another competent individual may cover your duties for you. She or he will need to understand your finances to a certain extent, in order to manage them. They will need to see and understand all your accounts. In Rita's case, that person, city clerk Kathe Swanson, would discover Rita's false account and bring it to the mayor's attention while Rita was still away on vacation.

BUILDING THE TRAP

Smartly and wisely, Ms. Swanson and the mayor of Dixon called the FBI. They did not take things into their own hands. They did not confront Rita. They did not tip their hands. They engaged the FBI to start to investigate and then, when Rita returned from vacation, they acted as normally as possible and allowed her to go back to work and incriminate herself while the FBI was watching.

CAUGHT

Finally, on April 12, 2012, after approximately five months of surveillance, the FBI was waiting for Rita at her office and arrested her. She was ultimately charged with stealing $53 million over twenty-two years. She would be sentenced to almost twenty years in prison. Her estate was auctioned off for $9 million. The city of Dixon sued the auditors who had helped Rita by being so lax in their duties for over twenty years and won a $40 million settlement from the accountants. One of the critical parts of Rita's fraud was that she had become friendly with her auditors, who continually audited Dixon's books for over twenty years. Because these auditors had lost their independence and turned a blind eye to Rita's fraud, the auditing firm ultimately collapsed in the wake of their $40 million settlement to Dixon. While the city regained a large portion of its stolen funds, the damage done in people's lives and the life of Dixon, Illinois, with lost jobs, lessened safety, and civic decay was incalculable. [39, 40, 41, 42]

QUESTIONS ON THE CASE

How could Rita Crundwell embezzle $53 million from the town of Dixon, Illinois, whose annual budget is only $8 million? How did she get away with it for so long? Who is responsible for what she did?

As treasurer *and* comptroller for the city of Dixon, Rita had complete control and oversight over Dixon's finances. Because she was alone in these duties, she was free

to set up false accounts, transfer money, cut checks, and hide deposits at will. So even though it's hard to fathom someone stealing $5 million per year on average on a budget of $8 million, she could do it because of a total lack of internal controls, the people, tools, and processes needed to protect funds, and the financial integrity of the organization. The city should have hired more people to monitor the city's finances. They should have developed better tools to monitor the city's finances, including a simpler financial dashboard display, so anyone on the city board could read and understand them at a glance. The city—and the mayor—also needed to be aware that the auditors were no longer independent of Rita but had become protective of her and so were covering up her misdeeds, either consciously or unconsciously. The mayor should have insisted on changing auditors. The city moving forward should ensure the auditors are replaced at least every five to seven years. This newly implemented process would help ensure the auditors' independence going forward.

Beyond the inclusion of more people to share information at all times, the development of better financial tools like budget dashboards and the hiring of new auditors every few seasons, the staff leadership of Dixon, Illinois, should also invest the time and trainings needed to shift their company culture to one of responsibility, transparency, and honesty, to ensure everyone feels pride in working for a company that cares for its resources and strives to implement its mission with those resources every day.

While the mayor and the city clerk might bear some responsibility for Rita's crimes, as well as the auditors, and anyone else who turned a blind eye over the years, Rita is the culprit in this story and ultimately responsible.

If you ever feel at risk at your organization and need to talk with someone about what's going on (including potential fraud), contact your supervisor. If your supervisor is unavailable, you may need to confide in a family member and gain their help.

What internal controls could have been implemented that would have avoided this fraud?

Segregation of Duties. This "best practice" in financial management would have required different people perform different parts of the financial management of the city, allowing for more air and sunshine to flow onto their operations and avoiding possibilities for fraud. If someone opens the mail, but then another person records income and expenses from the mail, and yet a third person actually deposits income and pays bills, a clear path of how income and expenses are flowing from the organization can be seen and established. The person who cuts the checks should not also sign the checks. The person depositing money should not be the only person with access to those account records. And so on. The comptroller and the treasurer should not be the same person, as these two roles are meant to oversee finances from different perspectives, in case one catches something the other one misses. Having Rita serve as both mixed and muddied those roles.

Clear Reporting Documents. Weekly and monthly income and expense reports should be distributed to the mayor and department heads, especially when money is running tight, so that all members of the government can see and understand where the income and expenses are being spent. A simple dashboard page followed by a sum-

mary income and expense statement would allow everyone to watch trends and not get bogged down in the nitty gritty of gaining and spending weekly. At the same time, if a department is being asked to cut costs or withhold services, a more detailed income and expense statement could be shared with that department head, the mayor, the city clerk, the comptroller, and the treasurer so everyone is on the same page and everyone can collaborate on solutions.

Regular Meetings. A simple process that would have helped tremendously would be weekly meetings of senior staff members to review and discuss finances. Questions would be encouraged and answered—or answered at the next meeting. A culture of transparency and responsibility would be developed, avoiding any sense that just one or two people hold the purse strings and the knowledge. Moments of crisis would be times for *more* transparency, not less.

More People. With more money available now that the fraud has been detected and stopped, the city needs to hire a separate comptroller and perhaps more staff members to manage the finances of the city, with two or three new staff positions to support the separation of duties detailed above.

Independent Auditors. The reason it is important to change auditors on a regular basis is to ensure your auditors retain independence. Too much familiarity with a company's finances can increase the chance that something important will be missed during the audit. Becoming too personally reliant or familiar with staff members at an organization can lead auditors to write off any suspicions or concerns because they believe that person or persons is completely reliable and would *never make a mistake or do anything illegal.* It is better to keep an arm's length with auditors, so the focus remains on the numbers and cold hard facts.

As an arts manager, if you discover fraud in your organization, to whom would you speak and why? How would you know to whom you should speak?

First, seek out your supervisor to discuss any issues. If your supervisor seems unwilling to hear you out or is in fact part of the problem, seek out their supervisor or another colleague. You should have an employee handbook. If not, request to see one. In there you should see how these issues should be handled. If need be, contact the leadership of the company via email to see if they would have five minutes to talk with you. If they also refuse, see if you can find a listing for their board members. Their board members will be listed on their latest 990, available on the GuideStar online database for free.

Approach any of these conversations in a spirit of inquiry rather than accusation. People are happy to answer questions; they are likely to become defensive if you approach them with anger, hostility, or accusatory language. Instead of "There's a big problem here and I don't think you all know what you're doing," try "I'm a little confused on this aspect of the company and I'd love to ask you some questions. Is this normal? Should we be concerned about this?" The conversation can flow more easily from a spirit of inquiry and trying to find out the truth (as opposed to declaring a truth that may be incorrect).

FINAL THOUGHTS

Solid internal controls can save an organization from fraud. Rather than rely on every person's consistent good will and honesty, internal controls help to eliminate even the *possibility* of fraud.

THE CASE OF THEATRE DE LA JEUNE LUNE

It's a shame they didn't make it.

—Peter Remes, former Theatre de la Jeune Lune board member[43]

THE STORY

In 2005, the renowned regional theater Theatre de la Jeune Lune of Minneapolis won the Regional Tony Award, an honor reserved for one regional (aka resident) theater each year, in recognition of overall excellence and contribution to the field. This national stamp of honor from Broadway is highly sought after by regional theaters, as a way of raising each honoree's national profile. It often takes years for a company to woo the Tony Awards and gain their attention. Theatre de la Jeune Lune, a company started in 1978 and well known in the field for its commedia dell'arte, mask work, and theatrical innovations, was a prime example of gaining national recognition from their award. The theater seemed at the height of its powers and renown in 2005, ready for a new phase of growth and artistic achievement. In 2007, Theatre Communications Group, the national membership organization for theaters in the United States, hosted its annual convention in Minneapolis, in part featuring Theatre de la Jeune Lune for a national audience of colleagues and critics. But within a year of that convention, in July 2008, the company was dead. What happened? How does an organization win a Tony Award and then collapse only three years later? Who might be responsible?

In the summer of 2007, during the annual Theater Communications Group convention conference in Minneapolis, Theatre de la Jeune Lune performed the opera *The Marriage of Figaro*. It was a wonderful, multilayered performance. The stage was a flat platform built into their main warehouse space, with actors in modern dress. While the opera was performed, a camera crew also tracked across the space, carefully choreographed to not interfere with the stage pictures. They captured performances in closeup and from the back, images simultaneously projected onto two or three huge screens in the set. The audience could see both the macro staging of the opera but also the micro close ups of emotional moments and intimacy between characters. The scale of the production was huge and glorious. It therefore was all the more surprising when the company imploded less than a year later.

Autopsying a company after its death can paint a clearer picture than trying to analyze a still struggling, still living organism. Because you know the ending and can track backward from there. What killed it? How was it managed? How was it financed, marketed, planned? Was its death the result of one of these areas or a combination? *Spoiler*: It is almost always a combination of factors, though usually you can track through the critical mistakes or the company culture that predicted its demise. For your consideration of this case, I offer the following evidence.

ARTISTRY

Even as it collapsed, the company's artistry was still heralded as vital and important, especially for local audiences, as described in one story on Playbill.com from June 2008 that announced the company's demise:

> Dominic Papatola, theatre critic at the Saint Paul Pioneer Press since 1999, and an observer of Jeune Lune's work since the early '90s, told Playbill.com on June 23, "At its best, Theatre de la Jeune Lune was a model for what theatre in the Twin Cities—and, I would argue, throughout the country—could be. The company not only was visionary, but it remained true to its vision; challenging audiences as it delighted them. Through their partnerships with companies across the country, they breathed new life into the American regional theatre movement."[44]

COMMUNITY SUPPORT

It was clear that Theatre de la Jeune Lune operated on a shoestring budget, even though it had existed for thirty years by the time it collapsed. But it was also clear that the company had raised and taken millions of dollars of support over those years, enough to eventually buy their own building in downtown Minneapolis, as stated by artistic director and founder Dominique Serrand in that same article on Playbill.com:

> We have always created our work for and because of our audience. Over the years we have cultivated a loyal audience locally, regionally and nationally. We have garnered numerous awards and accolades, and of course at times we have elicited criticism and consternation. We have benefited enormously from the support of foundations, corporations, state and national organizations, all those who have served as board members, staff and volunteers, the incredible generosity of thousands of individuals, and especially all of the artists. . . . For the first 14 years we were itinerant, making the most of any venue we found ourselves in. Then in 1992, with an amazing groundswell of support, we purchased and renovated the Allied Van Lines building in the Minneapolis warehouse district.[45]

FISCAL RESPONSIBILITY

But while the company had relied on generous donations and community support over the years, the founders seemed to disregard any responsibility for growing or sustaining the organization long-term, as stated by Serrand in the closing days:

> We never sought nor desired to be an institution. Our home was always intended to be a playground in which we could gather with other adventurous souls and create the unimaginable. We have benefited enormously from the incredible generosity of this community, and especially all of the artists without whom we would never have survived this long or created as much. We can never thank them enough.

In fact, rather than secure their home for the future growth of the company and service to the community, Theatre de la Jeune Lune used their building as a credit card to cover their debts for years, as also explained in the same Playbill article:

> For years the theater has borrowed against its home, a warehouse in downtown Minneapolis, to cover its debts. Artistic Director Dominique Serrand says many people assume the $3 million building has been a millstone around the company's neck, but that's not so. He says the many financial gifts the company received to purchase and refurbish the building back in the early 1990s made it into a real asset. "What happened after the theater opened was that the building, instead of being a burden, was actually an endowment," Serrand said. "Since we couldn't build an endowment for the theater, we borrowed against its equity. So, the theater, the building, has actually helped us live and survive for many years."[46]

But a building is not an endowment. The gifts given in support of the purchase and renovation of the theater were intended for just those projects and not intended to cover future operating costs. A quick look at the company's 990 tax returns reflects the reality that they were continually using the building to take on more and more debt. In their 990 from 2006, they showed a deficit of $375,586 for the year. At the same time, their debt on their building jumped from $661,446 to $925,000. In 2007, they showed a deficit for the year of $305,748. Their debt on the building then jumped from $925,000 to $1,000,000, while their accounts payable was $147,480. After years of spending over $300,000 more than they brought in *each year*, the bill was coming due, just as the Great Recession began.

LEADERSHIP AND FUNDRAISING

The Board, led by Board Chair Bruce Neary, seemed well aware of their funding gap, but did not seem able or willing to solve it. As state by Neary in the closure announcement:

> Theatre de la Jeune Lune board chair Bruce Neary says, given the institution's more than $1 million of debt, closing is the right option. "It's the fiscally responsible thing to do to meet all our financial responsibilities to our staff, artists, donors, creditors," Neary said. "It was time to do it." When asked if the company ever mismanaged its money, Neary replied the budget was simply not big enough to meet the needs of the theater. "We've never had a revenue stream commensurate with the impact we've had on the community," Neary said.[47]

Ultimately, the board of directors is responsible for an organization's fiscal health. At best, this board's lack of action to improve Theatre de la Jeune Lune's financial situation seems irresponsible. At worst, it seems negligent. Thirty years into its existence, the company was also still led by its artistic founders, or at least by one founder. As stated on Minnesota Public Radio on June 22, 2008:

(Dominique) Serrand co-created Theatre de la Jeune Lune in 1978 with fellow Frenchman Vincent Gracieux, and Minnesotans Barbara Berlovitz and Robert Rosen. They trained together at the Jacques Lecoq school for theater in France. At first the company spent half the year in Minnesota and half the year in France, but they eventually settled down in Minneapolis with all four sharing the title of artistic director. Just a few years ago the founders had a falling out, and Dominique Serrand became sole artistic director.[48]

After thirty years of existence and fundraising, like it or not, a company has become an institution. But in many ways, in this case, the theater was still in the fledgling founder stage, meaning one person's vision led the organization and there had not been the kind of leadership transition that usually brings in a new stage of growth and vision of an organization as an institution, growing beyond the original founders. Theatre de la Jeune Lune had a managing director when it collapsed, but perhaps they needed an executive director. If the board themselves could not rein in Serrand's spending, perhaps a stronger administrative structure could have.

Even though Theatre de la Jeune Lune had existed for thirty years, taken millions of dollars in donations, and raised money to buy their own building, Serrand demonstrated in his comments and actions that he had never intended for the organization to last. But after decades of important work and millions of dollars of investment, the board and staff had a responsibility to at least consider and communicate with the community whether this institution needed to continue, regardless of what the original founder thought.

At the same time, saying that closing the company and selling the building was the fiscally responsible thing to do for the artists and staff seems a little far-fetched. Instead, the board could have launched an emergency fundraiser to pay their debts. They also could have activated their national and regional networks to gain new support. They could have admitted their problems and leaned into saving the company, rather than liquidating it. By suddenly closing, they left their artists and staff unemployed and artistically homeless and their community without a beloved and much-invested-in community asset.

As covered by CNN at the time, it seems company leadership was incapable or just completely uninterested in making plans for the organization:

> With corporate philanthropy drying up, landmark cultural institutions are in danger of disappearing as they face declines in both ticket sales and the grants they rely on to survive. In June, Minneapolis' Theatre de la Jeune Lune closed its doors after a three-decade run. "When you approach the foundations and the corporations, they are asking for the five-year plan and a business model," co-founder Dominique Serrand told the Associated Press in July. "That's not how art is created."[49]

ONE MORE FACTOR

After the company decided to dissolve, the theater was put up for sale. For almost three years, the building stayed on the market, with at least one potential sale falling through

during that time. Finally, in spring 2011, it was announced that a former Theatre de la Jeune Lune board member had bought the building. He intended to turn it into a nightclub as part of his business, according to an article at the time of the sale:

> Former Theatre de la Jeune Lune board member Peter Remes has bought the former home of the theater at 100 First Avenue North in downtown Minneapolis and is on the verge of launching the space as a new cultural and music venue that he says will transform the arts scene in Minneapolis. Remes bought the Jeune Lune building because he believes it's "the coolest building in Minneapolis," he told me at a fundraiser for Midway Contemporary Art, which rented the building for the event. At the party, all the seats were cleared out of the main theater area, a large chandelier hung from the ceiling, and lights colored the tall brick walls.
>
> Remes joined the Jeune Lune board of directors three years before the theater company dissolved, which happened in 2008 as a result of mounting debt. He joined the board because he felt the company was "innovative and amazing," he said. "I loved the organization," Remes said. "It's a shame they didn't make it. Unfortunately, by the time I joined, there were severe financial issues—the organization was swallowed up by the building." Remes is confident, he says, that the new venue will be an innovative social hub in the Minneapolis arts scene.[50]

The Duty of Loyalty dictates that members of a board of directors should put their loyalty to the nonprofit organization first in dealings regarding the organization. Given he was a real estate developer and therefore presumably had expertise in buildings and debt, Remes perhaps could have taken action earlier to save the organization. Why would he wait three years to buy the building, if he always loved it? Why did he refer to the organization as "they," when he was a part of it?

FINAL THOUGHTS

So, why did this renowned theater die? Several factors contributed to its demise:

- The artists were not concerned about keeping an institution going long term.
- The founding artistic directors had a falling out, leaving only one to run the company with no apparent succession plan in place for new leadership to take over.
- The board of directors seemed unaware or unconcerned with the growing debt and unable to raise sufficient funds to retire it.
- The organization was still led by a founding artistic director and driven by his sole vision, it seems. A stronger administrative staff structure, with perhaps an executive director equal to or even above the artistic director, might have steered the company away from financial peril.
- The company used their building like a credit card, which enveloped the organization in debt and proved untenable when the Great Recession hit.

In Dominique Serrand's statements, we find someone seemingly at peace with the theater's collapse. What's wrong with artists wanting to do something for a while and then stopping wanting to do it? In the United States, arts nonprofits are granted their tax-exempt status as a gift from the federal government in support of their social service. Nonprofits do not need to pay income tax and therefore can accept gifts from individuals and funders tax free. This is a huge savings. It also means the money given to organizations in support of missions to make art and serve the common good is in the public trust. If your grandmother gave Theatre de la Jeune Lune her last $25 in early 2008 because she loved going to that theater and believed their work was helping the community, it is problematic that the company seemed to just say "oh well" when her money proved to be wasted just a few months later.

When donors or funders give, they expect you to be around for at least a couple more years, ideally for years and years to come, in service of your mission. Anyone can set up a street corner stage and say, "I'm going to do my work and, if you like it, drop a few bucks in my hat." No foul there. But once you incorporate, gain tax exempt status, and start taking people's hard-earned money as gifts to support you, you are making a pact with the public: "I thank you for your gift. I know you have many places and people where you can give, and we are honored by your support. We pledge to use this money well and to serve you, your friends, and your family with our mission." Organizations that exist for decades ultimately become institutions and owe their audiences, artists, funders, and individual donors clarity. A company can decide to dissolve, but that dissolution should ideally be planned, so that the organization's assets and audiences aren't just abandoned. When Theatre de la Jeune Lune collapsed, audiences, artists, and the community lost big.

THE CASE OF HEALING ARTS INITIATIVE

She started out saccharine sweet and very quickly devolved into something at the other end of the spectrum.

—Rev. Alexandra Dyer, former executive director of
Healing Arts Initiative[51]

THE STORY

Healing Arts Initiative (HAI) was based in New York City. Their mission was to provide art therapy for those in need, including hospital patients and persons with disabilities throughout the five boroughs. HAI had existed for decades, were much beloved by thousands of people, and had grown into a multimillion-dollar budget. Within two years of the arrival of a new executive director, however, the entire organization would collapse and disappear as if it had never existed, with a story of fraud, a physical attack, a staff suing its own board of directors, the board then firing that staff, lawsuits, arrests, a high-speed chase, bankruptcy, and the liquidation of the whole thing.

But unlike most collapses of nonprofits after a new leader arrives, this time it was not that new leader's fault. It was caused by multiple cracks and fissures throughout the organization, revealed and exploited by the main fraudster, an employee named Kim Williams. These cracks and fissures had predated Ms. Williams, though. The chief financial officer had been fired in 2012, shortly after Ms. Williams's arrival to HAI, when he reported to the board that he had found irregularities in their books. The board did not want to hear bad news, so they kept a blind eye to the organization—the exact opposite of what's expected of them.

BREAKING BAD

Kim Williams had begun work at HAI in 2011 as a temp and payroll clerk. By 2012, she had advanced to payroll manager and began setting up false accounts at the organization. From the *New York Times*: "Prosecutors said that, starting in 2012, Ms. Williams, 47, created dozens of bank accounts under fake names, where she deposited more than $600,000 for herself and another $150,000 for a friend, Pia Louallen, who was also arrested."[52]

Unlike Rita Crundwell, Ms. Williams had an accomplice, Pia Louallen, her friend and colleague who helped manage the fake transactions and cover Ms. Williams's internal tracks. Over the course of just three years, from 2012 to 2015, the duo embezzled almost $750,000 from HAI, causing checks to sometimes bounce and credit cards to be refused. These two staff members were able to continue because they were the only ones with total access to all of HAI's systems. At the same time, the board of directors seemed uninterested or unable to monitor irregularities and took very little action. An outside audit was performed sometime in 2014, but the auditor found no irregularities. One board member resigned in protest, fed up with problems not being addressed.

Strangely enough, the long-term executive director also resigned suddenly in the spring of 2015, giving the company only a few months' notice. The company culture, from board through staff, seemed to not encourage questions or clarity.

A NEW LEADER ARRIVES

Enter Reverend Alexandra Dyer. Rev. Dyer had led organizations in the past. When she began at HAI in the summer of 2015, she quickly surmised that something was not right. She hired a new Chief Financial Officer, Mr. Frank Williams (no relation to Kim), to help her figure out the company's financials. At first, Rev. Dyer did not suspect Kim Williams:

> Dyer acknowledged she was initially duped by her underling's public face after arriving at the institute. "She started out saccharine sweet and very quickly devolved into something at the other end of the spectrum," Dyer said of their professional relationship.[53]

Then she made perhaps a big error in judgment. Rather than quietly figure out and monitor what was happening, she held a staff meeting in the middle of August and confronted the staff. She let them know that she had found some strange things in their books, had suspicions of fraud, and that she and Mr. Williams would be getting to the bottom of it.

SURPRISE ATTACK

In the middle of the emergency staff meeting, Kim Williams announced she had a toothache and needed to go home. She left the meeting before it was over. She called in sick the next day, saying she had to go to the dentist for some emergency work on her teeth. Over the weekend on security cameras, she could be seen sneaking into the offices to retrieve some files and her personal belongings. She never came back to work. On August 19, 2015, at the end of a long day, Rev. Dyer was heading to her car in the HAI parking lot in Queens. A man stepped forward and asked, "Can I ask you something?" Before she could answer, he threw a cup of cleaning acid in her face. Rev. Dyer told police that night that "Kim Williams did this!"[54] Police would locate and arrest Kim Williams at a New Jersey Turnpike rest stop, as she was fleeing New York.

A TOXIC BOARD

When it became clear that the board of directors had ignored the fraud, Rev. Dyer and her new CFO, Mr. Williams, sued the board of directors on behalf of HAI, to try to have the board removed in order to save the organization. The board, in a stunning act, then fired Rev. Dyer and Mr. Williams, stating that Rev. Dyer and Mr. Williams had been holding back financial information from them, and that an IRS filing and several funding reports were due the next week and so the board felt the need to replace them

before these deadlines were missed. The board's arguments ring false, though, given pursuing and gaining an extension from the IRS for a tax filing from a nonprofit organization is not usually difficult. If funders had been alerted to the problems at HAI, they would have presumably understood why financial reports might have been a few weeks late. At the same time, the board itself seemed to be engaging in some questionable practices, including a board member, right up until the company's collapse, insisting that the company use $100,000 in city grants meant to support programs to instead pay his company for services rendered to HAI.

A LAST-DITCH EFFORT

On May 6, 2016, the *New York Times* shared the news that Rev. Dyer and Mr. Williams had been fired and replaced by Ken Berger, a former leader of the nonprofit Charity Navigator:

> "The only way to save this place," Mr. Berger said, was for them to work with him over "these precious few days." He said that though he knew some might be skeptical of him, there was no time to vet another executive director. "A decision has been made," Mr. Berger said. The staff members sat expressionless, except for a middle-aged man sitting across from Mr. Berger, who covered his face with his hands.[55]

All of the board's excuses seem unsupportable. Once the board had fired Rev. Dyer and Mr. Williams and hired Mr. Berger as an interim replacement, within just a few days the plan to save the organization quickly transformed into immediately shutting down the company. It had just been a matter of *nine months* from the time the fraud was discovered to the organization's total collapse. By May 11, just *five days* after Mr. Berger had been appointed to run HAI, the organization would be closed.[56]

HEALING ARTS INITIATIVE TIMELINE

- In 2010, according to their 990 reports to the IRS, the organization shifts reporting of their revenue from mostly contributed income to earned income. The fact that earned income is less subject to scrutiny and reporting than contributed income simply makes this choice in reporting interesting, assuming their actual income streams did not change that much in a single year, given what was about to happen, and the whistleblowing already happening by 2012, prior to Kim Williams's arrival.
- Kim Williams arrives in 2011.
- New accounts created in 2012 by Ms. Williams.
- Board fires CFO in 2012 after reporting concerns on mishandling of checks.
- Forensic accountant finds "no improper transactions" in January 2015.
- J. David Sweeny resigns suddenly in early 2015.
- Board member Kitty Lunn resigns over concerns in May 2015.
- Rev. D. Dyer arrives in July 2015.

- Rev. D. Dyer confronts staff on August 17, 2015, and announces the hiring of Mr. Frank Williams as CFO, who will "decipher the unbalanced books."
- Ms. Williams claims a toothache and leaves meeting on August 17; secretly clears out her files early morning of August 18, and calls in sick from work.
- Rev. Dyer is attacked on the evening of August 19, 2015.
- April 5, 2016: Kim Williams, Pia Louallen, and Jerry Mohammed are indicted for conspiracy.
- April 2016: Mr. D. Leslie Winter, chair of board, supposedly insists $100,000 from city for programming be used instead to pay off a loan from his small business loan company.
- April 2016: Rev. Dyer and Mr. Williams sue the board of directors to have them removed for malpractice.
- May 5, 2016: Rev. Dyer and Mr. Williams fired by board of directors; board hires Ken Berger to hopefully file 990 by May 15.
- May 10, 2016: Board announces closure of organization.
- June 2, 2017: HAI programs purchased by YAI (Young Adult Institute).[57]

QUESTIONS ON THE CASE

- Who is ultimately responsible for HAI's collapse?
- What roles did the board and staff each play in the company's demise?
- What issues of board and staff management are raised by the case?
- What role did the company culture play in the case?
- How could all these problems have been avoided? At what various points in the timeline could things have been handled differently and the company saved?

So, what happened? Yes, Kim Williams stole funds, was about to be caught, and hired someone to throw acid in the face of the new executive director. It is almost impossible to empathize with her or to understand her logic in seeing this attack as a means of escape. Perhaps she really meant to kill Rev. Dyer, not just wound her, or to at least scare her enough that she would leave HAI and never return. Ms. Williams certainly underestimated Rev. Dyer and her will to survive and pursue the truth. But beyond Ms. Williams, the HAI clearly had deep cultural problems. The board paid little to no attention to fiscal responsibility, internal controls, staffing or financial reports. They either did not understand or ignored their responsibilities as a board to govern and protect their nonprofit entity. They encouraged a culture of coverups and misinformation. They had perhaps been distracted by the purity of the HAI mission to ignore the structural deficiencies throughout the organization. While all these issues were ripe to explode, Rev. Dyer helped to light the match.

SEEKING OUTSIDE HELP

Instead of directly confronting a staff she barely knew about the fraud she suspected, Rev. Dyer could have gone to some select board members (either the chair or others she truly trusted) with these suspicions. Or if the board was unresponsive and she believed she could not trust them (which would be borne out later), Rev. Dyer could have contacted the New York attorney general's office or the FBI to ask them to investigate, as the mayor in Dixon, Illinois, had done to Rita Crundwell just four years earlier. When the internal politics or processes of a company make it unreliable and maybe unsafe to call out important issues, going to an outside authority, who is also charged to ensure nonprofits are operating legally, is the safer, more productive choice. We want to avoid getting personal or emotional when dealing with big issues of fraud and conflict in the workplace. It's better to call the authorities and have them slowly, silently build their case over time.

It is important not to blame Rev. Dyer for the actions taken by other adults. But unfortunately, everyone at HAI contributed in some small or large way toward its total annihilation. Similar to Theatre de la Jeune Lune, the loss of this organization ultimately mostly hurts its patients and artists. At the same time, Kim Williams, accomplice Pia Louallen, and the assailant Jerry Muhammad received sentences of seventeen years for their part in the fraud.[58] What a complete shame, to have these kinds of childish thefts and attacks on each other result in the loss of art for over 350,000 patients in need each year. Without HAI, their lives became a little bit darker and the work and legacy of this once-heralded organization have been completely lost to history.

BANKRUPTCY

John MacIntosh, who helped to lead HAI through bankruptcy court and to gain a merger with another New York–based nonprofit, the YAI, described their efforts in the *New York Times* in June of 2017.[59] Even though John seemed to think they had "saved" HAI at that point, he later led the efforts to completely dissolve and sell off what remained of the company's property. HAI's remaining programs and intellectual property were purchased by YAI, with the remaining program structures, their brand, and contacts. The then owners of HAI, Seachange Partners, also provided YAI with $100,000 to help support the integration of these existing programs into YAI, along with four members of the program staff from HAI, who needed gainful employment now that HAI was gone. This $100,000 presumably came in part from the over $600,000 insurance claim owned by HAI after its collapse. YAI in turn purchased the program branding, intellectual property and all the information on surviving programs from HAI for $25,000.

So, money changed hands, covering each organization's expenses in losing or gaining these final programs. As detailed in the court documents from the bankruptcy proceedings, YAI was the only organization willing to merge HAI programs into its organization. Beyond the existing programs aimed at serving community members in need with visits and performances, YAI also had little to no interest in exploring further

collaborations with HAI. The artwork and bus owned by HAI were to be sold to help pay off the company's debts. As some programs were shifted to YAI and remaining assets sold at auction to pay debts, HAI disappeared. It just flew into the wind, like blowing sand. In less than two years, it had gone from a thriving service organization doing good work and based in New York City, to a memory. Today, if you examine YAI's website, there's no mention of HAI, its programs, or its staff. It's gone. Poof.

FINAL THOUGHTS

The collapse of HAI is a tragedy, mostly because of the loss of services for patients who desperately need the arts in their lives as they heal. This case demonstrates how toxic the relationship between a board and staff can become, and how a lax company culture can predict disaster. Taking action earlier, asking questions, demanding answers, and seeking outside help when needed all could have saved this organization at different points in its history. Ultimately, a few mistakes in management coupled with a toxic board, rampant fraud, and a few bad staff members led to its demise.

THE CASE OF YOUNG PLAYWRIGHTS' THEATER

*I knocked on the door and said, "I'm 24. I'm here to teach playwriting. I've
never done it before, but I'll do it for free."*

—Karen Zacarías, founder of Young Playwrights' Theater

*The primary concern should be less about stability than it should be about re-
silience and adaptability, and how is it you build a resilient organization and a
flexible organization that can respond to periodic disruption.*

—Ben Cameron, president of the Jerome Foundation

*If you can't afford to make art and also be an antiracist organization, you don't
deserve to exist.*

—Brigitte Winter, executive director of Young Playwrights' Theater[60]

THE STORY

Young Playwrights' Theater (YPT) in Washington, DC, was founded by playwright
Karen Zacarías in 1995. Since then, the company has evolved and transitioned through
several life stages as an organization, surviving major crises in 2005 and 2017. Again
and again, YPT has demonstrated an ability to adapt and evolve in ways that other
organizations and managers can admire and hopefully learn from.

Beginnings

YPT founder, Karen Zacarías, reflects on how the company began: "I always
wanted to be a writer and an artist, but I didn't know how. I went to college for
international relations because I felt I needed to have some other job I could rely on.
My college did not have minors, but I did an equivalent of a minor in creative writ-
ing, but who's going to make a living from creative writing? So, I came to DC, and I
started working at the National Endowment for Democracy using my economics, and
Latin American policy. I looked at Georgetown evening classes, and Ernie Joselovitz
was teaching a playwriting class.[61] I'd written a play in college that had done well and
won a bunch of awards, and written some short stories that had done well. I attended
Ernie's playwriting classes, and that became my outlet while I was working this stress-
ful political job. I met Patricia Smith. We were the only two women in the class. We
became really good friends."[62]

Eventually Karen went to graduate school: "I decided to apply for graduate school
in playwriting. I also applied to Columbia Business School. I got into Boston Univer-
sity, which was a one-year writing program. I'm like, 'Oh, how hard could it be?' So,
I went and did my graduate work there in playwriting. It was one year. I was the only

student there who hadn't had any drama background, who hadn't majored in theater. That year, they only would produce one play by the five playwrights. And it ended up being mine. So, my play was the one that got produced and I had also received a scholarship." That scholarship would plant the seed that would quickly grow into YPT:

> Part of the scholarship was to try to design something to help the DC Community using what I learned in school. This is from the Melton Foundation. Because I had this background in working in international relations and working with nonprofit groups in Latin America, I wrote a pretty impressive grant proposal about using playwriting as a form of conflict resolution, as a form of arts empowerment and literacy in schools thinking that I would do it on weekends in a community center somewhere. And they so liked the proposal that they turned around and they said, "If we give you $20,000 to pay yourself and start the program, would you come back to DC and do it?" So here I was—I had the playwriting degree but I got this job. I said, "Sure, I'll come back" and that became the beginning of Young Playwrights' Theater. In the early '90s, DC was kind of at a turning point. And it felt to me that, you know, reaching out to kids and hearing their point of view was really important.

Karen identified so much with those kids that she dove forward into the work:

> For me, as an immigrant who came here at the age of ten, I really, really remembered how vulnerable it felt to be a ten-year-old here. I started by volunteering at Hardy Middle School. I knocked on the door and said, "I'm twenty-four. I'm here to teach playwriting. I've never done it before, but I'll do it for free." And one of the teachers handed me ten students, and I did the same at Bell Multicultural High School. I knocked on the door and I taught a high school class.

The power of what Karen was offering students was clear:

> That was the beginning, and it became very, very clear from the results of that there was something very empowering about it. That's where I started with the idea of YPT, but first YPT was just me. The money was channeled through Arena Stage and then through the African Continuum Theatre Company. It was during that process when I was working with Jennifer Nelson. She was a great mentor in that way. We started raising money. It worked well because we were both one-person operations, and we shared an office. Then, as we grew, Karen Evans left Arena Stage and Jose Dominguez left the Shakespeare Theatre Company, and we became our own company. Instead of being the appetizer, like at their previous companies, the work with students became the main course.
>
> I guess my career has always been about looking around where there's a need. People are like, "Oh, you're a playwright—you founded a playwriting company that didn't do your plays," I was like, "Yep. That's right."

Succession—The First Crisis

Nine years later, in 2004, Karen was ready to focus more fully on her playwriting career. YPT's board therefore hired an executive director from across the country, to

"professionalize" the organization and take the company to the next level. The new executive director had no background in arts education and no connection with or understanding of DC communities, schools, or students. Perhaps not surprisingly, this leadership transition failed. The new executive director failed to raise funds for the organization and incurred YPT's first ever major deficit, sapping the organization's cash reserves by approximately $250,000 (on a budget of under $500,000).

By late spring of 2005, the YPT board fired Karen's successor. The company was in crisis. Because the Melton Foundation had given YPT a gift of $500,000 to establish a cash reserve a few years before, the company still had approximately $250,000 in reserves. In early summer, the staff met with Karen to decide if the organization should continue or simply close. Maybe another organization should take the remaining cash reserves and run their own playwriting program instead of continuing YPT as a company? Maybe YPT had served its purpose and should cease to exist? Luckily, the staff discussed it deeply and honestly, and agreed that the organization should keep going. But if the cash reserve had not existed, YPT might have ended right then.

Second Chance

The YPT board of directors and Karen launched a search for a new successor. This time they looked for someone already working in arts education in DC, in hopes that an artist and educator already connected to this work and the DC community could better move the organization forward and drive its mission. After a search through the community and the interviewing of six finalists, David Snider was hired as the new producing artistic director and CEO.

Building a Better Boat

In August 2005, the company was still reeling from the trauma of the previous year. Programming was thin. The staff was down to two. Fundraising relationships were damaged. Finances were in tatters. Marketing didn't exist. The website was a placeholder with a few black and white photos. The company's computer equipment consisted of just a few old desktops, with no server or online backups, so files were scattered across various machines. YPT owned a fairly new touring bus that remained parked most of the year.

But the company did have strong relationships with a few donors and funders, deep ties to the community, and communal goodwill. Based on these few but important assets, and with the board and staff ready to try almost anything, the company slowly rebuilt staff, programming, fundraising, and finances. It pursued high-profile projects with partners, including the Smithsonian Institution, the White House, and the Kennedy Center. It deepened valuable school partnerships, working with the entire eleventh grade at Bell Multicultural High School. It also demonstrated that it was

reliable and innovative. A few key elements helped the company to survive and thrive beyond its first near-death experience:

- *Staffing.* The company hired Patrick Torres, a visionary young arts manager, to lead its programming. The next year Brigitte Winter and Elizabeth Andrews Zitelli rounded out the full-time staff, focused on fundraising and programming, respectively. With a stable, full-time staff of four, the organization developed programming, curriculum, fundraising, special projects, and productions.
- *Programming.* Under the leadership of Patrick Torres, the company refocused its programming to serve more students at fewer schools, in order to deepen its partnerships and develop laboratories where the curriculum could develop. Working every year with the entire eleventh grade at Bell Multicultural High School, for example, allowed YPT to fully integrate into the school's English curriculum.
- *Assessments.* A professional evaluator from New York, Dr. Barry Oreck, was hired to help develop new assessment tools aimed at capturing how playwriting in the classroom can affect and improve student learning.
- *Special Projects.* The company partially focused on creating plays based on specific social issues, with specific segments of the community and partner organizations. These projects allowed the company to raise its profile while developing new community-based work.
- *Awards.* From 2005 to 2012, YPT received the National Arts and Humanities Youth Program Award from the President's Committee on the Arts and the Humanities, the Essence of Leadership Award, and the Exponent Award for visionary leadership, among others.
- *Funding.* Within five years of Snider's arrival, YPT's cash reserves had been restored and the company was regularly raising half its annual budget prior to the beginning of the fiscal year. Corporate sponsorships, individual donations, and government grants all increased by at least 100 percent.
- *Marketing.* YPT developed a new logo and visual presence based on the company's mission and vision and designed two new websites, along with enhanced social media presences in order to communicate the work of its staff and students. In 2012, the company published its first book of student-written work, *Write to Dream.*

Under Snider's leadership, the mission of the organization focused on education, as demonstrated in the company's mission and core values from 2008:

"Young Playwrights' Theater (YPT) teaches students to express themselves clearly and creatively through the art of playwriting. YPT activates student learning and inspires students to understand the power of language and realize their potential as both individuals and artists. By publicly presenting and discussing student-written work, YPT promotes community dialogue and respect for young artists. Our Guiding Principles:

- Each student has a story worth telling.
- The arts are critical to excellence in education.
- The process is more important than the product.
- We strive for high standards from all who participate in our programs.
- We meet students where they are.
- We value collaborations and partnerships to leverage resources to accomplish our purpose.[63]

By the time David Snider stepped down in 2012, YPT possessed a sterling reputation, award-winning programming, clear policies, a restored cash reserve of over $500,000 and deep ties to funders, donors, and its community. Luckily Brigitte Winter, the company's deputy director, was eventually hired to succeed Snider as the new executive director of YPT, giving the company some much-needed continuity.

Next Phase of Growth—Next Crisis

Brigitte Winter then led the organization into a new phase of growth, continuing to develop programs and expand YPT's staff. Within three years, Winter had grown YPT to a staff of eight and had refocused the organization slightly away from arts integration to a more holistic approach, to emphasize "inspiring students to realize the power of their own voices," a core message that hearkened back to Karen Zacarías's original impulses. But in 2017, the company faced another existential crisis. This time, instead of a financial or leadership crisis, Young Playwrights' Theater faced a cultural crisis, as described on their website:

"In 2017, we found ourselves in crisis. For 20 years, Young Playwrights' Theater had been a predominantly white institution, and, like many nonprofit organizations, we had structures, policies, and practices in place that reinforced a white middle class dominant culture."[64] Further defining their use of "predominantly white institution," YPT Executive Director Brigitte Winter says:

> In the nonprofit space (outside of a university environment), "predominantly white institution" is a term used to describe an organization with majority white staff/contractors, especially when the people the organization serves are majority Black people, Indigenous people, and people of color. Defining YPT historically in that way does not erase the people of color who have worked with us since our founding. It acknowledges the ways that our organizational culture, and aspects of our program model, business structures, policies, and practices were influenced by white dominant culture, and needed to be examined, and in many cases reimagined in order for us to evolve into the actively anti-oppressive organization that our students, staff, and artists needed us to be.

While YPT had leaders, managers, and students of color throughout its history, it became suddenly apparent that white-, middle class–dominant culture had pervaded the company in ways that needed to be addressed and uprooted:

> Similar to other institutions, we knew we had a problem with diversity, and we made the too common mistake of trying to address that problem directly through intentional hiring before examining whether we had a culture in place that would actually be safe, inclusive, and welcoming for Black people, Indigenous people, and people of color. Pushing for rapid staffing change without truly examining our underlying culture led to an emergency. Our Black employees said they were unable to fully participate in YPT's office culture and do their best work. They were excluded from a culture that assumed trust, sameness, and 'good intentions,' and they had no clear or effective process for reporting or resolving micro-aggressions and other oppressive behavior they experienced from both managers and subordinates.
>
> And, when we attempted to talk as a staff about this issue, it became clear that we did not have a shared language for discussing racism and oppression, or a shared understanding of the harmful impact of our workplace culture. Our first internal conversation caused even greater harm, and led us to understand that we needed support from outside consultants to move toward repair and organizational transformation."[65] As Winter notes: "I knew right away that we needed help. There was a crisis. Our culture was broken.

Realizing they needed outside help, YPT engaged others with greater expertise:

> At the height of this crisis, we began work with antiracism consultants, Aaron Goggans and Rebecca Mintz, and focused on identifying the areas where YPT's culture and structures were perpetuating oppression. The first step in this process involved naming the harm that had occurred throughout our history and taking steps to repair that harm. Through facilitated staff meetings, caucuses, and one-on-one conversations, our consultants supported conversations about harm that had occurred, the ways white staff members had been harmful or complicit, and began to establish steps we had to take to repair that harm. As these conversations occurred over multiple months, we began to develop a shared language and regular practice of discussing race and oppression, a practice that is central to today's culture at YPT.[66]

YPT then describes how they turned their findings into action:

> The next step in our process involved coming together through a strategic planning process grounded in our antiracism and anti-oppression work, and facilitated by Aaron, Rebecca, and their collaborator, Brigette Rouson. With the support of these consultants, we created a shared set of antiracist and anti-oppressive values, rooted specifically in addressing anti-Black racism, that would become our guiding document and the lens for power distribution, organizational culture, and decision-making. In 2018, we developed our Touchstone and Core Values, a list of organizational values and guidelines for how we implement them.[67]

The company then lists their new Core Values: Acknowledging Oppression and Reducing Its Harm; Anti-Oppressive Communication; Responsive Flexibility; Respecting Autonomy; Commitment to Craft; Creative Collaboration; Commitment to Health and Safety.[68] They describe how these values helped them "re-center YPT's structure on anti-oppression and antiracism, including:

- Flattening our leadership structure and creating a shared leadership model in which each department director has full autonomy over their vision, budget, and staffing;
- Moving into a new office space following the unaddressed racial profiling of our employees and students perpetuated by our landlord in our previous space;
- Transitioning all administrative employees into W2 staff positions with access to all our benefits, regardless of the number of hours worked each week;
- Creating a No Retaliation Policy that covers micro-aggressions and other manifestations of oppression and prioritizes employee safety over employer security by exceeding existing anti-discrimination law, with a clear process for conflict reporting, and for resolving incidents of racism and oppression;
- Building a wellness room in our new space to support all nursing parents, despite our small staff size;
- Instituting twelve weeks of fully paid family and medical leave that exceeds the new DC requirements in both amount and eligibility for coverage.[69]

These extraordinary changes shifted YPT's way of working and provide a roadmap for other companies seeking to transform their company culture with active antiracism.

AROW and Antiracism

But YPT was not done there. They created a "Strategic Frame" to ground and activate their work: "Most importantly for YPT, our work is ongoing. Following the creation of our Core Values, we built a Strategic Frame that combines our mission, the touchstone informing our work, and our organizational values in a guiding document for our organization. We employ our Strategic Frame daily, grounding every organizational decision—from program delivery to production practices, from hiring to external communications, from fundraising to partnerships—in antiracist and anti-oppressive values. This Strategic Frame is a living document used every day at YPT, and we most recently updated it in 2020 to reflect new health and safety values codified during the COVID-19 pandemic."[70]

The company further reflects how this work has transformed the organization once again:

Today, YPT is a very different organization than we were in 2017. Thanks to our antiracism and anti-oppression work, not only is YPT a more just and inclusive or-

ganization, our service, our culture, and our structures and practices are significantly stronger than they were before.[71]

Not only did YPT transform their own practices, but they shared their findings and launched a consulting effort to help other organizations tackle these important issues: "After sharing our story with the DC theatre community in a presentation at theatreWashington's 2019 DC Theatre Summit, we created Abolishing Racism and Oppression in the Workplace (AROW), an initiative that supports other organizations committed to building antiracist and anti-oppressive structures and practices."[72] YPT's anti-racism work via AROW also provided some much-needed earned income.

QUESTIONS ON THE CASE

Risk Tolerance

A quick look at YPT's 990 tax returns show deficits of $18,978 in FY15, $58,651 in FY16, $74,277 in FY17, $195,989 in FY18, and $46,238 in FY19. Their last publicly available year ending in a surplus was FY14.[73] With this trend of five years in the red, the company's Fund Balance (aka Net Assets) was reduced from $1,045,568 to $651,436. Total Assets in FY15 were $1,131,369 and reduced to $706,869 by FY19.[74] Ideally, arts organizations should fluctuate more often between surpluses and deficits, in order to retain a strong fund balance. YPT's five-year downward trend begs the questions: Must deep, transformational change cause financial instability? Can board and staff members take a leap of faith and stick to it if they start to see their business model fall apart? How long can a company lose money before people lose faith and run back to old models or simply quit? YPT executive director Brigitte Winter, and the entire YPT staff, had to fight to keep these efforts going:

> I had to constantly make the case that this was going to pay off. I had to say to the board: "We're going to rebuild this business model and, once it's rebuilt, it will work." But it was several years of fights over deep deficits. I was ready for the board to fire me every year.

In FY20, after the organization had significantly evolved, their financial picture started to improve. YPT ended the 2020 fiscal year with a surplus of $14,177. Net Assets improved slightly from $651,436 to $665,613. Total Assets also grew from $706,869 to $828,216.[75] According to Winter, the arrival at a surplus after years of intense change reflected the fact that donors and funders were finally understanding the new vision:

> I think it was mostly due to the pay-off of community-building with donors and funders that we had been doing around our new mission, touchstone, and values. 2020 was our 25th anniversary year, and we spent it rallying our community around our vision for the next 25 years. If the pandemic hadn't happened and we'd been able to host our 25th anniversary event that spring, I think our surplus would have been even larger. FY21 is looking to be an even better year for our financials, and I expect our next audit to reflect close to a $100K surplus.

Cultural change seems to have required risk—and risk tolerance:

> It didn't happen right away. It took a couple years. It worked. Financially it has paid off. But it could have not—and that needed to be okay.

Prioritizing Change

According to YPT executive director Brigitte Winter, the focus on organizational transformation required the company to accept financial losses for a while as they decoupled the company's practices from hierarchical, metric-based, and therefore often historically racist pursuits of funding. YPT also knew they needed to keep investing in their people, including an expansion of benefits for all staff members and the move to a new facility. They also faced the fact that YPT might not survive this level of transformation:

> We were going to try this—and if we failed at it, then we failed at it—but then maybe we don't deserve to exist. If there isn't a way for our business model to function, and for us to make the money we need to make, and also be actively anti-racist and anti-oppressive, then maybe YPT doesn't need to exist in this world.

YPT was willing to face extinction in order to change. They prioritized anti-racism and cultural transformation over survival. Hopefully other arts organizations can be as brave. With any luck, funders and donors will catch up with YPT.

This case also demonstrates that rotating leadership (with at least four major transitions in the company's twenty-five-year history) might also play a key role in helping a company be more adaptive. Historically, arts leaders have often stayed in their positions for several decades before finally retiring, allowing too many companies to stagnate. Perhaps a new model of rotating leadership, with executive and artistic directors only being allowed to stay a certain number of years, will help engender the kind of adaptability we so desperately need.

Ultimately, because YPT had rebuilt itself to be stronger, the whole team was better prepared when the global pandemic hit. They also knew the company valued and prioritized them: "We pivoted immediately on how to deliver on our mission because of the way we were working together. We did not furlough a single staff member. We did not lay anyone off. People knew their jobs were secure."

FINAL THOUGHTS

YPT has survived at least two major crises during its twenty-five years of existence, coming out stronger each time. Some of the key elements that have allowed YPT to survive and thrive through these evolutions include:

- A clear mission;
- A focus on values;

- Cash reserves;
- Committed staff members;
- Supportive board members;
- Rotating leadership;
- A focus on innovation and adaptation;
- An ability to tolerate risk;
- An ability to change programming;
- No facilities ownership or large debt;
- Partnerships, with large and small organizations;
- Deep ties to their community; and
- A willingness to end the organization.

Ironically, the willingness to face extinction during both crises made it possible for YPT to honestly interrogate its values and ultimately survive. Too often organizations refuse to ask if they still matter, and instead focus on long-term "sustainability," no matter the costs. This kind of thinking in the arts has led companies to build extravagant facilities, take on huge amounts of debt, and expand staffing structures in ways that push an organization away from its mission, values, and community, and toward the accumulation of wealth at all costs.

It is clear that YPT has learned how to be adaptive, resilient, and relevant in the face of major disruptions. Others should learn from their example.

THE CASE OF HUBBARD HALL

We gather people from all walks of life to create, learn, and grow together, while developing, producing, and presenting world-class art and artists.

—Hubbard Hall Center for the Arts and Education[76]

There's a lot happening here.

—Gina Deibel, former Hubbard Hall program director[77]

THE STORY

The Hubbard Hall Center for the Arts and Education is a thriving arts center in the middle of farmland in Upstate New York. With a full season of new works and classics in theater, music, dance, visual arts, opera, and year-round classes, this multidisciplinary arts center cultivates, promotes, and sustains the cultural life of its rural community. This rare gem is a minor miracle, having survived and thrived for over 143 years as of this writing. What started in a nineteenth-century opera house with traveling artists performing vaudeville, theater, music, dance, and opera, along with lectures, political rallies, and high school graduations, is now a thriving twenty-first-century community-based arts center producing and presenting theater, opera, music, dance, and visual arts as well as artist residencies. Hubbard Hall's survival and evolution beg several questions. How has it survived all these years? How has its role changed? What can artists and arts organizations learn from Hubbard Hall?

Community Based Arts

Hubbard Hall was built in 1878 by local business leaders Martin and Mary Hubbard, with the radical idea that their community needed the arts in order to be happy and prosperous. This seemingly prescient, progressive idea was fairly common in the United States in the late nineteenth century. Opera houses and small theaters dotted the Northeast United States by the 1880s. In Washington County, New York, almost every village had at least one opera house, with Cambridge having two. They were called "opera houses" to inspire respect and avoid the bawdy baseness of theater, vaudeville, and minstrelsy, though those were performed more often than operas in these spaces. Hubbard Hall is the last remaining nineteenth-century opera house in Washington County. Unfortunately, many of these all-wooden opera houses, lit by gaslights, had burned to the ground by the early twentieth century. Hubbard Hall luckily did not—in part because the lighting system was updated to electricity by the 1890s and in part because the building was never entirely empty or abandoned. The presence of so many gas-lit burners would be daunting to a contemporary audience but was heralded by the editor of the local newspaper in his review of the space on November 28, 1878: "The arrangements for lighting the room are simply perfect; from the center of the ceiling

hangs a magnificent chandelier of twenty-four burners; on the sides four clusters of two burners each; in the galley three of the same. In addition to these there are fifty burners on and about the stage. All three lights are controlled from the stage."[78]

An Earlier Resident Theater Movement

In the United States, the resident theater movement is believed to have happened in the first half of the twentieth century, with places like the Cleveland Play House, the Alley Theatre in Houston, Texas, and Arena Stage in Washington, DC. But in fact, opera houses like Hubbard Hall functioned in many ways as resident theaters, with hundreds of traveling troupes of actors, musicians, lecturers, comedians, and other performers traveling the country to perform in them regularly. But rather than focusing on the artists being in permanent residence, as the later movement did, the nineteenth-century resident theater movement was focused on audiences and communities. Residents of Cambridge, New York, in the nineteenth century would see operas, vaudeville, guest lectures, theater, music, and more every weekend. The building was built to support and showcase traveling performances. Hubbard Hall was outfitted with a magician's trap door, a raked stage, gas footlights and stage lights, and scenery flats showing six scenes, including a forest, a street, a jail, and a parlor. Every traveling theater troupe would know that their play needed to fit into these painted settings, so playwrights would write plays to suit spaces like Hubbard Hall.

After Hubbard Hall officially opened on November 21, 1878, the local news editor was effusive in his review: "*The New Hall*—The general appearance of the hall was an agreeable surprise to everyone, it was so much handsomer than any other hall in the village or in any of our sister villages of the county. The public expected a fine hall but hardly so good a one as Mr. Hubbard presented to them on Thursday night. But outside of the pleasure one experiences is the tasteful decoration of this hall. The room will fairly seat about 600 people and will probably hold 700." It's important to note that Hubbard Hall today seats a maximum of 150 people in modern seating.

The editor continued to describe the beauty of the interior: "The frescoing is in excellent taste and does credit to the taste of the painter, George W. Burnham of Manchester, Vermont. The woodwork of the room is all in chestnut, the room being wainscoted, and the color of the walls harmonizes well with the oiled chestnut. The other scenes are six—street, parlor, forest, prison, kitchen and landscapes. It is as good a building as could be made, and no amount of pressure that will ever be put on will affect it in the slightest. The Hall is an ornament to the village and M. D. Hubbard is entitled to great credit for the liberality displayed in giving it to the village. There are some criticisms that might be made about the hall, but when the general result is so pleasing it would be ill to carp."[79] Note the lack of mention of Mary Hubbard, who seems to have inspired her husband, Martin, to build the Hall but gained no notice from the press.

Mary Hubbard

When Martin Hubbard died in 1884, his wife, Mary Nye Hubbard, was forced to sue the village of Cambridge for control of her property and money. The local insanity commission, which had managed Martin's affairs for the last few years of his life, gave control of Mary's money and property to the village mayor, who was a man and therefore considered more appropriate to manage the Hubbard estate. Eventually, Mary won control of her estate and Hubbard Hall. She then led the Hall as a dynamic and socially active hotspot for the next twenty-five years. In 1891, she had the Hall renovated, expanding the stage, adding more decorative flourishes to the proscenium, and having artist Charles Huiest of Troy, New York, paint a new grand drape and six new sets of classic scenery for the theater (two of which are still in use today). Mary was also very active in social campaigns for Prohibition and Women's Suffrage with her dear friend and colleague Susan B. Anthony. During its first fifty years, Hubbard Hall functioned much as the town commons of Cambridge, New York, with continuous political rallies, high school graduations, and even church services, hosting equally Catholics and Protestants, Republicans, and Democrats. Susan B. Anthony led a three-day Women's Suffrage Convention in Hubbard Hall on February 8–10, 1894, hosted by Mary Hubbard.

The Golden Years

From 1878 until its initial closing in 1927, Hubbard Hall presented thousands of traveling operas, plays, concerts, magic acts, special events, and lectures to the people of Cambridge and Washington County, New York. It was very much a theater of its time, with gas lights throughout, a grand drape, painted stage flats with vaguely European scenes suitable to the traveling shows of the time, and details on its proscenium and walls that evoked the grander performance spaces of London and Paris. And while the Hall was certainly a product of its era, presenting dozens of touring productions of the antislavery *Uncle Tom's Cabin* along with decades of minstrel shows, it also awakened its patrons to world-class orators and artists from around the world.

The renowned Fisk Jubilee Singers performed five times. Go-Won-Go Mohawk, one of the only Native American actresses at the time, appeared in 1890. Camilla Urso, one of the first women in America to publicly perform violin, played in 1883. In 1894, on their way to perform in Washington, DC, the South African Native Choir shared their voices and spirits with the community. Durno the Mysterious, a famous Lyceum circuit magician from Illinois, dazzled Hall patrons many times. And hearts and minds were opened here by the orations of Judge Ben B. Lindsey, a prominent reformer of the juvenile justice system whose efforts also focused on women's issues, labor rights, sex education, environmental conservation, and censorship. Unfortunately, in 1909 Mary Hubbard died. Activities in the Hall began to focus more on pure entertainment and less on socially relevant programming.

The Hall Goes Dark

By 1927, the Hall was showing serious wear and tear, having not been updated since a minor renovation in 1916. Vaudeville and traveling theater circuits were dying out, as American audiences gravitated to their radios and the exciting movie houses cropping up all over the United States. A. B. McNish bought the Hall from Mary Hubbard's estate in 1913 and owned and ran his dry goods store on the ground floor. While he tried to make a go of the upstairs Hall with his 1916 installation of a new dance floor and newly varnished woodwork, Mr. McNish was a businessman focused on his store, rather than on programming the Hall in the dynamic ways Mary had done. In 1927 a movie theater opened in the same neighborhood as Hubbard Hall, consequently eliminating any remaining audiences in Cambridge for the few struggling vaudeville and theater troupes traveling through Upstate New York. While the store-fronts on the ground floor remained active as dry goods and village store businesses, the upstairs Hall sat mostly dark and inactive for fifty years.

A Reawakening

In 1977 a group of like-minded community members became aware of the Hall's owner's willingness to sell the property for the price of $20,000. Rallying the Cambridge community to raise most of this money from small donations, the community formed a nonprofit, Hubbard Hall Projects, Inc., and got to work restoring and activating Hubbard Hall once again, starting with a small café and coffeehouse in the basement, suitably named "Under the Bell Tower." Benjie White, one of the original founders of this nonprofit in 1977, became executive director of the organization in 1981 and led the company through a huge amount of growth, renovation, and artistic achievement until his retirement in 2014. The vast amount of work to restore and repair the Hall from 1978 until 2014, in addition to the purchase and transformation of three additional nineteenth-century freight buildings into a dance studio, art studio, and black box theater, allowed Hubbard Hall to become the Hubbard Hall Center for the Arts and Education, offering dynamic year-round programming in theater, opera, music, and dance, plus classes in a wide variety of arts and education, from Irish step and tai ji to yoga and gardening.

A Return to Progressive Ideals

For years after the Hall was reopened in 1977, the Hall's leadership only referred to Martin Hubbard, not Mary, and stayed conservative in their programming and practices, not wanting to agitate the locally conservative community. But with new leadership arriving in 2014, new research of the Hall's history began. Forty years after Hubbard Hall was reactivated, in 2017, the organization unearthed the history of Mary

Hubbard and her leadership of the Hall as a socially active space. After the rediscovery of Mary Hubbard and her support of both conservative and progressive causes, Hubbard Hall was again able to embrace and activate its role as a contributor to the social fabric of the Cambridge community. The Hall became more socially active, sparking new programs in support of the LGBTQIA+ community and the movement for Black lives, along with efforts to eliminate the local school's race-based mascot and raise funds for missing and exploited women. At the same time, Hubbard Hall leaned into supporting local entrepreneurs, helping to incubate, guide, and promote local businesses and artists. With a return to its role as more of the town commons for its community, Hubbard Hall returned to the progressive ideals of its original founder, Mary Hubbard. In some ways, the organization had come full circle, finding inspiration for its role in the twenty-first century from its nineteenth-century leader.

QUESTIONS ON THE CASE

Today Hubbard Hall is a thriving arts center dedicated to cultivating, sustaining, and promoting the cultural life of its rural community in Washington County, New York, and throughout the Capital Region.[80] Since 1977, the nonprofit has continued to grow and deepen its roots in the community. But how? What were some key elements that allowed this nineteenth-century opera house to survive and thrive to this day?

Strengths, Weaknesses, Opportunities, and Threats (SWOT)

A quick analysis of Hubbard Hall's inherent strengths, weaknesses, opportunities, and threats can help us understand why it has survived and what challenges it faces now.

Strengths
- *A flexible, beautifully designed space.* The original opera house is a rare, gorgeous example of nineteenth-century design and construction. Seating has always been flexible and never fixed in the Hall, so that the space can be used for dances, meetings, rallies, as well as performances. This flexibility means that the Hall can adjust the size of its audience at will. It also means, along with conservative budgeting, that the Hall does not need to sell a certain number of tickets in order to succeed.
- *No significant debt.* In the nineteenth century, the Hall was owned by a single patron and managed as a for-profit business. When the nonprofit was launched, the community raised the necessary funds and volunteered their labor to restore and reactivate the building. Fiscal conservatism kept the Hall from ever taking on onerous debts.
- *Deep community ties.* In its original nineteenth-century iteration and as a twentieth-century nonprofit, Hubbard Hall has been owned and operated by local

community members. These deep local ties helped garner local financial support and participation.

- *A committed board and staff.* Local leaders, parents, and business owners have served as the Hall's board; Hall staff members tend to stay more than five years each, giving the Hall much-needed continuity.
- *A large volunteer pool.* Local retirees and students volunteer to assist with Hall programs, performances, and projects.
- *Partnerships.* Hubbard Hall often partners with local school districts, businesses, and New York City–based arts organizations. These partnerships allow the Hall to provide programming in schools, gain sponsorships while highlighting businesses, and build artist residencies and collaborative projects.

Weaknesses

- *A lack of diversity.* Located in Washington County, New York, which is 95 percent white, Hubbard Hall suffers from a lack of racial and cultural diversity and must engage in partnerships, artist residencies, and fellowships to engage more racially and culturally diverse artists. In the nineteenth century, Hubbard Hall was able to host touring artists from around the world. Today, the Hall must proactively build these opportunities.
- *A small, mostly part-time staff.* In the nineteenth century, Hubbard Hall maintained one custodian or manager to maintain and manage the space, while all other functions including ticketing, show booking, and promotion were handled by other businesses in town. In recent years, the Hall still only maintains one or two full-time staff positions, because of the lack of resources available for an arts center in a rural community.
- *Four historic buildings with little to no facilities funding.* Hubbard Hall's space has always been maintained in part by volunteers. Today, the organization maintains four historic buildings often in need of repair. Raising funds to maintain or improve facilities can be challenging, as is finding quality human resources to maintain these facilities in a rural community.
- *Inadequate resources to produce and present theater, music, dance, opera, and the visual arts in ways that are competitive with nearby touring facilities.* With a budget of less than $500,000, Hubbard Hall cannot compete in production values with largely Broadway touring houses, opera or dance companies, or artist colonies.

Opportunities

- *Artist residencies.* With a beautiful, peaceful setting and several spaces on campus, Hubbard Hall is building partnerships with other arts organizations to host artists in residence while they develop new work. These residencies bring artists who enrich Hubbard Hall and the Cambridge community, while supporting artists, new work development, and the larger arts field.
- *A melding of community and professional models.* Many arts organizations are now searching for ways to engage their communities more deeply for the first time. Hubbard Hall already has a history and many precedents of creating work and

engaging its campus with a blend of community and professional artists. In the trend for arts organizations to become more community-engaged, Hubbard Hall is ahead of the curve.

- *A rural arts model.* Hubbard Hall has engaged and excited its rural audience for over 140 years and can demonstrate how the arts function in rural communities.
- *Healing opportunities.* Hubbard Hall can provide a safe space for people of diverse and divisive views, as it did in the nineteenth century. It can help heal its community and serve as the town commons again, via performances, classes, and community events.

Threats

- *Rising prices and regulations.* Costs of insurance, utilities, and other services continue to rise, especially in rural areas where services are limited and therefore vendors often have a de facto monopoly. The rising costs of maintaining four historic buildings, implementing programs, and supporting a staff in a rural community is outpacing any increases in funding or donations.
- *Climate change.* As the Hall's mostly wooden facilities continue to age, extremes in temperature and fuel costs threaten the organization's ability to maintain and update these facilities.
- *Extreme politics.* As U.S. politics become more and more divided and extreme, small rural communities can become deeply, bitterly divided. In a solidly progressive state but a drastically conservative region and county, Hubbard Hall may lose audience members, students, and local artists if the community balks at spending time with their neighbors on the other side of the divide.
- *Social media and streaming services.* The pervasiveness of social media and online streaming is leading to more passive, toxic, and isolated communities. Hubbard Hall's campus is intended to be used and visited in person by its community. Society's trend toward living online threatens the live arts, especially live community-based arts.

FINAL THOUGHTS

The ways in which Hubbard Hall was built, managed, and brought back to life as a nonprofit infused the organization with deep community ties, flexibility, and a hybrid model of community and professional artists, in ways that many arts organizations might now envy. Because the building was never abandoned, badly damaged, or renovated, Hubbard Hall stands as a rare and active testament to performing arts in the United States in the late nineteenth and early twentieth centuries.

In many ways, Hubbard Hall's focus on high quality programming, coupled with the organization's focus on its local community, set it up for success in ways that many arts organizations are only now coming to understand. Studies like *The Alchemy of High-Performing Arts Organizations* by the Wallace Foundation and SMU DataArts reflect how essential the cornerstones of deep community connections and excellent programming are to any arts organization's success.[81] While the Hall's story is unique,

considering how Hubbard Hall survived and thrived can hopefully help other arts organizations do the same.

<div align="center">NOTES</div>

1. Valentina Di Liscia, "Indianapolis Museum of Art President Resigns After Facing Backlash for Offensive Job Posting," *Hyperallergic*. February 17, 2021. https://hyperallergic.com/622740/indianapolis-museum-of-art-president-resigns/.

2. Sarah Bahr, "Indianapolis Museum of Art Apologizes for Insensitive Job Posting," *New York Times*, February 13, 2021. Accessed June 3, 2021. https://www.nytimes.com/2021/02/13/arts/design/indianapolis-museum-job-posting.html

3. Ibid.

4. Domenica Bongiovanni, "Curator calls Newfields culture toxic, discriminatory in resignation letter," *Indianapolis Star*, July 18, 2020. Accessed June 3, 2021. https://www.indystar.com/story/entertainment/arts/2020/07/18/newfields-curator-says-discriminatory-workplace-toxic/5459574002/?fbclid=IwAR0SBlSi70kri2wsMOB0WEfET1I4TxeCViLyechkgRmL_2Pigj7OVPIJCt4.

5. Ibid.

6. https://docs.google.com/document/u/0/d/1yL1oStV2qc5Kj_V8ldego89SwQ_kBC-NEe27EX2jwpQ/mobilebasic.

7. ARTFORUM, "CHARLES VENABLE STEPS DOWN AS HEAD OF INDIANAPOLIS MUSEUM OF ART," *ARTFORUM*, February 18, 2021. https://www.artforum.com/news/charles-venable-steps-down-as-head-of-indianapolis-museum-of-art-85095#:~:text=Charles%20Venable%2C%20president%20of%20Newfields,recruiting%20site%20drew%20public%20outrage.

8. Sarah Bahr, "Charles Venable Resigns as Head of Indianapolis Museum of Art," *New York Times*, February 17, 2021. Accessed June 3, 2021. https://www.nytimes.com/2021/02/17/arts/design/charles-venable-resigning-indianapolis-museum.html.

9. Newfields, "Letter from the Board of Trustees and Board of Governors," Newfield's, February 17, 2021. Accessed June 3, 2021. https://discovernewfields.org/statement.

10. Andrew Russeth, "The Ringmaster: Is Charles Venable Democratizing a Great Art Museum in Indianapolis—or Destroying It?" *ARTNews*, July 9, 2019. Accessed June 3, 20201. https://www.artnews.com/art-news/news/charles-venable-newfields-indianapolis-museum-12938/.

11. Robin Pogrebin, "Clean House to Survive? Museums Confront Their Crowded Basements," *New York Times*, March 12, 2019. Accessed June 3, 2021. https://www.nytimes.com/interactive/2019/03/10/arts/museum-art-quiz.html.

12. Andrew Russeth, "The Ringmaster: Is Charles Venable Democratizing a Great Art Museum in Indianapolis—or Destroying It?" *ARTNews*, July 9, 2019. Accessed June 3, 20201. https://www.artnews.com/art-news/news/charles-venable-newfields-indianapolis-museum-12938/.

13. Domenica Bongiovanni, "Mini-golf—yes, mini-golf!—returns with new Hoosier flair at Indianapolis Museum of Art," *Indy Star*, April 27, 2017. Accessed June 3, 2021. https://www.indystar.com/story/entertainment/arts/2017/04/27/mini-golf-yes-mini-golf-returns-new-hoosier-flair-indianapolis-museum-art/100716046/.

14. Andrew Russeth, "The Ringmaster: Is Charles Venable Democratizing a Great Art Museum in Indianapolis—or Destroying It?" *ARTNews*, July 9, 2019. Accessed June 3, 20201. https://www.artnews.com/art-news/news/charles-venable-newfields-indianapolis-mu seum-12938/.

15. Zachary Small, "How Museums Use—and Misuse—Corporate Consultants as a Bandaid to Address Diversity and Solve Their Biggest Problems," *artnet news*, February 25, 2021. Accessed June 3, 2021. https://news.artnet.com/art-world/museum-consultancy-1946134.

16. Maxwell Anderson, "I Led the Indianapolis Museum of Art for Five Years. Here's How Charles Venable, Its Recently Ousted President, Failed the Institution," *artnet news*, February 23, 2021. Accessed June 3, 2021. https://news.artnet.com/opinion/indianapolis-museum-of -art-maxwell-anderson-1945878.

17. Robin Pogrebin, "Amy Sherald Directs Her Breonna Taylor Painting Toward Justice," *New York Times*, March 7, 2021. Accessed June 3, 2021. https://www.nytimes .com/2021/03/07/arts/design/amy-sherald-breonna-taylor-painting.html?action=click&modul e=RelatedLinks&pgtype=Article.

18. Scott Reyburn, "JPG File Sells for $69 Million, as 'NFT Mania' Gathers Pace," *New York Times*, March 11, 2021. Accessed June 4, 2021. https://www.nytimes.com/2021/03/11/arts/ design/nft-auction-christies-beeple.html?searchResultPosition=10.

19. Kyle Chayka, "How Beeple Crashed the Art World," *New Yorker*, March 22, 2021. Accessed June 3, 2021. https://www.newyorker.com/tech/annals-of-technology/how-beeple -crashed-the-art-world.

20. Robin Pogrebin, "Amy Sherald Directs Her Breonna Taylor Painting Toward Justice," *New York Times*, March 7, 2021. Accessed June 3, 2021. https://www.nytimes .com/2021/03/07/arts/design/amy-sherald-breonna-taylor-painting.html?action=click&module =RelatedLinks&pgtype=Article.

21. Ibid.

22. Valentina Di Liscia, Hakim Bishara, "Whitney Museum Cancels Show After Artists Denounce Acquisition Process, Citing Exploitation," *Hyperallergic*, August 25, 2020. Accessed June 28, 2021. https://hyperallergic.com/584340/whitney-museum-black-lives-matter-covid -19-exhibition-canceled/.

23. Holland Cotter, "Breonna Taylor Show Puts Art Museums on a Faster Track," *New York Times*, April 11, 2021. Accessed June 3, 2021. https://www.nytimes.com/2021/04/11/arts/ design/breonna-taylor-review-museum-louisville.html?referringSource=articleShare.

24. Ibid.

25. Kyle Chayka, "How Beeple Crashed the Art World," *New Yorker*, March 22, 2021. Accessed June 3, 2021. https://www.newyorker.com/tech/annals-of-technology/how-beeple -crashed-the-art-world.

26. Ibid.

27. Ibid.

28. Hiroko Tabuchi, "NFTs Are Shaking Up the Art World. They May Be Warming the Planet, Too," *New York Times*, April 16, 2021. Accessed June 3, 2021. https:// www.nytimes.com/2021/04/13/climate/nft-climate-change.html?smtyp=cur&smid=fb -nytimes&fbclid=IwAR0oCK8-b6O2aEheidpnYfo-uHnsKGz-BRJWbHcCI7d-96 zsmBLPN8kcP2E.

29. Carolina A. Miranda, "Q&A: Artist Sam Durant was pressured into taking down his 'Scaffold.' Why doesn't he feel censored?" *Los Angeles Times*, June 17, 2017. Accessed May 29,

2021. https://www.latimes.com/entertainment/arts/la-et-cam-sam-durant-scaffold-interview -20170617-htmlstory.html.

30. Ibid.

31. Jeff Wagner, "Controversial Walker Art Sculpture to Soon Be Buried," CBS 4 WCCO Minnesota, September 2, 2017. Accessed May 29, 2021. https://minnesota.cbslocal .com/2017/09/02/scaffold-sculpture-burial/.

32. CBS 4 WCCO Minnesota, "Artist Behind Walker's 'Scaffold' Offers 'Deepest Apologies' For 'Thoughtlessness,'" May 30, 2017. Accessed May 29, 2021. https://minnesota.cbslocal .com/2017/05/30/scaffold-artists-statement/.

33. Sheila M. Eldred, "Walker Art Center's Reckoning With 'Scaffold' Isn't Over Yet," *New York Times*, September 13, 2017. Accessed May 29, 2021. https://www.nytimes .com/2017/09/13/arts/design/walker-art-center-scaffold.html.

34. Sheila M. Eldred, "Dakota Plan to Bury, Not Burn, 'Scaffold' Sculpture," *New York Times,* September 1, 2017. Accessed May 29, 2021. https://www.nytimes.com/2017/09/01/ arts/design/dakota-plan-to-bury-not-burn-scaffold-sculpture.html.

35. Ibid.

36. Andrew R. Chow, "Olga Viso, Embattled Leader of Walker Art Center, Steps Down," *New York Times*, November 14, 2017. Accessed May 29, 2021. https://www.nytimes .com/2017/11/14/arts/design/olga-viso-walker-art-center-to-step-down.html.

37. Alicia Eler, "Walker Art Center rebuilds its relationship with Minnesota artists. The center is taking steps to repair relationships," *Minneapolis Star Tribune*, March 12, 2021. Accessed May 29, 2021. https://www.startribune.com/walker-art-center-rebuilds-its-relationship-with -minnesota-artists/600033532/.

38. The Fifth Estate, "Rita Crundwell—Fraud in Dixon Illinois: Small Town Shakedown," July 25, 2016. Accessed May 29, 2021. https://www.youtube.com/watch?v=WAYtaFxlw3M.

39. Harry Bradford, "Dixon, Illinois Comptroller Allegedly Embezzled $30 Million to Fund Horse Breeding Business," *Huffington Post*, April 19, 2012. Accessed May 29. 2021. https:// www.huffpost.com/entry/rita-crundwell-comptroller-dixon-illinois-embezzling_n_1435899.

40. Fox News, "Illinois city official accused of stealing $30M from taxpayers," Fox News, December 23, 2015. Accessed May 29, 2021. https://www.foxnews.com/politics/illinois-city -official-accused-of-stealing-30m-from-taxpayers.

41. WQAD HD News 8, "Nervous, like a spooked horse." Last updated May 4, 2012. Accessed May 29, 2021. https://www.youtube.com/watch?v=oJcsjoyPq9o.

42. The Fifth Estate, "Rita Crundwell—Fraud in Dixon Illinois: Small Town Shakedown." Last updated July 25, 2016. Accessed May 29.2021. https://www.youtube.com/ watch?v=WAYtaFxlw3M.

43. Sheila Callaghan, "Former Theatre de la Jeune Lune board member plans new cultural venue in the company's past home," *TC Daily Planet*. Accessed April 25, 2021. https://www .tcdailyplanet.net/former-theatre-de-la-jeune-lune-board-member-plans-new-cultural-venue/.

44. Kenneth Jones, "Theatre de la Jeune Lune, Innovative Tony-Winning Regional Troupe, to Shut Down." Accessed April 25, 2021. https://www.playbill.com/article/theatre-de-la-jeune-lune-innovative-tony-winning-regional-troupe-to-shut-down-com-151134#:~:text=The%20 board%20of%20directors%20of,arts%20group%20as%20currently%20organized.&text=The%20 announcement%20was%20made%20June%2022.

45. Ibid.

46. Ibid.

47. Ibid.

48. Marianne Combs, "Theatre de la Jeune Lune closes," Minnesota Public Radio, June 22, 2008.

49. CNN Money, "Victims of the crash." Accessed April 25, 2021. https://money.cnn.com/galleries/2008/smallbusiness/0811/gallery.victims_of_the_crash.smb/6.html.

50. Sheila Callaghan, "Former Theatre de la Jeune Lune board member plans new cultural venue in the company's past home," *TC Daily Planet*. Accessed April 25, 2021. https://www.tcdailyplanet.net/former-theatre-de-la-jeune-lune-board-member-plans-new-cultural-venue/.

51. Noah Goldberg and Larry McShane, "Queens acid-toss victim hails prison term for mastermind of her gruesome attack," *New York Daily News*, January 17, 2019.

52. Rick Rojasapril, "Nonprofit Executive Attacked with Drain Cleaner in Embezzlement Cover-Up, Officials Say," *New York Times*, April 5, 2016.

53. Noah Goldberg and Larry McShane, "Queens acid-toss victim hails prison term for mastermind of her gruesome attack," *New York Daily News*, January 17, 2019.

54. Andy Newman, "Missing Money, a Vicious Attack and Slow Healing for a Charity's Leader," *New York Times*, April 28, 2016.

55. Andy Newman, "Charity Fires Leader Who Questioned Finances and Suffered Lye Attack," *New York Times*, May 6, 2016.

56. Andy Newman, "Charity Whose Leader Was Attacked with Lye Closes," *New York Times*, May 11, 2016.

57. https://www.yai.org/about.

58. Noah Goldberg and Larry McShane, "Queens acid-toss victim hails prison term for mastermind of her gruesome attack," *New York Daily News*, January 17, 2019.

59. John MacIntosh, "Coming back from bankruptcy: How we fixed Healing Arts Initiative," *New York Times*, June 5, 2017.

60. Author interview with Brigitte Winter, June 15, 2021. All quotes from Brigitte Winter that follow are from the interview, unless otherwise noted.

61. Ernie Joselovitz later became one of YPT's early playwriting instructors along with Karen.

62. Patricia Smith was then Patricia Smith Melton, and the Melton Foundation provided a scholarship for Karen to attend Boston University and would ultimately provide a $500,000 cash reserve to secure Young Playwrights' Theater.

63. Young Playwrights' Theater, "Young Playwrights' Theater Case for Support," September 2, 2008.

64. Young Playwrights' Theater, "Our Story." Accessed June 13, 2021. https://www.youngplaywrightstheater.org/our-story-1.

65. Ibid.

66. Ibid.

67. Ibid.

68. Ibid.

69. Ibid.

70. Ibid.

71. Ibid.

72. Ibid.

73. "Deficit" here indicates a net negative at the end of the fiscal year, with expenses higher than income. "Surplus" indicates a net positive, with annual income greater than expenses.

74. GuideStar, "Young Playwrights' Theater, Inc. IRS forms 990: 2015-2019," Accessed June 13, 2021. https://www-guidestar-org.lib-proxy01.skidmore.edu/profile/52-2102391.

75. Kositzka, Wicks, and Company (KWC), "Young Playwrights' Theater Financial Statements June 30, 2020 and 2019," Kositzka, Wicks and Company (KWC), October 26, 2020. Accessed June 15, 2021.

76. Hubbard Hall, "About." Accessed June 14, 2021. https://hubbardhall.org/about/.

77. Gina Deibel, "What's Hubbard Hall?" Hubbard Hall. Accessed June 20, 2021. https://www.youtube.com/channel/UCmQhVFPqEG8cO5X-V4DMAEw.

78. James S. Smart, "The New Hall," *Washington County Post,* November 28, 1878.

79. Ibid.

80. David Snider. "Historical Background and Context with Chronology of Development and Use for Hubbard Hall," Hubbard Hall, December 8, 2019.

81. Dr. Zannie Voss and Dr. Glenn Voss, "The Alchemy of High-Performing Arts Organizations," SMU DataArts, August 2020, 2–21.

INDEX

ABOUT THE AUTHOR

David Andrew Snider has more than twenty-five years of experience as an educator, producer, and administrator and is the president and CEO of Integrated Arts Management, LLC, a consulting firm dedicated to helping arts organizations thrive. Currently also the executive and artistic director of the Hubbard Hall Center for the Arts and Education in Cambridge, New York, David has launched several new artistic and education programs on the campus of Hubbard Hall, greatly expanded the company's outreach to the community, and established the company's first ever major endowment fund. Prior to Hubbard Hall, David served as the director of artistic programming at Arena Stage at the Mead Center for American Theater in Washington, DC, where he directed artistic programming and season planning, oversaw new work development, and commissioned a wide array of artists, including commissions to Lynn

David Andrew Snider.
John Sutton.

Nottage for the Pulitzer Prize–winning *Sweat* and Lawrence Wright for *Camp David*. David once worked with Pulitzer Prize–winning playwright Katori Hall on five plays in six days and witnessed her brilliant artistry and management firsthand.

As the producing artistic director and CEO of Young Playwrights' Theater, David established partnerships and developed projects with the White House, the Kennedy Center, and the Smithsonian Institution, while building nationally recognized programs, a resident company of high-profile artists, and a series of award-winning community-based projects. David received the Meyer Foundation's $100,000 Exponent

Award for visionary leadership of a nonprofit, the National Arts and Humanities Youth Program Award from the President's Committee on the Arts and the Humanities, and the Hands On Greater DC Cares' Essence of Leadership Award. David is a directing fellow of the Drama League of New York, a past president of the League of Washington Theatres, a member of Leadership Greater Washington, and a National Arts Strategies chief executive fellow. David received his MFA from New York University, Tisch School of the Arts, and his BA in English Literature/Russian language from Dickinson College, magna cum laude, Phi Beta Kappa. David has taught arts management for over a decade at the graduate and undergraduate levels, first at American University and currently as a lecturer in the Arts Administration program at Skidmore College. He resides in the village of Cambridge, New York, with his wife and children. For more information, visit thedavidsnider.com.